the haunted self

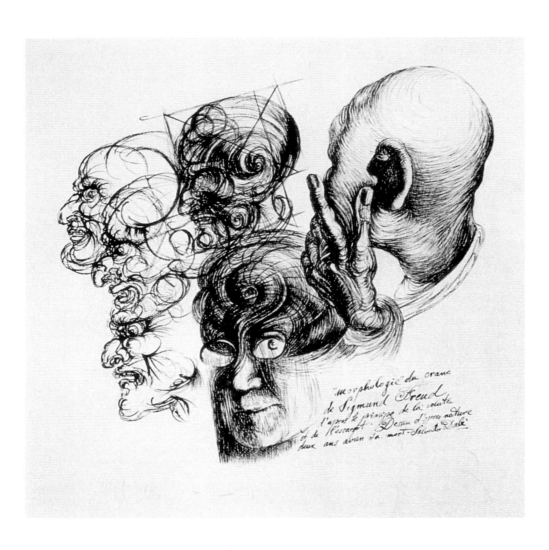

"morphologie" du crane
de Sigmund Freud
d'après le principe de la voûte
et de l'escargot. Dessin d'après nature
deux ans avant sa mort - Salvador Dalí

the haunted self

SURREALISM

PSYCHOANALYSIS

SUBJECTIVITY

david lomas

YALE UNIVERSITY PRESS

NEW HAVEN AND LONDON

Designed by Abby Waldman and Elizabeth McWilliams

Printed in China

Library of Congress Cataloging-in-Publication Data

Lomas, David
 The haunted self : surrealism, psychoanalysis, subjectivity / David Lomas.
 p. cm.
 Includes bibliographical references and index.
 ISBN 0-300-08800-0 (cloth : alk. paper)
 1. Psychoanalysis and art. 2. Surrealism I. Title.
 N72.P74 L66 2000
 759.06′63′019 – dc21 00-040835

A catalogue record for this book is available from the British Library

The author wishes to acknowledge Sigmund Freud © Copyrights, The Institute of Psychoanalysis and the Hogarth Press for permission to quote from *The Standard Edition of the Complete Psychological Works of Sigmund Freud* translated and edited by James Strachey.

Some parts of this book have been previously published as follows:

'Mirô: Tracing the Origin. From *Moi* to *Birth of the World*', *Apollo* 139, no 381 (November 1993): 279–83.

'Inscribing Alterity: Transactions of Self and Other in Mirô Self-Portraits' in *Portraiture: Facing the Subject*, edited by Joanna Woodall (Manchester: Manchester University Press, 1996), 167–86.

'The *Metamorphosis of Narcissus*: Dalì's Self-Analysis' in *Salvador Dalì: A Mythology*, edited by Dawn Ades and Fiona Bradley (Tate Gallery Liverpool, October 1998 – January 1999), 78–100.

'Time and Repetition in the Work of André Masson' in *André Masson: the 1930s*, edited by William Jeffett (Salvador Dalì Museum, St. Petersburg, Florida, October 1999 – January 2000), 37–54.

Frontispiece: Original pen and ink drawing for Salvador Dalì, *The Secret Life of Salvador Dalì* (New York: Dial Press, 1942). Photograph supplied by courtesy of MAN International Arts Holding Corporation. The inscription on Dalì's Leonardoesque study of Sigmund Freud alludes to their meeting in London in 1938 and to an impression Dali formed that the inventor of psychoanalysis had a cranium shaped like the volutes of a snail shell. As Freud does in his analysis of Leonardo, Dali dissects the the physiognomy of genius.

CONTENTS

ACKNOWLEDGEMENTS

And indeed there will be time . . .
Time for you and time for me,
And time yet for a hundred indecisions,
And for a hundred visions and revisions,
Before the taking of a toast and tea.[1]

There have been visions and revisions aplenty as this book, which began its life as a doctoral thesis, slowly edged towards completion. Without the patience, encouragement and judicious advice of my supervisors, Dawn Ades and Christopher Green, the thesis would not have been finished. How much I absorbed by slow osmosis over a long period from both of them is evident to me only now as I survey the end result. To the cohort of graduate students at the Courtauld Institute with whom I began my doctoral research I also owe a great deal, not least for the invaluable titbits one exchanges over toast and tea. My thanks especially to Sophie Bowness, Tony Halliday and Sean Higgins. While the camaraderie of those years is not easily recreated, a number of friends and colleagues at Manchester have by their shared interests sustained my enthusiasm for the subject of this book; in particular, for his erudition on all things surrealist I am grateful to Jeremy Stubbs, and for his unrivalled knowledge of hysteria, Mark Micale. Numerous people have assisted in other important ways the writing and production of this book. The insightful comments of the dissertation examiners, Briony Fer and Margaret Iversen, and the anonymous readers for Yale University Press have helped me to clarify the core arguments as well as, I hope, to render the whole more cohesive. Feedback from those audiences who listened to earlier versions of chapters, or parts thereof, has on many an occasion proven indispensable. Generous assistance from Tom Bilson, William Jeffett, Kelly Reynolds and Ann Simpson has made the task of gathering illustrations less arduous than it otherwise might have been. For her dedication and utmost professionalism, I am hugely indebted to Gillian Malpass, the editor of this volume at Yale University Press. Her assistants, Abby Waldman and Elizabeth McWilliams, have steered the book through each stage of production and the finished product owes much to their sound judgement and aesthetic sensibility. Delving into old files of hand-written notes in a sometimes vain effort to put right the deficiencies that their meticulous copy-editing exposed has led me on an imaginative journey back to the past, for which I am also grateful. On a pragmatic note, I wish to acknowledge financial support received from various sources: a Commonwealth scholarship from the British Council allowed me three years of unimpeded research; a grant from the University of London Research Fund enabled me to carry out research at the Fundació Joan Miró in Barcelona; a British Academy grant contributed towards the cost of purchasing photographs. Without the benefit of research leave, currently being funded by the Leverhulme Trust, this project also would not have seen the light of day. The largest debt of thanks, however, is owed to my family to whom I promise that my endless deferring of those little pleasures of living that writing a book has necessitated is now over.

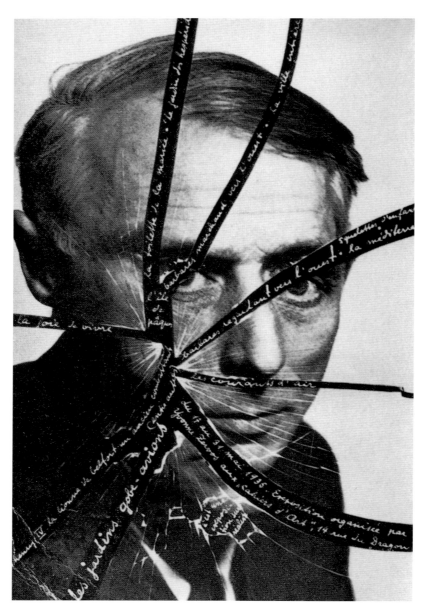

1 Max Ernst. Invitation for Max Ernst Exhibition. 1935. Photocollage, 15 × 10cm. Location unknown.

INTRODUCTION

'What is myself? Don't know, don't know, don't know.'[1]

the subject in question

An invitation card for an exhibition of his work in 1935 (fig. 1) serves as an occasion for Max Ernst to interrogate our culture's most tenacious illusions about the self and the self-portrait. The collagist has taken to his own face with a pair of scissors, portraying himself as if seen in a mirror, but one that has been shattered somehow. Writing fills the spaces amongst the broken shards of this reflected self; where physiognomic theories of character would have us read the lines of the face, here we are required to read between the lines if we are to know the truth about the subject. Is it not the realm of the unconscious, this between-the-lines which is structured like a language? One is reminded that the technique of automatic writing practised by the surrealists with some fervour was widely understood by them as fracturing an illusory unity of the self. This voice from an other scene (*ein anderer Schauplatz*), as Freud termed the unconscious, gave proof of an irreducible heterogeneity or 'otherness' within the self – a view endorsed in the surrealists' case by their avid reading of psychoanalysis, 'a method I esteem and whose present aims I consider nothing less than the expulsion of man from himself' was how André Breton appraised it.[2]

To the reader of this book an invitation is extended to view together some surrealist works of my choosing, not in the expectation of dispelling their enigma but with the hope of responding to their interrogative voice. 'Who am I?' – the question(ing) of identity resounds across the surrealist project, but for the surrealist artist or writer there were no ready-made answers. Indeed, the hypothesis of an unconscious, of the subject's radical determination by an elsewhere ('the self's radical ex-centricity to itself with which man is confronted'),[3] seemed to render obsolete the ethical and philosophical imperative to know thyself. 'Who am I?' Breton asks in the memorable opening passage of *Nadja*, and then promptly rephrases it: 'If this once I were to rely on a proverb, then perhaps everything would amount to knowing whom I "haunt"?'[4] Not only is the subject not master of its own house, as Freud once said, with surrealism it is no longer at home.

surrealism and psychoanalysis

The heyday of surrealism coincides with the rapid diffusion of the psychoanalytic doctrine in France. One writer in a round-up of views printed in *Le Disque vert* in 1924, a psychology professor at the Sorbonne, spoke of a vogue for Freud without equal since Bergsonism had swept through intellectual circles in 1910 and evoked with evident disdain the posturing (*snobisme freudien*) that accompanied its uncritical reception in lay circles. While it might be a

fitting subject for 'novelists adroit at probing the human heart' this author was not alone in declaring that scientists and medical men were right to be sceptical.[5] Opposition from the establishment was fierce and took the form not, as one might expect, of a critique of the scientific bases of psychoanalysis, but more often of crudely stereotyped judgements about national character. A theory that might hold true for the German psyche was judged uncongenial to the descendants of Descartes.[6] Dr Hesnard, expounding in 'French Scientific Opinion and Psychoanalysis', objected to the temerity of Freud's alleged mysticism and to the gratuitous vulgarity of a 'pansexualist dogma' which cast a slur on the virgin souls of all French mothers and sons.[7] The bigoted attitudes of the medical establishment could have served only to galvanise the surrealists' opinion in favour of Freud, encouraging them to think of psychoanalysis as an instrument with which to oppose institutional psychiatry, their eternal *bête noire*.

Opponents of psychoanalysis liked to have things both ways. On the one hand, the doctrine is supposedly anathema to the French spirit; on the other, Dr Hesnard informs us that Freud has invented nothing. Analytical psychology was conceived in France which can rightly claim to have its most illustrious exponent, Pierre Janet, 'whose doctrine is much more alike than is generally thought in France to that of Freud, which is both later than his [Janet's] and derivative from it'.[8] Even the advocates of psychoanalysis were inclined to play down Freud's role as an innovator, a strategy they possibly hoped would increase the theory's palatability to a very partisan audience.[9] This widely held view, which Breton espoused more than once, may explain why he felt comfortable borrowing the terminology of automatic writing from Janet while claiming to base the technique on Freud. A tendency to consider psychoanalysis as derivative of a homespun tradition of philosophical psychology is germane to another distinctive feature of the reception of psychoanalysis in France, namely a reorientation of the science of psychoanalysis around the more properly philosophical problematic of the subject (Freud, who professed disinterest in philosophy and metaphysics, generally eschews use of this term). Seen most notably in Jacques Lacan's 'return' to Freud, a concern with the subject, or, more precisely, with the implications of Freud's discoveries for philosophical notions of the subject, is also a salient aspect of the surrealists' response to Freud.[10] As a further consequence of the manner in which psychoanalysis was initially appropriated in France, the surrealists show relatively scant regard for any distinction between psychoanalysis and other areas of research that had currency and respectability in late nineteenth-century psychology but that today might be regarded with suspicion, managing to combine their study of Freud with an equal passion for hypnosis and mediumistic phenomena, states of possession, and so on.[11]

The surrealists were party to a debate over who was qualified to use psychoanalysis, an issue that had a high profile in France owing to a split between the Société psychanalytique de Paris, founded in 1926 with Marie Bonaparte, a lay analyst, as its head, and the Evolution psychiatrique group of medical psychiatrists.[12] Significantly, a lengthy excerpt from Marie Bonaparte's translation of 'On the Question of Lay Analysis' was published in the pages of *La Révolution surréaliste* in 1927, the only text by Freud to appear in the journal,[13] and on several occasions, Breton defended the right of poets to utilise the new technique, implicitly challenging the professional jurisdiction of medical psychiatrists over the mind's dominion:[14]

> The imagination is perhaps on the point of reasserting itself, of reclaiming its rights. If the depths of our mind contain within it strange forces capable of augmenting those on the surface, or of waging a victorious battle against them, there is every reason to seize them – first to seize them, then, if need be, to submit them to the control of our reason. The

[psycho]analysts themselves have everything to gain by it. But it is worth noting that no means has been designated a priori for carrying out this undertaking, that until further notice it can be construed to be the province of poets as well as scholars, and that its success is not dependent upon the more or less capricious paths that will be followed.[15]

With psychoanalysis as their muse, artists and poets were ready to tap into the unconscious well-springs of creativity for so long obscured by the veils of repression. The imagination is on the point of reclaiming its rights . . . surrealism is littered with such optimistic predictions, yet how successful were they in realising these aims in their art? What, we shall be asking repeatedly, is the status of the unconscious in surrealist images and objects? Can a discourse *about* the unconscious, whether textual or pictorial, actually provide any evidence for its existence or, on the contrary, are surrealist works destined to betray the unconscious in the course of trying to represent it? Georges Bataille defined the paradoxical predicament of the modern artist who, in searching for a more elemental and authentic state of being, is forever distanced from their goal:

> What distinguishes modern man, and perhaps especially the surrealist, is that in returning to the primitive he is constrained to consciousness ['à la conscience'] even as he aims to recover within himself the mechanisms of the unconscious, for he never ceases to have consciousness of his goal. Consequently, he is at once both closer and yet further away.[16]

Accordingly, one of the most frequent accusations levelled against surrealism by its critics was that it is too conscious. Eugène Tériade wrote in *Cahiers d'art* in 1930 that the 'return to instinct' undertaken by the surrealists was self-defeating for the very reason that 'everything in this effort was conscious, highly conscious, calculation and premeditation'. Tériade claimed with an air of triumphalism that there is more unconscious in works of art made before Freud than in those made according to his dicta.[17] Insofar as there was a debate on this matter it seems to have been sparked off by Dalí who, in outrageously exhibitionist fashion, paraded for all and sundry the dirty linen of the analytic session – Breton was caused to reflect that no one was better versed in psychoanalysis than Dalí, who used it not for the purpose of curing his complexes but in order to nourish and preserve them.[18] Dalí's immoderation, in this as in all other matters, helps us to delineate Breton's views. Writing in *Communicating Vessels* (Les Vases communicants), Breton expresses reservations about the explicit symbolism in the surrealist objects fabricated by Dalí, commenting that: 'The willing incorporation of latent content – decided on in advance – in the manifest content serves here to weaken the tendency to dramatise and magnify, which the censor [the agency whose task is to prevent forbidden wishes from becoming conscious] imperiously uses with such success in the opposite case.'[19] What Breton seems to imply is that the transmutations that the unconscious wish undergoes in an effort to bypass the censor – the displacements, condensations and other poetic operations so vividly described by Freud – are necessary to the creation of genuinely surrealist images, and the poet or artist should not attempt to bypass or pre-empt them. A degree of unawareness is hence preferable to Dalí's ultra-lucidity. Breton's views were, in fact, consonant with sentiments expressed by Freud in a letter to Stefan Zweig the day following his meeting with Dalí who had proudly shown Freud a recently completed picture, the *Metamorphosis of Narcissus* (fig. 100). Freud confided that: 'From the critical point of view it could still be maintained that the notion of art defies expansion as long as the quantitative proportion of unconscious material and preconscious treatment does not remain within definite limits.'[20]

Dalí's hand-painted colour photographs were dismissed as an academicism of the unconscious by Jean Frois-Wittmann, a psychoanalyst sympathetic to the surrealist cause: 'The reproach I would make to S. Dalí, as to Breughel and Bosch, is not to have exposed their petty obsessions, but of defining their phantasms to such a degree that no place remains for the spectator to make any associations other than those. They are Meissoniers of the Unconscious.'[21] Frois-Wittmann favoured the strategy adopted by Max Ernst who, on the contrary, 'knows to remain more vague'. Miming the substitutions and condensations of the dream-work, Ernst's collage paintings are like an impenetrable enigma, mysterious and poetic in their effect.[22] Yet the technique of dream painting modelled on de Chirico is judged deficient by Max Morise, in an article that appeared in the first issue of *La Révolution surréaliste*, for the reason that, however faithful the process of transcription, dreams are inevitably subject to secondary revision by consciousness in the course of notation. The subject matter of Ernst's work may be surrealist, but the method of its execution is not.[23] André Masson, whose automatic procedure will be analysed in greater detail in chapter 1, took a somewhat different approach. His was a two-stage process: the first phase in the creation of an image for Masson consisted of essentially abstract rhythms and gestural lines which he saw as corresponding to instinctual drives in their unrepresented state; in the second phase, various figurative elements to which these unconscious drives are directed begin to emerge. To attain the endpoint of a figurative image but without the instinctual component would, in Masson's opinion, have risked creating something that was academic in a surrealist way ('académique surréalistement').

Of interest because of the notoriety it enjoyed was a polemic by Emmanuel Berl titled 'Freudian Conformities' which appeared in the artistically conservative magazine *Formes* in May 1930.[24] Again, the timing would suggest that Dalí was the implied target. Looking around, Berl discerned a perverse academicism in which the phallus had simply replaced the fig-leaf of old. The cry he facetiously imagined emanating from all the fashionable art dealers was: 'Beaux complexes à vendre, beaux complexes!' Berl found fault with such art for the reason that the unconscious complex was no longer sublimated into painting, as was the case with Leonardo, but had become its object – as banal as a scene from mythology or the Bible once was for artists of yesteryear. In his view, art had been fatally weakened by this loss of innocence: 'The academicism of the subconscious provokes and denotes the failure of the subconscious in the arts.'[25] Berl's conclusion seems to have been taken up by Tériade in his critique of surrealist art later in the same year; it also prompted a reply by Robert Desnos and another by Georges Bataille which came out in *Documents* in 1930.[26]

While for Bataille there could be no question of simply abandoning psychoanalysis and returning to the halcyon days when artists were ignorant of their unconscious motives, he nevertheless found himself agreeing, up to a point, with Berl: 'one must recognise with him, that in spite of any illusion, the "reign" of the unconscious *as such* is terminated.' There is every reason to believe that Dalí, whose reception piece among the surrealists, *The Lugubrious Game*, was the subject of a detailed analysis by Bataille which draws attention to its shamelessly explicit treatment of the theme of castration anxiety, was instrumental in helping to shape Bataille's views on this matter. In the earlier version of the article, titled 'Dalí Screams with Sade', Bataille outlined his objection to art that plays a polite game of symbolic transpositions on the grounds that it is tantamount to siding with the censor: 'The elements of a dream or a hallucination are transpositions; the poetic utilisation of the dream comes down to a consecration of the unconscious censorship, that is to say to a secret shame and cowardice.'[27] To an art modelled on psychoneurosis, that is to say on the indirect, sublimated expression of

unconscious phantasies, Bataille posited an art of conscious lucidity – of perversion, in effect.[28] With a jibe at the Bretonian surrealists, his trenchantly worded reply to Berl warned that: 'The reduction of repression and the relative elimination of symbolism evidently are not favourable to a literature of decadent aesthetes, entirely deprived even of the possibility of contact with the lower social strata.'[29] A consistent aesthetic stance was evolved by the authors writing in *Documents* that rejected the play of metaphor in favour of an ever more abrupt encounter with the unadorned reality of unconscious desire. Michel Leiris wrote of the sculptures of Giacometti, which he compared to precipitates of a psychical crisis, that they are 'true fetishes, that is to say those which resemble us and are the objectified form of our desire'.[30] The divergences on this issue throw into heightened relief the polarised aesthetic positions of Breton and Bataille, and also show the extent to which Dalí was a crucial defining influence for both of them.

psychoanalytic interpretations

Every bit as contentious as the uses to which psychoanalysis was put by surrealist artists is the issue of how to use psychoanalysis validly in order to read or interpret their art. Does not the first step, the deliberate inclusion of stock psychoanalytic themes, render the second step redundant somehow? Breton, writing in the *Entretiens*, is scathing in his remarks about a psychiatrist lecturing at the Sorbonne who purported to analyse the work of surrealist artists as if they were patients on his couch, ignoring the fact that they had knowingly exploited and manipulated psychoanalytic symbolism: 'from the outset psychoanalysis held no secrets for surrealist painters and poets such that on many occasions they *played consciously* with the sexual symbolism associated with it.'[31] Accessing the individual psyche of Ernst or Picasso or whoever via a highly mediated set of cultural artefacts is an enterprise fraught with difficulty, and not one that I shall attempt. But beyond that rather obvious point, Breton might have been objecting to the conduct of analysis *per se*: a crucial distinction between psychoanalysis and surrealism, one might have supposed, hinges on the very question of analysis. Where the surrealists were prepared to marvel at the products of the unconscious, for the psychoanalyst their only value was as the raw material of interpretation. Freud, declining Breton's request for a contribution to a collection of dreams, cites this as his reason:

> that which I called the 'manifest' dream, is not of interest to me. I dealt with the search for the 'latent dream content' which one can extract from the manifest dream by analytical interpretation. A collection of dreams without enclosed associations, without knowledge of the dreaming's circumstances, says nothing to me, and I can hardly imagine what it could say to others.[32]

While Breton plainly had reservations about interpreting the products of the unconscious, and continued to prevaricate on this question, he never definitively rules it out. He admits of the possibility in the *Manifesto of Surrealism*, a position he again reiterates in 1932: 'Surrealism, surpassing all preoccupation with the picturesque, will soon pass, I hope, to the interpretation of those automatic texts, poems or others, which it covers by its name, and the apparent bizarreness of which shall not, according to me, resist this test.'[33] For Dalí, on the other hand, it is a weakness of automatist practice that its products are susceptible to a process of rational interpretation that risks dissipating their apparent absurdity (its 'symbolic passivity lending

itself precisely to interpretative intervention'). Dalí makes this the basis for a claim to the superiority of his paranoiac-critical method, and it is perhaps in order to resist appropriation of the artwork by psychoanalysis in the mode of interpretive reason that he is led to espouse his notion of a 'concrete irrationality'.[34] For all the surrealists, it seems to have been important to preserve the kernel of enigma that is a marker of all the products of the unconscious.[35]

Issues of interpretation crop up at more than one turning in this book, particularly in the sections dealing with Max Ernst and Salvador Dalí. A study of Dalí's illustrations for Lautréamont's Les Chants de Maldoror will argue that the images interpret the text, disclosing, as it were, a textual unconscious. Interpretation is an integral aspect of the paranoiac-critical method which Dalí claimed to base on the paranoiac delirium of interpretation (délire d'interprétation). The paranoiac's delusion, Freud believed, lays bare the content of an unconscious impulse which in other cases analysis would be required to uncover. As Dalí insisted, referring to Lacan's doctoral thesis on paranoia in order to buttress his claim, 'the paranoiac delirium already constitutes in itself a form of interpretation.'[36] The paranoiac, an inveterate interpreter who sees every minor event as filled with significance, can in that respect be likened to a psychoanalyst, an irony that Dalí sought to play to his advantage: 'On this subject, how can one refuse to envisage sciences such as psychoanalysis as being brilliantly systematized deliriums (naturally without intending by that anything pejorative).'[37]

Psychoanalysis has been much criticised for its tendency to systematise, posing as a master narrative that purports to speak the truth of other discourses.[38] Interpretation, these critics presume, is a process of translation employing a code that consists of typical dream symbols and a few restricted originary phantasies. 'Such explications,' wrote Theodor Adorno, 'force the luxuriant multiplicity of surrealism into a few patterns; cram it into a few limited categories such as the Oedipus complex without attaining to the power which radiates from the surrealistic ideas, if not always from surrealistic art itself; thus even Freud seems to have reacted to Dalí.'[39] In practice, the charges of reductivism have been more often levelled at psychoanalytic approaches to the work of Max Ernst, whose use of psychoanalysis in the collage paintings was quite different to Dalí's. Chapter 2 will address in some depth a controversy regarding interpretation which has surfaced around his work. For the moment, let us note that before Freud had set in place the Oedipus complex, psychoanalysis was a method of reading based on free associations without a predetermined code. Arguing for a reversion to this 'anti-hermeneutic', Jean Laplanche advocates a method of analysis that would remain faithful to the unconscious whose essential feature he defines as 'unbinding' (Entbindung). Carried over to the practice of textual or pictorial exegesis, the implication of his preferred approach, in which the 'associative pathways are followed, the points of intersection are noted, but no synthesis is proposed', is that something akin to free association may be the most appropriate and desired model.[40] We shall have occasion to test out such a model in the pages that follow; my hope is that the results may be judged no more than moderately systematized.

• • •

There has been a flourishing of scholarship on surrealism in the past decade, as witnessed by a plethora of exhibitions and books that have been both popular and intellectually ambitious. One can ascribe this phenomenon to the demise of a formalist hegemony in studies of modern art, leading to a reappraisal of the dada and surrealist avant-gardes which stood outside of,

and were in essence unassimilable to, a modernist trajectory. A new agenda, dictated by feminism and poststructuralism, and overtly informed by psychoanalysis in many instances, has taken its place. Questions of identity and sexuality have been paramount in the new art history which, in consequence, has proved to have a fundamental affinity with the concerns that animated the surrealists more than half a century ago. That certainly is how I would choose to situate my project.

If asked to name what psychoanalysis and surrealism fundamentally had in common, one could say unhesitatingly that it was their firm belief in the existence of something called the unconscious. Chapter 1 looks at practices of surrealist automatism, since it was there that the problem of the unconscious and its relation to the visual image was most directly posed. Artists seeking to translate into a visual register what was in the first instance a practice of automatic writing faced obstacles that were both theoretical and practical. Joan Miró and André Masson were two pioneers in this area whose automatist practices will be analysed with regard to the metaphoricity of the procedures they adopted. Miró's use of tracing and imprinting for generating sequences of automatic imagery I relate to Derrida's analysis of the unconscious memory trace and metaphors of writing and inscription in Freud. My study of André Masson ranges more widely across his career but takes as a starting point his observation that there is a space and a duration belonging to the unconscious which he meant to embody in his work. Masson's linear, graphic style of automatism will be discussed in terms of binding and unbinding (Bindung–Entbindung), key concepts or metaphors in Freud's model of the psychic apparatus, and in relation to the themes of lack and loss. In the automatist practices of both artists one can discern a play of presence and absence which implicates, and calls into question, the authorial subject. Chapter 2 addresses the status of hysteria in surrealist discourse and iconography. One section of this chapter is centred around 'Les Possessions', five automatic texts in which André Breton and Paul Eluard attempt to simulate the speech and ideation of the insane. The sources for this project lie in late nineteenth-century investigations of hypnosis, spiritism and multiple personality – a murky area of rather dubious scientificity, but for wide-eyed observers such studies revealed the subject to be haunted by alien voices. A second case-study looks at the complex alliance between Max Ernst and the female hysterics who star in his collage novels. Contrary to those who dismiss surrealist representations of female hysteria as a matter of visual delectation, I will argue that the unruly hysteric, whom Ernst names 'perturbation, my sister', actively subverts patriarchal authority and destabilises gender norms; and furthermore, that the phenomenon of hysterical identification holds the key to Ernst's own convulsive self. Chapter 3, in common with a number of recent studies, invokes the uncanny as a conceptual parallel for the state of estrangement the surrealists sought to induce in the beholder whereby the familiar, oneself included, is suddenly rendered strange or alien. This is brought to bear upon the matter of Picasso's oscillation between opposing styles, a pattern of working he established soon after the war and which remained salient throughout the years of his involvement with surrealism. I shall be drawing upon Julia Kristeva's reading of the uncanny as a 'destructuration' of the self to explore the shifting relationship of Picasso's work to classicism at various moments. Most dramatically in a sequence of heads of harlequins where identity is suspended between the alternatives of classicism and a transgressive, surrealist idiom, Picasso aggressively deconstructs the unified self. Chapter 4, on abjection, incorporates a study of Dalí's etchings for *Les Chants de Maldoror* and another of the *Metamorphosis of Narcissus*, the picture he took with him when he visited Freud in 1938. It emerges that Dalí's analysis of abjection concurs on a number of points with that of Kristeva who sees the abject as

both a correlative of narcissism and an ever-present threat to it. This chapter also explores a number of parallels as regards the issue of abjection between Dalí and Georges Bataille, each of whom was preferentially drawn to circumstances where horror and fascination are balanced as if on a knife edge. At variance with recent appropriations of the Bataillean *informe*, my comparison with Dalí stresses the psychoanalytic moorings of the concept and its dual reference to the body and the subject. Chapter 5 returns to a leitmotif of surrealism, namely the unconscious as a locus of heterogeneity, of otherness, shattering the presumed transparency of the subject to self-reflection. An analysis of three self-portraits by Miró, including an etched (self-)portrait produced in an experimental collaboration with Louis Marcoussis, reveals a close accord between surrealism and a Lacanian description of the subject as constituted in a dependent relation to the Other, that is to say, to language and the unconscious.

At times, this study necessarily ranges beyond the parameters of surrealism as such in order to situate, and hopefully understand, the surrealists' motivations in the context of a turbulent and polarised interwar visual culture. Though the individual chapters are intended to stand alone, their consistency lies in the attempt to bring psychoanalysis to bear upon the visual image and to highlight, at the risk of privileging, those moments when surrealism succeeded in radically challenging and destabilising the dominant forms of Western subjectivity. Of course, with hindsight, one cannot be blind to the limits or even failure of the surrealist project to emancipate human desire, and psychoanalysis can help us to recognise those symptomatic points. Much of what follows in this book has the character of a dialogue with other scholars whose work, even where my views eventually came to differ from theirs, has been indispensable to me. My hope is that by seeking to foreground throughout issues of identity and subjectivity, this book will have contributed to a greater awareness of what I believe is the key problematic of surrealism and a reason why it continues, half a century on, to compel our attention.

1 TRACES OF THE UNCONSCIOUS

Under the deeply ironic banner of 'Beaux Arts', the third issue of *La Révolution surréaliste* carried the blunt opinion of Pierre Naville that: 'No one can any longer ignore that there is no such thing as *surrealist painting*.' Flatly contradicting Breton who had earlier given his tacit approval to the graphic automatism of André Masson, Naville adds: 'Neither the pencil line given over to a chance gesture, nor the copying of dream images, nor imaginative fantasies, it is well understood, can be so qualified.'[1] In the previous issue of the review, an article by Max Morise surveyed these various painterly options in terms of how well they measured up to Breton's definition of automatic writing and found each of them wanting in one respect or another. For Naville, however, painting is discredited on the prior grounds that it is inevitably mired in aesthetic considerations: 'I know nothing of taste but distaste' he professes. The alternatives Naville advocates are three: cinema, the sheer visual spectacle of the city, and photography. It was Naville's categoric rejection of painting that led Breton to oust him from the editorship of the journal and to enlist Picasso in order to prove that, while it may be a lamentable expedient, painting was a viable area of surrealist activity.[2] From the very moment of its inception, therefore, a polemical divide existed within surrealism between the proponents of painting and those of photography that could not be conciliated by Breton's hopeful assertion that 'automatic writing . . . is a true photography of thought'.[3] The most influential of recent writing on surrealism has tended to side with Naville, and for much the same reasons, to the extent of asserting the photographic conditions of surrealism over and against the automatist practices that had been the keystone of Breton's definition of surrealism.[4] Testifying to Walter Benjamin's prestige as the arbiter of postmodern priorities, photography is privileged as the site of a radical and subversive practice.

The rationale for returning to automatism in this chapter – to the practices of drawing and painting so reviled by Naville – is that one finds there the problem of the unconscious, and of its representation, most urgently addressed by the surrealists. No sooner is this issue raised, however, than one abuts against the thorny question of whether or not the surrealist notion of psychic automatism can be reconciled with a Freudian model of the unconscious. How much Breton owes to Janet as opposed to Freud is perennially debated. Let us for the moment simply note that the doctrine of 'pure' psychic automatism holds out the promise of a certain plenitude which is foreign to a Freudian conception of the unconscious. Implicit in the use of automatic writing by Janet and subsequently the surrealists was a belief that by tuning in to the unconscious one could listen to its unadulterated speech.[5] By contrast, Freud, at least when in a cautious frame of mind, speaks of the unconscious as an inference made from the gaps or omissions in conscious discourse, or from the roundabout form in which unconscious wishes manifest in dreams or symptoms, but not as something that is knowable in itself:

> We have discovered technical methods of filling up the gaps in the phenomena of our con-
> sciousness, and we make use of those methods just as a physicist makes use of experiment.

In this manner we infer a number of processes that are in themselves 'unknowable' and interpolate them in those that are conscious to us.[6]

Historically, the practice of automatic writing is closely bound up with studies of hysteria in which condition there was believed to be a splitting (*dédoublement*) of the personality that in extreme cases could lead to the subject's consciousness alternating between two (or more) selves, each of which is unaware of the other. Breton's absorption in this whole area of psychological investigation is shown towards the end of the decade in the series of automatic texts called 'Les Possessions' which he wrote in collaboration with Paul Eluard. Implicit in the study of double or multiple personality was a belief in the unconscious as a hidden or latent consciousness, a notion that Max Ernst alludes to when he titles one of his works from the early 1920s, *One Man Can Hide Another*. By contrast, Freud often enough insisted that his concept of the unconscious should not be confused with or pictured as a second consciousness.[7] Freud believed that the unconscious has properties that belong to it alone and are not reducible to those of conscious thought: 'To sum up: *exemption from mutual contradiction, primary process* (mobility of cathexes), *timelessness*, and *replacement of external by psychical reality* − these are the characteristics which we may expect to find in processes belonging to the system Ucs. [the unconscious].'[8]

Visual artists, as we shall see later, were at a particular disadvantage when they sought to implement what was in the first instance a practice of automatic writing. The always compromised status of the visual image within the discourse of surrealist automatism might account for the relatively short heyday of automatism in the visual arts, which had certainly gone into abeyance well before the end of the decade − in fact, 1927 seems to be a turning-point for a number of surrealist artists − and it may also be for this very same reason that they were less susceptible to Breton's faith in a pure psychic automatism that could be embodied unproblematically in representation. Dalí, whose experiments with automatism were abortive and short-lived, voiced his scepticism about the surrealists' aspiration to open wide the floodgates of the unconscious. But equally, surveying the methods adopted by the pioneers in this area, Ernst, Miró and Masson, one discovers a predominance of surface inscriptions and traces that at best refer to the unconscious, which of itself remains enigmatic and unrevealed. It is fruitful to think about the frottage and grattage techniques employed by Max Ernst to create images layered and textured like a palimpsest in these terms. So too, the notion of the unconscious as a trace rather than a presence is applicable to the automatist procedure of Joan Miró whose precise nature only became clear with the rediscovery of his notebooks. My study of the drawings contained in these notebooks will explore the role of tracing and pressing as forms of inscription, and will consider their significance in the light of Jacque Derrida's analysis of the metaphors of writing and inscription in Freud's theories of memory and the unconscious. I shall venture a parallel between Miró's use of tracing and Derrida's thinking of the trace in relation to non-presence, as the erasure of presence.[9] Finally, since the sequence of drawings to be examined in depth are antecedents to *The Birth of the World*, a picture that ineluctably poses the problem of its origins and genesis, I will be asking what are the implications of a tracing that Derrida contends is at the same time an erasure for the ideological construct of the artist as origin?

The second part of this chapter is a study of the work of Miró's neighbour at 42 rue Blomet, André Masson, which again will be occupied with the metaphorical character of his automatist procedure. Masson endeavoured to adhere to a Freudian conception of the unconscious as

governed by the free mobility of *unbound* instinctual energy. Once again, Derrida has high-lighted the fundamental importance in Freud's writing of a second set of metaphors, a figurative language of binding and unbinding: 'The German *Binden*, concept or metaphor, plays, as we know, a formidable role in this text and this problematic. Everything seems to be played out, or rather knotted, in the more or less loose stricture of energy, in the more or less dissolved, detached, resolved, absolved (*aufgelöst*) ties or bonds', Derrida writes.[10] Beneath the overarching motif of the labyrinth, Masson's choice of symbol for his work, we shall be pursuing a number of threads which I trust are at some level knotted together, more or less loosely, in his linear, graphic style of automatism. An analysis of the problem of repetition in Masson's work will allow us to discern the many links between his work of the 1920s and that of the following decade. The labyrinth, a spiralling *unbounded* form, is a potent emblem for an oeuvre whose dominant impulse, I shall argue, is an unbinding which points beyond the regulatory homeostasis of the pleasure principle and in the direction of a repeated, uncanny and traumatic, encounter with loss and death.

i a mental notebook: trace and erasure in Joan Miró's automatic drawing

'The trace is the erasure of selfhood, of one's own presence, and is constituted by the threat or anguish of its irremediable disappearance.'[11]

Dominick LaCapra, in 'Psychoanalysis and History', suggests that Freud's theorisation of the primal scene (*Urszene*) of the observation of parental coitus, an event he infers in the case of the Wolf Man, is of practical and conceptual interest for the historian.[12] Freud's observation that such scenes, which are presumed to have taken place at an early, pre-verbal stage, 'are not reproduced during the treatment as recollections, they are the products of construction' is true also of historical narratives which construct rather than simply reproduce versions of the past.[13] By the same token, Freud's incessant worrying over the 'reality' of the primal scene chimes with one's everyday experience as an historian striving nobly after truth but all the time aware that the best one can achieve is a paltry 'reality effect'. Moreover, the concept of deferred action (*Nachträglichkeit*) which Freud invokes to explain how an event that was not in the first instance traumatic can become so retroactively has, LaCapra claims, far-reaching implications for our understanding of historical temporality and causality. As Derrida has remarked, the factor of delay and repetition means that the past with which we are concerned (origin, primal scene) was never fully present.[14] The primal scene was one of a cluster of archetypal scenarios which were regularly uncovered by Freud during analysis.[15] Laplanche and Pontalis in *The Language of Psychoanalysis* comment that in content and function the primal (or originary) phantasies (*Urphantasien*) are similar to myths. In each of their typical forms they stage an origin of one sort or another: 'In the "primal scene", it is the origin of the subject that is represented; in seduction phantasies, it is the origin or emergence of sexuality; in castration phantasies, the origin of the distinction between the sexes.'[16] These phantasmatic scenarios purport to represent and explain 'the major enigmas' with which the subject is confronted. If, as is coming to be acknowledged, such phantasies can be operative even in an enterprise like art history, then

a picture with the evocative title *The Birth of the World* can probably be relied upon to elicit them.

the birth of the world

Entranced by the earliest manifestations of art on cave walls, or the first scrawls of an infant, Miró continually recalls us to the origins of things. The poet Georges Hugnet whose volume, *Enfances*, Miró illustrated in 1933, wrote that he traced 'the index of the child and of prehistory, the very first line, the only line at its commencement, the egg.'[17] This avid orientation towards the zero point of art, coupled with his renowned personal insouciance, gave rise to a prevalent view of Miró as a sort of naïf – 'a partially arrested development at the infantile stage' was Breton's caustic appraisal[18] – when in reality his fixation on the beginnings of art, and of symbolic systems in general, was of a piece with the prevailing *Zeitgeist*. Introducing an ambitious five-part article which intended to survey the prehistoric sources of art and human culture, the editor of *Cahiers d'art* states almost as a moral imperative a guiding principle of Miró's generation: 'One must return to the origin.'[19]

The Birth of the World (fig. 2), its title bestowed upon it by one of the surrealist poets, does just that.[20] Condensed within the picture are multiple, layered references to the origins of things: an orange disc with motile tail is like a sperm cell navigating its way across the pictorial field towards the moment of conception; a reclining figure – Adam, the first man – evokes the biblical Genesis; whilst the inchoate background is evocative of an even more remote event, the dawn of the physical universe. Added to these is yet another tale of origins apparently told by *The Birth of the World*: as spectators are we not treated to a painterly counterpart of the primal scene in which colours, lines and forms coalesce out of nothingness? From this it has been concluded, too hastily as it turns out, that the image stages its own origin, that it recapitulates the path by which it was pictorially conceived.[21]

Freud conjectured that adult intellectual curiosity stems from the thwarted desire of children to know the secret of where babies come from. Certainly it is true that art-historical accounts of the genesis of *The Birth of the World* bear more than a passing resemblance to that first quest for origins which is doomed to failure because the infantile researcher lacks crucial knowhow concerning the anatomical distinction between the sexes. Undaunted, the child concocts the most fantastic hypotheses instead, which Freud amusingly recounts – the cloacal theory of birth, and such like.[22] It was likewise for art historians: long kept in the dark about the real state of affairs, they were left to embroider the most extravagant tales about the birth of a painting. It was once believed that background splotches and stains provided the starting point for *The Birth of the World*, that Miró took advantage of these evocative but indistinct shapes as a springboard for his imagination much as Leonardo had advised artists to do in the *Trattato della pittura*. Miró's often-repeated claim to have painted under the effect of hunger-induced hallucinations during his first years in Paris helped to reinforce this erroneous view. In an interview in 1948, Miró reported that 'in 1925, I was drawing almost entirely from hallucinations. At the time I was living on a few dried figs a day. I was too proud to ask my colleagues for help. Hunger was a great source of these hallucinations. I would sit for long periods looking at the bare walls of my studio trying to capture these shapes on paper or burlap.'[23] Breton, too, drew upon a tradition linking spiritual revelation to fasting when he confides in the *Manifesto of Surrealism* that, at the time he and Philippe Soupault wrote the first revelatory automatic texts, 'The fact is that I wasn't

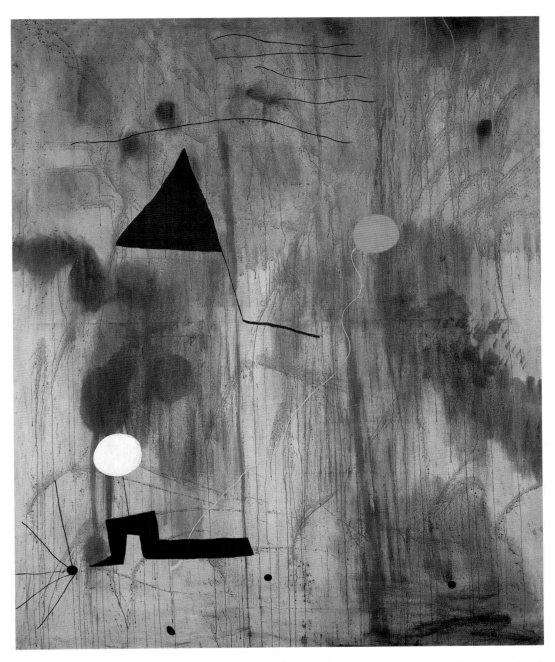

2 Joan Miró. *The Birth of the World*. Summer 1925. Oil on canvas, 250.8 × 200cm. The Museum of Modern Art, New York. Acquired through an anonymous fund, the Mr and Mrs Joseph Slifka and Armand G. Erpf Funds, and by gift of the artist.

eating every day.'[24] This aside to the reader prefaces a lengthy quote from Knut Hamsum's novel *Hunger* which concerns a down-at-heel writer surviving on meagre rations who discovers one day that, as a result, poetic images flood unbidden into his mind. Profiting from his adversity, he jots these down in true stream of consciousness fashion. Breton cites the entire episode as illustrating the mental state ideally conducive to automatic writing. My suspicion is that Miró's story about hunger-induced hallucinations sprang in part from this piece of fiction, to which it can once again be consigned.

With the publication of a sketchbook drawing for *The Birth of the World* in 1976, what had formerly posed as historical fact was similarly exposed as fantasy.[25] Miró had ferreted out of storage tattered and fragile sketchbooks containing precise preparatory drawings for nearly all of the 115 or so dream paintings. This dramatic return of the repressed had as a further consequence that the presumed automatism of these works was now opened to question. However, a detailed analysis of the sketchbooks by Christopher Green has demonstrated conclusively that at this level, the sketch, a notion of automatism does still pertain.[26] There are abundant instances where Miró has incorporated chance marks and stains on notebook pages, and employed tracings and pressings from one sheet to the next in a remarkably improvisational and open-ended way. Thus it is to the drawings that we must turn if we are to retrace the origins of *The Birth of the World*.

The sequence of drawings (figs 3–7) is found in a notebook that contains sketches for several other major pictures of the period.[27] Four drawings occupy the front side of consecutive pages in the notebook, and a remaining one the reverse side of a page. The most plausible order in which they were executed is from back to front in the notebook, making the sketch for *The Birth of the World* (fig. 7) last in the sequence. The unorthodox nature of this back-to-front working method may explain why the sequence as a whole has not been pieced together before. Because of the transparency of the paper Miró was able to trace over elements of the immediately underlying drawing using a soft pencil. For the single drawing on the back of a sheet (fig. 6) he apparently used a sharpened pencil to force an imprint through to the final page in conformity with the overall direction in which he was working. Retracing this decidedly quirky path abundantly confirms the truth of Miró's assertion that 'I don't progress [in an orderly way], I leap from one thing to another.'[28]

A dandy sporting a showy bow-tie begins the sequence (fig. 3). This comical relative of a de Chirico mannequin is composed of an upper body shaped like a decorative hat pin attached to an oddly geometric base. 'Moi', a near anagram of Mi[r]ó, emblazoned across one corner, establishes the identity of this assemblage: it is the same bow-tied figure, tight-lipped and wistful, who peers out from early photographs of the artist ('Idea for a Disguise' (FJM 632) jotted down in another notebook hints at the degree of artifice behind this persona[29]). Slight traces of the first drawing are visible through the next sheet (fig. 4) where 'Moi' can still be discerned like a fading retinal after-image. The right edge of the foot, body and upraised arms have been traced over but undergo a drastic switch in signification to become a figure reclining beneath the trunk and branches of a tree.[30]

Confronted with a sequence of images that seemingly follow the dictates of primary process thought, something akin to free association may be the correct model for analysis and interpretation. The motif of a figure beneath a tree points to a range of possible sources in Romanesque or early medieval art. Miró was steeped in the art of that period which had been widely publicised by a programme of conservation involving the removal of frescoes from

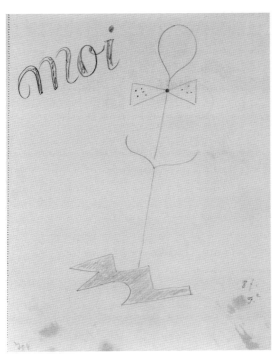

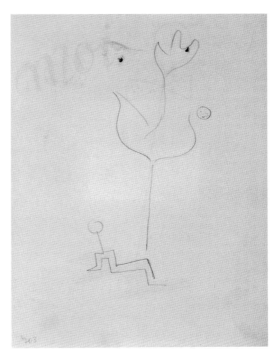

3 Joan Miró. *Automatic Drawing* ('*Moi*'). 1925. Pencil on paper; 26.4 × 19.8cm. Barcelona: Fundació Joan Miró (FJM 704).

4 Joan Miró. *Automatic Drawing*. 1925. Pencil on paper; 26.4 × 19.8cm. Barcelona: Fundació Joan Miró (FJM 703).

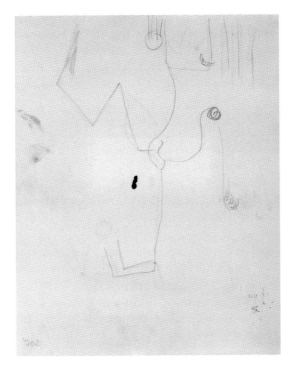

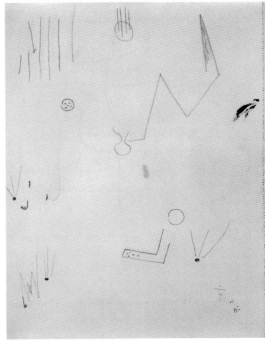

5 .Joan Miró. *Automatic Drawing*. 1925. Pencil on paper; 26.4 × 19.8cm. Barcelona: Fundació Joan Miró (FJM 702a).

6 Joan Miró. *Automatic Drawing*. 1925. Pencil on paper; 26.4 × 19.8cm. Barcelona: Fundació Joan Miró (FJM 702b).

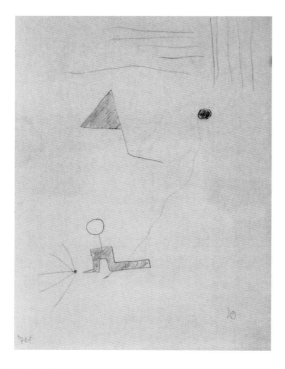

7 Joan Miró. *Automatic Drawing* (*The Birth of the World*). 1925. Pencil on paper, 26.4 × 19.8cm. Barcelona: Fundació Joan Miró (FJM 701).

churches in remote parts of Catalonia and their eventual relocation to the Museu Nacional d'Art de Catalunya in Barcelona.[31] It might represent the tree of Jesse which depicts the genealogy of Christ or, alternatively, Jonah under the gourd tree, a possible explanation for the inclusion of a fruit. The tree of Jesse was a popular subject in the Mediterranean region (the cathedral in Barcelona has an ironwork Tree of Jesse above one of the portals) and the overt phallicism of the motif is entirely in keeping with the unabashed eroticism of Miró's work at this juncture. Schematic trees also feature prominently in the treatises of Raymond Lulle, a Catalan mystic beloved of the surrealists and by Miró especially. Continuing on this train of thought, the Middle Ages saw a flourishing of the *arbores affinitatis* and *abores consanguinitatis* in which a genealogical tree was superimposed upon the body of Adam, the first man and hence origin of all genealogies. One need not worry unduly about the presence of savant allusions to past art in supposedly automatist drawings, since they are essentially no different to the day residues that are woven into dreams.[32] Depending on what weight one attaches to them, these biblical allusions might be seen as introducing ideas of origins and genesis – and of the self as origin. Closer to home, a Miró family tree which likely pre-dates this period includes a picture of Joan as an angelic winged putto seated beneath a tree bearing his name along with those of other family members (fig. 8).

This sheet was followed by another that is drawn upon on both sides. The image on the front of the page (fig. 5) probably preceded its near mirror-image on the reverse side (fig. 6) but Miró could have worked to-and-fro between them. The elements comprising these two drawings are more dispersed and less recognisably figurative than the foregoing images. At this stage an array of new signs are introduced: dots, parallel and radiating lines, a zig-zag flame shape. An earlier visual rhyme between a circular fruit and head is now extended to a solar disc which is juxtaposed against a lunar crescent, reinforcing the expansive cosmic dimension of the drawings, and alluding possibly to the conjunction of opposites (*conjunctio oppositorum*) of alchemy. Both drawings were preparatory to paintings that are reproduced in Jacques Dupin's oeuvre catalogue (D 160 [fig. 9] and D 162, D 162 being rotated through ninety degrees from its sketchbook orientation). Dupin gives these images the generic title of *Painting*, since they clearly defy any precise signification, and assigns them both to 1926 indicating that in some instances considerable time elapsed between preliminary sketch and painting.[33] Various elements of this poetically imprecise iconography are preserved in the final image of the sequence (fig. 7) which is, properly speaking, the sole preparatory drawing for

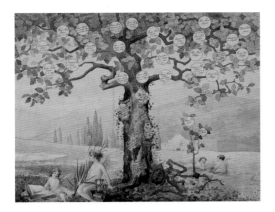

8 (above) Anon. *Miró Family Tree*. n.d. Palma de Mallorca: Collection Dolorès Miró.

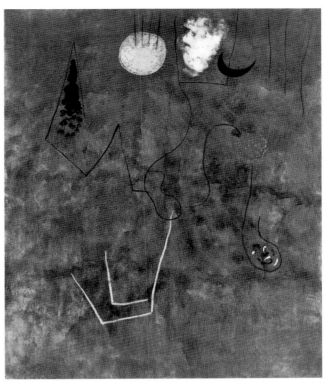

9 (right) Joan Miró. *Painting*. 1926. Oil on canvas, 100.2 × 81.5cm. Toronto: Art Gallery of Ontario.

The Birth of the World. The figurative idea with which Miró began is retrieved ultimately after its radical dispersion in the intervening sketches.

The playful frivolity of Miró invariably surprises and confounds our judgements about the importance or seriousness of an enterprise. That such a casual sketch could serve as template for his largest painting to date underscores the inspired audacity of a working method which, quite plainly, is poles apart from the academic routine of laboriously working up a composition via preparatory drawings. The transposition from drawing to painting adds new levels of complexity. Tension between different spatial registers is created by superimposing the graphic signs of the flat notebook page on a deep atmospheric ground, which Rosalind Krauss analyses in terms of a structural opposition of writing and painting.[34] Attention has also been drawn recently to the presence of a subtle colour symbolism in the painting which for a long time escaped notice. Robert Rosenblum observes that the orange and yellow of the central motif, the sperm cell, are the colours of the Catalan flag.[35] With the *Catalan Peasant* series also embarked upon in 1925 it is hardly likely that this is an incidental detail; rather it seems probable that Miró is discreetly encoding a reference to another facet of his identity, namely his Catalanness. Unlike the majority of the dream paintings which were painted in Paris, *The Birth of the World* was, according to Miró's recollection, painted at the family farm in Montroig, a circumstance that may have contributed to its political colouring.[36]

The choice of materials in the dream paintings is not without consequence either. Miró reported to conservators at the Museum of Modern Art that tempera was used in painting the

airy backgrounds, and oil paint for the elements transposed from drawings, this distinction in technique tending to accentuate the polarity of painting and drawing in the images.[37] Miró's revival of tempera, an egg medium used in fresco painting, is on a par with the previously noted iconographic allusions to art of the Romanesque period and carries the same connotative range of meanings. Knowledge about the technique would have been fostered among local artists commissioned to make copies of Catalan murals *in situ*, part of the conservation programme underway since the turn of the century.[38] Miró was not personally involved, but even so in a letter of 27 October 1918 he passes on to a fellow painter a recipe for preparing canvases which consists of a mixture of egg yolk, plaster and zinc white. The letter contains some homely advice: 'The secret of making a yolk increase its volume considerably is to beat it well, as though you were going to make an omelet (your maid will tell you how to beat an egg).'[39] The thought that amongst the list of ingredients in *The Birth of the World* may be a well-beaten egg strikes one as wholly apposite.

a simple matter of tracing

The dream paintings, produced during the relatively brief heyday of automatism in the visual arts between 1925 and 1927, were Miró's response to the clarion call of the *Manifesto of Surrealism* and it was these works that earned him the notoriously equivocal approbation of Breton:

> Joan Miró cherishes perhaps one single desire – to give himself up utterly to painting, and to painting alone (which, for him involves limiting himself to the one field in which we are confident that he has substantial means at his disposal), to that pure automatism which, for my part, I have never ceased to invoke, but whose profound value and significance Miró unaided has, I suspect, verified in a very summary fashion. It is true that that may be the very reason why he could perhaps pass for the most 'surrealist' of us all.[40]

What then are the salient features of this pure automatism which we now know to reside not in the paintings themselves but in the drawings that preceded them? First, the procedure displays a high degree of randomness, advancing by a series of detours and oblique knight's moves as if the guiding hand of the artist was absent. Breton seems to have intuited this, since he refers to Miró as 'this traveller who walks all the faster because he has no idea where he is going'.[41] What permits these startling leaps in meaning from one drawing to the next was the sheer elasticity of the visual signs Miró employs. Visual rhymes, or metaphors, connecting the forms of disparate objects abound in his work up to 1925 giving it its poetic character, but this capacity of a sign to signify in multiple ways – its polysemy – is pushed to the utmost in the automatic drawings where, as we noted, the same disc shape can just as readily stand for a head, an egg, a fruit or a sun, dependent on the context. In these works, the graphic trace is seen to approach the condition of a linguistic sign, an equivalence that Max Morise had been eager to affirm in 'Les Yeux enchantés' (Enchanted eyes), writing that 'the element direct and simple consisting of the mark of a brush on canvas carries meaning intrinsically . . . a pencil line is equivalent to a word.'[42] The other remarkable feature of this concatenation of images is that its momentum depends on a quasi-mechanical process of tracing from one sheet to the next. While such a technique is in keeping with the childlike idiom emulated by Miró, it is also relevant to note that Breton in the *Manifesto of Surrealism* refers to automatic writing as *écriture mécanique*.[43] He is adamant that for artists the recording of automatic imagery is a

simple matter of tracing: 'Armed with a pencil and white paper, with eyes shut, I could easily follow their outlines', he writes. 'Here again it is not a matter of drawing, *but simply of tracing* ['il ne s'agit que de calquer'].'[44] It might have been out of a desire to adhere strictly to Breton's textbook formula that Miró makes tracing an integral part of the automatic method he evolves. There is good evidence that Miró had recourse to tracing elsewhere in the dream pictures: Green and Lanchner have both drawn attention to a ghostly trace of the stretcher cross-bars that appear on several canvases.[45] So too, a penchant for reversing compositions, elegantly described by Lanchner, can be ascribed to Miró's habit of tracing on the backs of drawn pages in the notebook.[46]

'A trace is left in our psychical apparatus of the perceptions which impinge upon it. This we may describe as a "memory trace"; and to the function relating to it we give the name of "memory".'[47] In 'Freud and the Scene of Writing', Jacques Derrida has shown that from its very inception tracing and imprinting are the recurrent metaphors in Freud's theorization of memory and the unconscious. As early as 2 November 1896 in a letter to Wilhelm Fleiss, Freud asserts that memory is to be understood as a set of inscriptions (*Niederschriften*). In the same letter, he also states as a fundamental postulate that memory and consciousness are mutually exclusive, in order that the field of consciousness should remain permanently receptive to new perceptions. Were it to retain a record of perceptual events, its capacity to accept new sense impressions would soon be overwhelmed. Freud remarks that 'our psychical mechanism has come into being by a process of stratification' and that a single 'event' may be registered in more than one layer within the apparatus: 'Thus, what is essentially new in my theory is the thesis that memory is present not once but several times over, that it is registered in various species of "signs" . . . I cannot say how many of these inscriptions . . . there may be: at least three and probably more'.[48] Once laid down in the unconscious, Freud believes that these memory traces are ineradicable, though they may not be available for conscious recall due to repression.

An extended account of the psychic apparatus and of the mnemic (memory) system is found in *The Interpretation of Dreams* along with the schematic picture below. A series of mnemic elements (Mnem, Mnem', Mnem", . . .), multiple registrations arising from a single sensory impression, are displayed like pages of a book layered behind the always blank page of the perception-consciousness system.

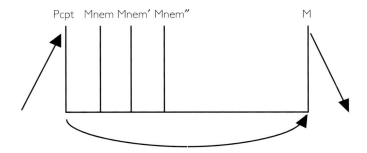

'The *structure of the psychical apparatus* will be *represented* by a writing machine' remarks Derrida, underlining the problem of representation that his novel conception of the mind presented to Freud.[49] From its first description, Freud struggles to find an adequate visual analogy,

eventually discovering one in a writing device familiar from childhood known as the 'mystic writing-pad', which consists of a slab of wax covered by a sheet of celluloid.[50] Application of pressure causes the celluloid to adhere to the wax and where this occurs the whitish colour changes to a dark blue-grey. It is thus possible to write on the pad using a blunt stylus. Unlike an ordinary writing-pad, erasing what has been inscribed is easily done by lifting the sheet and breaking contact between the surface layer and wax slab. While the wax retains an imprint of what has just been written, the surface of the apparatus is cleared and ready to be written on once more. 'I do not think it is too far-fetched', writes Freud, 'to compare the celluloid and waxed paper cover with the system Pcpt.–Cs. and its protective shield, the wax slab with the unconscious behind them, and the appearance and disappearance of the writing with the flickering-up and passing-away of consciousness in the process of perception.' The surface layer, in a constant state of receptiveness to new inscriptions, has no capacity to store writing unlike the wax slab beneath, which in the same manner as the mnemic apparatus retains a permanent imprint or trace of the original writing – able to be read later under suitable lighting, Freud assures us.[51]

'A Note Upon the "Mystic Writing-Pad" ' begins with a fairly trivial comparison of a notebook in which one jots down things so as not to forget them and the function of memory itself: 'In that case the surface upon which this note is preserved, the pocket-book or sheet of paper, is as it were a materialized portion of my mnemic apparatus which I otherwise carry about with me invisible.' Miró used his notebooks in similar fashion, as a memory-bank containing permanent traces that could be revived whenever he chose to turn a drawing in to a painting (this transfer from one medium to another was a translation that entailed changes in scale, orientation and so forth).[52] But the analogy obtains on other levels as well.[53] If the hypothesis presented here is correct, that Miró worked on occasion by tracing over the top of a drawing visible beneath, each time he turned over to a new page he would have been presented with a fresh surface ready to receive new impressions. We can see this as broadly analogous to the receptive surface layer of the psyche, the Pcs.–Cs. system. The pages lying beneath containing permanent records of the automatic process could thus be likened to the stratified, unconscious traces laid down in the mnemic apparatus.[54]

Something akin to the retranscription of memory happens when imprints or faintly visible traces are used as a spur to the imagination, being modified in sometimes surprising ways from one sheet to another. It is tempting to see this process as being governed by the same laws of association and displacement of cathexis as those regulating the unconscious. Carolyn Lanchner has convincingly shown that Miró came back on at least some occasions to fill in blank pages or the reverse sides of pages in the sketchbook. A consequence of this is that the sketchbook stores images of varying age side by side – pictorial anachronisms capable of being revisited (and reinvested psychically) at a later date, adding a further layer of complexity to the temporal profile of the sketchbook.

Virtually the entire pictorial output of Miró in the years 1924/27 had its origin in these notebooks. Their blanket suppression by the artist, his willingness to consign them to oblivion for a period of more than forty years, and tacit encouragement of the erroneous accounts that proliferated in their absence, raises a host of questions. What prompted this repression? And what of the spectacular return of the repressed (whose trauma to certain art historians is doubtless still being felt)? What are the implications of this anamnesis for our understanding of Miró as an authorial subject and of his work during this crucial period? In recent years, a

revisionist art history has drawn attention to the metaphysical suppositions that lie behind the art-historical commonplace of 'the man and his work' or, in Foucault's words, 'the manner in which a text apparently points to this figure [the author] who is outside and precedes it'.[55] Art history, these critics note, employs a circular logic in order to construct from the oeuvre a unified authorial subject who then functions as the source and foundation of meaning and also as a guarantor of the value that is invested in the original work of art, a vital prop of the art market. This ideological construct of the artist is modelled on a theology, Donald Preziosi has argued in his book, *Rethinking Art History*, in which:

> the disciplinary apparatus works to validate a metaphysical recuperation of Being, and a unity of intention or Voice. At base, this is a theophanic regime, manufactured in the same workshops that once crafted paradigms of the world as Artifact of a divine Artificer, all of whose Works reveal a . . . set of traces oriented on a(n immaterial) center. In an equivalent fashion, all the works of the artist canonised in this regime reveal traces of (that is, are signifiers with respect to) a homogeneous Selfhood.[56]

The trace as an attribute of the linguistic sign is a key term for Derrida who, in order to differentiate his use of the term from the common meaning of a trace as the marker of a former or original presence, introduces the concept of an arche-trace to indicate that the origin always already bears the imprint (trace) of a non-origin: 'The trace is not only the disappearance of origin – within the discourse that we sustain and according to the path that we follow it means that the origin did not even disappear, that it was never constituted except reciprocally by a non-origin, the trace, which thus becomes the origin of the origin.'[57] The trace is therefore a marker of effacement which has the effect of placing presence under the sign of erasure (*sous rature*). It deconstructs the origin and, specifically, the self as origin: 'The trace is the erasure of selfhood, of one's own presence, and is constituted by the threat or anguish of its irremediable disappearance.'[58]

Derrida's deployment of a notion of the trace in order to deconstruct a metaphysical conception of the self as origin and full presence, placing it under the sign of erasure, is consonant with our reading of automatism. Automatic writing, as the trace of a voice emanating from another scene, the unconscious, was seen as displacing the authorial subject from its position as origin. Whether as a simple recording instrument – or removed to the sidelines, as a spectator at the birth of the work, in Max Ernst's felicitous expression – the author is diminished in status by comparison with the automatic message for which he acts merely as a passive conduit.[59] By giving due weight to tracing as an integral part of Miró's automatist practice and recognising its significance for the subject, one can begin to break with the powerfully ideological readings which, in the absence of this material evidence, the dream paintings gave rise to. Indeed, were one to cast another glance back over the sequence, it would be seen that there is a bold sacrifice or relinquishment of the self, notably in figure 4 where the 'Moi' of the first page is quite literally placed under the sign of erasure and confronts its imminent disappearance. Automatic writing forces upon the subject a realisation of its subordinate status with respect to language – language *precedes* the self, as Walter Benjamin said.[60] Just as Breton declares his willing subjection to the signifier with the lyrical exhortation, 'After you, my beautiful language', so too Miró's *Moi* (the French translation of ego) is swept along by the play of a chain of visual signifiers. The penultimate image represents the culminating point in the dissemination of signs, and of the self, across the spatial field. A comparable state of

dispersion is attained in a nearly contemporary version of the *Catalan Peasant*, in which an abstract schematic figure is totally submerged in an expansive washy space, and in the following year, 1926, Miró scatters all the letters of his name across the picture, *Landscape* (*The Grasshopper*) in a gesture at once whimsical and nihilistic. 'With difficulty, I tear myself from contemplating . . . the human apparition which disperses ['qui dissémine']', Breton remarks as he too submits to the anguished yet ecstatic experience of self-scattering in the face of the automatic message.[61] Thus decentred and displaced, the artistic subject *Moi* – Miró is a mere spectator at the birth of the world.[62]

coda: language takes precedence

A straightforward chronology of surrealism reveals that language took precedence over the visual image. Pierre Janet, who coined the term 'automatisme psychologique' from which the surrealists in turn derived their notion of *automatisme psychique pur*, had used automatic writing to gain access to a split-off, traumatic kernel of ideas dissociated from the individual's conscious mind which he believed to be the causative factor in hysteria. In addition, Breton had more recently become acquainted with the method of free association and had had occasion to use it in treating soldiers afflicted with war neuroses.[63] Profoundly impressed by the poetic imagery thus obtained, he resolved to try out the technique himself. And so, in 1919, in the space of only six days, Breton and Philippe Soupault wrote *Les Champs magnétiques*. A full year before the *Manifesto of Surrealism* officially launched the movement, those who identified themselves with the nascent surrealist group were busy proselytising the virtues of automatic writing as a royal road to the unconscious. Breton, writing in November 1922 in the essay 'Entry of the Mediums', states without equivocation that the word surrealism designates precisely 'a form of psychic automatism', and by way of illustrating this he is able to refer the reader of course to *Les Champs magnétiques*, texts written in strict 'obedience to this magic *dictation*'.[64]

Practices of automatic writing were consequently well established by the time of the first faltering efforts of Ernst, Masson, Miró and others at translating this dictation by the unconscious into a visual register, and they provided a standard by which the latter would continue to be judged. Arguably, it was only as automatic *writing* that the visual image was wholly acceptable to the ideologues of surrealism and as a result one sees some curious experiments by artists with hybrid forms, attempting to bridge the divide between word and image.[65] But the obstacles they faced were not only of a practical nature to do with the lack of suitable visual models. To ascribe the primacy of language over purely visual forms of expression wholly to contingent circumstances, to the fact that automatism was in the first instance a practice of writing, or even to André Breton's admitted prejudices as a poet and writer, would be to overlook the privileged status of a linguistic paradigm in the theories Breton and his fellow surrealists looked to in order to shore up the doctrine of automatism.[66] What follows, then, is a discussion of the word–image relation as it is construed in two of the theoretical models to which Breton had recourse.

Letters to Théodore Fraenkel at the time of Breton's first revelatory experiences at Saint Dizier in 1916 and 1917 prove incontrovertibly that a Freudian technique of free association provided the initial impetus. Breton's knowledge of psychoanalysis at that date was patchy, based on the flawed and crudely bowdlerised secondary sources available to him, but as Freud was translated his understanding indisputably grew and became more nuanced.[67] We can be cer-

tain that the psychoanalytic 'talking cure' offered Breton and surrealism firm grounds for believing that language (speech, writing) was the preferred road to the promised land of the unconscious. John Forrester's lucid study, *Language and the Origins of Psychoanalysis*, demonstrates that the preeminence afforded to language in Freud's metapsychology had its origins in his early neurological studies of the aphasias, disorders of speech caused by lesions in the brain.[68] Breaking radically with accepted classifications based on cerebral localisation, Freud proposed a quasi-structural model of aphasia based on a distinction he drew between 'word-presentations' and 'object associations'. A word presentation is made up of elements of visual, acoustic and kinaesthetic origin; foremost amongst them, Freud stated, is the acoustic sound-image for the reason that language is acquired first from the spoken word. Of the object-associations, it is visual memory traces that are the most important and, as it were, stand in for the object. On the basis of this distinction Freud posited two fundamental types of aphasia, one resulting from a disturbance to relations between elements of the word-presentation (verbal aphasia), and another (asymbolic aphasia) in which the link between the word-presentation and object-associations is interrupted.

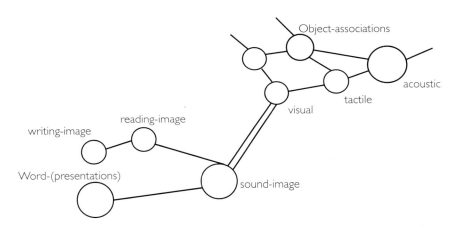

Psychological Diagram of a Word-Presentation.

From his explanation of the aphasias, Freud derived the main elements of a theory designed to account for the operations of the psychical apparatus as a whole. 'The Project for a Scientific Psychology' of 1895 advances a fundamental hypothesis that consciousness arises only when a thought becomes attached to a word-presentation and thereby attracts a sufficient quota of energy (cathexis) to itself.[69] This claim is reiterated once again in 1915 in the essay 'The Unconscious' where Freud writes: 'The system *Ucs.* contains the thing-cathexes of the objects, the first and true object-cathexes; the system *Pcs.* comes about by this thing-presentation being hypercathected through being linked to the word-presentations corresponding to it.'[70] In a manner akin to asymbolic aphasia, the phenomenon of repression is attributed to severing of the connection between a thought, which as a result is destined to remain unconscious, and the word-presentation corresponding to it (or, alternatively, to the failure to establish such a connection in the first place).[71] Freud's theory of repression was evolved in conjunction with his studies of hysteria, and he invokes it in this context both to

account for hysterical conversion symptoms and as an explanation for the talking cure which had come to replace hypnosis as a method of abreaction. The cause of hysteria was, Freud postulated, a trauma of a sexual nature which had very often occurred before the child had acquired linguistic competence. For this reason it could not be integrated into language but instead remained imprinted as a visual memory in the unconscious. A hysterical symptom was thus, like aphasia, the effect of a failure of speech; as Forrester puts it, 'words find their material locus in the body rather than in sound.'[72] The aim of therapy was to restore broken connections between the unconscious thing-presentation and its word-presentation, whereupon the symptom would disappear. Forrester cites a passage in which Freud goes so far as to imply that the repressed visual memory when revived and put into words actually fades away; 'The patient is, as it were, getting rid of it by turning it into words.'[73]

All of this is recapitulated by Freud in a section of 'The Ego and the Id' quoted almost verbatim by Breton in the essay 'Political Position of Surrealism'.[74] Freud begins by asking the basic question: 'How does a thing [an unconscious thought] become conscious?' (For Breton, this question defines the central issue of automatism, namely the conditions of representability of the unconscious.) The question itself may be reformulated as: 'How does a thing become pre-conscious?' to which Freud answers: 'Through becoming connected with the word-presentations corresponding to it.' The task of psychoanalysis is to overcome repression by supplying the pre-conscious intermediaries, that is to say, verbal memories – or, more technically, 'mnemic traces originating principally in acoustic perceptions'.[75] Breton claims that these verbal representations are the very stuff poetry is made from and, pursuing an analogy with the talking cure, concludes with the emphatic assertion: 'I shall never tire of repeating that automatism alone dispenses the elements upon which the secondary work of emotional integration ['amalgame émotionnel'] and passage from the unconscious to the preconscious can operate validly.'[76]

By contrast, optical mnemic residues (visual memories), though not excluded from Freud's account, are described as 'only a very incomplete form of becoming conscious'.[77] The subsidiary status of 'thinking in pictures' for Freud is shown by his theory of dream symbolisation. In this, the manifest dream image is shown to be derivative of the underlying dream thoughts, which are themselves structured by the psychical mechanisms of condensation and displacement. As Roman Jakobson demonstrates in his essay 'On Two Types of Aphasia', these mechanisms have close affinities with the linguistic tropes of metaphor and metonymy respectively.[78] Lacan's best-known aphorism, 'The unconscious is structured like a language', is abundantly proven by the dream analyses comprising Freud's *The Interpretation of Dreams*, a book in which it can safely be assumed the surrealists were thoroughly versed.

Also bearing upon the relationship of verbal to visual imagery in a way that is pertinent to our discussion is the notion of *endophasie* or *langage intérieur* (these terms were synonyms) which had some currency in late nineteenth-century French psychology.[79] *Endophasie* is defined by Lalande's *Vocabulaire technique et critique de la philosophie* as the 'succession of verbal images that accompany the spontaneous exercise of thought'. The definition of pure psychic automatism that Breton subsequently provides in the *Manifesto of Surrealism* is plainly dependent on the concept of an unregulated flow of verbal images that the term *endophasie* served to denote. By this definition, automatism subsists at the level of thought, and the task of automatic writing is the faithful notation of this *dictée de la pensée*. For Max Morise, writing in the aftermath of the *Manifesto*, the uninterrupted flow of ideas is the main criterion for either accepting or dis-

qualifying a visual practice as surrealist: 'the succession of images, the flight of ideas are a fundamental condition of every surrealist manifestation.'[80]

Spoken phrases or visual images that are perceived in states of diminished mental alertness, typically on the point of going to sleep or awakening, were considered to be examples of *endophasie*. Breton often refers to hypnagogic images and phrases in the same breath as discussing automatism. The particular example he gives in the *Manifesto* is of a clearly articulated phrase which he heard late one evening: 'There is a man cut in two by the window.'[81] Breton recalls that the acoustic image was accompanied by a fainter visual image, enabling him to forge a parallel of sorts between the verbal and visual forms of automatism. Were he a painter rather than a poet, the visual representation would doubtless have been the stronger, he reflects. Pierre Quercy, author of *L'Hallucination*, a book Breton refers to in 'The Automatic Message', also gives credence to the notion of *endophasie* in explaining hallucinations, these being ascribed to an accentuation of *langage intérieur* to such an extent that their subjective origin ceases to be recognised. Consequently, it is only a difference of degree which separates surrealist automatism from hallucination, something Breton was able to confirm from his own personal experience: 'Automatic writing, practised with some fervour,' he opines, 'leads in a straight line to [visual] hallucination.'[82]

Langage intérieur was subdivided according to which component of the word-image couplet predominated into either verbo-auditory, verbo-motor, or verbo-visual types. Concerning the last-mentioned, Jean Cazaux cites an authority who explains: 'Some people see printed in their minds every word they pronounce. They make use of the visual equivalent and not the auditory equivalent of a word. And, in speaking, they read the words, as if they were printed on one of those long strips of paper used for telegraphic transmissions.'[83] Seeming to employ this very specific terminology, Breton in 'The Automatic Message' argues that visual images generated from automatism in which the auditory element is dominant are superior to those originating in verbo-visual automatism. Once again, painters would be allowed to draw little comfort:

> In poetry, it always has seemed to me that verbo-auditive automatism creates for the reader the most exalting visual images. Never has verbo-visual automatism seemed to create for the reader visual images that can in any ways be compared . . . I continue to believe blindly (blind . . . with a blindness that covers all visible things) in the triumph auditorially of what is unverifiable visually.[84]

Protesting on these grounds to the Romantic ideal of the poet as seer, Breton claims that neither Rimbaud or Lautréamont *saw* what they described. Rather, 'they threw themselves into the dark recesses of being; they heard indistinctly, and with no more comprehension than any of us had the first time we read them . . . "Illumination" came afterwards.' He continues, throwing down the gauntlet to those of a more retinal disposition: 'This much having been said, the painters obviously are now the ones to speak, whether or not to contradict me.'

Breton's claim that these poets responded first to the murmurings of the unconscious and only afterwards did they visualise what they had heard brings us back to Miró. Michel Leiris reports that Masson, during the period when he and Miró shared adjacent studios, would utter out loud certain keywords that served as a stimulus to picture-making. Words, often exclamations or onomatopoeias where an auditory component is intrinsic to the written word, crop up not infrequently in the notebook drawings Miró executed in this period, suggesting at very least the possibility that in his case too the starting point of an image could be not an image

seen, as the visionary paradigm of the artist would have it, but instead the written, or spoken, word. Language takes precedence . . . as a concluding thought, we might ask if *The Birth of the World* did not come about in just this fashion with, in the beginning, 'Moi', whose visualisation came only afterwards?

ii labyrinths: reading the work of André Masson

'With eyes closed . . . I would plunge, with the certainty of finding myself again, into a maze of lines ['un dédale de lignes'] which at first would seem to be leading nowhere. And, upon opening my eyes, I would obtain a very strong impression of something "*jamais vu*".'[85]

One ought not be surprised, Breton remarked, to see surrealism establish itself at the outset almost uniquely on the plane of language.[86] Painting would always remain for the surrealists an object of suspicion, a lamentable expedient. Proof, if it were required, of the subordinate status of visual art is to be found in the demeaning footnote to which it was relegated in the surrealist *Manifesto*. Immediately after Breton, in the same document, had given his famous dictionary definition of surrealism as 'pure psychic automatism', an article followed in the first issue of the journal *La Révolution surréaliste* which purported to evaluate the various contenders in the visual arts for their compliance with the definition. Max Morise, in 'Les Yeux enchantés', identifies as a major drawback of visual media in general their static and simultaneous nature. With the notable exception of film, they are destined to betray the flow of (unconscious) thought, for which purpose the written word was more congenial. Morise comes out strongly against Chiricoesque dream painting for the reason that the unconscious impulse is especially prone to be distorted and betrayed because of the length of time it takes to paint such a picture: they may look surrealist, but the means of expression definitely are not. By contrast, he takes a more favourable view of graphic methods of notation which, like a seismograph, he suggests are capable of registering the merest undulations in the flux of thought. Surprisingly, cubist pictures are proposed as a desirable model for the aspiring surrealist to emulate since, Morise believes, they are made without any preconceived subject and afford 'a cinematic record' ('un cliché cinématique') of thought. He also sings the praises of madmen and mediums, whose drawings, he says, consist of rudimentary signs jotted down according to the random dictates of their mind.[87] Of work already being produced in the surrealist orbit, Morise was more sparing in his praise, though Masson he evidently judged to meet the criteria best since he supplied the only illustration to the piece. That more space was allotted to works by Masson in early issues of *La Révolution surréaliste* than to any other artist suggests that this view was officially sanctioned by Breton. Indeed, he can only have had in mind Masson when, in order to indicate possible directions for a visual practice of automatism, he speaks in the passage quoted above of plunging headlong into 'un dédale de lignes' – a maze or labyrinth of lines.

The labyrinth is a ubiquitous and overdetermined motif in Masson's art. The purpose of this study is to reconsider its role as a metaphor of the unconscious, self-evidently by constituting

a shadowy, subterranean space inhabited by the instinctual forces of Eros and death, but additionally by invoking a distinctive mode of temporality, a psychic time that is premised on spiralling recurrence and repetition. Masson himself once commented that what is most striking in a dream, and by inference a painted or drawn image, where unconscious psychical processes predominate is that 'the forms that compose it appear in a space and a duration which are specific to them ['un espace et une durée qui leur sont propres']'.[88] He alludes thereby to the Freudian view that unconscious primary process thinking does not conform to the Kantian space and time coordinates which govern logical or conscious thought. In the first part of the study, we shall see that the pictorial architecture Masson constructs, self-consciously modelled on the labyrinthine spaces of Piranesi's *Carceri*, is one in which reason is led astray, loses its way. Through a comparison with purism, which in its painting no less than its functionalist architecture sought to embody Enlightenment reason, Masson and his brand of surrealist painting can be situated as the unconscious underbelly of that vision of modernity as rationality which in Masson's view had relegated to the shadows the instinctual drives that are at the very root of our being.

The labyrinthine metaphor also serves to evoke a mode of temporality (deferral, repetition) belonging to the unconscious and determined in opposition to the linear, unidirectional time of consciousness and rational causality.[89] Freud speaks of a repetition compulsion (*Wiederholungszwang*) first in relation to trauma and especially war neuroses, matters of direct relevance to Masson. But over and beyond these pathological instances, timelessness and indestructibility and a concomitant tendency to recur are the features of unconscious, instinctual 'id' impulses in general: 'it is possible to recognize the dominance in the unconscious mind of a "compulsion to repeat" proceeding from the instinctual impulses and probably inherent in the very nature of the instincts', writes Freud.[90] Our consideration of the significance of repetition in Masson's work will open onto a symptomatic reading of the visual culture of the interwar period. It will also cause us to return to the issue raised by Max Morise of time and the visual image. It might be expected that recurrence would manifest solely as a relationship *between* images viewed in sequence, but I shall be arguing with reference to the Massonian image that the time(lessness) proper to the unconscious manifests at the level of the individual work as well. Overcoming the static nature of visual art in order to register flux and mobility, the circuits and circulation of drives and energies within the human body and by homology the universe as a whole, was an imperative that connected with the widest philosophical ambitions of Masson's art.

the revenge of pleasure

Why return to the subject of automatism? One possible direction from which to reread the efficacy of surrealist automatism as an avant-garde strategy was suggested to me some time ago by what at first I had been inclined to dismiss as nothing more than a minor typographic slip. Having prepared a lecture on surrealism and automatism, I found my audience expecting a disquisition on the altogether more abstruse topic of surrealism and automation, as my title had appeared misprinted on the timetable. Reflecting afterwards upon this happenstance, it struck me as meaningful given the values then being espoused by universities that a word meaning for the surrealists an undirected flow of thought should have been usurped by another having connotations of assembly-line production.[91] It occurred to me then that this

doublet (automatism–automation) might be useful in conceptualising how automatism signified as an oppositional practice between the wars.

At the point when André Masson embarked on his first automatist doodles, as he modestly called them, purism was the most advanced and coherent expression of a modernist ideology in the Parisian avant-garde. The purists Le Corbusier and Amédée Ozenfant extolled the machine age but in their paintings at least they preferred to represent familiar objects drawn from the everyday world: bottles, pipes, hats and so forth. These so-called 'type-objects' were held to be perfectly adapted to their function as the result of a long evolution, and while none is a machine in the usual sense, they embody in their forms an ideal state of efficiency and utility which could be said to render them machine-like. Ozenfant and Le Corbusier believed that the same principle governing the fabrication of these man-made objects also steered the process of evolution in the natural world: 'ECONOMY is the law of natural selection', they insist.[92] This principle of economy is reflected pictorially in compositions which have the clarity and precision of an engineer's blueprint, where the neat orchestration of elements reads as an analogue for mechanical perfection. A painting is a synthesis of elements purified and combined as an architectural ensemble ('architecturé').[93]

During the war and immediately afterwards, when reconstruction was an urgent priority, Le Corbusier embraced Taylorism, an American system of scientific management which promised industry greater efficiency and profit through the automation of factory production and standardisation of the goods produced. In the Dom-Ino project, a system of low-cost housing based on standardised modules and prefabricated materials, Le Corbusier sought to adapt Taylorism to architectural design.[94] If one were to imagine the same principles carried across to painting, purism would be it: in its inert and mechanistic character the relentless logic of the assembly-line is writ large. Repeated circular forms traced by bottles, plates and pipes disposed across the canvas evoke, if only subliminally, a vision of well-oiled cogs whirring in a coldly reified universe.[95] Après le cubisme, the purist manifesto, declared in 1915 that: 'Instinct, trial and error, as well as empiricism are to be replaced by scientific principles of analysis, organisation and classification.' And, with an unwarranted optimism given the insanity of the war being waged on their doorstep, they conclude: 'Never since the time of Pericles has thought been so lucid.'[96]

Surrealism naturally found itself at loggerheads with the form of Enlightenment rationality uncritically embraced by the purists, an instrumental or purposive rationalism (Zweckrationalität) which endeavoured to subordinate all activity to calculable ends.[97] For Georges Bataille, whose post-war writings on surrealism reveal him as an insightful and sympathetic commentator, not the implacable foe we have been conditioned to view him as, it was the chief merit of surrealism to have:

> released the free activity of the mind from servitude. Rationalism, by rejecting into the shadows this activity, brought into light the enslavement of acts and of all thought to the end pursued. In the same way, rationalism liberated poetic activity from this enslavement, leaving it suspended. The difficulty remained however to affirm the value of that which in shadows was finally unchained. In this way, what has proved to be simultaneously attained and liberated is nothing other than the instant . . . And the principle of automatic writing is clearly to have put an end to goals.[98]

Paradoxically, the term 'automatisme' is derived from mechanistic theories of causality, and in the field of psychopathology the term implied that the higher mental faculties responsible for

volitional thought had been disabled allowing the lower, more reflexive operations of the nervous system to predominate. More or less contemporary with the surrealists, the psychiatrist Gaëtan Gatian de Clérambault (who is a target of Breton's vituperation in *Nadja*) advanced a notion of *automatisme mentale* that was of this type.[99] Within the surrealist lexicon, on the other hand, the term undergoes a semantic shift that imbues it with connotations of spontaneous, undirected flow – whether that be of words, of mental images in the doctrine of *endophasie*, or in Masson's case of sand, glue and paint. Consistent with its decisive break with all ulterior goals, Bataille saw this undirected process as affirming the value of the unique moment in which it unfolds: 'The incommensurable value of the instant is all that counts.'[100] Indolence has its rewards under this credo: the terms of Bataille's analysis allow us to appreciate that the surrealists' scorn for work is at one with their cult of the unforeseen, with an aesthetic of surprise and a predilection for chance finds or chance encounters. Or for the unexpected image that erupts unbidden from the unconscious whilst the subject is in a willed state of distraction and passivity, the two main prerequisites for automatic writing. The surrealist writer wilfully obviates the rule that language should serve the ends of communication: like Marinetti's *parole in libertà* (words in liberty), the doctrine of automatic writing marks 'an act of rupture . . . with an enslavement which, beginning with the world of technical activity, is determined in words themselves to the extent that these words participate in the profane world or in the prosaic world'.[101]

Taylor's scientific management, the rational values of efficiency and functionality of which were wholeheartedly embraced by Le Corbusier, imposed a strict discipline on the worker's body. Taylor aimed to streamline assembly-line production by eliminating any superfluous bodily movements, turning the worker as far as possible in to a soulless, choreographed robot (Charlie Chaplin, in *Modern Times*, extracts humour from prevalent anxieties about the resultant dehumanisation of the labour process at this time). Pleasure and corporeal excess are anathema to profits. In consequence, Max Weber long ago recognised a strongly puritanical streak running through capitalist modernity which it has been argued can also be discerned in the culture of modernism.[102] In the purist lexicon, for instance, the words order (*ordre*) and purification (*épuration*) occur with such regularity that one begins to suspect them of performing, in Weber's words, an anxious 'repudiation of all idolatry of the flesh'. From this point of view, the quest for aesthetic order and purity can be understood as equivalent to an obsessive hand-washing ritual: that is to say, as a symptomatic attempt to repress the unclean body and its wayward drives.[103] Its counterpart is Le Corbusier's near obsession with bodily health and hygiene. An article in *L'Esprit nouveau* ushers in a new body as a wholesome receptacle for the 'new spirit' announced in the journal title: 'The body is going to reappear naked beneath the sun, washed, muscular, supple' its author, Dr Winter, declares.[104] Winter's cult of the clean, well-muscled body plainly owes a good deal to the pursuit of *Korpskultur* by fascists across the Rhine, but doubtless had also the full backing of Le Corbusier who believed fervently that the heart of old Paris, a labyrinth of narrow, airless streets never exposed to sunlight, was a disease-ridden, festering sore which his Voisin Plan promised to excise. Masquerading under the functionalist rhetoric of Le Corbusier's architecture and urbanism was an incitement to cleanliness that also manifests in his *Still Life with Stack of Plates* (fig. 10) as a pristine array of emblematic 'type-objects' from which all reference to bodily needs and desires is carefully expunged. Are we not entitled to regard the neat, fastidious placement of each and every object in this still life as a token of good housekeeping carried to a neurotic, obsessively ruminative, extreme?

André Masson.

An article in the journal *Documents* by Masson's close friend Michel Leiris, titled 'L'Homme et son intérieur' (Man and his interior), begins with a cautionary tale about the dangers of excessive cleanliness.[105] It concerns a woman who was so disgusted by the thought that people might contain intestinal viscera like a slaughtered ox she had glimpsed at a butcher's shop that she resolved never to eat again and starved herself to death. For a return of what purism represses, of the *ord(u)re* within the body,[106] one need simply look to the automatist works executed by Masson which reveal in his own words a visceral obsession by their exposure of the body's labyrinthine cavities and *dis*orderly instinctual drives: 'These images, almost invariably labyrinthine, presented the body disemboweled with the digestive organs displayed. This visceral obsession was sometimes veiled by the symbolic substitution of an open fruit when it was the case of female figures.'[107] Masson's complaint against the cubist painters, and the distinction he draws between them and his own pictorial concerns, would hold for purism as well: 'They refused to represent not only the dream, but also those instincts at the root of being: hunger, love and violence.'[108] The resurgence of an iconography of the sensual body (fig. 11 appeared in *La Révolution surréaliste* above a text by Michel Leiris titled 'La Revendication du plaisir' [The revenge of pleasure]) is described by Masson in terms befitting the overcoming of a repression: 'I could not defend myself from a reaction of shame – from an indescribable malaise – joined to a vengeful exaltation. Like a victory won over an unknown oppressive force.'[109]

While it is not necessary to claim that Masson's automatism was consciously pitched against a purist aesthetic ideology, it is on their home ground in the genre of still life that some telling differences between their approach and his emerge.[110] There are enough points of correspondence between *The Rope* of 1924 (fig. 12) and a typical purist still life – evident, for example, in the selection of transparent objects, beakers and bottles, orchestrated to achieve an effect of rhyming disc and conic shapes, plus an overall geometry – all of which indicates that Masson had looked attentively, and not unsympathetically, at their painting. But the purpose for which these formal devices are utilised, and the symbolic resonances of the objects themselves, are in each case utterly different. Whereas for the purists, transparency signifies a Platonic realm of ideal forms disclosed by the pure light of reason, Masson uses the selfsame device to evoke an

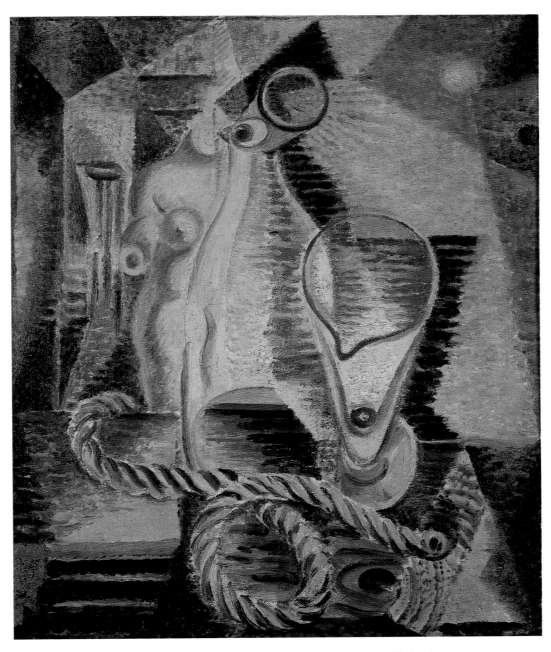

12 André Masson. *The Rope*. 1924. Oil on canvas, 44 × 38cm. Edinburgh: Scottish National Gallery of Modern Art.

10 (*facing page left*) Le Corbusier. *Still Life with Stack of Plates*. 1920. Oil on canvas, 81 × 100cm. Basel: Oeffentliche Kunstsammlung Basel, Kunstmuseum. Gift of Raoul La Roche 1963.

11 (*facing page right*) André Masson. *Automatic Drawing. La Révolution surréaliste* n° 3 (15 April 1925): 24.

13 Giovanni Battista Piranesi. *Carceri d'Invenzione* (Rome: 1761). Folio of etchings, 57.5 × 42.2cm. Manchester: The Whitworth Art Gallery, University of Manchester.

irrational dream-space of condensations and non-causal connections. As Bataille noted, the surrealists were preferentially drawn to all that the march of rationality had banished to the shadows. Among those works, neglected or outlawed, which Masson felt presaged a surrealist aesthetic he mentions in particular Piranesi's 'metaphysical' prisons, the *Carceri d'invenzioni* (fig. 13). Most conspicuously in the drawn and painted variants of the *Nudes and Architecture* series, but also visible in *The Rope*, are indications of columns, archways and ramifying, dimly-lit interiors plainly inspired by the sepulchral spaces of Piranesi's ruins. Beyond evoking in general terms a world of classical myth – what Masson would later refer to as 'La Grèce tragique', a world of dark myths and sombre rites – the significance of these architectural containers can be gauged from an evocative article on the *Carceri* etchings which appeared in the journal *Documents*. The author, Henry-Charles Puech, speaks of Piranesi as conjuring 'this dream of a subterranean architecture, disproportionate in its dimensions and its multiplications'; the spiralling arches and labyrinthine recesses invented, it is said, by a nihilistic architect have the sole effect of leading the beholder to the point of illness, 'to a state – ridiculous or sublime – of vertigo'.[111] Destroyed, in a ruinous state from the moment of their inception, the *Carceri d'Invenzioni* are a monstrous, parodic inversion of the utopian schemes and edifices of modernist architects. We may assume that for Masson likewise they were a space as far as possible removed from the envisioned spaces of modernity for which Le Corbusier's painting, composed as we saw on the principle of 'éléments épurés, associés, architecturés', every bit as much as his architecture or urban planning, provided a utopian blueprint.

Access to the nocturnal dream-space of Masson's painting is via a thick, braided cord which stretches from the front of the picture plane towards the female torso hovering behind the table. Of sufficient importance to have given a title to the picture, this Ariadne's thread leading into the maze might have been inspired as well by Piranesi's pictorial imagination: Henry-Charles Puech draws attention to an 'immense rope – the *antenna* – which traverses the entire field of certain engravings' and which, he notes, has no discernible practical function. We can only surmise what might have caused Piranesi to bestow such care and finesse in delineating the great coils of rope seen in the lower part of the illustration, but in Masson's case, bearing in mind his professed visceral obsession, it seems more certain that the cord is invested with bodily associations linked to its pictorial functions of binding and connecting. Most probably

Masson would not have disagreed with Freud that in the legend of the Labyrinth 'the twist-ing paths are the bowels and Ariadne's thread is the umbilical cord', though it was not until 1936 when the *New Introductory Lectures of Psychoanalysis* was published in French that he could have read of this.[112] There is another context in which Freud invokes this same bodily meta-phor in a way that accords with its allotted role in Masson's imagery, and that is in *The Inter-pretation of Dreams* (once again not translated until 1926):

> There is often a passage in even the most thoroughly interpreted dream which has to be left obscure; this is because we become aware during the work of interpretation that at that point there is a tangle of dream-thoughts which cannot be unravelled and which moreover adds nothing to our knowledge of the content of the dream. This is the dream's navel ['der Nabel des Traums'], the spot where it reaches down into the unknown.[113]

The looped cord, a recurrent motif in Masson's automatist drawing and painting, performs just such a function of permitting entry into the pictorial dream-world, suspending us as desir-ing subjects from that enigmatic point, the picture's umbilicus, of which any rational solution is forever blocked.

a maze of lines

The first issues of *La Révolution surréaliste* were profusely illustrated with drawings by Masson that apparently had Breton's official stamp of approval as corresponding best to the doctrine of psychic automatism, but not until 1961 did Masson give an explanation of the procedure that lay behind their creation:

> Materially: a little paper, a little ink.
>
> Psychically: make a void within oneself; the automatic drawing, having its source in the unconscious, must appear like an unpredictable birth. The first graphic apparitions on the paper are pure gesture, rhythm, incantation, and as a result: pure *doodles*. That is the first phase.
>
> In the second phase, the image (which was latent) reclaims its rights. Once the image has appeared, one should stop. This image is merely a vestige, a trace, a bit of debris. It follows that any break between the two phases must be avoided. If there was a pause, the first result would be total abstraction, and persisting too long in the second phase, something that was academic *surrealistically!*[114]

Though its remoteness from the event may be said to vitiate its reliability as evidence, for an artist's perspective on the issue of how to represent the unconscious in a visual register his account is of great interest. While broadly adhering to Breton's recipe for automatic writing, it may be said to differ in at least one respect. Far from sharing in the 'good faith' and 'certi-tude' of those on the literary side as regards the annexation of the unconscious to language, Masson seems quite circumspect about the representability of the unconscious *tout court*. The process seems most vulnerable in the passage from the first phase to the second, implying at this level a refractoriness or resistance to representation.

Conceptually, this two-stage process is formulated in broadly Freudian terms. As 'gesture, rhythm, incantation', the first stage which is non-representational could be said to correspond

psychically to the system *Ucs*. At this level, the drives exist in an unbound state. Freud describes mobility of cathexis, the free flow of energy, as a defining property of the primary process: 'Impulses arising from the instincts do not belong to the type of bound nervous processes but of freely mobile processes which press towards discharge . . . In the unconscious, cathexes can easily be completely transferred, displaced and condensed.'[115] Only subsequently, according to Masson, do discrete objects begin to take shape. Typically these are what psychoanalysis would call part-objects – breasts, torsoes, and so forth – to which the component drives (*Partieltriebe*) from the previous phase are directed. At this point, the binding of libidinal energy brings to a halt the flux and rhythm of the primary process: 'there one must stop' ('il faut s'arrêter'). It is vital in Masson's estimation that the two moments be bridged, otherwise the imagistic component remains uncathected by the drives and the outcome is at best a sterile academicism *à la* Dalí. And yet the passage from one to another constitutes an aporia that he is unable to precisely define or account for. Automatism is hence the name for an unstable relation between desire, which is unfixed and by nature unrepresentable, and the contingent objects of desire – 'fusion of the elemental force with the fortuitous image' was how Masson himself expressed it.

The successive stages that Masson describes are both visible in the final state of an image (fig. 14) as a delicate intermingling of formed and unformed elements: 'le mariage de l'informé et du formé'.[116] The residue of the primary process is a non-representational tangle of lines consisting mainly of curvilinear contours which by their repetition generate a sense of rhythmic movement and flow. Wiry filaments that ramify and rejoin, they are reminiscent of Freud's hand-drawn diagrams of the neural pathways which transmit the flow of quantity (Q) in the psychical apparatus:[117]

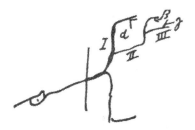

Scattered amongst the mesh of lines comprising Masson's image are discrete forms that coalesce out of the flux only to be reabsorbed back into it. Hands grasp at nothing, birds take to flight. The elusive object of desire (the maternal breast spurting milk at the top of the page) can never be attained: 'When the original object of a wishful impulse has been lost as a result of repression, it is frequently represented by an endless series of substitute objects none of which, however, brings full satisfaction', writes Freud.[118] Desire, being desire for an object that is irretrievably lost, is in essence desire for no-thing.

'This, then, was the complete game – disappearance and return', observes Freud of a ritual his grandson of one and a half years performed when his mother was absent.[119] The game consisted of throwing away a wooden spool with a piece of string tied around it, the child exclaiming as he did so the German word *fort* (gone), an action that Freud speculates symbolised the mother going away and leaving her son. Restaging what must have been in reality a painful sep-

aration enabled the child to turn a passive experience in to an active one and so achieve a semblance of mastery over its situation. By clinging tightly to the string he could also assure himself of her eventual return; in fact, the whole game involved hauling back the reel that had been thrown over the side of the cot, its reappearance greeted with a joyful whoop, *da* (back). In this game of presence and absence, a pact is signed between loss (renunciation of the maternal object),[120] desire and accession to the symbolic order of language. Freud recalls another game played by his grandson that entailed standing in front of a mirror and then crouching down so that now his own image was gone – 'during this long period of solitude the child had found a method of making *himself* disappear.'[121] It is as though the subject himself were now suspended on a string from the reel (*le réel*). Compare this with Breton plunging blindly into the labyrinth which Masson creates for us, losing himself in the

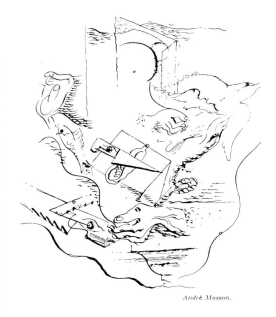

André Masson.

14 André Masson. *Automatic Drawing. La Révolution surréaliste* n° 1 (1 December 1924): 14.

hope and expectation of finding himself again with the aid of a thread offered by his Ariadne.

How does a subject represent to itself the lack which constitutes it as a subject of desire? Lacan answers this by invoking a special category of part-objects which he denotes with the term '*objets a*' that are ambiguous in their relation to the subject. They are parts of the body, in effect parts of oneself, from which the subject has had to separate in order to become itself. The *objet a* rests as the token of a division that is internal; it thereby '*embodies* and ultimately *images* the division of the subject, the break in the image, the cut of castration', writes Mikkel Borch-Jacobsen.[122] The breast and faeces are cited by Freud as examples of objects (part-objects) that must be parted with, an experience of separation that lends reality to the phantasmatic threat of castration.[123] Returning to Masson's drawing, in a clearing at the heart of the labyrinth are two motifs that occur either singly or together in nearly all his works of 1924, a knife on a cutting-board and a loop of braided cord. Lacan writes: 'Here *separare*, separate, ends in *se parere*, to engender oneself.' By imaging the cut – of castration, evidently, but also of the umbilical cord – Masson manages to make present the lack and loss which engenders the metonymy of desire ('le Labyrinth éternel du Désir' as Masson preferred to put it).[124]

The binding (*Bindung*) of instinctual impulses that impinge upon it is one of the most basic operations in Freud's model of the mental apparatus.[125] Freely mobile, unbound energy belonging to the unconscious primary process is bound and so transformed into the tonic energy of the secondary process. By the same token, the binding and unbinding of energy (*Bindung–Entbindung*) will define the pleasure–unpleasure axis as well as, later on within Freud's conceptual armoury, the relation of Eros and the destructive instinct: 'The aim of the first of these instincts is to establish even greater unities and to preserve them thus – in short, to bind them together; the aim of the second is, on the contrary, to undo connections and so to destroy things.'[126] If one were to seek to draw together the various strands of our discussion, it would

be to describe Masson as straddling a double bind. Life and death are yoked together via the intermediary of a *calembour*, or double meaning, of *grenade* which in French is the word for a pomegranate. This is a quite ambiguous symbol in Masson's work: on the one hand, the succulent flesh and seeds of the opened pomegranate fruit made it an obvious symbol for female sexuality, and it very often appears in the place of the womb, but the same image also reminded Masson of the sight of a dead soldier whose skull had been burst apart by an exploding shell. Bearing in mind that *grenade* can also refer, as it does in English, to a hand grenade, a wrenching ambiguity is thus inscribed at the heart of the two automatic drawings we have discussed. As a pomegranate fruit, it symbolises the object cause of desire, but as the lethal grenade used in the close combat of trench warfare, it was a horrifyingly real cause of the body in pieces visibly scattered across the page. Likewise the rope, which as umbilical cord thematises operations of binding or bonding, in other situations carries more sinister implications of a ligature or garotte. Without wishing to preempt the discussion of repetition that follows, it can also be noted that similar kinds of ambivalent associations (pleasure/unpleasure, life/death) attach to Masson's depiction of wounds, which are very often overtly vulva-shaped, and that eroticism is twinned with violence and death throughout his work but most especially in those works dealing with themes of the Minotaur and the labyrinth.

trauma, memory, repetition

As the decade of the 1930s progressed, an ominous sense of history repeating itself was almost universally felt. Repetition frames and defines what is commonly known as the interwar period. Belatedly, in *Mémoire du monde* published in 1974, Masson provided some indication as to how the matter of repetition in his own work might be approached when he spoke frankly about his horrific experience in the First World War, having maintained up until that point what a fellow surrealist called a discreet silence on the question.[127] The harrowing account of an appalling daily encounter with death, of being injured and left for dead on the battlefield, and of the psychological trauma that ensued, leading to his internment in a hospital for mentally disturbed war veterans, raises questions about the relationship between Masson's art and this catastrophic past.

Before proceeding further, it is salutary to ask why it is that repetition, in spite of the various hints Masson gave, has been consistently bypassed in favour of what is more generally recognised as the defining trait of his art, incessant change and metamorphosis.[128] The latter, which has been dealt with fairly exhaustively in recent exhibitions and scholarly accounts of Masson, is more readily accommodated to habitual ways of thinking about artistic creativity, whereas repetition when it is discovered is liable to be edited out as pointless redundancy. Fostering this bias is Masson's allotted position within dominant narratives of modern art as a progenitor of abstract expressionism, heralding its gestural spontaneity and absolute freedom of expression.[129] The frequent stylistic changes for which Masson is renowned also tend to obscure an underlying pattern of recurrence. The usual means for managing this diversity is to compartmentalise the work decade by decade, a curatorial strategy which can be justified in the interwar period by the shift in Masson's allegiances from Breton and a concern with automatist practices during the 1920s, to a preoccupation with themes of sacrifice and the sacred reflecting his involvement in the following decade with Georges Bataille. Though this division has a basis in fact – Masson was undeniably embroiled in the expulsions, defections

and regroupings that wracked surrealism at the end of the 1920s – it is inadequate for reasons that will become clear for an adequate understanding of his work at the end of the 1930s. At any rate, I shall be disregarding these conventional distinctions in order to trace the persistence, or more precisely the recurrence and transformation, of certain fundamental themes and motifs across two decades or more of Masson's artistic output.

One of the acutest commentators on his own art, Masson drew our attention to a compulsively repeated iconography of mutilation and dismemberment that surfaces first in his automatic drawings from 1923 and 1924, noting with hindsight that the male body wherever it occurs, is 'never exempted from cuts, wounds, or mutilations'.[130] Are we not warranted in thinking of the prevalence of such motifs occuring after the war with a lag period of a few years as analogous to the nightmares endured by victims of shellshock which repeatedly transported them back to the traumatic scenes they had witnessed – one of the chief pieces of evidence Freud cites of a compulsion to repeat (*Wiederholungszwang*) that overrides, or contradicts, the pleasure principle. In an interview, Masson reported what a young German had confided while he was residing in Belgium before returning home to enlist: 'You know, it isn't being wounded or killed which is terrible, it's what one sees.'[131] Like the female hysterics of Freud and Breuer before them, male victims of shellshock were made ill by their reminiscences. *Mémoire du monde* is filled with these snapshots, at more than fifty years remove still etched in his memory with the vividness and immediacy of something perceived only moments ago. One section, entitled 'Membra disjecta', describes catching sight of a detached limb – the lower part of a leg still inside a boot – macabre debris that littered the field of battle. The iconography of Masson's automatist works we might justifiably compare to the physical conversion symptoms of traumatic hysteria: both register at the level of the body a horror that could not otherwise be spoken of, mutism along with amnesia being frequently associated with war neuroses. (Walter Benjamin noted poignantly that men who returned from the war had grown silent, impoverished not enriched by the things they had witnessed.)[132] It is worth recalling

15 André Masson. *Battle of Fishes*. 1926. Sand, gesso, oil, pencil and charcoal on canvas, 36.2 × 73cm. The Museum of Modern Art, New York. Purchase.

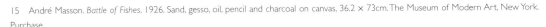

MASSACRES

DESSINS PAR
ANDRÉ MASSON

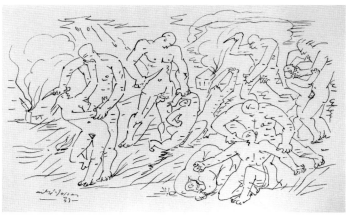

17 (above) André Masson. *Massacre*. 1933. Pen and ink on paper. *Minotaure* n° 1 (July 1933): 59.

16 (left) André Masson. *Massacre*. 1933. Pen and ink on paper. *Minotaure* n° 1 (July 1933): 57.

that the automatist procedures adopted by the surrealists had been employed initially by Pierre Janet for the purpose of accessing a dissociated, unconscious kernel of traumatic memories that was believed to be a cause of hysteria, and it was his participation in treating shell-shocked soldiers during the First World War that led Breton to his first experiments with the technique.

Combat and discord are constants throughout Masson's oeuvre. Repeated across more than two decades, disguised and displaced, the theatre of war is transposed in to an abstracted theatre of cruelty. Inspired by Lautréamont, it is initially animals in such works as the *Battle of Fishes* of 1926 (fig. 15) that play a lead part in dramatising a Heraclitean world of perpetual war and destruction, a role later assumed by murderous praying mantids whose anthropomorphic aspect enables us to recognise easily the human combatants masked behind them. Between 1930 and 1932, Masson concentrated to the point of excluding any other subjects upon themes of abduction, rape and murder.[133] As Laurie Monahan notes in a study entirely devoted to the *Massacres*, the staged and stylised violence of the series has a repetitiousness which Masson did not conceal but, on the contrary, emphasised.[134] A sequence of pen and ink drawings (figs 16 and 17) were reproduced over several pages in the first issue of *Minotaure* in 1933, ranging from single male and female figures like lead dancers in a *pas de deux*, to more complex variants where these individual modules are repeated and added together to create a mass of figures consumed in a bacchic frenzy of violence. The confection of these scenes from preformed elements repeated with minor variations diminishes the anecdotal or narrative interest of the *Massacres*; so too the short, jagged and jabbing strokes of Masson's pen are dispersed evenly across the sheet so that there is no sense of hierarchy or focus. The effect, as in the Sadean text whose formal properties they emulate, is to foreground the operations of an

impersonal force that we might identify as the death drive, which through a play of repetition and difference builds complexity and generates the series in its entirety. As yet another instantiation of the theme of combat, private phantasy rejoins collective reality in *The Andalusian Reapers* of 1935, where undead skeletons reap a grim harvest in killing fields that are at one and the same time those of the First World War and a Spain about to be consumed in the horrors of civil war.

Death and repetition are most conspicuously linked in the theatre of sacrifice. Reflecting the ethnographic interests of the dissident surrealists grouped around Georges Bataille and the journal *Documents*, this preoccupation is abundantly represented in the 1930s by Masson's images of the bullfight. Equally, the German critic Carl Einstein, writing in *Documents*, argued that it is possible retrospectively to interpret much of the artist's production of the previous decade through the lens of sacrifice. Einstein claimed that the animal victims of torture and violence, birds pierced by arrows and so forth, are to be understood as totem animals, identificatory surrogates for the artist and a means to express the sacrificial loss of self.[135] The bullfight, a subject of obsessive interest to his friend Michel Leiris as well as to Masson, is portrayed as a tragic drama at the heart of which is a killing, predestined to occur and repeatedly enacted, but where the *dramatis personae* of sacrificer and victim are fluid and interchangeable.[136] For Bataille, and one may infer likewise for Masson, the essence of sacrifice is a self-sacrifice in which 'the one who sacrifices is himself affected by the blow which he strikes – he succumbs and loses himself with his victim.'[137] What possible connection can we discern between the repeatedly staged confrontation with violent death and the events recounted in *Mémoire du monde*? One learns, for instance, that after being injured in the chest Masson toppled into a trench where he lay unable to move beside the body of a dead German soldier. Believing he was on the point of dying, there he was literally face to face with a grimacing death's head.[138] One could seek to apply a Freudian view of repetition here and assert that replaying the traumatic event permits a degree of retrospective mastery that was not possible in the original situation. But mastery seems an inappropriate notion when the repeated element is the *loss* of oneself. It may be more fruitful to consider these works as a sequence of encounters, or missed encounters, in accordance with a Lacanian conception of trauma and repetition as a structuration of the subject in relation to an unrepresentable, unassimilable real.[139]

Jay Winter, in *Sites of Memory, Sites of Mourning*, a major recent study of the cultural repercussions of the First World War, discusses the many and complex issues that surrounded burial of the war dead. This was a matter of wide public concern in the aftermath of the war because of the sheer numbers of bereaved. Official policy during the war had discouraged the return of bodies to relatives and hence the dead were generally buried in or near the field of battle in makeshift burial sites, but after 1919 there were moves to have these bodies disinterred in order to be reburied closer to home. Some four hundred thousand eventually were. The dead returned in other ways as well: in the post-war context, Winter fascinatingly documents a revival of spiritualism and belief in ghosts – in French, *les revenants* – and in the cultural arena there was a spate of literary, artistic and even cinematic depictions of the return of the dead.[140] At some level, it seems, people stubbornly refused to believe in the death of their loved ones and such images and cultural practices answered to a deeply felt need. Winter is the first to draw attention to this as a background to the surrealists' dalliance with mediums and spirits (one could cite, in addition, their experimentation with trance states recalled by André Breton in 'Entry of the Mediums'), and the relevance of these matters for Masson warrants consideration. Might it not account for the somnambulistic state of the figures he habitually portrays,

hands with the palm displayed, as well as globes, playing cards and other spiritualist para-phernalia? In the mid-1920s Masson experienced a number of quite frightening incidents involving ghostly apparitions, reported in *Mémoire du monde*, which convinced him the house he was staying in was haunted. The recounting of these in a book that is concerned with the ineradicable character of certain memories and their power over him serves to emphasise the degree to which his everyday world was infiltrated by ghosts from the past.

The topical matter of the war dead, their burial and return (sometimes unbidden and unwel-come), supplied Masson with a rich system of metaphors that enabled him in the years after the war to explore memory, its burial and retrieval. Arguably, such concerns antedate his involvement with surrealism, but they certainly propelled him into its fold at a time when the catchphrase was psychic automatism and plumbing the depths of the unconscious. Subter-ranean and sepulchral associations accrue to the penumbral interiors of post-war works such as *The Sleeper* of 1924, and the isolated, melancholy figures who inhabit these claustrophobic spaces seem weighed down and oppressed by thoughts locked inside them. Subsequently, in works more overtly automatist, the metaphorical potential of such spaces, now inspired as we have seen by the lugubrious columbariums and dungeons of Piranesi, becomes more fully realised as an architecture of the mind. These works, especially the paintings, articulate at the level of pictorial structure a dialectic of repression and the return of the repressed, in which architectural elements englobe and contain the mind's contents. In conformity with his sur-realist orientation, Masson described those contents in terms of the instinctual drives – hunger, love, violence – but equally we have seen how these bodily part-objects can be thought of as vestiges of the past, memory fragments that lie entombed or encrypted there.[141]

The biblical theme of the general resurrection of the dead, 'when all who are in the tombs will hear his voice and come forth',[142] treated in Abel Gance's hugely popular film, *J'Accuse* of 1919, as well as in literature and art at this time, is alluded to – albeit indirectly and divested of any salvational meaning – in Masson's imagery. Once again his deployment of the subject is metaphorical and linked with the problematic of repetition, namely, the return or anamne-sis of buried, traumatic recollections. *The Cemetery* of 1923 (fig. 18) is such a picture. Rays of sunlight stream down upon a forest clearing in the midst of which are several tombs, the intense light charging the scene with a supernatural intensity as in a moment of revelation (the Greek term for which is 'apocalypse'). Though Masson eschews the literalism of dead bodies clambering out of the ground, the tombstone in the foreground of the picture has been partially drawn back, and the swaying trees with ghostly anthropomorphic limbs strain sug-gestively upwards. Beside the tomb an especially ghoulish hand and forearm, actually a small sapling, emerges from the ground and gesticulates skywards. The fright seeming to emanate from this detached limb I want to suggest relates to the hallucinatory return within the depicted scene of a dissociated visual memory belonging to a prior traumatic moment. The poet Georges Limbour offered a clue to its nature when he wrote of this 'fearful landscape' in a preface to Masson's first exhibition in 1924, describing the work as an accurate record of the war-ravaged terrain with denuded tree trunks 'like railings round a monument after an explosion'.[143] One could carry this intuition further and argue that the sun's piercing radiance revivifies a memory of the explosive detonation of a bomb or grenade, along with all its horrifying consequences, and that this is compounded with an uncanny evocation of the dead returning. Indelibly etched on his memory, we shall see that same visual impression (*explosante-fixe*) provide a template for works of more than a decade later where the explosive rupture of discrete, bounded forms by energies reverberating outwards from a focal source, usually the

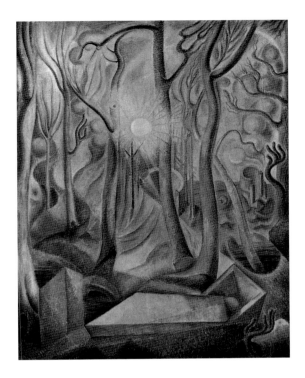

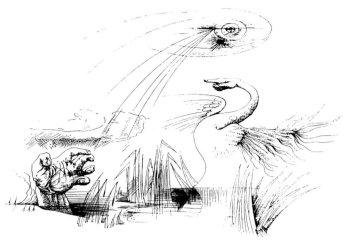

19 (*above*) André Masson. *Mythologies* (Paris: 1946 [1938]). 'Près des signes de feu' (Close to the signs/swan of fire).

18 (*left*) André Masson. *The Cemetery*. 1924. Oil on canvas, 116 × 89cm. Grenoble: Musée du Grenoble. Donation André Lefèvre, Paris 1960.

sun, is an often-repeated motif. Masson habitually portrays '*not finitude but explosion*', declares Sartre.

Memory has a pronounced telluric quality for Masson. It resides in the earth. It is, in the most literal sense a *mémoire du monde*, interred or encrypted there, from whence it also returns. Several illustrations in the *Mythology of Nature* album of 1938 show bodies or limbs which either meld into, or emerge from, the physical terrain, and in one case (fig. 19) a hand eerily pokes up out of the earth, with connotations either of resurrection from the dead or, more disconcertingly, of burial alive. It possibly needs to be specified that what is so horrifying about this prehensile hand, which grasps blindly at nothing, is its imagined physical continuity with the artist's (or our) own body. Is it not the same hand, seemingly indestructable, that appeared first in *The Cemetery* and recurs again in *Road to Picardy* in 1924? While the earth yielded up these disturbing, uncanny and traumatic remnants of the past, it also wore a more beneficent face. Masson recalls the intimacy with the earth that was a result of living for long periods below ground in trenches which afforded their only protection from the dangers of snipers' bullets and exploding shells. There is something extremely primordial about seeking refuge in the earth that his reading Johann Bachofen's *Das Mutterecht* (Mother right) enabled Masson to give form to: an image from the series known as *Terres érotiques* depicts a naked male figure who escapes from the world above ground by climbing back into mother earth through a vaginal passageway. Swamps or ponds, another recurrent feature in these anthropomorphised landscapes, may also hark back to that experience of living in ground which constant rains had turned to a muddy quagmire 'like a tomb'. Though their ostensible subject is incessant change and metamorphosis, Gäeton Picon rightly insists it is a metamorphosis that forgets nothing.[144] The labyrinth, a conspicuous motif in the late 1930s, inevitably conveys the

meanings of death and entombment (in some versions of the myth the labyrinth is a royal tomb), as well as of return and resurrection. In several works dealing with this theme, notably *Story of Theseus* of 1938, a sand painting that literalises the metaphor of the surface of the painting as ground, the entrance to this subterranean realm of mysteries is in the form of a female sex. The complex, layered web of associations in these works thus leads in many directions, but *Mémoire du monde* offers a thread that shows that at the heart of them is the recrudescence of memories that are buried but not dead.[145]

double vertigo: ecstasy and the eternal return

On a winter's night in January 1935 Masson underwent an ecstatic, revelatory experience in the mountains of Montserrat near Barcelona that was immensely consequential for his art. One suspects he is not the first person to have done so: the place is steeped in religious significance (it is the location of a monastery housing an ancient statue of the Virgin, the symbolic protector of Barcelona) and the landscape with its towering rock formations has an undeniable grandeur. Masson had been sketching the sunset when a sea of cloud rolled in. It quickly became dark and he and his wife Rose were unable to climb back down. Finding themselves perched on the edge of a precipitous slope, he was gripped with extreme fear. He describes a sort of double vertigo: 'the sky itself appeared to me like an abyss, something which I had never felt before – the vertigo above and the vertigo below. And I found myself in a sort of maelstrom, almost a tempest, and as though hysterical. I thought I was going mad.'[146] All the while, and mingled with his terror, was a strong awareness of the sublimity of the vista.

Masson was clear in his own mind that this episode was 'a sequel to that nervous illness which followed my war wound'. Indeed, one is struck by its similarity to the account of being left for dead on the battlefield and thinking he was going to die. Let us now cite in full the description of that event on 17 April 1917:

> Never having seen artillery fire while facing the sky, I was seized by a terror without any limits. Sprayed by falling earth, stones and shrapnel, still conscious, I thought: 'This is the end.' Resigned, and with a fever, almost delirious, I watched the cross-fire, the flares of all colours with admiration. Festival for a *gisant*. A farewell.[147]

So many of these features are again repeated in 1935 that one is inclined to view the later event as a sheer repetition of the earlier one, a flashback induced by the circumstances in which Masson found himself: one can imagine the shooting stars in the night sky rekindling memories of the criss-cross of flares and gunfire and associated feelings of vulnerability. Complicating the situation somewhat is the fact that published versions of both incidents appeared within three years of each other, and in an order that was the reverse of their true chronology. If, as seems possible, the Montserrat episode directly influenced the later textual presentation in *Mémoire du monde* of his wounding and the ordeal that followed it, then we are precluded from seeing either of these moments as originary with respect to the other. What we are faced with instead is a structure of repetition without beginning or end.

Masson's nervous crisis could be ascribed to the repetition compulsion Freud had observed in those afflicted by traumatic hysteria, causing them to replay the horrific scenes they had witnessed. What actually happens, however, is that the reliving *for a second time* of an event becomes for Masson an occasion for affirming and redeeming it. Georges Bataille indicates

how when he asserts that it is only through contact with its glacial opposite that life achieves an incandescent intensity. 'No less a loss than death is needed,' he writes, 'for the brilliance of life to traverse and transfigure dull existence, for it is only in its free uprooting that *becomes in me* the strength of life and time.'[148] The inversion of valence brought about by repetition is reflected in the transmutation of dread into rapturous delight, and also most dramatically in the feeling of double vertigo, a vertigo of *height* as well as of depth. '*To redeem the past* and to transform every "It was" into an "I wanted it thus!" '; such an unconditional affirmation of existence was at stake in Nietzsche's idea of the eternal recurrence, 'the highest formula of affirmation that can possibly be attained'.[149] We can gauge the signifi-

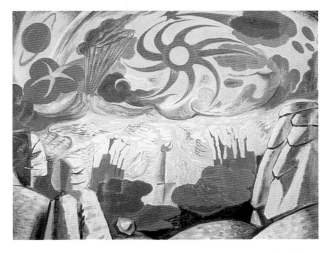

20 André Masson. *Dawn at Montserrat*. 1935. Oil on canvas, 50 × 65cm. Private collection.

cance for Bataille and Masson of the notion of the eternal return, the basic conception of Nietzsche's *Thus Spoke Zarathustra*, by examining their responses both textual and pictorial to Masson's night at Montserrat.[150]

Reproductions of two pictures inspired by the event, *Dawn at Montserrat* (fig. 20) and *Landscape of Wonders*, appeared in the journal *Minotaure* in June 1936 together with a poem by Masson, 'Du Haut de Montserrat' (From the heights of Montserrat), and a text by Bataille which, although it relates to an experience he had undergone, is there to be read as a commentary on Masson's images.[151] While they were reproduced in black and white, and hence the visionary intensification of colour would not have been apparent, the revelatory and ecstatic character of both the works is none the less clear. The anthropomorphised rocks in the foreground of *Dawn at Montserrat*, like figures from traditional religious painting with hands raised in gestures of wonderment or ecstasy, justify and perhaps even motivate Bataille's claim that the reality to which these works bear witness is something that can only be attained in states of religious ecstasy. In saying this, Bataille announced a concern that would dominate his thinking for several years following, culminating in the book *Inner Experience* where significantly he chose to reprint an edited version of the *Minotaure* text. 'No limit, no measure can be given to the violence of those who are liberated by the vertigo felt before the vault of the sky' he writes in response to the rapturous experience of Masson. What I want to suggest here is that the theme of ecstasy, of a sovereign rupture of limits, cannot be dissociated from the notion of the eternal recurrence. Masson dedicates his pictures to Zarathustra – 'I salute you from the heights of Montserrat' he declares. Aspects of the iconography of both works are highly suggestive of passages in *Thus Spoke Zarathustra* which presage, more so than actually revealing, the obscure doctrine of eternal recurrence. The hallucinated figure in *Landscape of Wonders* wandering mage-like high up in the mountains, communing with the firmaments and kept company by a serpent – one wonders if that is not Zarathustra (advocate of life, advocate of suffering, advocate of the circle)? The nature imagery in both Masson's pictures is emphatically circular as is the case also in Nietzsche's supremely poetic text: 'I shall return, with this sun, with this earth, with this eagle, with this serpent.'[152]

When Bataille comes to write about the eternal recurrence, it is not so much the ideational content of the notion that he finds arresting as the extreme pitch of feeling with which it is imbued, its excessive, sundering quality. Nietzsche recounts in *Ecce Homo* how the vision came to him as a revelation while he was walking through woods high above sea level. A letter to Peter Gast written soon afterwards enables us to share in the intensity of his emotions:

> Ah, my friend, I sometimes think that I lead a highly dangerous life, since I'm *one of those machines that can burst apart!* The intensity of my feelings makes me shudder and laugh. Several times I have been unable to leave my room, for the ridiculous reason that my eyes were inflamed. Why? Not sentimental tears, mind you, but tears of joy, to the accompaniment of which I sang and talked nonsense, filled with a new *vision* far superior to that of other men.[153]

Bataille trembles too when he imaginatively retraces Nietzsche's footsteps, pausing beside the mighty pyramidal rock where the revelation occurred. What overwhelms, he says, is not the idea of the return *per se* as what it discloses: an absence of all foundation, the impossible depth of things (Zarathustra: 'My abyss *speaks*').

We can credit Masson with giving a stamp of authenticity to the abyssal, vertiginous quality of the eternal return, the 'heart-rending fall into the void of the sky'.[154] A glance at the system of metaphors and imagery employed by Bataille in order to evoke the state of ecstatic rupture and surpassment of limits, which becomes a central object of his reflection in the late 1930s, suggests that in this area as well Masson's past exerted a powerful hold. Aside from the explosiveness of his vision (Bataille's term is '*temps-explosion*'), another set of images pointing to a similar derivation from Masson relate to the topos of the wound or of wounding, metaphor for a subjectivity torn apart which Bataille elevates to the status of a quasi-metaphysical principle in his writing in the 1930s.[155] Being is equated with a wound as the expression of a principle of insufficiency at the base of human life, he writes. Sartre recognised that the female sex when it appears in Masson's art often carries the significance of a wound inflicted on the body[156] – a body that, it should be added, is not exclusively female: when Masson comes to propound his metaphysical vision in the *Mythologies* of 1946, one of the emblematic images in that volume portrays a male torso entirely bisected by a vaginal opening, the edges of which gape apart to reveal 'a thousand fulgent [*foudroyants*] suns'.

The thematization of lack via a proliferation of castration symbolism in French avant-garde art and literature, with its implication of devirilisation, has been attributed by several authors to a growing political impotence and marginalisation of the avant-garde in the 1930s.[157] Without necessarily contradicting that hypothesis, one can confidently say that the preponderance of wounds and wounding as metaphors for the human condition in the case of Masson would be inconceivable without its link to events more than a decade before. Masson recalls being warned that if one is lucky enough to return from the war wounded but alive 'your soul will be wounded as well, for ever, and there will be something torn [*déchiré*] inside you that can never heal over [*se cicatriser*].'[158] Veterans were scarred permanently by the terrible traumas to which they had been exposed. Moreover, the spectacle of grown men shaking uncontrollably and cowering under their beds at the slightest noise caused some to conclude that they had failed to live up to an heroic male ideal of stoicism in the face of danger; the link with female hysteria also ensured that the disablement caused by war neuroses would leave the male body branded with a marker of femininity. For Masson, and perhaps more generally, therefore, we should be alert to ways in which culture in the 1930s replays symptomatically and at a remote distance features of a traumatic past.

Thus far, we have traced a play of repetition and difference across Masson's work as a result of which a number of iconographic schemas or topoi that surface first in automatist works of the 1920s recur, transvalued, more than a decade later. The fact of recurrence across time and between images has been discussed first in terms of trauma and a compulsion to repeat, and then with reference to the eternal return. I now wish to examine what on the surface may seem a paradoxical notion, if not simply impossible: that repetition can be manifested at the level of a single image. At stake here is a general philosophical issue of time and the visual image, as well as of the formal equivalents within a work that function to denote repetition. From the outset, we noted, the static and simultaneous nature of the visual image had been regarded as a drawback by the surrealists whose aim was passively to record via the techniques of automatic writing or drawing an uninterrupted flow of thought.[159] The task of overcoming this seemingly inherent limitation of the visual medium was made more urgent for Masson by his passionate adherence to a Heraclitean view of the universe as governed by flux and eternal change. Against this background, Masson formulated a practice of graphic automatism that would seek to express 'a movement enamoured of itself' and, we may infer, it is as a byproduct of the attempt to incorporate movement into the static visual image that he is led to invoke a dimension of temporality. How he manages to achieve this is a complex matter.

Writing on the quintessentially Heraclitean subjects of combat and discord, Georges Limbour made a number of highly prescient observations concerning time in the Massonian image.[160] Noting that 'the principal actor in the tableau is movement', Limbour (quite likely prompted by Masson) states that the effect of this is to conjure a space that is not inert but which is borne along in time. Masson conveys 'the event in its succession' and it appears that the choice of subjects is significant here: 'he chose subjects which unfold in durational time as much as they extend in space: combats and later the metamorphoses.' Apart from these intrinsic associations of the subject matter, Limbour is rather vague about how precisely duration enters the image. The theme of metamorphosis we shall come back to; we have already noted, however, a quasi-cinematic repetition from one image to the next in the *Massacre* series, which are like a succession of film stills.[161] Multiplication of these individual frames, which Masson assembles to create larger, more extended compositional variants, could be understood as transposing into space a form of repetition premised on sequentiality.

Limbour's allusive but unelaborated remarks were taken up and brilliantly extended by Sartre in an essay that has been rather undeservedly neglected in the literature on Masson. Sartre notes, firstly, that actual depicted movement is of secondary importance to Masson whose primary concern is with a virtual movement which the drawn line itself evokes. How does it do so? Once again, Sartre makes a distinction between the deadening, inert contour that surrounds or delimits form with the openness and mobility of Masson's line which he likens to a vector or arrow of the kind that indicates on a map the trajectory of an army, an expedition or the direction of winds. Such a line is imbued with the property of a unique directionality, and leads the eye on an itinerary which cannot then be followed in a reverse direction. It is 'this impossiblity [which] confers on space in a defined region the irreversibility which belongs only to time.' Furthermore, and crucially, Sartre contends that the line as an arrow or vector orientates the subject in a trajectory that runs from the past through the present and into the future. At each of its points, such a line is 'a becoming [un *devenir*], an intermediary between one state and another'.[162] This insight certainly gels with Masson's view of subjectivity as a continual process of becoming rather than static Being, and it causes us to reflect

on the prevalence of the arrow as a motif in his work – the *Bird Pierced by Arrows* of 1925 is an early instance – which by the late 1930s becomes harnessed to a metaphysical conception of the subject with precisely the significance that Sartre assigns to it.[163] A possible objection to Sartre's unidirectional vector or arrow is that it could be construed as expressing a conscious intentionality and causality, a counterpart to the rational, goal-directed ego to which Masson is implacably opposed. We may infer it is this linear, geometric conception of time which Masson himself disparagingly labelled as secular in order to contrast it with a mode of temporality he saw as belonging to his own work. This aspect of Sartre's argument requires to be nuanced, I believe, to take account of a family of non-linear motifs in Masson's image-making repertoire – vortices, spirals and above all labyrinths – essentially abstract schemata or patterns we shall postulate as the formal correlative of temporal recurrence.

Masson apparently had a habit of uttering aloud words that acted as a stimulus while he painted. *Tournoiement*, meaning 'whirling, swirling, eddying or wheeling', was one of these so-called *mots soutiens* that are relatively few in number and succinctly encapsulate his core objectives as an artist.[164] *Tournoiement*, which can also refer to a feeling of spinning inside one's head, to the state of vertigo, corresponds to a plastic configuration that occurs everywhere in Masson's work extending across more than two decades. Looking back at the photograph of an early picture, Leiris discerns what he terms a constellation of objects in the central section of the composition which seem to comprise fixed points, and 'around them everything gravitates, is tied and untied [*se noue et se dénoue*].'[165] From his description, it appears that Leiris is referring to *The Repast* of 1922, a picture once owned by Gertrude Stein, in which still life objects are grasped by figures disposed around a table in such a way that their arms radiate outwards from the centre like spokes on a turning wheel. A similar format can be found slightly later in automatic drawings where typically the outer part of the image consists of a skein of lines forming a sort of web around a clearing which contains figurative elements: very often a torso, a breast or hands. It is evident from looking at these images, which Masson stated have neither top nor bottom, that in some cases the sheet has been deliberately rotated so that the final orientation of a figure no longer corresponds to how one imagines it being drawn.[165] Reinforcing these compositional indications of *tournoiement*, Masson commonly depicts forms which have either a spiral or circular configuration: the braided rope that twists or loops back upon itself, scroll-like sheets of paper that curl and unfurl, or sections of patterned plaster moulding.

The durability of the schema identified by Leiris can be shown by its persistence in a broad range of subjects treated by Masson in the following decade. It is evident, for example, in the bullfight where as a rule the protagonists form a central focus or object constellation surrounded by the blank space of the arena, its curvature strongly marked, a clock-face upon which the sacrificial ritual of the bullfight is enacted again and again. The spiral or vortex, of which the labyrinth (fig. 25) is also a variant, gyrates outwards from a centre. It is an unbounded motif without a definable inside or outside and thus connotes a subjective state of rupture and ecstasy, as well as by its very corkscrew shape indicating a movement that repeats or recurs.[167] Both these properties are relevant to the vertiginous feeling of disorientation Masson sought to replicate for the beholder in *Dawn at Montserrat*. Were one to compare works from the 1930s with those of the previous decade, however, it perhaps could be established that the way *tournoiement* is evoked shifts to become more decentred. Eddies and circuits – dispersed, multiple foci that dispense with any idea of a fixed, stable centre – become the norm. Certainly this view is endorsed by some interesting observations Masson has to make

about the baroque. Though obviously in sympathy with the excess of this aesthetic, which he describes in terms of a 'jubilant gyration of intersecting ellipses and spirals', Masson notes as a constraint the general adoption by baroque artists of a single core towards which the rhythmic energies of the composition inevitably lead and retract. Imagine, he says, this counterpoint enlarged and distributed across the page until there are 'several foci and multiple concentric and excentric directions'.[168] Masson has in mind here Van Gogh and it is evident from the sheer chromatic intensity of his work throughout the 1930s that Masson owes a great deal to his example. An additional source of inspiration was provided by Leonardo's splendidly observed studies of eddies and currents which Masson views with the eye of Heraclitus who took the case of a fast-flowing stream to prove that the constancy we habitually attribute to things is illusory. Because the water will have moved on, you cannot ever step into the same river twice. Carrying this sort of speculation across to himself, an ink drawing by Masson from 1945 portrays his face as if reflected on the bubbling, evanescent surface of a stream. Similar in spirit are the numerous passages from texts by Bataille in the late 1930s where the flow of water or electric current is used to denote the instability of identity, its perpetual openness and incompletion:

> Being, in man's definition and as instantiated by him, is never present in the fashion of a pebble in the river, but rather as the flow of water or that of electric current. If there does exist some unity within presence, it is that of eddies, of circuits which tend toward stability and closure.[169]

Spirals, vortices and other like motifs convey centrifugal expansion and rupture, a dominant impulse in Masson's work of the 1930s, but they can also be seen as embodying the eternal return. Gilles Deleuze is undoubtably right to insist that Nietzsche's concept of recurrence (*Wiederkunft*) must be distinguished from all cyclical notions of time – it is not a repetition of the same and, moreover, belongs wholly to the future. Nevertheless the imagery in *Thus Spoke Zarathustra* is predominantly circular and appeals to natural analogies in order to convey the idea of a cyclical recurrence: 'Everything goes, everything returns; the wheel of existence rolls on for ever. Everything dies, everything blossoms anew; the year of existence runs on for ever.'[170] Also disposing Masson to view the eternal return as basically cyclical was the fact that he tended to conflate Nietzsche with a kindred spirit from the past, Heraclitus, who held that time is bound to repeat itself in the form of a Great Year of which the winter is a flood (*cataclysmos*) and the summer a world conflagration. Alone among his predecessors, Nietzsche was prepared to concede a possible antecedent in Heraclitean thought for the radically novel idea of the eternal recurrence, 'that is to say of the unconditional and endlessly repeated circular course of all things'.[171] Consequently, it is in a natural register as a mythology of nature that Masson expounds his conception of time as recurrence to which he as a subject is beholden.

It is typical of myths and of a mythic style of narration that things repeat each other: events are foretold, predestined to happen, and fated to recur. Metamorphosis, a component of numerous myths, possesses an intrinsic circularity and we may regard it as significant that quite a number of the illustrations in Masson's *Mythology of Nature* refer explicitly to Ovidian sources, notably to the myth of Apollo and Daphne where the themes of pursuit and of Daphne's transformation into a laurel bush to evade capture were famously rendered as a spiralling baroque composition by Gian Lorenzo Bernini.[172] Leiris informs us that Masson's first sculpture, *Metamorphosis I* (fig. 21), was the solution to a problem that had perplexed him of how to 'show something with neither beginning nor end'.[173] It is a fundamental property of

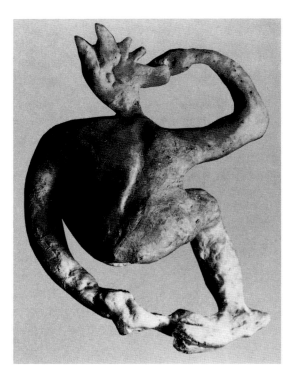

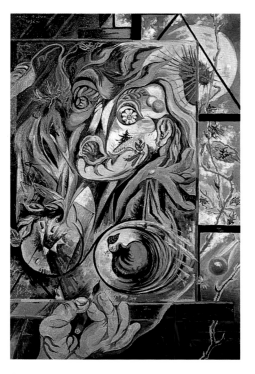

21 André Masson. *Metamorphosis, 1.* 1927. Plaster. Reproduced in *Le Grand Jeu* n° 2 (May 1929): 31–2.

22 André Masson. *The Painter and Time.* 1938. Oil and sand on canvas, 116 × 73cm. Private collection.

23 André Masson. *Mythologies* (Paris: 1946 [1938]). 'At the same time a trap and the prey.'

the circle to have neither beginning nor end, and the sculpture consequently personifies time as a figure devouring itself thereby bringing about its own inevitable, eternal return. In profound agreement with Masson, Bataille wrote in *Acéphale* that 'everything exists by destroying itself, consuming itself and dying, each instant producing itself only in the annihilation of the preceding one.'[174] These sentiments, essentially Heraclitean in character, are reflected in a watercolour from 1935 which depicts a mythic hybrid with the head of a cockerel, the body of a snake, and a tail that is a ripened head of wheat. One can imagine that this creature has only to feed upon itself to close the circle of its existence. Again, unceasing destruction and metamorphosis are linked with an implicit circularity in several illustrations to the *Mythology of Nature*: 'A la fois le piège et la proie' (At the same time a trap and the prey), the caption appended to a drawing dominated by a serpent (fig. 23), refers to the Heraclitean notion of the unity of opposites on the circle.[175]

Heraclitus saw an essential homology of human nature with the natural world. Thus man must submit himself to the cycles of germination, growth and perishability that govern all of nature. An Arcimboldesque game of substitution permits Masson to illustrate this philosophy of time with programmatic clarity in *The Painter and Time* (fig. 22), a picture belonging to the same year as the *Mythology of Nature*. Here Masson pulls out all the stops in an effort to eliminate whatever divides and separates and to convey his total immersion in nature. Apollo becomes one with Daphne in her botanical metamorphosis. For the dionysiac artist, even the minimal gap imposed by representation between self and the world must be obliterated, hence the recourse to transparency, overlap, the device of a *mise en abyme* or picture within a picture, the hand which crosses these spaces, and so forth. Awareness of time as the eternal recurrence occurs in a visionary intensification of ordinary consciousness: 'the circle itself is pure intensity,' writes Klossowski. The artist's mouth is opened, but whether to emit a scream – 'the scream of lacerated existence' – or in ecstasy is unsure. Time itself becomes an object of ecstasy, Bataille writes, when it is explosively liberated from the subordination to all ends. Accordingly, and in a way that palpably harks back to the early 1920s, the motif of the exploding grenade recurs, integrated as one of the elements of Masson's self-representation.[176]

labyrinthine man

Masson recalls how Bataille gave him free rein to construct an effigy of the Acéphale to adorn the cover of their new magazine. He drew a sort of Vitruvian man deprived of his head and proceeded to arm it with symbolic attributes: a dagger, a flaming heart, a death's head in the place of the genitals and so on. 'Fine, all of that, but what to do with the stomach?' he asks. The solution that naturally suggested itself, and which he says became their trademark (*signe de ralliement*), was to form the entrails into a labyrinth.[177]

Bataille was much pleased by this felicitous choice. As Masson noted, the dark myths and sombre mysteries of tragic Greece were the order of the day (the mainstream surrealist journal in this decade was *Minotaure*). That Masson alighted upon this motif also gains in interest in the light of his observations regarding a visceral obsession which he says is evinced in his earliest automatic drawings: 'These images, almost invariably labyrinthine, presented the body as disemboweled, exposing the digestive organs.'[178] The reconstruction *après coup* of his own earlier work is such that it anticipates or adumbrates something that is destined to recur much later, a propensity for this mythic style of narration we have already detected.[179] What I would like to suggest in concluding is that the significance of the labyrinth and associated myths stems from

the fact that it embodies the same structural relation to trauma and repetition as the work itself. To be sure, the darkly symbolic architecture of the Cretan labyrinth encompasses a multiplicity of meanings in the work of Masson, as it does in Nietzsche.[180] But something of its uncanny, traumatic character can be grasped incidentally from an anecdote told by Freud. He was wandering around the deserted streets of an old provincial town in Italy when he found himself by chance in the red light district. Hastily leaving the narrow street, he continued walking until suddenly he found himself once more in the very same place, where his presence was beginning to attract attention. Again he left, only to find himself after a brief detour through the maze-like streets in the same place for a third time. This time he was possessed by a feeling of uncanniness which he attributes to 'the factor of the repetition of the same thing'.[181]

It was only upon rereading Mémoire du monde recently while thinking about its relation to his work in the decades covered by this study that I became aware of the many references to the labyrinth threaded through the ostensibly factual account of Masson's wartime exploits, a veritable leitmotif that structures the narrative as a repeatedly missed encounter with the Real.[182] It is first alluded to when he describes a farmer woman guiding a recalcitrant bull towards a heifer, oblivious of the fact that a company of soldiers preparing to depart for the front is watching her until she is roused by their raucous laughter. The farmer woman quietly going about her 'immemorial rite' reminds Masson of Pasiphae and the Bull, while the soldiers about to set off for 'the Kingdom of violent death' seem to be fatefully reenacting something as old as the Trojan wars.[183] What priority myth or reality here? Are these mythic associations a case of secondary revision or were they there already prestructuring Masson's wartime experience? Which is more originary: the events narrated or the timeless myth? Undecidable questions perhaps. Further on, Masson and a comrade are assigned to lay telephone wire along an enemy trench captured that morning – 'a thread which is not that of Ariadne, but which could conduct us to the redoubtable Minotaur'.[184] On the following page, while carrying out this risky operation comes the fateful rendezvous with a sniper's bullet from which he very nearly dies. Labyrinthine is the oeuvre whose many divagations repeatedly lead back to that same uncanny and traumatic point.

While epitomising the shared predilections of Bataille and Masson, the works Masson produced on the theme of the labyrinth, richly represented by Ariadne's Thread (fig. 24), also coincide with his reconciliation with André Breton near the end of the 1930s, once more confounding the conventional polarisation of Bataille against Breton. The use of sand and glue poured onto a wood panel is an overt reprise of the drip technique pioneered in the mid-1920s in such works as Battle of Fishes in an effort to comply with the Bretonian doctrine of psychic automatism. Things had, so to speak, come full circle. Masson professes to Leiris that: 'what's more I find myself at the moment in the same cycle.'[185] One more time, then, repetition. Both as a reversion to automatism and as a deferred rereading of the artistic production of a decade before whose labyrinthine character is stressed in all Masson's retrospective accounts. With the thread Masson had offered him, Leiris, in the subsequently penned biographical notes, was able to unravel the labyrinthine meanderings, the to-and-fro movement of return and recurrence, that structures these two decades. He mentions, in particular, the rope motif, the 'sinuosity of which one of the most recent avatars is Ariadne's Thread'.

'The processes of the system Ucs. are timeless; i.e. they are not ordered temporally, are not altered by the passage of time; they have no reference to time at all' writes Freud.[186] The timelessness of the unconscious, its ineradicability and propensity to recur, were amply confirmed

for Masson by his lived experience, most forcefully on the occasion of the night spent at Montserrat. Coinciding with the Nietzschean reflections of himself and Georges Bataille upon this event, Masson chose to place the labyrinth in the belly of the *acéphale* and to adopt it as his trademark. The labyrinth, Deleuze contends, 'designates the eternal return itself: circular, it is not the lost way but the way which leads us back to the same point, to the same instant which is, which was and which will be.'[187] At its most abstract (fig. 25), it is akin to the whorls of a thumbprint ('I am thy labyrinth'), the signature and emblem of an oeuvre whose hallmark is, as Masson came to recognise, 'meanderings of the eternal return of the same'.

24 (*above*) André Masson. *Ariadne's Thread*. 1938. Oil and sand on wood, 22 × 27cm. Private collection.

25 (*below*) André Masson. Illustration to Georges Bataille, 'Corps célestes [Celestial Bodies]', *Verve* (spring 1938): 98–9.

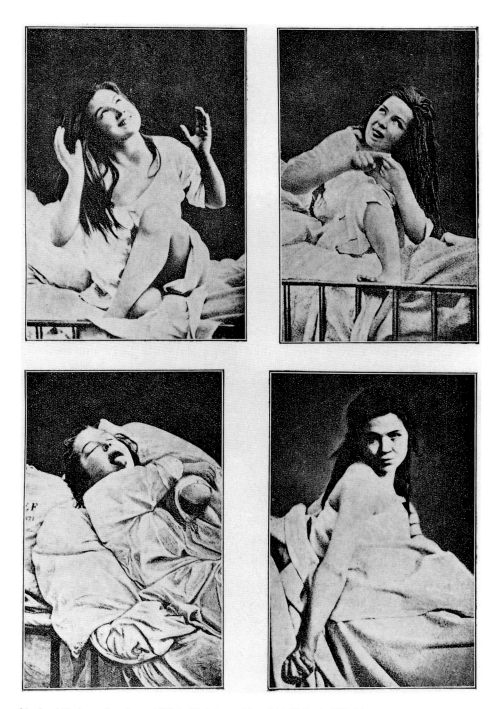

26 'Les Attitudes passionnelles en 1878'. *La Révolution surréaliste* n° 11 (15 March 1928): 21.

2 SEDUCTIONS OF HYSTERIA

Reporting back to readers of the Catalan review *L'Amic de les Arts* in March 1929 on the latest fad gripping the Parisian avant-garde, Salvador Dalí wrote, 'Today we observe the normal and poetic recourse to hysteria', adding as a rider that: 'what is more, while waiting for the moment to dwell on this issue at greater length, let us note also the moral sense of the question.'[1] At the time, Dalí's claim for a poetic recourse to hysteria must have relied on the sole evidence of a text by Louis Aragon and André Breton effusively celebrating the fiftieth anniversary of 'the greatest poetic discovery of the end of the nineteenth century' which had appeared in *La Révolution surréaliste* the previous year.[2] Illustrated with photographs of Augustine purloined from the *Iconographie de la Salpêtrière* (fig. 26), 'Le Cinquantenaire de l'hystérie, 1878–1928' had as its objective to wrest hysteria from the hands of a medical profession which until then had exerted sole jurisdiction over it.[3] Noting that medical taxonomies had failed to master this 'complex and proteiform illness called hysteria which escapes all attempts at definition' except by the expedient of denying its very existence, Aragon and Breton proffer one of their own. Hysteria they propose to define as: 'a more or less irreducible mental state characterised by subversion of the rapports established by a subject with the moral world under whose authority they believe themselves, practically, to be'.[4] Some insight into the form this subversion of moral authority might take can be had from the assertion that immediately follows: 'This [hysterical] mental state is founded on the need for a reciprocal seduction.'[5]

In marked contrast to Aragon and Breton, or for that matter Dalí, most recent commentaries on the role of hysteria in surrealist texts and visual iconography have not judged it especially subversive. On the contrary, it has been seen as yet another instance of a tendency relentlessly to objectify and fetishise the female body, a case forcefully argued by Susan Rubin Suleiman who writes: 'The madwoman observed, theatricalised, photographed, eroticised – this was clearly the aspect of Charcot's legacy to which Breton most deeply responded.'[6] Whatever subversive intent the surrealists may have professed is vitiated by their unquestioning complicity with a dominant phallocentrism. Formerly incarcerated at the Salpêtrière, the hysterical woman is hardly any less oppressed in her latterday visual appropriation by the male surrealists. That the body of the hysteric, convulsed by desire, serves primarily as a spectacle for the delectation of male viewers is unwittingly borne out, it would seem, by the concluding line of Breton's *Nadja*: 'Beauty will be CONVULSIVE or will not be.'

The Phenomenon of Ecstasy (fig. 27), a photocollage Dalí made in 1933 at a point when his passion for hysteria had clearly not abated, can be used to illustrate some of the general issues raised by surrealist representations of the condition. It is noteworthy first of all that Dalí does not use actual clinical photographs of hysterics as Aragon and Breton did; rather hysteria, the female malady, seems to be the condition of femininity in general. Upturned eyes and parted lips are physiognomic clues to the state of ecstasy which, with its overtones of sexual arousal, was one of the typical poses (the so-called 'attitudes passionnelles') assumed by Charcot's

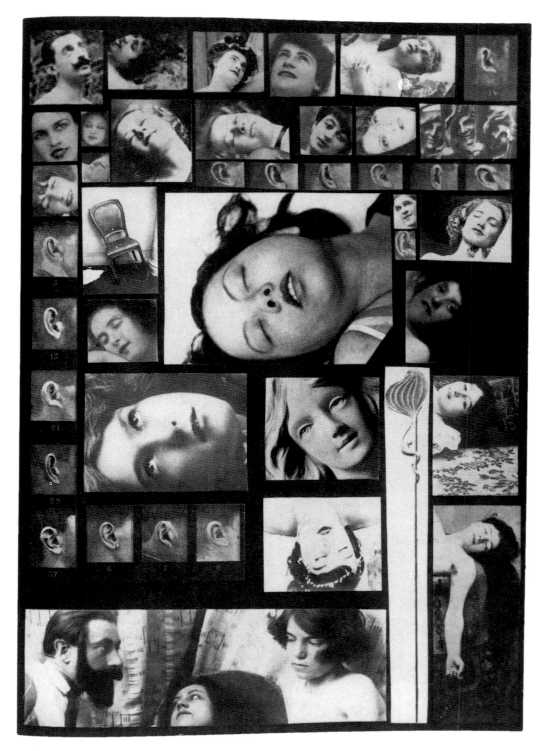

27 Salvador Dalí. *The Phenomenon of Ecstasy*. 1933. Photocollage, 27 × 18.5cm. *Minotaure* nº 3–4 (14 December 1933): 77.

hysterics in the course of an hysterical attack. Interspersed with these secular St Theresas are photographs of sculpted figurines in an art nouveau style which, Dalí asserts in an accompanying article, display 'contractions and poses without antecedents in the history of statuary' indicating their filiation with the Salpêtrière hysterics.[7] The organic forms of art nouveau architecture concretise our desires, Dalí writes, opposing them to the hardedged geometry of Corbusian modernism.[8] Completing this panorama of *fin de siècle* visual culture are rows of ears snipped from a late nineteenth-century manual for identifying criminals compiled by Alphonse Bertillon, a pioneering criminologist.[9] Neatly arrayed and severed from any connection with hearing, they are the product of a policing gaze – the same gaze of positivist science which recorded the minutiae of an hysterical attack to produce the roll-call of women, silent and anonymous, who fill the pages of the *Iconographie de la Salpêtrière*. Reiterating overall the configuration of a human ear ('celles-ci toujours en extase' [these are always in ecstasy]), Dalí's composition diverts this gaze from its objective by leading it on a giddily spiralling path towards ecstatic *jouissance*. But however infectious this spectacle is intended to be, Dalí remains susceptible to the charge that the visual pleasure on offer essentially relates to the hysterical woman 'observed, theatricalised, photographed, eroticised' – that's what the surrealist cult of desire was made of.

Introducing a recent volume of essays, *Seduction and Theory*, Dianne Hunter states that: 'The term "seduction" focusses a current debate concerning the status of woman – as fetishised object of the male gaze on the one hand, and, on the other, as a source of metaphor for deconstructive theory and practice.'[10] Now, it is evident that the orthodox view of surrealist iconography outlined above does not address the second of these alternatives. Without losing sight of the justifiable reproaches that have been levelled at the surrealists by Suleiman and others, my aim in this chapter is to reopen the issue of *subversion*, the central plank of Aragon's and Breton's redefinition of hysteria, by examining what it was that so fascinated them about the hysterical mental state; to do so by revisiting the scene of their seduction.

Seduction is one of the so-called primal scenes (*Urszenen*) described by Freud. Disposed initially to accept as factual truth the stories of childhood seduction which his female patients revealed in the course of analysis, Freud later came to doubt the veracity of these memories, concluding instead that they were the reversal of a primary wishful phantasy to seduce the father. Abandoning belief in the reality of the event led him to the threshold of that other scene, psychical reality, and to a recognition that perceptions and affects arising from phantasies can have a pathogenic force equivalent to those derived from events in the external world: 'If hysterical subjects trace back their symptoms to traumas that are fictitious, then the new factor that emerges is that they create such scenes in *phantasy*, and this psychical reality requires to be taken into account alongside practical reality.'[11] Phantasies, the stuff of psychoanalysis as much as of surrealism, are narrative scenarios which have as their purpose a *mise-en-scène* of unconscious desire. Explaining the Freudian concept of phantasy, Laplanche and Pontalis stress the role of staging and performance: 'phantasies are still scripts (scenarios) of organised scenes which are capable of dramatisation – usually in visual form'; they are 'a sequence in which the subject has his own part to play and in which permutations of roles and attributions are possible'.[12] The subject may be simultaneously a witness of, and a participant in, the phantasy narrative which typically offers more than one possible entry-point. Identity is not fixed and unitary in phantasy but fluid, multiple and open to dramatic improvisation.

My argument that seduction be viewed as a subversive operation draws upon an essay by Jean Baudrillard, *Seduction*, in which seduction is defined as a guileful play of masks and artifice.[13] Seduction thrives on (dis)semblance and inauthenticity and hence to search for a reality behind appearance in the play of seduction would be to break with the rules of the game. Seduction deploys as its resources the system of signs, it is 'a mastery of signs, in contrast with power, which is mastery of the real'.[14] Baudrillard has been rebuked for falling back on a gender essentialism and trading on the negative female stereotype of the seductress.[15] But is it the case that seduction inevitably comes back to the feminine? My contention is that a potential for subversion arises precisely because of a gap opened up in the scene of seduction between the apparent reality and immutability of sex and the staged performance of a gendered subjectivity, something I shall argue in relation to the work of Max Ernst.

Seduction as a potentially subversive strategy will be explored via a study of Ernst and hysteria focussed on his 1930 collage novel, *Dream of a Little Girl Who Wished to Enter the Carmelite Order* (Rêve d'une petit fille qui voulut entrer au Carmel). At the outset, it must be conceded that this tale of erotic awakening in a pious fifteen-year-old girl is not unproblematic. As a narrative of desire, one is compelled to ask whose desire it is that is narrated. Is it really the dream of a 'little' girl, or is it not rather Ernst's wishful phantasy about what little girls dream of? The youthfulness of the protagonist, moreover, indicates how the idolatry of hysteria can shade into a more overtly exploitative cult of the *femme enfant* within the male, heterosexist surrealist imaginary.[16] None the less, I hope to be able to demonstrate that the scene of seduction is a space of indeterminacy in which a productive confusion as regards masculine and feminine subject positions arises, and where the identities of male artist and female hysteric are liable to merge and exchange. Seduction, as John Forrester points out, is inherently ambiguous, meaning either *actively* seducing or *passively* being seduced.[17] Activity and passivity, conventionally designated as masculine and feminine, are reversible within the seduction scene. Ernst illustrates the subversion of relations between the hysterical subject and a world of moral authority symbolised most overtly in the collage novel by the religious order to which the heroine, Marceline-Marie, gains admittance, but also by what we shall designate as a father series whose authority her childish coquetry subversively undermines.

Before coming to Ernst, we shall examine 'Les Possessions', a collection of five automatic texts by André Breton and Paul Eluard in which they attempted to simulate the speech and ideation of the insane. Simulation, long recognised as a feature of the hysterical condition, was put back on the agenda by the First World War which confronted the medical profession with vast numbers of male shellshock victims exhibiting all the bizarre physical symptoms of female hysterics. It is probable that these particular circumstances, which brought home to many for the first time the reality of male hysteria, was a necessary precondition for the appropriation of hysteria by a male avant-garde.[18] There can be no doubting that Breton's wartime experience as a medical auxiliary predisposed him to view hysteria as a form of insubordination − a protest, albeit a mute one, against military and medical authority. My analysis of 'Les Possessions' will draw out some of the implications for identity of the fact of simulation. The collaborative aspect of the texts itself poses questions for authorial identity − questions about who speaks and from where. More far-reaching, however, in its challenge to the fundamental bases of subjectivity (of the subject in Western metaphysics as *subjectum*, or true foundation) is the strategy of simulation *per se*. Simulation, we shall see, operates by confounding the distinction between semblance and reality, between authenticity and the inauthentic, ersatz copy. The modernist preoccupation with authenticity is rendered obsolete by simulation which exposes identity as a mimetic performance devoid of any essence.

'From the unity of the body we too quickly infer the unity of the soul, whereas perhaps we harbour more than one conscious self.'[19]

who speaks?

'Oh no no I bet Bordeaux Saint Augustin . . . That's a notebook there' – complete gibberish, but what marked out this phrase as noteworthy for Breton, causing him to begin a major essay, 'The Automatic Message', by citing it, was the child-like intonation of the voice.[20] In this respect, it stood apart from examples of inner speech he had recorded before which he was able to cite without quotation marks, such was their apparent commensurability with his own personality. As Breton ruminates on the mystery of the voice we, the bemused readers, are led to ask the question posed in *Nadja*: by whom is Breton haunted?

The question 'Who speaks?' is one that the shadowy world of mediums posed to men of science in the late nineteenth century. Let us take the case of the medium Hélène Smith, observed over a period of five years by the psychologist Théodore Flournoy, whose 'admirable explorations', as Breton describes them, gave rise to a book-length study, *Des Indes à la planète Mars: Étude sur un cas de somnambulisme avec glossolalie* (From India to the planet Mars: A case of multiple personality with imaginary languages), published in Geneva in 1900.[21] Whilst in a state of induced somnambulism, Smith would make contact with a querulous personage named Léopold who presided over the seance like an imperious stage-manager, forcing Smith to acquiesce puppet-like to his demands and remonstrating with her if she resisted. Discounting the view to which Smith herself subscribed, namely that Léopold was an incarnation of the soul of someone deceased, Flournoy is convinced that the extensive cast of characters with whom Smith communicates, or who speak through her, like Léopold, are actually manifestations of her subliminal self. This Léopold-consciousness, independent of the normal waking Hélène-consciousness, would make his heavy-handed direction felt in various ways: by raps on the table, by pointing with her finger, and by means of automatic writing (*écriture mécanique*). However by far the most spectacular of these incarnations occurred when the Hélène-consciousness lay dormant during episodes of complete somnambulism and he would speak through her mouth. To recapture the high drama of these occasions we must leave it to Flournoy, who admits that he did not always maintain the strict detachment of a scientific observer at such moments, to speak for us:

> Soon after a series of hiccoughs, sighs, and various noises, indicating the difficulty that Léopold is experiencing in taking hold of the vocal apparatus, speech surges forth, grave, slow, strong, the low powerful voice of a man, a little confused, with a foreign pronunciation and strong accent, certainly more Italian than anything else.[22]

Just as Flournoy sought to bring such phenomena within the purview of respectable science, so too Breton – however reluctant a child of a secular, materialist age – rejects out of hand the 'nauseating terminology' of spiritism: 'For us, obviously, the question of the exteriority of the "voice" (repeating for the sake of simplicity) could not even be raised.'[23] Flournoy had no doubts that Léopold was unwittingly the creation of Hélène Smith's imagination, and sprang from the newly discovered domain of the unconscious. It is to that realm that Breton alludes when, in 1930, he imagines not just Léopold but the whole of mankind virtually, clamouring to be heard via the agency of *his* vocal apparatus:

If I can successively cause to speak through my mouth the richest and poorest beings in the world, the blind and the hallucinating person, the most frightened and the most menacing beings, how can I accept that this voice, which is after all mine alone, comes to me from regions that are even provisionally condemned, from regions where I must, like most ordinary mortals, despair of having access?[24]

So asks Breton in the introduction to the collection of five automatic texts known as 'Les Possessions', written in September of 1930, in which he and his collaborator, Paul Eluard, simulate the speech and ideation of the insane, adhering to then current taxonomies of mental illness.[25] One of the most intriguingly contradictory of surrealist documents, they have attracted possibly more attention even than *Les Champs magnétiques* with which they share the fact of being jointly authored.[26] Samuel Beckett was so captivated that he took on the daunting task of translating some of the texts, which include passages of entirely neologistic speech. (In 1935, Eluard wrote a preface for a Japanese edition!) Rare in Breton's oeuvre is the humour that surfaces at a number of points. Responding to the authors' suggestion that these attempts at simulation could advantageously replace the ballad, the sonnet, the epic and other defunct genres, one early commentator was of the opinion that the chapter simulating the form of insanity caused by syphilitic infection 'is possibly the most beautiful hymn to love in French poetry'.[27]

It is easily forgotten that 'Les Possessions' comprises just one section of a longer book, *L'Immaculée Conception* (The immaculate conception), in which one reviewer discerned a bold project aimed at 'the reconstruction of human existence in its totality, from conception, passing via the intra-uterine life and birth, up until death'.[28] Breton's claim to have gained access to the outlawed recesses of the human spirit would seem to be in keeping with a monumental ambition of this scale, the implication being that madness is a latent possibility of the human mind which they seek to recuperate. Viewing 'Les Possessions' in these terms, Marguerite Bonnet has argued that the experiment was informed explicitly by a Hegelian anthropology. In Hegel's *Phenomenology of Spirit*, insanity is the second of three stages traversed by the feeling soul on its path to absolute self-possession and consciousness of itself. It is not the case that madness has actually to be experienced in the course of this movement, rather it exists as a virtuality that serves to define what it is to be human. The possibility of insanity arises because the human 'I' is wholly abstract and indeterminate and hence is capable of being filled with any content: I can believe that I am a dog, for example, or Jesus Christ. According to Hegel, 'Man alone has the capacity of grasping himself in this complete abstraction of the "I". This is why he has, so to speak, the privilege of folly and madness.'[29]

In support of Bonnet's hypothesis, a special insert written for the first edition of *L'Immaculée Conception* states that the simulation of 'delusions systematised or not' − one can detect Dalí's fingerprints in the choice of language here − has 'for transcendent effect' to consecrate 'the free categories of thought culminating in madness'. Recognising thought's capacity to adopt at will all the modalities of madness is said to be, in a genuinely Hegelian formulation, 'equivalent to admitting the reality of such madness and to affirming its latent existence in the human spirit'.[30] There is good evidence that Breton was acquainted with the broad outlines of Hegel's philosophy and especially his views on madness. Pierre Naville has confirmed that Breton early on discovered in the first volume of Vera's standard French translation of Hegel 'on the dream and madness, pages which greatly impressed him and are moreover quite surprising even to reread today, since Hegel has the soul in its struggle for liberty pass first

through the dream, then madness, and only following that, "consciousness"'.[31] Breton's penchant for grand syntheses – not least his passionate faith in 'the future resolution of these two states, in appearance so contradictory, which are dream and reality, in a kind of absolute reality, a *surreality*'[32] – may well stem from this decisive early encounter with Hegelian philosophy, as has been argued at length by Bernard-Paul Robert in *Le Surréalisme désocculté* (Surrealism demystified).[33] Indirect support for the notion that Breton and Eluard sought to bring about an idealist synthesis of the personality in 'Les Possessions' can possibly also be found in the claim made subsequently by Breton that surrealism aims at nothing less than the unification of the personality.[34] Nevertheless, we may wonder why the authors should have left it to another party to state in a loose insert their core philosophical aims if indeed it was the Hegelian enterprise that Bonnet contends.

One can readily appreciate the desire to *désocculter le surréalisme*. 'Who would not wish to see these adoptive children of revolution most rigorously severed from all the goings-on in the conventicles of down-at-heel dowagers, retired majors, and *émigré* profiteers?' asked Walter Benjamin, embarrassed by the surrealists' willing suspension of disbelief when it came to the fraudulent activities of crystal-ball gazers and table-rapping mediums.[35] Dialectics, even the idealist sort, are preferable to the unsavoury intellectual backrooms happily frequented by the surrealists. And yet the sublimatory operation (*Aufhebung*) that aims to distil from the 'mystico-poetic eclecticism' of surrealist thought a project with an air of philosophical rigour transforms it beyond recognition. The matter of the voice addressed by Breton in his introduction to 'Les Possessions' points to the origin of these seminal texts in a less august set of concerns. The study of cases of double and multiple personality (so-called 'disaggregations of the personality'), of which there was a near epidemic in the late nineteenth century, caused a number of investigators to raise doubts about the philosophical premise that the human subject is a unity. With regard to the displays put on by these latterday cases of spirit possession, some of whom were celebrities widely reported in the medical literature, the issue of feigning or simulation was never far from the scene. A question we shall have to ask in response to 'Les Possessions' is what consequences follow for our concepts of identity when the pathological dissemination of the self in states of multiple personality is taken as a general condition of subjectivity, and when it is our capacity to simulate which becomes the measure of our human freedom? From the fact of simulation, I want to argue, it is possible to extrapolate a notion of selfhood as devoid of any essence and as something performed, albeit unconsciously.[36]

surrealism and insanity

'Les Possessions' are to be understood first and foremost in the context of modernist experiment with linguistic forms. The authors were motivated in the first instance by a conviction that madness liberates language from convention, the intense lyricism of the texts they created backing up Breton's contention that the rantings of the insane are a worthwhile model for writers wishing to escape the stifling confines of traditional literary genres. Far from being perceived as an affliction taking possession of its hapless victims, therefore, insanity is avidly embraced. The third essay, simulating the 'delirium of interpretation', which Breton felt to be the least successful, expresses very clearly the hope that madness held out to perceive the world

afresh, unencumbered by the strait-jacket of reason. The narrator of the piece believes himself to be a bird – rather implausible from a clinical point of view, Alain Rauzy claims.[37] That may be so, but one can see why Breton has resorted to it because it evokes more effectively than strict adherence to the textbook syndrome could have done the altered world-view that is implicit in the 'flight into madness'. Insanity denotes a realm of freedom by contrast with the dreary conformity of bourgeois values which they submit to stinging satire in the first essay, a simulation of mental retardation. Contrary to conventional wisdom, the surrealists believed 'it is us who are locked up when one shuts the door to the asylum: the prison is outside, liberty within [in the minds of the inmates].'[38]

By openly celebrating the linguistic inventiveness and creative freedom of the insane, 'Les Possessions' are undoubtedly to be understood, as Breton implied, as settling an old score with psychiatry. The surrealists were the anti-psychiatry movement of their day. In an open letter to directors of insane asylums published in *La Révolution surréaliste*, they are scornful of psychiatry and its institutions which they saw as the apparatus of a repressive social order: 'The madhouse, under cover of science and justice, is comparable to a barracks, a prison, a penal colony.'[39] When a copy of Breton's *Nadja* that had been circulating in an asylum was confiscated and found to contain a passage inciting the inmates to kill their doctors, there was an outraged reaction.[40] Debate at the Société Médico-Psychologique about how to respond to the perceived threat was reported widely in the medical and lay press, provoking an equally overheated reply from Breton. Preferring the label of *autiste* to that of *artiste*, Breton compares the plight of the mad (*les aliénés*) with what he believed, in accordance with a post-Romantic ideology, was the necessary alienation of the artist or writer implacably opposed to the norms of bourgeois society. The notion of autism, which Bleuler had regarded as a basic feature of psychosis, works to stigmatise as pathological all forms of rebellion, Breton claims – 'all cases of refusal, of insubordination, of desertion which until now have appeared worthy or not of regard (poetry, art, love–passion, revolutionary action, etc.). Autistic today are the surrealists as well (for Mr Janet – and for Mr Claude, no doubt).'[41] For Breton, avant-gardist and *aliéné* are condemned by society to share the same cell; a paradoxical liberty in solitude is the price of their refusal to conform. In an etched portrait by Max Ernst used to advertise a collection of his poems (fig. 28), Breton, wound tightly in bandages reminiscent of a straitjacket, occupies the position of the Romantic *poète maudit*, resigned victim of this double bind.

Surrealist folklore has it that Max Ernst arrived in Paris in 1921 clutching a copy of Hans Prinzhorn's *Bildnerei der Geisteskranken* (Artistry of the mentally ill) which he duly presented to Paul Eluard, thus igniting a passion for art of the insane (Eluard, smitten, was reportedly delving into Prinzhorn at the time of writing 'Les Possessions'). Ernst recalled: 'They touched deeply the young man, who is tempted to recognise there the glimmer of genius and makes the decision to explore this faraway and dangerous terrain, situated at the borders of madness.'[42] But on this score, the surrealists were barely one step ahead of a buoyant and expanding art market which greeted this new merchandise, happily redefined as art, with open arms. Francis Picabia, subversive dadaist and inveterate socialiser, proves to be the most acerbic chronicler of this art world phenomenon, opining that:

> Connoisseurs ruin everything; as soon as they touch anything fresh with their greasy hands the pollen sticks; look at what they've done to gypsy songs, to negro music, to the drawings of children and the mad! These were wild creatures that have been put into cages and have lost their colour waiting to be flogged off bit by bit and exchanged for banknotes.[43]

In practice, it was not necessary in the 1920s to have read one's Hegel to have a passion for outsider art: its virtues were being extolled over cocktails on many an opening night at commercial galleries all around Paris. At one such show mounted by the Galérie Max Bine in 1929, works were catalogued according to the mental condition suffered by their creators, who generally remained anonymous, showing that the old taxonomic impulse died hard.[44] Not surprisingly, a number of the categories match those which Breton and Eluard attempt to simulate. One section was devoted to 'Mental weakness, congenital and acquired'; a group of pictures described as 'Etruscan Visions' included a work by an erotomaniac titled *Afternoon of a Faun* which had to be withdrawn from public display on grounds of obscenity; another section consisted of thirty-five works by schizophrenic artists borrowed from the major collections of Prinzhorn, Sérieux and Vinchon among others. It is known that at one of these exhibitions Breton acquired a box assemblage consisting of obsessively arranged buttons, broken scissor handles and assorted other discarded objects retrenched from useful service. Illustrated in an issue of *La Révolution surréaliste* in December 1929, this object may well have sparked off the craze among Dalí, Brauner and others for fabricating similar kinds of offbeat assemblages. In general, however, instances of demonstrable borrowings from insane art are relatively few which somewhat belies the surrealists' fullsome praise for the inspirational value of this work,

28 Max Ernst. *André Breton*. 1923. Ink on card, 40.5 × 31cm. Advertising flyer for André Breton, *Claire de terre* (Paris: 1923). Paris: Bibliothèque Littéraire Jacques Doucet 7208–43.

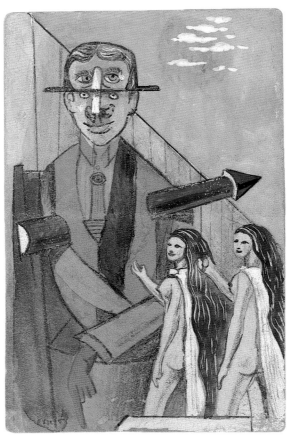

29 Max Ernst. *Schizophrenia*. c.1923. Watercolour and pencil on postcard, 14 × 9cm. Christie's, London, 29 November 1989. (See note 42.)

though a definitive judgement on this matter would need to await a more thorough study than has as yet been made.[45]

Despite Breton's protestation that the least hint of borrowing from clinical textbooks – that is to say of an inauthentic pastiche – would suffice to render their efforts worthless, it was plain to Rolland de Renéville that 'Les Possessions' was the work of researchers expert ('très avertis') in their subject.[46] Breton was captivated by the speech and ideation of the insane from the moment of his first encounter with them while working as a medical auxiliary in 1916. His avowal in the *Manifesto of Surrealism* that 'I could spend my life prying loose the secrets of the insane' culminates in the glossolalia that concludes the attempt to simulate schizophrenia where any message to be gleaned is solely for initiates:

> Gaci zulo plef. U feaïva oradarfonsedarca nic olp figilê. U elaïaïpi mouco drer hôdarca hualica-siptur. Oradar-gacirog vraïlim . . . u feaïva drer kurmaca ribag nic javli.[47]

'How many are you . . . for whom the dream of the schizophrenic and the images to which they are prey are other than a word salad?' the surrealists demand accusingly in their 1925 letter to directors of insane asylums.[48] In truth, by celebrating the linguistic inventiveness of psychotic states, they were building upon an interest in verbal and visual productions of the insane that arose first in medical psychiatry in the late nineteenth century where, in keeping with the prevailing obsession with nosology, such material was employed initially as an adjunct to clinical diagnosis.[49] In some quarters, however, clinical applications came to be supplanted by an appreciation of its poetic and aesthetic worth: by contrast with previous investigations of insane art, Marcel Réja's study *L'Art chez les fous* was pioneering in its sympathetic evaluation of works against aesthetic criteria.[50] It transpires that Marcel Réja was actually the pseudonym of Dr Paul Meunier, a psychiatrist who had access to the collection of drawings, sculptures and other artefacts amassed by his colleague Auguste Marie at the asylum at Villejuif. Michel Thévoz, whose research it was that first brought to light this remarkable case, believes that Meunier's adoption of a pseudonym and his decision to publish with Mercure de France, a literary publisher, shows that the book sprang from aesthetic rather than medical interests – 'registers entirely separate in his work and maybe also in his persona'.[51] Whilst it is not rare for French writers to adopt a *nom du plume*, the 'schizophrenic' splitting of Meunier-Réja can be regarded as symptomatic of the fact that the valorisation of madness from an aesthetic standpoint was not easily reconciled with the institutional power and authority wielded by psychiatrists.[52]

One wonders if the avant-garde reception of outsider art would have taken place at all had it not been already defined as art within a medical context – a paradox, given that for a lot of modern artists such work was seen as a resource enabling them to bypass traditional aesthetic categories altogether. Recall that for Breton their attempts at simulation afforded a standard for modern poetry that would render obsolete 'the ballad, the sonnet, the epic, the poem without head nor tail and other outdated genres.' Katia Samaltanos, in *Apollinaire: Catalyst for Primitivism, Picabia and Duchamp*, presents evidence that in the years before the First World War Apollinaire's circle of intimates, which included Marcel Duchamp, were absorbed in the art and writings of the insane.[53] She speculates that the poet's friendship with the psychiatrist Jean Vichon, himself the author of a book on art and madness, may have brought him in to contact with Marcel Réja. Samaltanos convincingly locates Duchamp's renowned proclivity for puns and homonyms within the orbit of these medical studies. A more general convergence with a

modernist sensibility can be discerned in the way that words are treated by the schizophrenic: as Freud put it, there is a 'predominance of what has to do with words over what has to do with things'.[54] It was held to be typical of psychotic speech that words are strung together on the basis of rhyme or assonance with scant regard for meaning.[55] These whimsical permutations of language in psychosis are oftentimes every bit as inventive as Duchamp's dadaist antics: a superb example of this word play, in which a *dédoublement* of sense refers simultaneously to splitting of the soul or self, is Nadja's 'l'âme du blé' – 'l'âme doublé', reported by Breton. A particularly florid instance of this homonymic play on language, impossible to preserve in translation, is found in 'Les Possessions' in the essay on schizophrenia (dementia praecox):

> Lorsque je me cape de pied en cap pour être le hêtre, l'avant-nom, le contre-nom, l'entre-nom et le Parthénon me prière et je dis non et canon . . .[56]

Breton also adroitly imitates the schizophrenic propensity to treat words as things – evident in the narrator's conviction, for example, that 'the words *se peut* artificially prolong each one of the *cils* [eyelashes] of my upper eyelid.'[57] Carried across to a visual domain, this tendency to concretise metaphor by treating words as things can explain a good many of the parallels that obtain between works by surrealist artists and the insane. These are especially impressive when, as is often the case, evidence of a direct influence is lacking. The substitution of a birdcage for the human ribcage in Magritte's *The Therapeutist* of 1936 is typical of the surrealists' use of visual puns; precisely the same operation can be observed in an image dated c.1947 by the schizophrenic Raymond C. illustrated in Breton's *L'Art magique*.[58] A regression from word to image or thing also underlies the burlesque absurdity of Dalí's *Anthropomorphic Cabinet* of 1936 where the figure's breasts and torso are quite literally a 'chest' of drawers.

Breton observes in *Nadja* that: 'That which seemed most inimitable in Duchamp in the form of several mysterious word plays (Rrose Sélavy) recurs in Desnos in all its purity and suddenly obtains extraordinary amplitude.'[59] It is quite obvious from the collection of experimental poems, *Aumonymes*, but also from Desnos's efforts at painting and drawing, that he too kept the company of the insane. Several ink drawings by Robert Desnos which purport to be the work of schizophrenics appear as illustrations to a magazine article in 1924, 'Le Génie sans miroir'.[60] It transpired that Desnos also wrote the text that accompanied the drawings though, presumably to cover his tracks, the published version was signed with Paul Eluard's name. The drawings – imitations skilful enough to have fooled the editor – were sufficiently notable to warrant comment by Breton, who was a party to the scam, in the *Manifesto of Surrealism*. Notwithstanding Breton's assertion that *his* simulations had nothing at all in common with practices of pastiche, one cannot help thinking that Desnos's light-hearted spoof contains the germ of an idea that later on became 'Les Possessions'.[61]

Dream – Poetry of 1923 (fig. 30), painted by Robert Desnos during the period of experiment with trance states, is informative with regard to the specific confluence of ideas that occupied the surrealists at that juncture and also reveals the nature of their underlying compatability. The depicted space is a hybrid of landscape and interior still life, a conflation of inner and outer worlds derived from Giorgio de Chirico that had become a byword in surrealist visual art for a dream-space. Breton wrote in *Nadja* of the oracular character of the utterances made by Desnos under hypnosis; with the benefit of hindsight, the phrases 'Chirico je veux parler' (I want to speak to Chirico) and adjacent to it 'on ne répond pas' (there's no reply) would seem to augur a major rift that was, in point of fact, just over the horizon. Painted with a

30 Robert Desnos. *Dream – Poetry. c.*1922. Watercolour and ink, 31.3 × 48cm. Sotheby's, London, 29 March 1988. Lot n° 359.

water-based paint rather than oil, the awkward drawing style and written inscriptions reflect Desnos's study of art by the insane, as does the homonymic phrase, 'La Milice des déesses se préoccupe peu des délices de la messe' (The militia of the goddesses is little preoccupied with the pleasures of the Mass). Marcel Réja had claimed that such plays on language are, in the case of the insane, 'the fruit of a more or less pure psychological automatism'.[62] Additionally, the incorporation of imagery evoking sound broadcasting and reception – gramophone horns, telegraphic wires and a receiver – may allude to the phenomenon of auditory hallucinations, or the typical schizophrenic delusions of thought broadcasting or thought insertion. By the same token, it had become a commonplace to describe mediumistic communication and telepathy by analogy with the wireless;[63] and, with a motif that obviously has multiple associations, there may also be a reference to the Bretonian metaphor of the poet as a simple recording instrument, a mere passive conduit for the automatic message. 'Télégraphie sans fil, téléphonie sans fil, imagination sans fil, a't-on dit . . .'[64]

• • •

'The only difference between a madman and myself is that I am not mad', proclaimed Dalí. It may be that a degree of ignorance about what insanity actually entailed in the way of pain and distress for those afflicted lies behind some of the more facile assertions that were made on the topic. One suspects that the enthusiasm of modern artists for insanity and their readiness to appropriate its creative resources was to some extent a byproduct of the vast expansion of mental asylums in the late eighteenth century, the *grande renfermement* described by

Michel Foucault, which saw the mad themselves locked away out of sight.[65] In a manner akin to modernist primitivism, the desire on the part of avant-garde artists and writers to arrogate to themselves the authenticity of vision that belonged to the insane poses a host of ethical questions. Indeed, the *Oxford English Dictionary* definition of 'appropriate' (from AP *propriare* [*proprius* – to own]), to 'take possession of . . . especially without authority', points to some rather problematic issues – of property and propriety, of possession and *dis*-possession – raised by 'Les Possessions'.

One writer who addresses this issue in a way that has relevance to our discussion is Georges Bataille, who ponders the implications of Nietzsche's succumbing to madness on our behalf. Referring implicitly to Hegel, Bataille remarks that 'Madness cannot be rejected outside of the human *totality* ['integralité'], which could not be accomplished without the madman.'[66] He then proceeds to ask a question that seems not to have bothered unduly the authors of 'Les Possessions': 'can the gift that a madman makes to his fellow men by his madness be accepted without having to be repaid with interest? And if it is not by one's own unreason ['déraison'] that one accepts the madness of another, how else is this royal gift to be recompensed?' Is it not then disconcerting to find Breton, who is ever ready to take the moral high ground in his polemic with psychiatry, blithely purporting to show that for the normal, fully sane man: 'it is within the mind's power to assume at will the commonest delusional ideas without this leading to any lasting disturbance, nor compromising at all the faculty of equilibrium'?[67] No mention here of any recompense. And yet it may be that the avant-garde eventually paid a high price, ranging from public incomprehension and hostility right through to the sinister exhibition of *Degenerate 'Art'* mounted by the Nazis in 1937, for preferring to keep the company of the mad.

automatism and possession

The introduction to 'Les Possessions' boasts that the exercise proves that it is possible to escape from the prison house of identity and recover faculties denied to our habitual selves. As if to exemplify this theme, the narrating 'I' of the attempted simulation of dementia praecox, scripted by Breton, grandiloquently proclaims himself to be an entire extended family of selves: 'I am the grandfather, the father, the father-in-law, the brother, the brother-in-law, the uncle, the son-in-law, the daughter-in-law, the cousin, the godfather, and the parish priest of the current pope who is merely a spy in disguise.'[68] The experience of automatic writing had long ago raised doubts in Breton's mind about the presumed unity of the soul by showing the subject to be riven by the unconscious; indeed, Pierre Janet believed that automatic writing was possible only where there was already a cleavage in the consciousness of the subject, *un dédoublement du moi*. Janet was of the opinion that an induced state of distraction, emphasised by Breton in the *Manifesto of Surrealism* as a prerequisite of automatic writing, facilitates such a division: 'In a word, distraction seems to divide the field of consciousness into two parts: one which remains conscious, and another which seems to be ignored by the subject.'[69] The phrase that Breton reports in the *Manifesto* as an example of inner speech, 'There is a man cut in two by the window', was possibly selected by him because the image of itself visualises the split (*Ichspaltung*) that is constitutive for the subject of the unconscious. It was a phrase that presented itself to his conscious mind with insistence – 'a phrase dare I say *which knocked at the glass*.'[70] The necessary inference to be made is that the man cut in two by the windowpane is

none other than Breton himself. Some three years before the *Manifesto*, but with the experi-ence of writing *Les Champs magnétiques* already behind him, Breton muses: 'From the unity of the body we too quickly infer the unity of the soul, whereas perhaps we harbour more than one conscious self.'[71]

From the late nineteenth century such queries had been increasingly raised within main-stream psychology, and for good reason. It is scarcely an exaggeration to claim, as Ian Hacking has done, that multiple personality disorder (currently undergoing a revival of fortunes espe-cially in North America) was 'invented' in 1875, such was the sudden and dramatic increase in case reports.[72] Hacking argues that a hidden agenda lay behind these scientific observations of cases of double and multiple personality in hysterics and in mediums. He cites Pierre Janet who said of Felida X, a celebrated case of split personality: 'This humble person was the edu-cator of Taine and Ribot. Her history was the great argument of which the positivist psy-chologists made use at the time of the heroic struggles against the spiritualist dogmatism of Cousin's school.' Taine, Ribot and Janet, founders of a modern French school of psychology, each sought to mark out the new positivist science as different from an older tradition of metaphysical psychology as well as from philosophy.

Hippolyte Taine, in *De l'Intelligence* of 1870, paved the way for those psychologists who fol-lowed by exposing to critique the 'sort of mathematical point . . . that each one of us calls I or me'.[73] The subject or soul that philosophy and religion both posit and assume to have a reality and permanence that transcends the ever-changing contents of our mind, what is it? And where is it? 'We have there metaphysical beings, pure phantoms, engendered by words and which evaporate as soon as one examines scrupulously the meaning of the words' was Taine's reply.[74] For Taine, the self is a sort of chimerical artefact conjured by language. At best it is a mere epiphenomenon since objective scrutiny shows that we are no more than the sum of our mental contents: the concatenation of memories, perceptions, ideas and images that occupy us. Théodule Ribot, a pioneer in the new discipline of clinical psychology, was simi-larly dismissive of the pretensions of metaphysicians who sought to define the subject *a priori* as 'perfectly one, simple and identical'. The opinion he expresses in *Les Maladies de la personnal-ité* of 1885 is that such a view offers only 'false clarity and the semblance of a solution'.[75] Ribot, an associationist psychologist, viewed the personality not as a preordained unity but as the outcome of a process of integration of discrete faculties: 'The unity of the self is hence not the same as the entity of spiritualists which scatters into multiple phenomena, but rather the coordination of a certain number of states ceaselessly reborn, and having as its sole basis an awareness of our body.'[76] Where this synthesis was more than usually precarious, as was thought to be the case in hysterical subjects whom Ribot described as unstable *par excellence*, it was liable to disintegrate, thereby enabling one or more separate personalities, each with its own stock of memories, to emerge and to alternate with each other.[77] Like the French state whose unity in the 1880s must have appeared at best fragile in the face of seething antago-nisms, these 'selves' did not always coexist peaceably. Pierre Janet, in *L'Automatisme psychologique* of 1889, records in a section of the book titled 'Possessions' an extreme case of disaggrega-tion of the personality, that of a patient for whom the subconscious was: 'like another self and as though I had two souls . . . the two minds in combat on a single field, which is the body, and the soul so to speak shared between them'.[78] The age-old belief in possession thus contained a kernel of psychological truth. In another case reported by Janet, at least three personalities – Lucie 1, 2 and 3 – were able to be elicited under hypnosis.[79] Janet, like Ribot, was inclined to the view that such patients had an underlying hysterical disposition. Curiously,

given his aspirations to scientific objectivity, in common with other psychologists studying multiple personality, many of his reported cases are subjects who were mediums by trade. Undeterred by the charges of fraud frequently levelled at them, Janet asserts that: 'Mediums, when they are perfect, reveal the most complete form of division where the two personalities ignore each other completely and develop independently one from the other.'[80]

The seance was the true laboratory for the study of multiple personality. When, in 1899, Théodore Flournoy published *Des Indes à la planète Mars* based on his attendance over a five-year period at seances held by Hélène Smith, a Genevan medium, she rose to celebrity status among cases of multiple personality. Aside from the very dramatic incarnations in which Léopold took control of her vocal apparatus, the audience at these events (Ferdinand de Saussure, Professor of Sanskrit at the University of Geneva, was among the regular observers) was treated to episodes of glossolalia in which Smith would communicate in Hindi and, more exotically, in Martian. Flournoy analyses in exacting detail the diverse forms of automatism to which Smith was prey as she relayed the extra-terrestrial messages that impinged on her conscious mind in the form of auditory or visual hallucinations. What entitles us to situate 'Les Possessions' within the same discursive field as studies of multiple personality disorder? Aside from the likelihood that a chapter on possessions in Janet's *L'Automatisme psychologique* was the source for Breton's and Eluard's title,[81] and the evident parallel between Hélène Smith's glossolalia and that which concludes the 'Essai de simulation de démence précoce', the strongest evidence for a link comes from Breton's essay, 'The Automatic Message'. Whereas previously Freud had been the guarantor of the legitimacy of surrealist automatism, in 1933 Breton seemed to recant on this, and invented an entirely new genealogical tree:

> In spite of the regrettable ignorance many people still have regarding his work, which antedates that of Freud, I consider that we are to a greater extent than is generally realised dependant on that which William James rightly called the *gothic psychology* of F.W.H. Myers who, in a world entirely new and full of excitement, brought us in turn to the admirable explorations of Th. Flournoy.[82]

Frederick W.H. Myers, one of the founders of the English Society for Psychical Research, believed that man possesses psychical resources of which normally we are only dimly aware. Just as the visible part of the spectrum includes only a fraction of the radiation emitted by the sun, so too our conscious self is only one small part of an extended psychical entity. Myers believed that under certain privileged circumstances – notably in cases of double or multiple personality – we can catch a glimpse of the subliminal self which, in spite of its reticence about disclosing its presence, he believed was vastly superior to our mundane, everyday self. Though he refers to the Janetian notion of dissociation, Myers sharply disagreed with Janet's view that the alternation of personalities in the case of Lucie was due to a pathological retraction (*rétrécissement*) in the field of consciousness. For Myers, by contrast, like other spiritist manifestations, it was an indication of the existence of a more extended psychical field that overflowed bodily limits.

As Jean Starobinski long ago noted, there is much that Breton would have found congenial in Myers' notion of a subliminal self.[83] 'Our consciousness at any given stage of our evolution is but the phosphorescent ripple on an unsounded sea', declares Myers in his *magnum opus*, *Human Personality and Its Survival of Bodily Death*, which was published posthumously in 1903.[84] Breton, too, aspired to plumb the great submerged depths of this unsounded sea and shared Myers' estimation of the unconscious as vastly superior to our mundane, everyday self. It has

been argued that the oddball mixture of science and spiritism in Myers' psychical research evinces a displaced religious longing that was tailored to a secular, materialist age.[85] His notion of a subliminal self expressed a yearning for a lost unity that transcended the fragmentation of modern experience: 'I desire integration of the personality – intellectual, moral, spiritual concentration' writes Myers. Breton too subscribes to this view, echoing Myers in 'The Automatic Message' when he states: 'contrary to what spiritualism proposes, a dissociation of the psychological personality of the medium, surrealism proposes nothing less than the *unification* of that personality.'[86] A question remains, however, as to whether Breton's glowing tribute to the gothic psychology of Myers, Flournoy et al. had any practical significance, or was it merely a tactical rewriting of the history of automatism in response to changing priorities signalled by the *Second Manifesto of Surrealism*'s call for the 'PROFOUND, VERITABLE OCCULTATION OF SURREALISM'?[87] Neither Starobinsky in his classic article 'Freud, Breton, Myers' nor Jean-Louis Houdebine in his bitter *Tel Quel* polemic against Breton based on that source make such a case.

Since Breton only acquired his copy of the French translation of Myers' *The Human Personality* in 1925, Marguerite Bonnet is justified in concluding that there is no evidence of Myers having any bearing on the formulation of psychic automatism in the *Manifesto of Surrealism*.[88] By the same token, it is proven that by the time he wrote the *Second Manifesto* in December 1929 Breton *had* made his discovery of Myers and thence the admirable explorations of Flournoy. In as far as 'Les Possessions' do represent a departure from automatism as it had been practiced hitherto, they owe much to Breton's new-found intellectual interests. It may be relevant to the collaborative aspect of the exercise to note that while Breton ridicules the spiritist hypothesis of messages from the departed, he does not rule out the possibility of subliminal communication among the living. Indeed, a footnote in the *Second Manifesto* backs up the call for surrealism's occultation by referring to the collective game of *cadavre exquis*, in which each person would draw part of a figure or write a phrase, and fold over the sheet before passing it on to the next person who then made their contribution without any knowledge of what had been done already (fig. 116 is an example of the collective product), as evincing 'a strange possibility of thought, that of its *pooling* [*mise en commun*].'[89] That this was more than just a momentary fancy is shown by the fact that Breton, writing on the same topic in 1948, continues to entertain 'the idea of a tacit communication – occurring only in waves – between the participants'.[90]

Breton is seriously taken to task by Jean-Louis Houdebine on grounds of his alleged 'mystico-poetic eclecticism' in an article entitled 'Méconnaissance de la psychanalyse dans le discours surréaliste' (Misunderstanding of psychoanalysis in surrealist discourse) that appeared in *Tel Quel* in 1971.[91] The main bone of contention for Houdebine is Breton's seeming indifference to a radical schism which he claims inaugurates Freudian psychoanalysis and differentiates it absolutely from the psychology that came before. Lumping Freud together with the tradition of psychical research is for him a reprehensible idealist deviation which travesties the science of psychoanalysis. Up to a point, one must sympathise with Houdebine's impatience. Breton, and other surrealists as well, too readily overlook the distinction that Freud often enough makes between his own conception of the unconscious, as a psychical locality with properties and mechanisms that are qualitatively different from consciousness, and any idea of the unconscious as a second – masked, hidden or virtual – self.[92] Alas, however, the seductive illusion of a rupture (*coupure freudien*) that inaugurates in all its purity the *science* of psychoanalysis is no longer tenable. As John Forrester remarks: 'The telepathic question par excellence, one

31 Man Ray. *Photograph of Robert Desnos*. From André Breton, *Nadja* (Paris: 1926). 'Once again, now, I see Robert Desnos . . .' Edinburgh: Scottish National Gallery of Modern Art.

which reveals its kinship to psychoanalysis immediately is: "whose thoughts are these, inhabiting my inner world?" '[93] Psychoanalysis is haunted by the ghosts of a prehistory it claims to have left behind, alien voices that erupt from within and disturb its proper identity. The official history of the psychoanalytic movement has it that 'psycho-analysis proper began when I [Freud] dispensed with the help of hypnosis',[94] yet as Mikkel Borch-Jacobsen reveals with devastating effectiveness, while psychoanalysis purports to found itself on the repudiation of hypnosis, it does so only to have the question of hypnotic suggestion recur uncannily, in the guise of transference, at the very heart of the analytic method. Besides reappraising the status of that which psychoanalysis has striven to relegate to its prehistory, Borch-Jacobsen's revisionist analysis permits one to view in a slightly less censorious light Breton's acceptance of that aberrant branch of psychology predicated on the study of hypnotic and mediumistic phenomena; 'all that', maintained Breton, 'found ways of linking up, of conjugating with my other interests', notably with his abiding attachment to Freud.[95] The experiments with hypnotic trances, whilst antedating the *Manifesto* (fig. 31), were an integral part of the movement's history and, in Breton's view, of no lesser importance for the theoretical speculations contained therein than automatic writing itself.

32a and b Max Ernst. *Lesson in Automatic Writing* ('THE MAGNET IS CLOSE NO DOUBT') (and detail). c.1923. Pen and ink on eight joined sheets of paper, 17.3 × 169cm. Sotheby's, London, 25 June 1997. Lot n° 227. 32a.

References to hypnotism as well as hysteria are woven into the fabric of Max Ernst's *Lesson in Automatic Writing*, a quite unique work usually assigned to 1923 (fig. 32). Drawn on eight sheets of paper joined together to create a long continuous strip, Ernst leads the eye on a voyage through an imaginary landscape punctuated by strange rock formations, fragments of architecture and wondrous aerial flowers.[96] Near the centre of this *terre de trésors* is a sphinx-like head on whose forehead is an enigmatic inscription: 'THE MAGNET IS CLOSE NO DOUBT'. As the execution of this drawing appears to coincide with the *époque des sommeils*, so-named after the craze for hypnotic trance states that gripped Breton and his comrades, including Ernst who attended some of the sessions, it is more than probable that the magnet is a reference to hypnotism, commonly known then as magnetism. In this telling detail, Ernst reveals surrealism's debt to one of the more bizarre episodes in nineteenth-century psychology. An article by Anne Harrington, 'Metals and Magnets in Medicine: Hysteria, Hypnosis and Medical Culture in fin-de-siècle Paris', offers a fascinating glimpse into a range of practices that blurred the boundaries between medicine and occultism, and helps to explain why the *fin de siècle* appealed to the surrealists far more than the rationalist cast of their own age.[97] Against a backdrop of hypnosis and nearly rampant hysteria, there was a revival of popular and scientific interest in diagnostic and therapeutic applications of metals and magnets. This was a time, Harrington writes, when 'people of nervous dispositions took to wearing metal plates, and women with hysterical tendencies sought solace in bathtubs filled with rusty pieces of scrap iron'.[98] A resurgence in the medical fortunes of mesmerism, by mid-century regarded as suspect, began when Charcot took an interest in claims by Victor Burcq, an elderly physician and magnetiser, that the best mesmeric subjects were hysterics. Charcot saw there a chance to prove his critics wrong by showing once and for all that hysteria had a physiological basis in the nervous system and was not just an artefactual product of suggestion. From 1877 to the mid-1880s, Charcot experimented extensively with hypnosis, concluding that it was 'an artificially induced modification of the nervous system which could only be achieved in hysterical patients'.[99] Harrington recounts how magnets were credited with the transfer of hysterical paralyses from one side of the body to the other, or even from one patient to another.

We cannot ignore that surrealism was born from this exotic *fin-de-siècle* cocktail of discourses on automatism, hysteria and hypnosis. To excise, through embarrassment, this chapter of surrealism's history would be to lose sight of the sense of the marvellous that *possessed* them as they journeyed into an uncharted conceptual terrain opened up by the nineteenth-century discovery of the unconscious. Induced somnambulism, dissociated secondary selves, alternating and multiple personalities, these were the disorienting signposts on a voyage 'To the end of the Unknown to find the *new!*'[100]

simulated states

In the introduction to 'Les Possessions', Breton declares that he and Eluard are greatly pleased at the results achieved by 'this novel exercise of our thought'. Even so, one can appreciate the

perplexity of Rolland de Renéville at what seemed – not to his eyes alone – a backsliding on the doctrine of pure psychic automatism. While acknowledging the ambitious nature of the undertaking, a veritable renewal of automatic writing, it is 'this time guided in a direction chosen beforehand, which leaves us with matters to reflect upon' he observes, plainly doubtful that imitation of the forms of language induced by mental derangement could possibly shed an authentic light on the obscure recesses of the human spirit.[101] Breton's reply to Rolland de Renéville, however, repudiates any suggestion of compromise and anxiously fends off charges of inauthenticity.[102] While admitting their antecedence in studies of schizophrenic speech and writing, Breton is adamant that the texts have nothing in common with practices of pastiche. All the textbook models have done is to provide himself and Eluard with broad outlines which the spontaneous flow of automatic imagery then fill. With evident pride, Breton notes that Jacques Lacan and colleagues in the *Annales médico-psychologique* had commended 'Les Possessions' for demonstrating 'the remarkable degree of autonomy that can be attained by graphic automatism without any hypnosis'.[103] Consistent with this viewpoint, in 'The Automatic Message' Breton later decries the half-measure that consists in allowing 'the eruption of automatic language within more or less conscious elaboration' and warns that 'numerous pastiches of automatic texts have been recently put into circulation, texts not always easy to distinguish from authentic ones, since all criteria of origin are objectively absent.' Demanding 'a complete *return to principles*', he is led contradictorily to denounce 'these attempts at simulation' ('ces efforts de simulation').[104]

Breton's comments suffice to show how anomalous the *essais de simulation* are within the terms of a discourse that privileges authenticity over the inauthentic, ersatz copy. From the fact of simulation alone, we can infer that a crucial model for 'Les Possessions' from the realm of psychopathology was hysteria. Though it is not one of the conditions they chose to imitate, imitation itself was an essential ingredient in the medical construct of the hysterical woman. Even in its heyday under Charcot, the malleability and suggestibility of the hysterics with their sham displays of symptoms and patently theatrical convulsive attacks drew comment. The term 'simulation' used in this setting was synonymous with feigning or pretence, if not outright malingering. So too, it conveyed fraudulence when applied to the fairground exhibitions of mediums and spirits; Walter Benjamin alludes to this somewhat dubious provenance of surrealism when he remarks that 'the writings of this circle are not literature but something else – demonstrations, watchwords, documents, bluffs, forgeries if you will.'[105] Among the surrealists, the accusation of simulation was first explicitly raised during their hypnotic trance sessions by those who doubted the genuineness of the goings on. Replying to these sceptics in *Une Vague de rêves* of 1924, Louis Aragon registers the terms of a still-topical debate on simulation that had racked the medical profession during wartime: 'It was asked if they were truly asleep . . . The idea of simulation is brought into play. For myself, I have never been able to form a clear notion of this idea. To simulate something, can that be anything other than to think it? And that which is thought, is.'[106] In 1903, the eminent neurologist Joseph Babinski set about revamping the miscellaneous disease category of hysteria, first by extracting those organic disorders erroneously categorised with it, and renaming what was left 'pithiatisme'. A former star pupil of Charcot, Babinski's *coup de grâce* was to refute the sole basis for his mentor's opposition to the Ecole de Nancy, his unwavering belief that hysteria was a functional disorder of the nervous system. More or less conceding victory to Hippolyte Bernheim's explanation of hysteria as a product of suggestion, Babinski redefined hysteria as a form of simulation occurring without the subject being aware that she (or he) is imitating. The hysteric is an unconscious simulator, a 'demi-simulateur':

It is impossible to distinguish objectively these two orders of facts one from another, something that moreover is easily comprehended, since they are produced by the same mechanism and their difference lies solely in the mental state of those who bring the mechanism into play: the simulator [malingerer] is conscious of the nature of their complaints and their acts, whereas in the subject under suggestion [the hysteric] these things are unconscious or rather subconscious: the latter is, so to speak, a demi-simulator.[107]

By drawing what to many medical men appeared to be a very fine line between hysteria and the outright feigning of illness, Babinski's dismemberment of hysteria came as a devastating blow to the respectability of the condition. No less damning to the hysteria diagnosis and by extension war neuroses was Babinski's opinion that: 'When the human mind is shaken by profound and sincere emotion there is no place for hysteria.' In the words of one commentator, 'This affirmation in no small way contributed to discrediting the study of this neurosis, and to ranging it among the category of simulations more or less recognised.'[108] Doctors now felt vindicated in their belief that they were being duped by devious, mendacious patients. But the very reasons Babinski gave for the non-existence of hysteria as a real affliction led the surrealists to welcome it as a subversion of mundane reality: 'How would we be affected by the laborious refutation of organic disturbance, for which it is only in doctors' eyes that hysteria is on trial?'[109] From their point of view, the hysteric's simulation was an indictment of the real, not vice versa. Breton, in the introduction to 'Les Possessions', is scornful of the medical point of view: 'The concept of simulation in psychiatric medicine being restricted almost exclusively to wartime, and otherwise replaced by "sursimulation", we are impatient to learn what morbid basis the judges competent in these matters will attribute to our work.'[110]

The reference to wartime points to one of the reasons for the wide reception given to Babinski's intervention on hysteria.[111] As war dragged on, ever growing numbers of military recruits, facing the prospect of a sordid death in the trenches, chose insanity instead. By 1916 this had become an unstoppable epidemic and, from the standpoint of military commanders, an alarming drain on the available pool of fighting men. Those who succumbed to shellshock exhibited many of the strange mental and physical symptoms previously seen almost exclusively in female hysteria. The main task of psychiatrists in such cases was to distinguish genuine shellshock from deliberate malingering for which severe punishments were meted out.[112] Even supposed therapies for war neuroses were overtly punitive in character, as if the victim deserved to be punished for his failed masculinity. Clovis Vincent, whom Breton would later derisively brand 'the Raymond Roussel of science', advocated painful electric shocks as a cure for the frequent limb paralyses.[113] By contrast, Breton's involvement in treating such patients at Saint Dizier in 1916 employing the technique of free association convinced him of the remarkable poetic capacities that could be unleashed by mental illness. It may have been the still vivid recollection of this formative experience that led him to extol hysteria in the 1928 article with Aragon as 'the greatest poetic discovery of the end of the nineteenth century, and that at a moment when the dismemberment of the concept of hysteria seemed to be complete'. Recognition of the existence of male hysteria as a result of this wartime experience may have opened a window whereby hysteria could propose to the male surrealist a model for identity – a case to be argued with respect to Max Ernst. For the moment, let us simply note that Breton's wartime service as a medical orderly might have predisposed him to view hysteria as a subversive protest, albeit a mute one, against military and medical authority and that this subversion was connected with the matter of simulation.[114]

Looking back at 'Les Possessions' in the *Entretiens*, a series of radio interviews recorded in the 1950s, Breton conceded their close proximity to the intellectual pursuits of Salvador Dalí who, at the time of their writing, was a relative newcomer to surrealism.[115] Besides creating a frontispiece etching which set a virulently sacrilegious tone for *L'Immaculée Conception*, Dalí was also invited to write an insert for the book which identifies as a guiding impulse of 'Les Possessions' 'an original will to *simulation* of delusions, systematised or not'. That same impulse would determine the main direction of Dalí's own researches over the ensuing several years, in the course of which he expounds the paranoiac-critical method, based on the very same condition Breton and Eluard had chosen to simulate in one of their texts. It goes without saying that Dalí, who before long openly revolted against the Bretonian surrealist orthodoxy of pure psychic automatism, was unconstrained by the sorts of concerns about authenticity that, as we have seen, bedevilled attempts to implement the doctrine. Of all the surrealists, it is Dalí who most assiduously explores the far-reaching implications of simulation which, in agreement with more recent theories of simulation and the simulacral, he recognised as confounding distinctions between the real and the imaginary. Jean Baudrillard has argued that while feigning or pretending preserves the reality principle, in cases of simulation this is short-circuited: 'Simulation threatens the difference between "true" and "false", between "real" and "imaginary". Since the simulator produces "true" symptoms, is he ill or not?'[116] Viewed in this manner, simulation can be understood as realising a core ambition of surrealism that of finding and fixing a point of the mind at which the real and the imagined cease to be perceived as contradictory.[117] The problem of simulation and the simulacral encompasses the whole of Dalí's activities, ranging from his seemingly perverse use of collage in such a manner as to obscure the distinction between painted and collaged elements, through to his perception of himself as a surrogate for an older brother also named Salvador who had died scarcely a year before Dalí was born – thus, a simulacral copy of a non-existent original.[118]

Woven into the textual fabric of *L'Immaculée Conception* like so many clues for the attentive reader are a host of references to Max Ernst. Listening in on this intertextual conversation from afar one is destined to miss many of the signals though some are readily detected. As other commentators have noted, Ernst refers to the Immaculate Conception in captions for several of the collages in *La Femme 100 têtes*, for which Breton had written a foreword in 1929.[119] It seems probable that a reference to Ernst was intended in the third essay of 'Les Possessions' where the narrator believes himself to be a bird, and there are other yet more subtle allusions that could only have been available to a select few. Whom apart from the surrealist inner sanctum would have realised that the line 'My mother is a spinning top for which my father is the whip' refers back to a childhood memory reported by Ernst in *La Révolution surréaliste* in 1927?[120] Replicating in a parodic vein aspects of the Freudian primal scene, Ernst recounts how an obscene little man bearing the moustache of his father removed from his trouser pocket a soft crayon with which he began to perform certain indecent acts by inserting the offending article into a vase. 'He whirls the contents of the vase by stirring it, faster and faster, with his fat crayon. The vase itself in whirling becomes a spinning top. The crayon became the whip.'[121] How does one account for the recurrence of this image some three years later in what is supposed to be an unpremeditated stream of consciousness? Was it intended? Or was it perhaps an instance of cryptamnesia in which a buried memory of something previously read resurfaces without any indication as to its original source? Can we rule out a more obscure form of thought transmission amongst a small group of adepts – a curious possibility of thought, that of its *mise en commun*? One wonders how Houdebine with his zeal for exacting

science would have settled the issue. Note, incidentally, that Breton and Eluard are not content merely to paraphrase the content of Ernst's phantasy, they interpret it for us!

Hysteria, which lay behind the attempts at simulation by Breton and Eluard, also affords a key to Ernst's collage novels which roughly coincide in date with 'Les Possessions'. The punning title of *La Femme 100 têtes* of 1929 evokes hysteria by referring, on the one hand, to the woman as having lost her head (*femme sans tête*) and, on the other, to the now familiar propensity of the hysteric to switch from one personality to another (*femme cent têtes*). Scattered throughout the book as a consistent sub-plot are yet other sly invocations to the hysterics of the Hôpital Salpêtrière: the second plate, subtitled 'The not-quite-immaculate conception' (fig. 46), employs as a source image an engraving of Albert Londe's photographic laboratory where they were expected to perform on cue before a camera. Plate 32, in which 'The *femme 100 têtes* opens her august sleeve', depicts a young woman in a billowing white gown who recalls the photographs (fig. 26) of Charcot's most famous hysteric, Augustine (whose name Ernst puns on), alluringly dressed in white hospital attire. Likewise, the caption to plate 17, which reads 'The unconsciousness of the landscape becomes complete', we may surmise makes a veiled reference to hypnosis with a phrase possibly uttered by a medical man whose authority Ernst undermines by his single word substitution of 'paysage' for 'patient'.

In the next section, Ernst's continually reinvented persona will be seen to flout a conception of identity as fixed and static, a strategy that is indebted to the example of the hysteric. With Ernst we pass from the gothic psychology of Myers and Flournoy to a Freudian universe where each of us is a product of shifting and unstable identifications on the theatrical stage-set of phantasy. In a letter to Wilhelm Fleiss of 2 May 1897, Freud tentatively advances the following proposition: 'MULTIPLICITY OF PSYCHICAL PERSONALITIES . . . The fact of identification perhaps allows us to take the phrase *literally*.'[122]

33 André Brouillet. *Clinical Demonstration at the Salpêtrière*. 1887 Salon. Oil on canvas, 290 × 430cm. Paris: Musée d'Histoire de la Médecine.

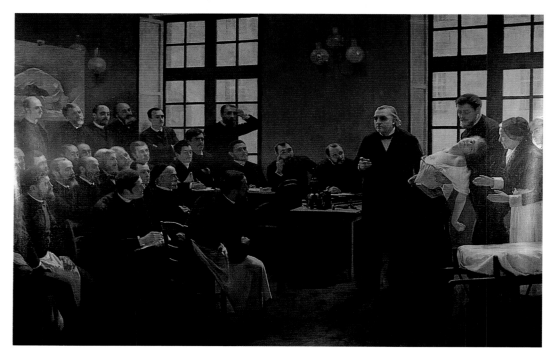

ii perturbation, my sister: Max Ernst and the *femme hystérique*

'The correct interpretation is: I = she . . .'[123]

André Breton, in 'The Automatic Message' of 1933, traces back to Charcot, 'at the origin of the magnificent debate on hysteria' instigated by his teachings, responsibility for a project of research which engaged ('qui sollicitent') his attention as well as that of a good number of his fellow surrealists.[124] Returning to this origin, to the source of Breton's solicitation, one enters upon a veritable seduction scene.

André Brouillet's *Clinical Demonstration at the Salpêtrière* (fig. 33), exhibited in the Salon of 1887 at the height of the hysteria epidemic that swept Paris, captures the sense of melodrama that attended Charcot's public lectures on the condition.[125] These were highly choreographed events that generally finished up with a demonstration of the hysterical attack as a sort of *grand finale*. Blanche Wittman, depicted with a wrist contracture, one of the stigmata of long-standing hysterical paralyses, was a house favourite who could be relied upon to perform on demand. The fascinated gaze of an audience consisting entirely of medical men is riveted upon her, and Brouillet, in this patently theatrical scene, invites us to read a romantic sub-text into Wittman's interaction with the debonair young house doctor, Joseph Babinski, in whose tender embrace she swoons. This he does by discreetly intimating its denouement: behind the audience but readily visible to the woman, for whom it acts as a visual cue, is a representation of the next stage of her attack, the so-called *arc en cercle*. One strongly suspects that Freud was not the only spectator at these pantomimes to conclude that this baroquely contorted pose was a scarcely disguised expression of a wish for coitus.

Turning to Ernst's *Pietà, or Revolution by Night* of 1923 (fig. 34), one observes the presence of a statuesque figure wearing a white smock cradled by an avuncular older man. The former is easily recognisable by the profile as Ernst himself, while the figure holding him we infer is Ernst's father. Given that a revolution is supposedly being enacted here, it is at first sight perplexing that Ernst does not, as Malcolm Gee notes, 'represent conflict between father and son, but the reverse'.[126] Gee relates this configuration to the inverted Oedipus complex, a symmetrical counterpart to the hostile, rivalrous feelings that a boy is said to harbour towards the father: 'at the same time,' writes Freud, 'he also *behaves like a girl and displays an affectionate feminine attitude to his father*.'[127] That the rapport between son and father in the dream-like scenario depicted by Ernst is almost devoid of emotion does not contradict this interpretation since, as Ernst would surely have known, the displacement of affect is one of the ruses

34 Max Ernst. *Pietà or Revolution by Night*. 1923. Oil on canvas, 116 × 89cm. London: Tate Gallery.

commonly employed by dreams. A plausible explanation for the curious white smock worn by Ernst has been suggested by Dawn Ades who notes that the picture was painted not long after the so-called period of sleeps ('époque des sommeils') in which the surrealists were concertedly delving into hypnosis, much as Charcot had done.[128] During one of these notoriously riotous occasions, Robert Desnos under hypnosis was making cryptic replies as a roll-call of names was read out to him when in response to the name Max Ernst he blurted out, one imagines to a flash of delighted recognition amongst the assembled onlookers, 'the white smock of the Salpêtrière'. While we as historians are necessarily excluded from the possible meanings such a picture may have held for an immediate circle of intimates, on the strength of this word association it is fair to conjecture that Ernst by portraying himself in a white smock covertly identifies himself with the female hysterics of the Salpêtrière. Undeniably it is the case that his subject position vis-à-vis the symbolic representative of patriarchal authority is exactly analogous to that of the hysteric in the scene represented by Brouillet.[129]

The theme of hysteria is dealt with by Ernst in a spate of images from around 1923, notably in the cycle of murals he painted on the walls of a house at Eaubonne on the outskirts of Paris where he stayed with the Eluards after his arrival in the French capital. *One Must Not See Reality Such as I Am* (fig. 43) is one of these murals that Elizabeth Legge has shown portray Gala Eluard, his host's wife (with whom Ernst, incidentally, was having an affair), as an hysterical muse. Painted at a moment when the nascent surrealist group was exploring all possible means of plumbing the newly discovered depths of the unconscious, from automatic writing to hypnotic trance states, these images remind us that in surrealism as in French psychology the fortunes of hysteria and automatism were closely tied. Again at the end of the decade, responding to Breton and Aragon's celebration of the fiftieth anniversary of hysteria, Ernst's work in the collage novel format is once again peppered with references to hysteria. My aim in the remainder of this chapter is to investigate the nature of Ernst's attraction to hysteria, the sources of his solicitation as it were, by focussing on this latter period and especially the collage novel, *Dream of a Little Girl Who Wished to Enter the Carmelite Order*,[130] arguably his most sustained treatment of the hysteria topos and where a subversive alliance with the Salpêtrière hysterics, first adumbrated in the *Pietà*, comes unmistakably to the fore.

seduction/disruption

If the dream and hysteria are interwoven in Ernst's dream-book, it is because Freud does likewise in his. A letter to Wilhelm Fliess in January 1899 whilst Freud was in the midst of writing *The Interpretation of Dreams* observes: 'I will only reveal to you that the dream-pattern is capable of the most general application, that the key to hysteria as well really lies in dreams.'[131] That one may lead to the other, (day)dreams to hysteria, is already implied in the 'Preliminary Communication' by Freud and Breuer when they remark that the hypnoid states conducive to hysteria 'often, it would seem, grow out of the day-dreams which are so common even in healthy people and to which needlework and similar preoccupations render women especially prone'.[132] The frequent asides on hysteria within the main plot of Freud's narrative are intended to assert a strict parallelism between dreams and the symptoms of hysteria, in both of which Freud claims to discern the fulfilment of an infantile wishful impulse.[133] A similar temporal structure of delay or deferral governs both, with archaic material being recapitulated in dreams and neuroses alike; preserved in the neuroses, Freud writes, are 'more mental antiquities than

35 Max Ernst. *Dream of a Little Girl Who Wished to Enter the Carmelite Order* (Paris: 1930). Chapter 1, plate 2. 'The father: "Your kiss seems adult, my child. Coming from God, it will go far. Go, my daughter, go ahead and . . ."'

36 Max Ernst. *Dream of a Little Girl Who Wished to Enter the Carmelite Order* (Paris: 1930). Chapter 1, plate 3. 'Marceline-Marie: "My costume seems indecent, Papa, in the presence of Father Dulac. It's a delicate situation for a child of Mary . . ."'

we would have imagined possible'.[134] Already, by 1897, Freud was convinced that in hysteria 'everything goes back to the reproduction of scenes' and it is in this context that he first introduces the notion of a primal scene, speculating that: 'the psychical structures which, in hysteria, are affected by repression are . . . *impulses* which arise from the primal scenes.'[135] By the same token, in *The Interpretation of Dreams* one learns that a dream likewise 'might be described as *a substitute for an infantile scene modified by being transferred onto a recent experience.*'[136]

Ernst's *Dream* opens with the reproduction of an infantile scene. Plate 1 (fig. 35) is based on an illustration of a passionately embracing couple snipped from some pulp novel to which a caption has been added that transforms its meaning completely. It reads: 'The Father: "Your kiss seems adult, my child. Coming from God, it will go far. Go, my daughter, go ahead and . . ."' As an assiduous reader of Freud, Ernst most certainly would have been aware of the frequent tales of childhood seduction that were adduced by hysterical patients in the course of analysis. Having initially believed that these stories of being seduced by the father were actual memories of traumatic incidents of abuse, Freud eventually came to the conclusion that they were, in fact, the reversal of a primary wishful phantasy to seduce the father. Ernst leaves no doubt that the event is to be imputed to the child's own nascent sexual desire: 'Enter, dear knife, enter into the incubation chamber!' the under-age heroine cries out ecstatically at one point. Even in her sleep, the hysterical Marceline-Marie is never idle: wreaking havoc in the father's house, she is a constant source of perturbation with her fits and spasms and unseemly behaviour. Once it is recognised, the seduction motif can be seen played out in relation to a

37 Max Ernst. *Celebes*. 1921. Oil on canvas, 125 × 108cm. London: Tate Gallery.

succession of male figures who embody patriarchal authority and values. In addition to the girl's father, a Christian-Socialist deputy, there is Reverend Father Denis Dulac Dessalé (fig. 36) and, completing the trinity, God the Father. Even in her hour of prayer she eggs the father on: 'Dear Lord, fondle me as you knew so well how to do, during the unforgettable night when . . .' runs the caption to a quite primordial-looking landscape. Marceline-Marie plays with masculine authority, plays around with it, perverting and subverting it all the while.[137]

In Ernst's work of the 1920s, the father is a derisory and humiliated figure, the token representative of an axis of authority which the son sets out to subvert by whatever means. A thumbnail sketch of his own father, Philippe Ernst, describes him as a petty tyrant, staunchly upholding values as outmoded as his Wilhelmine moustache.[138] We recognise him playing the part of a stern, bowler-hatted bourgeois in *Pietà, or Revolution by Night*; again, with the benefit of clues supplied by Ernst, one can identify the obscenely threatening contraption in *Celebes* (fig. 37) as a stand-in for the father. The childhood phantasy Ernst recounted in 1927 contains a description of a quite repellant personage who appears before the boy Max's bed: a black, shiny man with a tell-tale moustache, he makes some indecent gestures before removing from his trouser pocket 'a large crayon in a soft material, that I have not succeeded in defining more precisely'.[139] In the foreground of the picture, meanwhile, the hysterical *femme sans tête* makes a first cameo appearance as a headless mannequin beckoning with a gloved right hand.[140] Her seductive gesture seems almost to mock the elephant celebes who is so huge and cumbersome it is scarcely imaginable that his sexualised machinery is capable of performing – Ernst deflates the overbearing father by condemning him to an impotent celibacy.[141]

By the end of the decade, the father series has very clearly come to symbolise the moral world that Aragon and Breton declared was subverted by hysteria. The Catholic Church and the patriarchal institution of the family were two bugbears of the surrealists and frequent targets of their derision. Enlisting the hysteric, as Ernst does, in order to blaspheme the Church and impugn its authority brings to mind a current of anti-clericalism in Charcot's work that has been discussed by Jan Goldstein and which Ernst might well have intuited of his own accord.[142] Charcot delineated a phase of the hysterical attack in which poses evoking religious piety or ecstasy, mingled often with a blatant eroticism, would be assumed by the subject. In a parodic version of the *Imitatio Christi* of early Christian saints and martyrs, the hysteric would sometimes take up a crucifixion pose during the attack. One can imagine Ernst's glee at finding this illustrated in the *Iconographie de la Salpêtrière*, having previously identified himself with Christ in the *Pietà*, and mustering all his ingenuity to work it into the narrative of his collage novel *One Week of Kindness*.[143] Charcot sifted through religious art, claiming to discover in the poses and gestures innocently recorded by artists of the past independent validation for his clinical observations. The retrospective diagnosis of hysteria was one means whereby Charcot sought to defend the veracity of the condition against charges that it was merely a piece of theatre, of dissimulation, with no substance to it. The first such study by Richer and Charcot was published in 1887 as *Les Démoniaques dans l'art*. Goldstein believes that a republican, anti-clerical agenda also lay behind Charcot's triumphal claim to recognise in the visionary saints, witches and possessed of the past what in a secular age can finally be given its proper name – hysteria, 'the great convulsives of today'.[144]

Charcot had remarked upon the frequency of hallucinations, generally of animals, in the prodromal phase of an hysterical attack. In her dream, Marceline-Marie is plagued by swarms of insects, rats, rabbits, cockroaches, crows, vultures and other beasts. Amidst the ceaseless metamorphoses of *Dream*, people become confused with animals: the witch-like mother superior hallucinates herself as a wolf flying through space at the speed of words. Frau Emmy von N., whose case Freud reports, admitted under hypnosis that she too had had some fearful dreams: 'The legs and arms of the chairs were all turned into snakes; a monster with a vulture's beak was tearing and eating at her all over her body; other wild animals leapt upon her, etc. She then passed on to other animal-deliria . . . how (on an earlier occasion) she had been going to pick up a ball of wool, and it was a mouse and ran away; how she had been on a walk, and a big toad suddenly jumped out at her, and so on.' That a repressed wish of an erotic nature lies at the root of these hysterical phenomena is plain to see in the 'deliria [of] saints and nuns, continent women and well-brought-up children' claims Freud. In the case of his devout young heroine, Marceline-Marie, who enlists under the banner of St Theresa of Liseux,[145] Ernst clarifies for us the less than sacred meaning of her bestial visions: 'I accept the knife offered me and will give strict orders to the animal passions' she vows – quite the reverse of what actually happens in the adjacent plate where a fearsome panther leaps from a cage, its doors flung wide open, as Marceline-Marie simply looks on.[146] The disparity between the caption and the dream-image stages a conflict which is at the root of hysteria itself between, on the one hand, an erotic impulse striving for release and, on the other, forces of moral repression opposed to it.[147] As for the animal deliria to which Marceline-Marie is prey, their true character as symbols for her libidinal desire is made abundantly clear as she indiscriminately invites rats, rabbits, locusts and what not to take refuge underneath her white nightdress (fig. 38).[148] Only in a distorted form in phantasies is the hysteric able to give vent to her desire; it is in phantasy as well that she rehearses strategies of resistance to the patriarchal oppressor.

38 Max Ernst. *Dream of a Little Girl Who Wished to Enter the Carmelite Order* (Paris: 1930). Chapter 2, plate 31.'under my white dress, come with me, most terrifying grasshoppers . . .'

Comparing the hysterical attack to a pantomime, Freud claims the hysteric is capable of 'act[ing] all the parts in a play single-handed'.[149] A striking instance is given in the paper on 'Hysterical Phantasies and their Relation to Bisexuality' of an hysteric who plays both parts in a phantasy of forcible seduction. During the attack, she 'pressed her dress up against her body with one hand (as the woman), while she tried to tear it off with the other (as the man).'[150] The secret of cases of multiple personality, Freud speculates, may be explicable by this mechanism as 'different identifications seize hold of consciousness in turn.'[151] Ernst, for his part, plays both parts in a very similar pantomime when he supplies as a caption for a plate from *La Femme 100 têtes* (fig. 39), the first of his collage novels to deal with the hysteria theme: 'Loplop, drunk with fear and fury, finds again his head of a bird and rests immobile for twelve days, on both sides of the door.' The swan, an obvious symbol of ravishment, could refer to Jupiter donning this disguise (just as Loplop–Ernst does) in order to seduce a reluctant Leda. To remain on both sides of the door in this context betokens a simultaneous identification with both subjects in the phantasy scene.[152] Frozen immobility – a salient feature one recalls of the Wolf Man's dream – introduces a factor of suspense, or deferral of the climactic moment, which characterises the narrative structure of the collage novel in general. Werner Spies comments that time stands still and that recurrence and repetition are employed as structuring devices. This suspense factor in the organisation of the collage novel is complemented pictorially by numerous images of actual physical suspension as, for instance, in *Dream* where Marceline-Marie is depicted in one collage with the celestial bridegroom suspended on a tight-rope above the nuptial bed.[153]

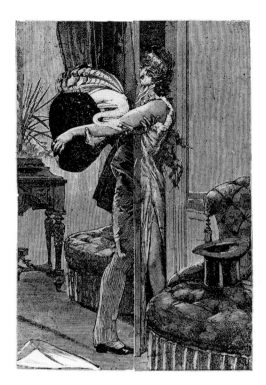

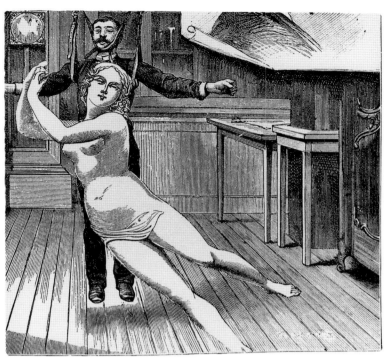

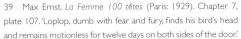

39 Max Ernst. *La Femme 100 têtes* (Paris: 1929). Chapter 7, plate 107. 'Loplop, dumb with fear and fury, finds his bird's head and remains motionless for twelve days on both sides of the door.'

40 Max Ernst. *La Femme 100 têtes* (Paris: 1929). Chapter 3, plate 44. 'The uncle no sooner strangled, the matchless young adult flies away.'

In order to draw out some of the implications for our reading of the collage novel we can usefully refer at this stage to one of the perversions, masochism, the salient features of which include phantasy and suspense. Parveen Adams, in an enlightening discussion of this matter, writes that:

> suspense, involves a delay, a waiting; it is a state with no definite end-point; it is an endless postponement of gratification. Actually being suspended, being hung, is the most transparent sign of this dimension . . . Hence the ritual scenes of hanging, crucifixion and other forms of physical suspension in Masoch's novels.[154]

Masochistic perversion (*père-version*) entails an overturning (*inversion*) of the Father's law (*Nom du père*); the masochistic scene thus displaces and transgresses the Oedipal law.[155] The typical masochistic scenario is described by Freud under the inverted Oedipus complex and entails the subject who is male adopting a passive, notionally feminine attitude towards the father – accompanied in *Pietà*, it should be noted, by the seemingly weightless levitation of Ernst.[156] Suspense or suspension 'is the mark of disavowal [of the Oedipal law] within the masochistic scene' writes Adams – a possible interpretation of the unruly hysterics who defy the law of gravity and fly through the air like witches in the final chapter of *One Week of Kindness*. Or, indeed, Marceline-Marie herself who remained immobile with arms outstretched for two hours during the benediction of a statue of St Theresa and then, at the very moment when the Hymn of the Ascension of the Children of Mary was being sung, 'floated up from the ground, remaining suspended in mid-air for several seconds'. Something akin to the psychic

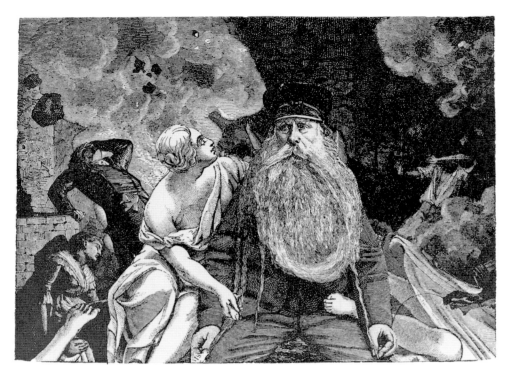

41　Max Ernst. *La Femme 100 têtes* (Paris: 1929). Chapter 3, plate 60. 'The Eternal Father, his beard laced with continuous lightning, in a Metro catastrophe.'

mechanism of disavowal is operative as a rhetorical device in *La Femme 100 têtes* in the form of phrases like 'l'oeil sans yeux' or 'corps sans corps' which negate themselves.[157] We ought not to forget, moreover, that disavowal of an existing reality was integral to Aragon's definition of the marvellous and, by extension, of surrealist collage in his 1930 essay, 'La Peinture au défi' (The challenge to painting).

The bizarre linguistic aberrations documented in cases of female hysteria have been viewed by feminist writers as the repudiation of an oppressive patriarchal symbolic order. Dianne Hunter argues this in relation to Fräulein Anna O, whose case is reported by Breuer and Freud in *Studies on Hysteria*. The course of her illness was marked by an inability (or a refusal) to speak in her native German and her only utterances were nonsensical mixtures of French, English and Italian: 'Jamais acht nobody bella mio please lieboehn nuit.' At one stage, Anna O became totally mute. Noting her orthodox Jewish background, Hunter contends that 'Bertha Pappenheim's linguistic discord and conversion symptoms, her use of gibberish and gestures as means of expression, can be seen as regression from the cultural order represented by her father.'[158] A similar disrespect for the language of the fathers is evinced by the fictional hysteric of Ernst's *Dream*, Marceline-Marie, who, the narrator confides, 'wrote rather playful phrases in which were revealed sometimes extreme delicacy, sometimes the sparkling verve of a Latin soul':

> – Diligembimini gloriam inalliterabilem mundi fidelio.
> – Benedictionem quasimodo feminam multipilem catafaltile astoriae.[159]

Latin, the language whose rules she openly flouts, is the language of the church fathers *par excellence*. In a similarly playful spirit, Ernst rejects the artistic language of his own father, an

amateur painter who made slavish copies of the Old Masters. He uses collage to subvert the very premises of realism – 'one must not see reality such as I am' declares his proxy, the hysteric. Indeed, it may be that Ernst had long ago become aware of the parallel between collage as a deviant pictorial language and conversion hysteria, a language of the body in which a wish repressed from the dominant symbolic order could find expression, albeit in disguise. Hysterical symptoms, write Freud and Breuer, are like 'a pictographic script which has become intelligible after the discovery of a few bilingual inscriptions', a description that applies nearly verbatim to Ernst's dada collages with their curious amalgam of French and German captions appended.

'The great problem', wrote Roland Barthes, 'is to outplay the signified, to outplay the law, to outplay the father, to outplay the repressed – I do not say to explode it but to outplay it.'[160] It appears that Ernst found a solution to this dilemma in the artful strategies of the hysteric, who switches between masculine and feminine positions in phantasy, acting as though *she does not know her place* within the patriarchal order. Donning and discarding identities with the skill of a seasoned bit-part actor, 'Perturbation, my sister' is one of her more fitting appellations. In plate 60 of *La Femme 100 têtes* (fig. 41), she sidles up to the Eternal Father whose beard is lit by lightning as a Metro catastrophe inexplicably unfolds behind them. Grasped in her right hand is what appears to be a small fish. One hardly need consult a dictionary of typical dream symbols to be persuaded that the seductive hysteric has, on this occasion, stolen more than father's thunder.

convulsive identity

The aspect of Ernst's dream-book that most closely ties it to textbook accounts of hysteria is the confusion of identity suffered by Marceline-Marie, a particular misfortune that the narrator ascribes to the fact that she was saddled from birth with a double-barrelled name: 'it is probably due to the troubles provoked by the coupling of two names of such a very different signification that we will see her slit herself up the middle of her back from the very beginning of the dream and wear appearances of two distinct but closely related persons.' In the course of her dream, Marceline-Marie never succeeds in wholly identifying with either of her dual selves whom she addresses alternately as 'moi' and 'ma soeur'. Her perpetual bafflement as to who she really is leads finally to her exasperated demand: 'Who am I? Me, my sister or this obscure beetle?'

Marceline-Marie exhibits to a quite alarming degree the doubling (dédoublement) of the personality which, it was noted previously, French psychologists had long regarded as an invariable feature of the hysterical diagnosis. It may have been Ernst's comically bizarre evocation of this state that prompted Louis Aragon to incorporate hysteria in a history of the marvellous traced in his 1930 essay on collage, where he spoke of the convulsive hysterics at the Salpêtrière as the 'materialisation of a miracle'. Given his extensive knowledge of psychoanalysis, Ernst could well have encountered the notion of dédoublement in early writings by Freud and Breuer who, in their 'Preliminary Communication' of 1893, remark that:

The longer we have been occupied with these phenomena the more we have become convinced that the splitting of consciousness which is so striking in the well-known classical cases under the form of 'double conscience' is present to a rudimentary degree in every hysteric, and that a tendency to such a dissociation, and with it the emergence of

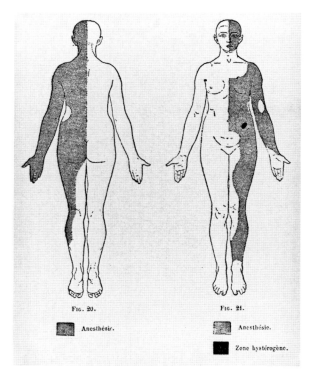

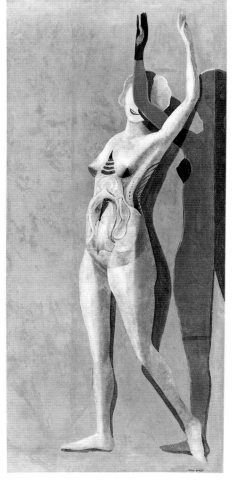

42 (*above*) Hysterical Anaesthesias. From *Nouvelle iconographie de la Salpêtrière* (Paris: 1888–1918).

43 (*right*) Max Ernst. *One Must Not See Reality As I Am.* 1923. Oil on plaster mounted on canvas, 175 × 80cm. Paris: Musée National d'Art Moderne, Centre Georges Pompidou.

abnormal states of consciousness (which we shall bring together under the term 'hypnoid'), is the basic phenomenon of this neurosis.[161]

Sensory deficits that failed to conform to an anatomical distribution of the nerves were commonly mapped and recorded in textbooks on hysteria: the so-called glove and stocking anaesthesias (fig. 42). Loss of sensation or paralyses affecting one side of the body were also frequent and once more a division of the mind of the hysteric was invoked in order to explain them.[162] It is plainly diagrams such as these that Ernst with a mixture of playfulness and erudition copies in *One Must Not See Reality Such as I Am* (fig. 43), alluding to the splitting/doubling of the hysterical subject by means of an uncannily animated shadow that interlocks arms with her. 'By whom am I haunted?' she demands and coyly invites us to join in the game. Indeed, Elizabeth Legge believes that Ernst carried this speculation centred on the hysterical woman across to himself when he came to reflect upon his creative alliance with Paul Eluard at this moment. With considerable ingenuity, Legge relates the image *One Man Can Conceal Another* of 1923, which likewise incorporates diagrams of hysterical anaesthesias, to a remark by Philippe Soupault who writes rather elliptically in a review of Ernst and Eluard's *Misfortunes of the Immor-*

tals that: 'The one hides behind the other, and the other conceals himself behind his collaborator.'[163] Later on, it would seem that the doubling of the hysterical subject opened up the possibility for Ernst to consider her as *his* double, a sort of twin sister, something that becomes clearer when one teases apart the name Marceline-Marie to find concealed behind it an extensive cast of characters which more than circumstantially links Ernst to the hysteric and her misdeeds. I had long ago suspected that the hybrid *Marceline-Marie* contained a veiled reference to Marcel Duchamp who it is well known was inseparable from his female *alter ego*, Rrose Sélavy.[164] Unravelling the densely knotted allusions in the name, Charlotte Stokes notes that Marie is the French form of the Latin Maria, the name of an older sister of whom Ernst was extremely fond who died tragically in 1897. Reinforcing this 'web of sisterly associations', it also happens that Maria was Ernst's middle name and consequently his forenames Maximilian Maria both start with M and homonymically resemble hers.

Marceline-Marie's insistent refrain, 'Tell me, who am I: me or my sister', resonates with a childhood memory which Ernst recounts in his mythologised autobiography:

> On the night of the fifth of January [1906] one of his closest friends, a most intelligent and affectionate pink cockatoo, died. It was a terrible shock to Max when, in the morning, he discovered the dead body and when, at the same moment, his father announced the birth of a sister.
>
> In his imagination Max coupled these two events . . . There followed a series of mystical crises, fits of hysteria, exaltations and depressions. A dangerous confusion between birds and humans became fixed in his mind. (Later M.E. identified himself voluntarily with *Loplop*, Bird Superior.)[165]

Ernst was at pains to stress that 'This phantom [Loplop] remained inseparable from another one called *Perturbation My Sister, La Femme 100 têtes*'; inseparable, in other words, from his subversive ally, the hysterical woman. The dangerous confusion of identity that Ernst describes himself as subject to can be attributed to the phenomenon of hysterical identification discussed by Freud in *The Interpretation of Dreams* and at greater length in chapter seven of *Group Psychology and the Ego*. The latter contains the relevant observation that: 'Identification with an object that is renounced or lost, as a substitute for that object – introjection of it into the ego – is indeed no longer a novelty to us. A process of the kind may sometimes be directly observed in small children.'[166] Freud proceeds to relate the example of a child 'who was unhappy over the loss of a kitten [and] declared straight out that now he himself was the kitten, and accordingly crawled about on all fours, would not eat at table, etc.'[167] Clinical facts like this indisputably show the persistence of totemic beliefs in the mental life of children, prompting Freud to concede that Jung 'had excellent grounds for his assertion that the mythopoeic forces of mankind are not extinct, but that to this very day they give rise in the neuroses to the same psychical products as in the remotest past ages'.[168] As a further example of the return to totemism, Freud refers to the ambivalent attitude of Little Hans towards his phobic animal. Hans was initially afraid of being bitten by a horse which Freud interprets as a fear of castration displaced from the father, the real source, on to the totem animal. As soon as his anxiety began to lessen as a result of the treatment however, the child 'identified himself with the dreaded creature: he began to jump about like a horse and in his turn bit his father'.[169] While this might be judged relevant to the emotional ambivalence that clearly attaches to the Loplop character in Ernst's work, of greater interest apropos of Ernst is the intriguing case of little Arpád's poultry perversion. Arpád had the misfortune to be pecked at by a fowl when he tried

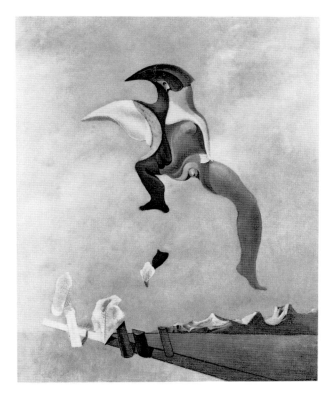

44 Max Ernst. *Loplop*. 1932. Oil on canvas, 100 × 80cm. Sotheby's, London, 12 June 1963. Lot n° 97.

45 Max Ernst. *One Week of Kindness, or, The Seven Capital Elements* (Paris: 1934). Plate 182. 'The key of songs. 10.'

to micturate into a fowl-house. 'A year later, when he was back in the same place, he himself turned into a fowl; his one interest was in the fowl-house and in what went on there and he abandoned human speech in favour of cackling and crowing.'[170]

The kinship Ernst implies between himself and the hysterical woman is borne out by a visual analogy between Loplop (with decidedly hermaphroditic genitalia) and the airborne hysterics of *One Week of Kindness* (figs 44 and 45), holding out the possibility of a visual exchange, or trading of places, between them. Ernst's adoption of the Loplop persona is linked via metaphors of flight to states of insanity: Freud speaks of a 'flight into illness', whilst in idiomatic usage the madman is described as 'away with the birds'. The bird is, like the bound madman or seductive hysteric, always an ambivalent symbol of freedom, something Ernst dramatises in the recurrent motif of a caged bird in a forest.[171] In dreams, the motif of flying or floating can express a wish 'to be like a bird' and often has a grossly sensual character, Freud writes.[172] Pursuing the analogy between dreams and hysteria, he adds that: 'Alongside of flying and floating in the air are to be put the gymnastic feats of boys in hysterical attacks, etc.' Real- ising his ambition to be like a bird allows Ernst to defy gravity – and, we can add, the Father's law.[173] The hysteric's refusal to conform to the principle of identity serves as an inspiration for his own: 'IDENTITY WILL BE CONVULSIVE OR WILL NOT BE' Ernst proclaims, in deference not so much to Breton (whom he paraphrases) as to the convulsive hysteric whose gymnastic feat he observes from the sidelines in the very last plate from *One Week of Kindness* (fig. 45). Georges Bataille is not a writer often mentioned in connection with Ernst but in a little-known preface

to a collection of the artist's work he asks: 'if one day philosophy should have the imprudence of hilarity, could we say that Max Ernst, in creating the universe of his tableaux, had ever diverted from that objective?'[174] In the spirit of Bataille, I propose that Ernst, artful conjurer with identity, henceforth be called the hysterical philosopher.

the scissors and their father

'Les Ciseaux et leur père' (The scissors and their father) is a caption appended to one of the collages in Misfortunes of the Immortals, an early forerunner to the collage novel format. Perhaps we can now add the immortal Charcot to the fathers whose authority Ernst set out to under- cut through his collage practice? Certainly it was the misfortune of the Iconographie photographique de la Salpêtrière, created under Charcot's auspices, to fall prey to his omnivorous scissors.[175] While Ernst integrates into his collages elements drawn from very diverse sources, as others have noted, he seems to have had a special predilection for encyclopaedias, catalogues and scien- tific magazines – and for those 'museological practices' like natural history or medicine that employed a taxonomic method for accumulating and displaying information.[176] Such a para- digm of knowledge underlay the project of the Iconographie which sought to assemble as near as possible a complete and exhaustive compilation of the infinitely variable tableau of hys- terical signs.[177]

Freud, whose own professional involvement with hysteria owed much to his stay at the Salpêtrière, said of Charcot that: 'He was not a reflective man, not a thinker: he had the nature of an artist – he was, as he himself said, a visuel, a man who sees.'[178] In his capacity as a physi- cian at the hospital, Charcot devised a diagnostic method based on the correlation of observ- able signs of disease with underlying lesions of the nervous system revealed at autopsy. The Salpêtrière – that 'museum of clinical facts' – was, as Freud noted, ideally suited to carrying out this research because of the large number of patients with chronic illnesses who lived out their remaining years inside its walls.[179] Through painstaking observation, Charcot strove to define patterns or constellations of visible signs associated with specific pathological condi- tions; Freud recalls that Charcot stressed 'again and again . . . the difficulty and value of this kind of "seeing"'.[180] His objective was, in a manner, to render the body transparent to the gaze: 'The anatomy of the human body's exterior forms does not concern only artists. It is of primary use to doctors . . . Exterior forms show, through their relationship with interior ones . . . what is hidden in the depths of the body through what is visible on the surface.'[181] Between 1862 and 1870, Charcot laid the foundations of the modern clinical speciality of neurology by the systematic application of this method and, as Goldstein notes, was duly rewarded for his efforts with a chair of anatomical pathology in 1873. After 1872, he began to turn his attention to hysteria and, from 1878 up until his death, the attempt finally to achieve mastery over a condition that had so far eluded the grasp of medical science – to submit its renowned capriciousness to a rigorous ordering principle – became an all-consuming crusade. The opening of a photographic laboratory in 1882 with facilities to record the most fleeting mani- festations of an hysterical attack using the newly invented technique of chronophotography gave a crucial boost to the task of recording, cataloguing, classifying.

A seeming anachronism in the era of mechanical reproduction was the installation of a museum of casts at the Salpêtrière which included such items as plaster casts of limbs affected by contractures in longstanding hysterical paralyses. This practice attests to the strength of a

desire to arrest and fix in tangible form a malady that was notoriously fluid and intangible. It may also have been done out of deference to Academic artistic practice, since casts of body parts were conventional Academic studio props. The gradual professionalisation of medicine throughout the nineteenth century meant that doctors looked enviously upon the institutional power and prestige of the Ecole and the Academy; it is perhaps for this reason that Charcot's clinical practices seem so often to recall those of academic artists.[182] His habit of examining patients in a state of complete undress is, to my mind, reminiscent of the Academic discipline of the life-class which, in parallel with their studies of dissection, taught artists to make correlations between surface anatomy and deep structures just as Charcot's anatomical-clinical method sought to do. As a further demonstration of how a kinship of cultures between art and medicine impinged on visual practices at the Salpêtrière, Paul Richer, who later became professor of anatomy at the Ecole des Beaux-Arts, would make line drawings from photographs of hysterics which served as textbook illustrations in preference to the photograph itself.

At stake in the iconographic assembly-line set up to process hysteria was, one suspects, a desire to impose order of an epistemological kind on a condition that, by its very disorderliness, was emblematic of unruly femininity. And this at a time when demands for emancipation by women were increasing and any unlicensed expression of female desire was liable to be construed as a potential threat to the patriarchal *status quo*. Through the diagnosis of hysteria, Martha Noel Evans convincingly argues, femininity itself was forced into a straitjacket: 'femininity was defined as a disease which medical men were then exhorted to contain and "cure" through the use of drugs, electric shocks, and confinement.'[183] The primacy of vision in Charcot's diagnostic method, its oculocentrism, meant the hysterical woman was effectively denied a voice; she was widely regarded as manipulative and prone to deception and therefore not to be listened to, anyway. More than just a clinical aid, as we have seen, photography embodied an ideal of objectivity to which the physician aspired: 'But in truth I am absolutely only a photographer; I record what I see' wrote Charcot.[184] Abstracted and vested in the camera lens, the keen gaze of the physician became a potent instrument of phallic mastery. 'The photographic plate is the true retina of the savant', boasted Albert Londe, director of the photographic laboratory at the Salpêtrière.

An article in the popular scientific magazine La Nature on the uses of photography at the Salpêtrière supplied Ernst with a source for the second plate of La Femme 100 têtes (fig. 46). The whimsical additions that Ernst makes to an engraving of the photographic studio strike at the heart of Charcot's empiricist project; they have the effect of subverting the pretensions of this place to being an arena for detached observation, revealing instead that perceptual reality is always already overlaid with phantasy. Titled 'The not-quite-immaculate conception', it is a highly ambiguous scenario that Ernst conjures: in part, an Alice-in-Wonderland place where the miraculous is everyday and rabbits skip playfully across the picture plane; at the same time, an air of menace pervades what might be a dimly lit bedroom with a startled child who recoils in terror from the bearded man standing overbearingly close to her bedside. Is he not the abusive father from a long-forgotten traumatic scene of childhood seduction?[185] A sobbing cherub in the foreground is the sole witness to this less-than-immaculate conception.[186]

Ernst in his collage practice aligns himself with the seductive hysteric in order to outplay the father. Seduction Baudrillard calls a 'superficial abyss'; its dissemblance of reality effects an 'undermining of all discourses aimed at truth, aimed at piercing through the veil of illusion and dissemblance to appropriate the truth (identified with what is real)'.[187] Charcot's

46 Max Ernst. *La Femme 100 têtes* (Paris: 1929). Chapter 1, plate 2. 'The not-quite-immaculate conception.'

anatomical-clinical method is a prime example of such a discourse, and though it had proven highly successful in charting organic pathology of the nervous system it foundered badly in the shallow waters of hysteria. Like hysteria, collage is shallow and inescapably surface-bound, a superficial abyss that cannot fail to impress on the viewer its absolute flatness even as it signifies depth and space. Admittedly, in formal terms, Ernstian collage is markedly different from cubist collages from which this argument is extrapolated: the relative homogeneity of source materials, mostly wood engravings, and the seamless joins of the collage fragments conspire to create a plausible illusory space in which the most implausible things happen. Nevertheless, one is constantly made aware of these images as collages – cut-out pieces of paper that have been arranged on a flat surface – even as one is invited to suspend disbelief and to see them as pictures of something. This is especially so where, as is frequently the case, a collaged element is conspicuously placed near the visual focus of the image in such a way as deliberately and pointedly to obstruct our view beyond. Collage emphatically negates a hermeneutics of depth, substituting instead 'the charm and illusion of appearances. These appearances are not in the least frivolous, but occasions for a game and its stakes, and a passion for deviation.'[188]

a simple phallic sense?

Louis Aragon, in 'Max Ernst, peintre des illusions', an essay contemporaneous with the collage paintings of 1921 to 1923 though unpublished then, holds out for the mystified viewer of Ernst's work a tantalising escape hatch from the enigmas they pose: 'Treat these drawings like

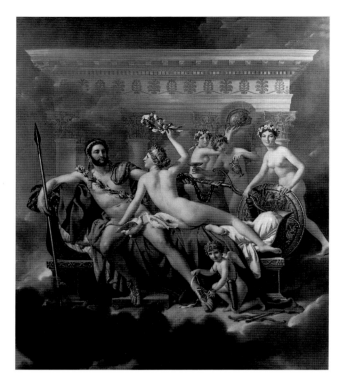

47 Jacques-Louis David. *Mars Disarmed by Venus and the Three Graces*. 1824. Oil on canvas, 313 × 266cm. Brussels: Musées Royaux des Beaux-Arts.

48 Max Ernst. *La Femme 100 têtes* (Paris: 1929). Chapter 3, plate 52. 'Open your bag, my good man.'

dreams', Aragon writes, 'and analyse them in the manner of Freud. You will find there a very simple phallic sense ['un sens phallique très simple'].' Scholarship on the artist has abundantly demonstrated the fruitfulness of such an approach. The collage process, with its displacements and condensations, has been viewed as analogous to the dream-work, thus sanctioning a hermeneutic method that proceeds from the manifest content of the image via a series of textual associations, mostly to be found within the twenty-four volumes of the complete works of Freud, to a presumed latent content. Flaunting the appearance of meaning with give-away titles like *Phallustrade* and *Oedipus Rex*, Ernst actively solicits this sort of attention.

Could it be, however, that Ernst entices us with the prospect of *un sens phallique très simple* in order to beguile and seduce us – and rob us unsuspecting of our interpretative authority? 'Before the problem of the creative artist analysis must, alas, lay down its arms' writes Freud in mock humility. Like Mars disarmed by Venus in Jacques-Louis David's phantasmatic staging of a seduction scene (fig. 47), we are scarcely aware that the hysteric's accomplice (fig. 48) in *La Femme 100 têtes* has stealthily made off with the arms. The hackneyed dream symbols liberally smattered through *Dream* are so blatantly Freudian as to be almost a tease. The caption to the second plate in chapter two ('The Hair'), for instance, verges on a parody of the section of *The Interpretation of Dreams* in which Freud enumerates common dream symbols: 'Baldness awaits you, my child! At the first shot your hair will fly away with your teeth and your nails.'[189] In such a case as this, the work of interpretation is already done and the authority that it normally confers on the interpretant is snatched away – just when one thinks one has a secure

49 Detail of fig. 35.

grasp on the meaning of the work. Warning of the pitfalls of treating surrealist works as though their makers were ignorant of Freud, Breton states: 'from the outset psychoanalysis held no secrets for surrealist painters and poets, such that on many an occasion they played consciously with the sexual symbolism attached to it'.[190]

The view of Ernstian collage as a seductive surface that I am proposing causes me to be wary of a hermeneutic method based on classic Freudian psychoanalysis which would search for a concealed, latent sub-text. Returning for a moment to the first plate of Dream which introduces the theme of seduction (fig. 49), at the point of maximal interest in the image our sight is occluded by a superimposed collage element. In the desire to see past this obstruction one readily overlooks what is literally being handed to us: a cup with a spoon plunged into it whose simple phallic sense interprets for us what at first sight it seems to conceal. Meaning is not hidden but ostentatiously displayed. Appropriately, the collaged fragment taken from La Nature illustrates the effects of the refraction of light, pointing out very obviously the perils of trying to see clearly. Not only is it suggested that vision of the sort Charcot aspired to is prone to error, being inevitably refracted through a screen of phantasy, but that specific dangers accrue to seeing what we are not meant to. The spoon sliced in two marks the site of a paternal interdiction to sight, a family romance that was meant to stay under wraps. Can we say finally that Ernst hands us the meaning or withholds it? The complex interplay of concealment and exposure going on here implies that we have both the structure of a concealed secret and the bringing of it to light.[191]

If Ernst stages a conflict with authority in his work, all the indications are that a battle for interpretative authority is currently being waged around it as well. Unable to restrain himself from indulging in a little *psychanalyse sauvage*, Uwe Schneede in the catalogue of a Max Ernst retrospective exhibition at the Tate Gallery in 1991 takes a swipe at all this 'rather compulsively psychoanalytic' interpretation of the artist's work. In a similar vein, another Ernst authority suggests that we lay down our arms and eschew interpretation altogether. Werner Spies regards the title of one of Ernst's collage-paintings, *Les Hommes n'en sauront rien* (Men shall know nothing of this) of 1923, as denoting the element of residual enigma that is vital to all his imagery. For all that they look dream-like, the secrets of collage are not meant to be unlocked by any key to dreams, they are there simply to be marvelled at:

> Max Ernst's work diverged from the beginning from the rebus or puzzle subject to logical solution . . . [Ernst] was interested foremost in the superadded value of the dream, the inexplicability produced by dream distortion and dream compression, and not in analysis or explication.[192]

In support of this hypothesis, Spies is able to call upon no less an authority than Theodor Adorno, who argued in 'Looking Back on Surrealism' that by trying to explain the strangeness of surrealism in terms of familiar concepts one finishes up 'explaining away that which only needed to be explained'. Adorno accuses psychoanalysis of cramming all the 'luxuriant multiplicity' of surrealism into a procrustean bed of limited, reductive categories. The shock value of surrealist imagery, a function of surprise and inexplicability, is dissipated if we know all the answers in advance.

The idea of an encrypted secret meaning, buried or unconscious, of which men shall know nothing, far from being alien to the conceptual apparatus of psychoanalysis, is in fact one of its fundamental themes. Elaborated by Freud in *Studies on Hysteria*, repression (*Verdrängung*) is a form of censorship that acts on ideational representatives of the instincts, i.e. memories, and is designed to exclude them from consciousness. Fending off unacceptable ideas with their associated affect results in the 'formation of a separate psychical group' that is withheld from knowledge. One might even suggest that Ernst figures the structure of a repressed complex pictorially in *Oedipus Rex* of 1923, a picture that more than any other holds out the promise of 'a very simple phallic sense'. The nutshell at the centre of the image, which the hand holding it seems to be trying unsuccessfully to prise open, is the visual analogue of an unsolvable enigma. In dreams, conversely, the censoring agency is relaxed enough to allow the repressed wish to become conscious again. The lifting of the veil of repression is comically shown in *Dream* as Marceline-Marie's dream is punctuated by her awakening periodically to discover that her immaculate white night-dress has slid up her thighs and is in need of rearranging. On the last occasion that it happens, 'Marceline-Marie wakes up, a little dishevelled. She puts right her night clothes which, this time, are truly indecent, and goes to sleep again smiling. The dream continues.'

Dream of a Little Girl Who Wished to Enter the Carmelite Order is patently not a very hopeful test case for Werner Spies' assertion that the dream-collage comparison is misleading and misdirected. The format of the collage novel in fact provides Ernst with an ideal vehicle for emulating the temporality of dreams and phantasies wherein 'past, present and future are strung together on the thread of a wish that runs through them'. Neither is Spies' contention that Ernstian collage is premised ultimately on inexplicability borne out by *Dream*, though plainly much happens in the course of it which defies everyday criteria of intelligiblity. The seduction

phantasy around which Ernst structures his/Marceline-Marie's *Dream* is a prime example of a repressed kernel of meaning – one *Les Hommes* would prefer to know nothing of, as the present-day debate over sexual abuse within the family shows.[193] Therefore, I would maintain that the subversion of patriarchal values that Ernst achieves in concert with the unruly, disruptive hysteric is dependent on a return of the repressed, that is to say, on a crucial shifting of the balance from repression to recognition.[194] The case for interpretation has been put more persuasively than I could hope to by Freud who wrote:

> I must, in other words, be able to *interpret* it. It is possible, therefore, that a work of this kind needs interpretation, and that until I have accomplished that interpretation I cannot come to know why I have been so powerfully affected. I even venture to hope that the effect of the work will undergo no diminution after we have succeeded in thus analysing it.[195]

50 Pablo Picasso. *Vollard Suite (Model with Surrealist Sculpture)*. 4 May 1933. Etching, 26.8 × 19.3cm. The Museum of Modern Art, New York. Abby Aldrich Rockefeller Fund.

3 UNCANNY DOUBLES

Surrealist images are apt to provoke a feeling of unease or disquiet. Indeed, the state of mind induced in the beholder when the familiar world is suddenly revealed in all its strangeness has become virtually synonymous in everyday speech with the surreal. Taken to its limit, the generalised state of disorientation which the surrealists aimed to foment would be indistinguishable from a psychosis: 'And if by chance everything that is thus extraordinarily ordinary does reach someone who can experience its strangeness, its paralysing strangeness, this person will be considered ill' remarks Louis Aragon.[1] The preface Aragon wrote for an exhibition of surrealist collage at the Galerie Goemans in March 1930 has an extended account of the marvellous, one of a cluster of terms within the surrealist lexicon that pertain to this subjective state of estrangement. What passes for quotidian reality contains within itself a forgotten principle of negation, Aragon contends; the world is cracking open, splitting apart. The marvellous is a catalyst that accelerates a crisis in reality and the bourgeois ideology that sustains it: 'the marvellous is born from the refusal of *a* reality, but also from the emergence of a new rapport, of a new reality which this refusal has liberated . . . The new rapport thus established is surreality.'[2] Collage tears the old world apart, permitting it to be created afresh. But, as Max Ernst confirms, the collagist can, by turns, use his terrorist scissors to attack his own face which disintegrates into a thousand shards. A displacement or an estrangement (*dépaysement*) that seems at first to bear only upon the world of objects also affects us and the relation that we maintain with ourselves. We become, as it were, strangers to ourselves. Julia Kristeva, in a book of that title, offers a new and compelling rereading of Freud's essay 'The "Uncanny"' which relocates the problem of the uncanny not in the world of objects but within the subject itself: Kristeva observes that 'if anguish revolves around an *object*, uncanniness, on the other hand, is a *destructuration of the self*.'[3] It is with such an emphasis that this chapter will invoke the uncanny in relation to Picasso and surrealism.[4]

But let us first of all consider what Freud had to say about the uncanny (*das unheimlich*).[5] The uncanny pertains to the frightening, to that which arouses dread or horror, though plainly not all that we find frightening is also uncanny. Seeking better to define the uncanny, Freud begins with a linguistic analysis of the German word *unheimlich* which discloses a basic ambiguity upon which the psychoanalytic reading turns. Freud discovers that the word *heimlich*, or homely, can also mean 'that which is concealed and kept from sight'.[6] While it does not exactly contradict the first meaning, none the less, the second or subsidiary definition of *heimlich* shades into that of its antonym, the *unheimlich* or uncanny. It would appear that even those things that are most intimately familiar to us, pertaining to the *Heim* or home, possess within themselves a kernel of strangeness. Freud goes on to resolve this paradoxical state of affairs by invoking the theory of repression: 'the uncanny is in reality nothing new or alien, but something which is familiar and old-established in the mind and which has become alienated from it only through the process of repression.'[7] Or, more succinctly, 'the *unheimlich* is what was

once *heimisch*, familiar; the prefix "un" ["un-"] is the token of repression.'[8] As an illustration of this, Freud adduces the testimony of certain male neurotics that they find the sight of female genitals uncanny, which leads to the observation that: 'this *unheimlich* place, however, is the entrance to the former *Heim* [home] of all human beings, to the place where each one of us lived once upon a time and in the beginning.'[9]

The experience of the uncanny corresponds, therefore, to an unanticipated return of the repressed: Freud strongly endorses Schelling's definition of the *unheimlich* as 'the name for everything that ought to have remained . . . secret and hidden but has come to light'.[10] Now one can begin to appreciate why the surrealists, who placed all their hopes in the repressed desires that bourgeois morality had outlawed, should valorise the uncanny instant and seek to exploit the visual image as a means for triggering it. An etching from Picasso's *Vollard Suite* (fig. 50) will permit us to explore in more detail just how this uncanny effect is elicited as well as to outline the implications of Kristeva's notion of a destructuration of the self for Picasso's art in the decade covered by this chapter. By a coincidence that one hesitates to call uncanny, the etching was executed in the very same year (1933) that Freud's text, 'The "Uncanny"', first published in 1919, was belatedly translated into French as 'L'Inquiétante étrangeté'. One of the best-known plates from the *Vollard Suite*, *Model with Surrealist Sculpture* belongs to a cluster of images dealing with the theme of the sculptor in the studio, generally with an attendant model or muse.[11] The narrative context allows the viewer to identify the classical nymph on the left as the model reaching out to touch, on the right, a whimsical surrealist assemblage concocted by the artist. The classical figure exists in reality, whilst her counterpart, the surrealist model, only has life in the imagination.

Freud makes the observation that in art far more resources are available for producing an uncanny effect than is the case in real life.[12] Picasso deploys the full gamut of such devices with masterly guile. Citing a paper by Jentsch, Freud remarks that waxwork figures, dolls and automata are liable to arouse an uncanny feeling, especially when there is uncertainty about 'whether an apparently animate being is really alive; or conversely, whether a lifeless object might not in fact be animate'.[13] There is little doubt that Picasso intended to propagate such a confusion by imbuing the assemblage, which he cobbled together like a de Chirico mannequin from assorted bits of furniture, toys and other bric-à-brac, with a lifeblood of its own. It has about it an air of plausibility such that one would not be that much surprised if it began to respire or got up from its pedestal (this is what Michel Leiris found so compelling about the 'Une Anatomie' drawings, its closest relatives). The net effect of this artful manipulation is to undercut the distinction between the imaginary and the real, a circumstance undoubtedly propitious for the eruption of the uncanny; 'uncanniness occurs when the boundaries between *imagination* and *reality* are erased' Kristeva writes.[14]

A further source of the uncanny resides in the near mirror symmetry of the two figures. (That Picasso had the previous year painted *Girl Before a Mirror* (fig. 51), which presents a close compositional parallel, makes it all the more plausible that the surrealist sculpture ought to be thought of as a quasi-mirror reflection of the classical nude.) While the model is turned decorously away from the viewer, the surreal assemblage faces us as one would expect if it were a mirror reflection, exposing the genitalia which – bearing in mind what Freud's neurotica had to say about their uncanny effect – oscillate undecidably, like one of Dalí's reversing images, between male and female.[15] Mirror reflections are a case of the more general phenomenon of the double, which frequently has associated with it an uncanny and malevolent aspect. The double arises out of a defence mounted by an ego that expels a part of itself:

51 Pablo Picasso. *Girl Before a Mirror*. Boisgeloup, March 1932. Oil on canvas, 162.3 × 130.2cm. The Museum of Modern Art, New York. Gift of Mrs Simon Guggenheim.

'the archaic, narcissistic self, not yet demarcated by the outside world, projects out of itself what it experiences as dangerous or unpleasant in itself, making of it an alien double, uncanny and demoniacal' writes Kristeva.[16] Recalling our earlier point about the *unheimlich* being immanent within the *heimlich*, one can appreciate that here too the alien other in truth belongs to the self. Is that not the real significance of the mirror symmetry here? The model recognises herself in her double, the burlesque surrealist sculpture, reaching towards it in wonderment as she does so. The classical border on the dress that she touches with her left hand – it is like a veil of repression that has been momentarily lifted – is a clue, perhaps, that this is indeed the case. Small wonder that André Breton, having just leafed through the pages of the *Vollard Suite*, is led to the following speculation:

> To reflect oneself, to reflect upon oneself, in a work of art, not merely aware that one is other than oneself, but willing oneself to be the contrary of oneself, tolerating the possibility . . . When Picasso is in playful mood, these days, he builds such mental snowmen.[17]

Personal metamorphosis, the self becoming other, is a recurrent topos in Picasso's imaging of the artist's studio. *The Sculptor* of 1931 in the Musée Picasso, Paris, articulates such a notion in the register of style. Harking back to cubist collage, a whole panoply of pictorial idioms jostle in this space with each other: *trompe l'oeil*, pointillist dots, perspective lines and so forth. The main contrast, though, is between a classical bust opposite the artist and a surrealist figure, composed of rounded, organic shapes, resting on a pedestal between them. At the centre of this topsy-turvy world sits the contemplative figure of the sculptor whose head combines profile and full-face views. The sculptor himself seems to share in the dual nature of his two

sculptural creations. Indeed, as his right arm metamorphoses in to something resembling an octopus one realises that he may be the sea-god Proteus – or Picasso, who could be classical and surreal all at once. Elsewhere in the *Vollard Suite* it is another hybrid, the Minotaur, in his capacity as surrogate for the artist, who acts as a vehicle for the representation of the self as other.[18] Elza Adamowicz convincingly argues that the hybrid monsters in the surrealist bestiary – Picasso's Minotaur is one, Ernst's Loplop another – embody just such a state of alterity: 'the monster is an articulation of the figure of identity comprising the self and the *other*, the other as the other in the self . . . identity stems not from a sense of unity of the self, but from participation with the radically *other*.'[19]

The hallmark of the *Vollard Suite* of etchings, observes Breton, is their unceasing to-and-fro movement between contraries. But it is the clowning with identity as the artist assumes the most varied disguises that entrances him most. The licence to imagine himself otherwise, Picasso's accepting, unparanoid embrace of what at first sight is foreign and strange, has for Breton a kind of ethical value. Amidst the rampant nationalism and racism of France in the 1980s, Julia Kristeva endeavoured to erect an ethics and a politics on the psychoanalytic insight that we are each of us strangers to ourselves.[20] So too, I suspect, does Picasso in this marvellously resolved and eloquent image. It is, above all, a relationship of (dis)symmetry between its component elements that is responsible for the uncanny effect of *Model with Surrealist Sculpture*. The word 'dissymmetry', one discovers on consulting the *Oxford English Dictionary*, harbours an intriguing ambiguity of its own, meaning either an absence of symmetry or symmetry 'as of mirror images'. In the second of these alternatives, which well describes the relation between the transgressive surrealist sculpture and the idealised, classical nude, *dis*symmetry is a special case of symmetry – just as Freud showed the *unheimlich* to be lurking within the *heimlich*. Hence, it will be argued in this chapter that Picasso deconstructs the classical body and the complex set of meanings – ideas of balance, symmetry and order through to notions of identity and national belonging – it connoted in interwar French culture (we ought not to forget that, like Kristeva, he was a foreigner residing in France at a dangerously reactionary time). One last detail of the surrealist assemblage, the alarmingly animate, masklike head atop the creature, adds yet another dimension to the uncanny racial and cultural otherness it inscribes. The *unheimlich*, it has been shown, is here the exotically foreign, i.e. the African, mingled in the same figure with a chair that might be found in any European *haute-bourgeois* household, that is to say with the archetypally *heimisch*.[21]

Straddling the stylistic antitheses of classicism and surrealism, *Model with Surrealist Sculpture* poses as an almost unresolvable question the nature of Picasso's artistic stance in a period where identities (cultural, political) were defined through allegiance to either one or other of these opposed idioms, but not generally to both. Given this calculated ambiguity, it is hardly surprising that defining Picasso's relationship to surrealism has proven such an intractable and contentious issue.[22] At stake in this long-running debate is a desire to resolve ambiguity by imposing a singular, homogeneous identity not only upon Picasso himself but also upon surrealism as an artistic movement and cultural force – a point we can illustrate by turning for a moment to William Rubin's *Dada and Surrealist Art*, a compendious book published on the occasion of a landmark exhibition at the Museum of Modern Art in New York in 1968. From the more than three hundred objects amassed for the exhibition one can infer a curatorial project to define what dada and surrealism are (or were), to confer an identity upon two cultural movements notoriously refractory to modernism's demand for formal and stylistic coherence (the sheer scale of the exhibition would, moreover, have reassured visitors that dada and sur-

realism had, despite the professed iconoclasm of their adherents, made a handsome contribution to the storehouse of Western art).

Within this project, Picasso plays a highly paradoxical role as a figure who is both marginal and central to *Dada and Surrealist Art*. Embossed on the velvet cover of the book is none other than the *Model with Surrealist Sculpture*, that most non-committal of Picasso's images, but with the classical model excised in order that the whimsical assemblage might unambiguously evoke the subject of the exhibition. Picasso can thus be taken to epitomise surrealism, and yet at the same time be declared not a surrealist. While desiring to settle the issue once and for all, as he worries incessantly over the problem of defining Picasso's relation to surrealism Rubin replays the very ambiguity he seeks to disavow. The statement that Picasso's 'relation to the movement was equivocal' is matched only by the equivocations of Rubin's text: 'True, between 1926 and 1935 he produced a few works that are of an out-and-out surrealist character, and many more which in one way or another of their aspects borrow from – or have affinities with – surrealist art. But these works are only part of an extremely varied oeuvre whose dominant spirit is foreign to surrealism.'[23] Acknowledging the surrealist assemblages Picasso made, the automatic poems he wrote, his predilection for erotic phantasy, and his sympathy with the politics of surrealism, Rubin nevertheless feels bound to maintain that: 'Surrealism promoted an attitude toward art that was essentially alien to Picasso.'[24] What is said ultimately to prevent him from joining the ranks of the surrealists is an abiding attachment to observed, concrete reality: 'Picasso's commitment to reality as a starting point has kept him . . . from making truly surrealist paintings.'[25]

A very similar claim was made in the journal *Documents* in 1930 by Michel Leiris who was a partisan in a polemic which saw Breton pitted against Georges Bataille. It was a *bataille* whose cause Leiris felt could be served by dissociating Picasso from the surrealists whom he describes in caricatural terms as intoxicated by a misty world of dreams: 'among the grossest and most pernicious errors which in these past years have been propagated about Picasso, the foremost is that which tends to confuse him with the surrealists, in short to make of him a sort of man in revolt, or rather in flight . . . from reality.'[26] It is reality that affords Leiris solid ground ('terre à terre') for his distinction: in the work of Picasso 'the real is lit up by all its pores, one penetrates it; it becomes for the first time and really a REALITY.'[27] It is this verdict that Rubin and others since have endorsed whilst inevitably refuting Breton. But let us not rush too precipitously to a conclusion, since the argument seems most unsteady on the very terrain over which it has been fought, namely reality. First, it needs to be asked whether surrealism can be taken *a priori* as an enemy of the real world. In making this assertion, Leiris surely alludes to Breton's famous repudiation of the model in the external world in the essay 'Le Surréalisme et la peinture' (Surrealism and painting),[28] but this often-quoted statement can be understood only as part of a complex stance vis-à-vis the real. Surrealism, despite its insistence that our perception of reality is always overlaid with phantasy, by no means rejects the real as such. In truth, the whole thrust of the surrealists' political activism was directed at the revolutionary transformation of the world in which they lived. So-called reality, they maintained, is actually nothing more than a pernicious ideological representation serving narrow class interests, and it is *this* reality they rejected.[29] Mismatch between desire and reality, the revolt of the pleasure principle against the reality principle, is the basis for a surrealist politics and aesthetics which exploits those uncanny moments when the seamless face of reality is shattered.[30] Neither can we accept at face value the second part of the argument, the alleged realism of Picasso. This first became a source of contention with the invention of cubism, one interpretation of which

was that it offered a more complete, and hence more realistic, view of the world by survey-ing objects from several different angles simultaneously. But no less plausible is Breton's asser-tion that the importance of cubism lay in its break with mimetic naturalism. Picasso himself cautioned against the naive realist view, remarking that the realism of cubist painting was something as elusive and impalpable as a perfume.[31] So the question of the real is one that cuts both ways and hardly constitutes the terra firma that Leiris and others since would like it to.

A reconsideration of Breton's essay 'Surrealism and Painting', and of Picasso's place within it, suggests a way beyond the impasse. The essay was meant as a retort to those within the surrealist group, most notably Pierre Naville, who objected to the very idea of surrealist painting. Coveting the role of poet among painters left vacant by the death of Apollinaire, Breton's vision of surrealism most definitely encompassed the visual arts. His task was to quell the sceptics by showing not just that surrealist painting was *possible* but that it already *existed* in the work of Picasso. This is the background to the infamous passage in which he ostensibly lays claim to Picasso for surrealism:

> For all these reasons, we claim him unhesitatingly as one of us, even though it is impos-sible and would, in any case, be impertinent to apply to his methods the rigorous system that we propose to institute in other directions. Surrealism, if one had to assign to it a line of conduct, has only to pass where Picasso has gone and where he will pass again . . .[32]

Elizabeth Cowling has argued that Breton sought to enhance the prestige of his fledgling move-ment by annexing an artist of Picasso's fame.[33] Yet such an indiscretion would have risked destroying a relationship Breton had been carefully nurturing: 'it is impossible and would, in any case, be impertinent to apply to his methods the rigorous system that we propose to insti-tute in other directions.' As it turns out, Breton's strategy as a critic is far more subtle and inter-esting. Insofar as he lays claim to Picasso for surrealism he does so by reinterpreting his cubist period, arguing, as he later put it, that: 'Picasso is surrealist in cubism.'[34] He alerts the reader to an erotic, lyrical and non-rational side of cubism which ran counter to the dominant reading of the movement in the postwar years promulgated by the purists. This point is reiterated very movingly in a piece Breton wrote near the end of his life in which he states that the term 'analytic' cubism was a misnomer that failed to do justice to Picasso, adding memorably that: 'In his case, the rigid scaffolding of so-called "analytical" cubism was very soon seen to be rocked by high winds, to be *haunted*.'[35]

Picasso's own sensitivities on this score are revealed in comments to Maurice Jardot at the time of a retrospective exhibition at the Musée des Arts Décoratifs in 1955, when he tetchily denied any influence of surrealism on his work except in 1933 and then only in his graphic work.[36] Relations between surrealism and the Communist Party had reached a nadir in 1955, so the imputation that the former had been a significant influence in the past would have been a potential source of embarrassment to him. The difficulty of arriving at any balanced judge-ment on this matter is shown by the selection of drawings published with Picasso's coopera-tion by the critic Waldemar George in 1926.[37] Alongside recent works, *Picasso. Dessins* brought to public attention a suite of drawings made at Avignon in the summer of 1914 which are remarkable for the abrupt appearance of a vocabulary of curved organic forms and for the resurfacing of a vein of eroticism which had been subordinated to formal concerns in the pre-ceding years. This last efflorescence of pre-war cubism could clearly be connected with his recent work and the release of these drawings from the studio at this point can hardly have

been fortuitous. Their inclusion implies a continuity between them and the recent surrealist-inspired efforts. Thus they narrow the gap between Picasso and surrealism, while at the same time demonstrating his independence. A fruitful approach to the work Picasso produced in response to the surrealist milieu is to view it as a deferred working through of problems and possibilities opened up by the discoveries of 1912/14 which had remained latent; indeed, returning for a moment to 'Model and Surrealist Sculpture', the surrealist assemblage – an example of the mental snowmen applauded by Breton – would appear to be an explicit reprise of an idea for a sculpture (fig. 52) first envisaged on paper but unrealised at the time in the summer of 1912.

> Basically I am perhaps a painter without style. Style is often something which locks the painter into the same vision, the same technique, the same formula during years and years, sometimes during one's whole lifetime. One recognises it immediately, but it's always the same suit. I myself thrash around too much, move too much. You see me here and yet I'm already changed, I'm already elsewhere. I'm never fixed and that's why I have no style.[38]

Style maketh the man, popular wisdom has it, underlining the fact that subjectivity ought to be understood as an effect of style rather than its source. As we shall see, the absence of a signature style could be construed as a sign

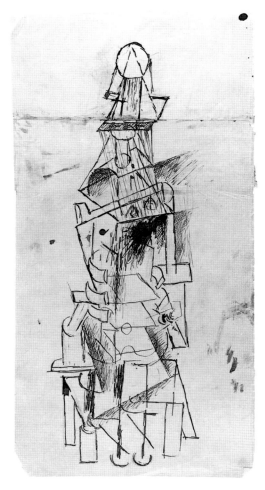

52 Pablo Picasso. *Guitarist (Idea for a Construction?)*. Summer 1912. Pen and ink, 40.5 × 19.5cm. Paris: Musée Picasso (Zervos XXVIII, 146; MP 700).

either of Picasso's strength or of his weakness, depending on whether one happened to be a supporter or a detractor of the artist, but what proved consistently worrisome for a host of writers was how to reconcile his divided stylistic output with a notion of the artistic subject as an integral, unified ego – a dilemma that Robert Goldwater pin-pointed, asking presciently: 'In what sense are his various periods and their different styles the work of one man; in other words, does Picasso have an artistic personality as this has been understood by the connoisseur of older art; can we see the same hand throughout his oeuvre?'[39]

The imperious drive to construct Picasso as a unified authorial subject is continually threatened by his split stylistic production of the 1920s. After all, the dominant idioms of his work in this decade, classicism and surrealism, connote more-or-less incommensurable world-views, so how could any artist be both at once? To concede this much would be to deny the substantial unity of the soul. In order to allay their anxiety, and preserve an image of Picasso as a

transcendant unity, we shall see a number of writers resort to a manoeuvre of which the cover of *Dada and Surrealist Art* offers a singular illustration: the disavowal of division and lack by splitting off one part of his output becomes a necessary precondition for the emergence of Picasso as a unified subject. Freud, in a late paper on fetishism, describes a process that is, in important respects, analogous to this. By its adoption of a fetish object as a substitute for the maternal phallus in which it once believed, the child disavows the reality of castration; the fetish is thus a kind of prosthesis that conceals this lack (what Lacan calls the *manque-à-être*). Freud describes how the child is able to satisfy both the demand to acquiesce in the reality of castration and a conflicting, narcissistic desire to disavow it by maintaining both beliefs concurrently, 'but at the price of a rift in the ego which never heals but which increases as time goes on'.[40] This split, running counter to the presumed synthetic function of the ego, is in fact a precondition for it; paradoxically, a narcissistic belief in the wholeness and integrity of the ego is founded on an irreparable rift (*Zweispaltigkeit*) in the ego.

Section i of this chapter will explore the origins of Picasso's 'polyphony of styles' in the immediate post-war years. Viewing this strategically as a response to a cultural climate in which conservative critics endeavoured to enforce a link between style and identity, I argue for a more favourable assessment of this period of work (characterised by an eclectic pastiche of past styles) than has been the case in recent scholarship. This section will also consider in some depth the nature of Picasso's engagement with classicism, since a shifting relationship to the classical style continues to be a defining feature of his artistic production throughout his involvement with surrealism. In section ii, I argue that Picasso's twin-track approach of the 1920s opens a space of difference and lack within identity. Suspended between the alternatives of classicism and surrealism, a cluster of harlequin heads from 1927 can be read as a far-reaching deconstruction of presence and self-identity. Art history suppresses the radicality of this manoeuvre when it attempts to construct a centred identity and presence for the artist, to erect in the place of Picasso a fetishised monument. In seeking to recover the anxieties of subjecthood that had to be surmounted before the name Picasso could become synonymous with a virile creator brandishing a phallic *pinceau*, it is not my intention to diminish either Picasso or his art. On the contrary, it is my belief that the imaginative transaction which occurs between viewer, artwork and artist is impoverished by this stultifying mould.

i Picasso and the classical body

'Picasso has legitimized a return from exile: and classicism has become the object of major experimentation.'[41]

a polyphony of styles

The daring juxtaposition of disparate styles as seen in 'Model with Surrealist Sculpture' had been a trademark of Picasso and a major source of contention among commentators on his work for more a decade. At the height of his classical period, so-called, whilst staying at Fontainebleau in the summer of 1921 Picasso painted two figure compositions: the *Three Musicians* and *Three Women at the Spring* (figs 59 and 60), one in a jazzy, late-cubist style and the other a ponderous, hyperbolic classicism. Of very nearly identical dimensions, these pendant

53 'A Corner of Picasso's Studio'. *Cahiers d'art* n° 5 (June 1926): 89.

images flaunt stylistic difference and diversity. Also revealing is a photograph (fig. 53) which appeared in *Cahiers d'art* fully seven years before the *Vollard Suite* where the works arranged in Picasso's studio had obviously been orchestrated to maximise contrast and disjuncture between stylistic idioms.

Kenneth Silver's *Esprits de Corps*, a major study of the Parisian avant-garde during the conflicted years of the First World War, argues that the wholesale adoption of classical and naturalistic styles by artists who abandoned their pre-war commitment to formal experimentation can be tied to gains made by right-wing ideologues.[42] Profiting from the climate of zenophobia that flourished in wartime, when an overriding imperative to defend *la patrie* could justify suspicion of foreigners and of anything perceived as alien to the French spirit, the right succeeded in hijacking the classical past to propagandise for a nationalist agenda. Seen at its most extreme in the cultural programme of Charles Maurras, leader of the royalist Action Française, classicism was a cultural signifier of Frenchness and an anti-modern adherence to French tradition. An additional, more diffuse, constellation of values was linked with the classical style, notably an authoritarian concept of order which its proponents contrasted with the supposed disorder and anarchic individualism of pre-war culture. Within Silver's narrative of retrenchment and compromise by a once resolutely forward-marching avant-garde, Picasso has a central role, his work illustrating 'better than any written evidence, the ideological turbulence of the period'.[43] Brilliant but doomed, Picasso is the tragic hero of *Esprit de Corps*, and the flaw that spells his eventual downfall is precisely that he is flawed, riven through, divided, eclectic: 'Picasso is truly an eclectic during and after the Great War. The brilliance of his eclecticism is of course unmistakable; perhaps at no other time does he seem to be so many different and consummate artists at once. But – and this will become clearer as we move into the post-war years – there is a striking lack of focus too.'[44]

Silver is unabashed in his advocacy of modernism and his analysis rests on the Manichean terms of a 'good' progressive modernism versus a 'bad' anti-modernism, the latter presumed to be politically, and artistically, reactionary. Within the overarching discourse of tradition in the post-war years were a number of competing traditions and counter-traditions, but Silver treats them all as if they were ideologically of a piece with the right-wing Action Française. There seems to be no scope for any legitimate expression of national or regional allegiances within this scheme of things.[45] Neither does it leave any place for dada which evinced profound disillusionment with capitalist modernity but was obviously also at odds with conservative opponents of modernism. More serious flaws ensue (one is tempted to say a striking lack of focus) when Silver enlists in support of his case an artist who embraces each of the binary terms that govern his narrative of a failed modernism. When the leading protagonist in the account is progressive *and* reactionary, modernist *and* traditionalist, right *and* left, then the conceptual categories themselves are thrown into disarray.[46]

Unexplained by Silver is why Picasso went to such extraordinary lengths to exhibit the very traits that are said to be the signs of his failure. Like the classical model reaching out to her opposite number, Picasso, even in 1921 when his classicism was apparently most pure, conspicuously embraced heterogeneity. If classicism stood for values of order, purity and homogeneity within a reactionary cultural discourse, how better to offend against those values than by a blatant admixture of styles? The net effect of this artistic strategy was to denaturalise the link between style and identity – identity construed as national belonging.[47] Picasso's weakness, his lack of one consistent style, is what posed the greatest threat to right-wing ideology and demonstrably it was this aspect of his work that most rankled with his critics.[48] The complexity and ambiguity in Picasso's use of a classical idiom, the patent hyperbole, the subtle shifts from reverence to satire, the deliberate admixture of cubist and classical styles, these conflations of different speech registers can be likened to Bakhtin's notion of a double-voiced discourse: that is, 'a mixture of two social languages within the limits of an utterance, between two different linguistic consciousnesses, separated from one another by an epoch, by social differentiation, or by some other factor'.[49] Following Bakhtin's argument, it could be claimed that a consequence of Picasso's anarchic mixing of styles is to relativise the classical and so undermine its hegemonic authority within the postwar culture.[50] André Breton was not in any confusion on that score:

> One would have to be entirely blind to Picasso's exceptional predestination to dare to fear or hope for a partial renunciation on his part. Nothing seems to me more entertaining or more appropriate than that, in order to disillusion insufferable acolytes or to draw a sigh of relief from the beast of reaction, he should occasionally make a show of worshipping the idols he has burnt.[51]

By supporters and detractors alike, Picasso's status as an insurgent foreigner was linked with his continual oscillation between styles; as time went on, the diatribes against him became increasingly overdetermined by the issue of race, in a quite unexpected way. Even for a sympathetic critic like Roger Bissière writing in 1921 there is a battle for domination going on in Picasso's work between, on the one hand, a sober French realism and, on the other, an *outré* Spanish mysticism (Bissière's terminology is underwritten by its proximity to a war that was not uncommonly portrayed as France versus the barbarians): 'Constantly the two tendencies battle in him and alternately dominate without succeeding in allying themselves closely enough to make a whole. This perpetual oscillation which is the weakness of Picasso becomes

also his strength . . . All his work is a combat from which he emerges each time vanquished and enlarged.'[52] A decade later the same cultural values can be discerned in the criticisms of Waldemar George who, in the 1920s, was the author of two appreciative monographs on Picasso. In a succession of articles from the early 1930s published in the review *Formes*, of which he was the art director, George continued to uphold the genius of Picasso but evinced a more guarded attitude towards an artist whose 'tragedy' was said to be the failing of a whole epoch, the expression of 'a modern disquiet'.[53] The deep ambivalence towards Picasso stems from George's own precarious position as an assimilationist Jew in the setting of increasingly rampant anti-Semitism. Romy Golan notes how French anti-Semitism which had been dormant since the Dreyfus Affair resurfaced after the war amid the general suspicion of foreign elements and became more widespread and sinister as economic depression started to bite in 1930.[54] Jews who had been conspicuous as artists, dealers and collectors in the buoyant market of the 1920s came to be seen as legitimate targets. As a strategy of survival, George, a French-born Jew, was anxious to dissociate himself from the *immigrés* and began with increasing desperation to ape the rhetoric of the nationalist Right, singing the virtues of rootedness and national belonging and decrying the pernicious influence of Jewish artists based at Montparnasse whose work he had once praised.[55] His attitude to Picasso undergoes a similar reversal: consistent with his assimilationist viewpoint, George regards Picasso's restless transitions between French and foreign styles as a weakness. 'Barbarian or civilised?' he asks of the Spaniard whose 'work displays a curious blend of cultural refinement and instinctive life'.[56] Picasso, a 'painter in whose veins, it has been said, flows Jewish blood', is a *déraciné* who wanders across stylistic terrains belonging nowhere: 'if [Picasso] cannot fix himself somewhere, find some stable ground, a centre of gravity, it is because he accepts his tragic destiny as one accursed, an atheist, too early deprived of faith and of divine protection.'[57] Not willing to trust in divine protection either, George opted for a universal humanism as an intellectual defence against the omnipresent threat of ostracism and persecution as a Jew. But the vulnerability of his position was revealed during the war when, in the course of a paranoid diatribe against the Bolshevik-Jewish conspiracy of modern art, Camille Mauclair made a cowardly denunciation of the 'demi-Jew' Picasso and his supporter, 'the Jew' Waldemar George.[58]

George elides the plight of Picasso with that of the Wandering Jew. An earlier reference to the 'Jewishness' of Picasso had been made by Adolphe Basler who, in 1925, alleged that Picasso was the incarnation of a 'pan-Semitic spirit'.[59] But the tendency to regard Picasso as a sort of *de facto* Jew only gained ground in the 1930s, writes Eunice Lipton, citing Germain Bazin for whom Picasso exhibits all the traits of a Semite soul, 'a sort of inner nomadism which condemns him to continually flee from himself . . . all his life has been a perpetual search for an alibi that would enable him to escape the interior void that oppresses him.'[60] Apart from the Semitic theme, what links George and Bazin is their belief that Picasso − 'that genius divided against itself' − is driven by an inner lack: a 'vide intérieur' (Bazin) or a 'horror vacui' (George).[61]

Another writer on Picasso whose own situation as an outsider leads her to appropriate the Picasso myth in a potentially subversive way is Gertrude Stein. It is on first sight perplexing that Stein reiterates the most banal stereotypes of masculine genius in what she says about Picasso. 'What is a genius. Picasso and I used to talk about that a lot' she confides, boastfully. In the 1935 conversation recorded by Zervos, Picasso had likened the artist to a receptacle for emotions that inevitably impregnate the work along with his ideas. Stein takes up this motif which she repeats, exaggerating it until it becomes a ludicrously blatant sexual metaphor: he

is described as one who always has need of 'emptying himself'.[62] But Stein gives to the commonplace equation of genius with male virility an unexpected twist by her musing that: 'Pablo and Matisse have a maleness that belongs to genius. *Moi aussi* perhaps.'[63] Her identification with a macho myth of Picasso is at once ironic and scandalous but also empowering for her as a female writer — Stein counters her own marginality by claiming the phallus as her own (a male biographer of Picasso pours scorn on her for this impudence), and she hints obliquely at yet another point of resemblance between herself and Picasso when she writes that: 'America and Spain have this thing in common, that is why Spain discovered America and America Spain, in fact it is for this reason that both of them have found their moment in the twentieth century.'[64] As Eunice Lipton comments, her view of Picasso 'was very much as she saw herself if one replaces "Spanish" with "American"'.[65] As a foreigner in Paris just like Picasso, Stein insists on the essential Spanishness of cubism — 'Cubism is a part of the daily life of Spain, it is in Spanish architecture'[66] — much to the annoyance of Braque who, as a Frenchman, was thereby relegated to a subsidiary role.

<p style="text-align:center">• • •</p>

When Picasso went public with his new classical style in 1917, Robert Delaunay was incensed, complaining bitterly about the Spanish artist in letters to Albert Gleizes. Excerpts from this correspondence cited by Kenneth Silver afford an unedifying spectacle of Delaunay spouting the worst reactionary rhetoric.[67] Given the wartime context Silver finds these remarks chilling, though one rather suspects that much of Delaunay's bluster could be ascribed to envy of Picasso's high profile at a time when his own career was going through a lean patch. None the less, the terms of vituperation with which Delaunay chose to attack work that he regarded as opportunistic and insincere are particularly revealing. Cubism — 'epoch of weak painting, hysterical, convulsive, destructive' — is first of all dismissed as the work of foreigners who skilfully exploit the 'Made in France' label. Then Delaunay turns to Picasso's involvement with the ballet *Parade* which fares no better: 'It is a completely crazy story — no success here, or even curiosity, when confronted with this hysterical thing — that's the only correct word . . . hysteria — painting of a sick mind — tortured.'

Germane to the discussion of style and identity is the only 'correct' word Delaunay finds at his disposal, namely hysteria, a term that would, by 1917, have carried specific connotations for both writer and recipient of the letter. As outlined in the previous chapter, female hysterics had long been notorious for their capacity for insincerity and deception; indeed, one of the commoner accusations levelled at Charcot by his detractors was of a naive credulity concerning the hysteric's 'gift for simulation', as André Breton later put it. Wartime added to the pejorative associations hysteria conveyed. Its association with femininity placed it at odds with conventional definitions of manliness and military valour. Furthermore, owing to the suspicion of malingering, hysteria (or shellshock) among combatants could even imply an unpatriotic cowardice. How better, then, to wound a foreigner said to be cynically exploiting the label of Frenchness? It adds venom to Delaunay's insinuation that Picasso's use of the classical style was illegitimate — 'his so-called classical period of these drawings which have neither father nor mother'.

'We all know that Art is not truth. Art is a lie that makes us realise truth . . . The artist must know the manner whereby to convince others of the truthfulness of his lies' Picasso provoca-

tively asserted in 1923.[68] The issue of sincerity, raised in medical discourse on the hysteric, was also a key term in cultural debate bearing on the use of style. Christopher Green contrasts the stylistic metamorphoses of Picasso with a notion of style that prevailed in the naturalist camp where 'style was made to appear "natural" to the artist who developed it' and 'consistency was a measure of sincerity' (conservative artists like Maurice Vlaminck and Dunoyer de Segonzac took care to avoid any change in their style).[69] But what made the epithet of hysteria, with its overtones of artifice and theatricality, seem so apposite was that *Parade*, the root cause of Delaunay's outburst, was precisely a theatrical production. The curtain designed by Picasso for *Parade* in 1916 afforded the first public glimpse of his return to classicism, and his use of a classical style from this point onwards is best understood in the context of theatre.[70] Jean Cocteau, who was the key intermediary between Picasso and the world of theatre, revelled in the fashionable pastiche of past styles. His notion of style *as* theatre corresponds closely to Picasso's own. A resurgence of *commedia dell'arte* subjects, to which the curtain for *Parade* bears witness, added to the impression of artifice and theatricality that his work of this period aroused, serving to situate his artistic project in the register of masquerade.[71] The mercurial harlequin had long been imbued with personal associations as a sort of *alter ego* by Picasso, who uses it as a vehicle through which his identity is performed within the field of representation.

Echoing the set of associations evoked in 1916 by hysteria – of insincerity, mimicry, theatricality, an absence of personality – Camille Mauclair would in 1930 proffer his own backhanded homage to Picasso: 'I regard him as a juggler able to imitate everything, . . . impersonal to such a degree that he can seem original, and chameleonesque in the "genius genre", as Degas said.'[72]

dead fathers, repentant sons

'To admire an old picture is to pour our sentiment into a funeral urn instead of hurling it forth in violent gushes of action.'[73] Revolt and defiance towards the past, epitomised by the belligerent tone of F.T. Marinetti's 'Manifesto of Futurism', were hallmarks of modernism before 1914, however by the war's end such attitudes had undergone a dramatic reversal. When the Louvre, which had been shut for the duration of the fighting, reopened its doors in 1919, artists who formerly had vowed to burn down this grand repository of European culture and tradition now returned to it in droves. Picasso was one of these prodigal sons.

Neither the *rappel à l'ordre* (recall to order), as this new tone of sobriety and deference to tradition has come to be designated, nor Picasso as one of its leading exponents has fared well in the estimation of critics and historians. Kenneth Silver, we noted, assembles a meticulous but largely circumstantial case to argue that by reengaging with classicism at this time avantgarde artists capitulated to a cultural programme dictated by the extreme Maurrasian Right of French politics. Picasso is the main protagonist in a disenchanted tale of retrenchment and failure by a once-progressive modernism. Rosalind Krauss, in *The Picasso Papers*, is similarly negative in her assessment of this period of Picasso's work, though for different reasons. It is difficult to do justice here to all the strands of her argument, but essentially Picasso is said to have shrunk from a course prescribed by his own cubist discoveries, which led logically to either abstraction or the readymade, taking refuge instead in a reactionary tradition of *belle peinture*.[74]

54 (*above*) Pablo Picasso. *Family by the Seashore.*
Summer 1922. Oil on wood, 17.6 × 20.2cm. Paris:
Musée Picasso (MP 80).

55 (*right*) Pablo Picasso. Study for *Family By the
Seashore*. 1922. Pencil on paper, 49.2 × 64.2cm.
Paris: Musée Picasso (MP 963).

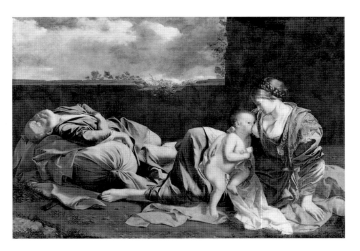

56 Orazio Gentileschi. *Rest on the Flight into Egypt*. 1628. Oil on canvas, 157 × 225cm. Paris: Musée du Louvre (INV 340).

57 Pierre Puvis de Chavannes. *The Poor Fisherman*. 1881 Salon. Oil on canvas, 155.5 × 192.5cm. Paris: Musée d'Orsay.

Their commitment to the ideal of a forward-marching avant-garde causes both Silver and Krauss to regard Picasso's change of course in the post-war years as an unforgivable dereliction. But with a growing wariness about modernism's progressivist claims reflected in the preoccupation of so many artists now with issues of cultural memory, mourning and loss, perhaps the time is right for a more neutral reassessment of the *rappel à l'ordre* and Picasso's place within it. Drawing upon psychoanalysis, the following discussion invokes a constellation of factors – chief amongst them guilt, mourning and reparation – which I will endeavour to show can assist in explaining the vast transformations that occurred at this moment in the sphere of artistic production. My analysis will focus on Picasso's *Family by the Seashore* (fig. 54), one of the most beguiling examples of his post-war neoclassicism. Painted at Dinard in the south of France in the summer of 1922, it could be mistaken as a holiday snapshot of the Picasso family were it not that the stylistic overlay drains away any sense of immediacy or presence. The here and now of a modern nuclear family on the beach with dad taking a nap and an inquisitive infant prying at his ear is overshadowed by the recollection of more-remote familial archetypes of which the present moment becomes little more than a pallid echo, a belated repetition or restaging. This pattern of temporality, proper to neoclassicism, permits the depiction of familial relations to become an occasion for a meditation on the artist's relationship to the past and to artistic tradition.

The starting point for my analysis is a perception that all is not as it should be in this Arcadia of family values. In one of the few direct comments we have on the picture, the critic Tim Hilton was moved to observe: 'Olga, if she saw it, must have wondered what lay in the mind of the man she had married.'[75] What, indeed, is one to make of a family where the slumbering *pater familias* is unresponsive to the infant who tries to rouse him and gives the appearance of being cocooned inside himself? We can begin to unpack the meanings that coalesce in this greatly condensed image by considering some of the visual exemplars Picasso might have chosen to follow.[76] Orazio Gentileschi offers a surprisingly close approximation to its distorted family dynamics in his *Rest on the Flight into Egypt* of 1628 (fig. 56), of which there are several versions including one in the Louvre, cleaving the sleeping Joseph from the mother and child

to underline his status as a mere stepfather.[77] Picasso, of course, lacks Gentileschi's theological rationale, and hence we shall have to find some other explanation for the father's psychological distancing and estrangement. The pale pinks and blues of *Family by the Seashore* suggest that, not for the first time, Picasso may have been looking to Puvis de Chavannes, always a cult figure with the avant-garde and especially so in the post-war years when his etiolated classicism and wistful, Golden Age nostalgia struck a chord. In particular, Puvis's *The Poor Fisherman* of 1881 (fig. 57) presents a striking parallel. The dislocation of the putative father, who is plunged in melancholic revery, from the mother and male infant poses as a question the nature of their relationship: like some dimly recalled preoedipal moment, the background idyll could be an imaginative projection of his. Puvis alerts us to the possibility that the Picasso image may likewise encompass more than one temporal moment and more than one subject position. The Christ-like association which lends pathos to Puvis's bohemian *pauvre pêcheur* may also be judged relevant to Picasso, though inflected by the very specific meanings that accrue to the recumbent male body in Western art. Quite apart from the culturally embedded connection of sleep with death, the stiff horizontality of the father is evocative of a funerary effigy and the woman occupies the position of the grieving mother in a traditional *pietà*, all of which is consistent with an alternative reading of the image as a scene of lamentation over the dead Christ – that Picasso has deliberately accentuated the stiffness of the lower limbs and body in such a way as to evoke funereal associations is shown by a comparison of the picture with related studies (fig. 55) where the knees are flexed and the relaxed, naturalistic pose more consistent with a figure asleep.

The cause of our initial unease is becoming clearer: these assorted references add up to a melancholy awareness that there is death even in Arcadia (*et in arcadia ego*). The dream-like condensation of biblical motifs, a Rest on the Flight into Egypt and a Lamentation, also introduces a confusion between fathers and sons that shall prove to be decisive for our understanding of the work. We have a situation where the 'son' is represented twice over, as the infant *and* as the father; put another way, the son *is* the father, but a 'dead' father – a paradoxical state of affairs that Freud's essay 'Dostoevsky and Parricide' can help us to resolve.[78]

From childhood, Freud reports that Dostoevsky was prey to episodes of a 'sudden, groundless melancholy'.[79] Associated with these mood disturbances were a profound somnolence and a strong presentiment of death. So fearful was he of being found in this state and thought dead that before going to sleep at night the young Fyodor would leave notes begging that in such an eventuality his burial should be delayed for six days. Later on the attacks became epileptic in form, causing him to lose consciousness and fall down as if dead, a worsening that is supposed to have occurred after his father was murdered when Dostoevsky was aged eighteen. Freud inclines to the view that these events were hysterical rather than true epilepsy because of the absence of any apparent mental deterioration. He claims that, as an hysterical symptom, the attacks have the meaning of an identification with a dead person in punishment for having once wished that person's death. For a boy, that person would normally be the father, his rival. Freud explains the meaning of the death-like attacks thus: 'You wanted to kill your father in order to be your father yourself. Now you *are* your father, but a dead father'.[80] The ego having identified with the father is punished for its crime (the parricidal wish) by the super-ego, the latter also a paternal derivative. 'Both of them, the ego and the super-ego, carry on the role of the father' Freud concludes.[81]

Dostoevsky provides grist for Freud's interpretive mill, an individual case that could validate a more general theory expounded in chapters seven and eight of *Civilisation and its Dis-*

contents concerning the role of an unconscious sense of guilt (*Schuldgefühl*) as a motive force in mental life. Freud claims that guilt originates as a reaction to our aggressive and destructive drives. Integrating this into a psychoanalytic fable of murder and original sin, Freud writes that: 'We cannot get away from the assumption that man's sense of guilt springs from the Oedipus complex and was acquired at the killing of the father by the brothers banded together.'[82] The essay on Dostoevsky affirms that parricide – murder of the hated father by the envious son – 'is the principal and primal crime of humanity as well as of the individual. It is in any case the main source of the sense of guilt.'[83] Within the psyche, guilt transpires mainly in the relation between the ego and the super-ego, the latter being an agency of internal surveillance set up in order to defend against the unruly, antisocial drives. In orthodox Freudian theory, the super-ego is a residue of the Oedipus complex and its cruelly implacable nature betrays its derivation from the hated and feared primal father; thus, aggressivity does not simply disappear from the equation but is coopted by the super-ego, a despotic overseer which takes on board the sadism of the drives it is meant to suppress.[84]

In the form of conscience, the super-ego enshrines all the rules and prohibitions that in a patriarchal society emanate principally from the father. Additionally, and highly significantly for our purposes, Freud describes the super-ego as 'the vehicle of tradition and of all the time-resisting judgements of value which have propagated themselves in this manner from generation to generation'.[85] Carrying this psychical schema across to the *rappel à l'ordre*, are we not entitled to think of classicism as a super-ego equivalent? Apart from prescribing a set of stylistic reference points, it also stood for a more abstract agglomeration of values which furnished strict, guiding precepts for artists. In *Family by the Seashore*, the stable pyramid comprised by the three figures and the arrangement of the background as neat bands analogous to stripes on a national flag work to connote a rigid sense of order, harmony and stability. Reinforcing a super-egoistic view of the classical tradition is the way that it tends to be personified in the visual arts as a pantheon of dead fathers, most memorably in Ingres' *The Apotheosis of Homer* of 1827 which gathers together the august representatives of this patrilineage in a manner that implies their simultaneous co-presence, and ours with them. The classical tradition presupposes a temporal order in which the present is wholly subsumed by the past, and entails the very particular form of historical consciousness defined by T.S. Eliot in his essay 'Tradition and the Individual Talent' of 1919 as:

> [awareness] not only of the pastness of art, but of its presence . . . a feeling that the whole of the literature of Europe from Homer and within it the whole of the literature of his own country has a simultaneous existence and composes a simultaneous order.[86]

Picasso's identification with the dead fathers thus gives visibility to a fundamental drive that permeated the return to classicism after the First World War. The feminine aspect of the male figure's pose, something I shall come back to, could be said to betoken abject passivity and submission before a tradition which by its insistence upon order and conformity wore the uniform of the psychical policeman. As Freud writes of Dostoevsky, 'The super-ego has become sadistic, and the ego becomes masochistic – that is to say, at bottom passive in a feminine way'.[87]

Of particular interest to the cultural historian in Freud's analysis of Dostoevsky is the manner in which an event is understood to interact with a preexisting structure of phantasy, and it is the conjuncture of these two separate realities that brings about material effects in the domain of cultural production.[88] The principal motives for Dostoevsky's death attacks were guilt and

a need to exculpate the crime of parricide, thus explaining the escalation of symptoms after his father's murder: when the phantasised wish came true the child was overcome with a burden of guilt that had to be assuaged. Carrying this model over to the cultural arena, 'a new setting on a fresh stage',[89] it might be said that the hostile and destructive drives flaunted by the avant-garde before the war, of which there are examples aplenty, are avenged by a cruelly punitive super-ego after it.[90] In this case, the trigger for the sense of guilt would be the war itself which unleashed a tide of actual death and destruction on a scale that could scarcely have been imagined. In a recent article, Nicola Lambourne raises the issue of the destruction of a French cultural patrimony during the First World War, saying that such events as the shelling of Reims cathedral attracted extensive coverage at the time but have tended to be ignored by art historians since who have concentrated mostly on avant-garde artistic production.[91] While this is certainly true, it is worth asking how the wanton destruction that took place in wartime impacted upon artistic production, given that only a few years beforehand avant-garde artists had been advocating just such a fate for the Louvre and other cultural institutions. Recognition of an unconscious sense of guilt as a coercive force within avant-garde culture permits us to explain the process of mediation involved in their dramatic volte-face.

Dostoevsky's attacks were apparently preceded by an aura in which the dominant affect was one of euphoria, a blissful feeling of happiness that was quite the converse of the attack itself. Interpreting this sequence with reference to the parricidal phantasy, Freud claims that the aura coincides with the moment of phantasised triumph over the hated and feared paternal rival – that is to say his murder by the Oedipal son – before guilt causes the attack to supervene.[92] In Family by the Seashore we find these two narrative moments rolled into one: Arcadian bliss as the male infant gestures triumphantly towards the father whom he has disposed of in phantasy (an attitude of revolt which corresponds to the typical posture of the pre-war avant-garde), and its sequel as the super-ego gains the upper hand and he himself becomes the dead father (the melancholic position of artists post-war). That Picasso keeps open his occupancy of these two subject positions, of revolt versus submission, in the Oedipal relation to tradition can be seen to colour his post-war classicism which is marked by an inner tension or 'double-voicedness' that constantly threatens to undercut the authority of the classical idiom. We can also see evidence of this psychic ambivalence in the Family by the Seashore registered as a disparity between the seeming monumentalism of the classicised figures and the actual diminutive scale of the work, scarcely bigger than a large-format postcard.

Compounding the ostensible subject of a sleeping figure watched over by two others, I have claimed that Family by the Seashore contains allusions to death and mourning. It might be objected that these are associations I bring to the image and not ones that can properly be said to inhere within it. In response, we should note that neoclassical artists in general appropriate their visual resources from an inventory of poses and compositions supplied by the past. That Picasso especially draws upon a prodigious visual memory and operates in the mode of visual citation is well recognised, entitling us to view the image as overdetermined, as a dream-like condensation of more than one theme or motif. Because it provided an accessible and readily understood visual language of mourning, the traditional iconography of the pietà, as Jay Winter has shown, was widely appropriated and paraphrased in war memorials where the body of a soldier would typically be substituted for the dead Christ.[93] Picasso, by conferring his own features on the foreground figure, is simply investing with personal content a motif that was widely available in the post-war visual culture.

Freud's account of Dostoevsky's death-like attacks, in which the dominant mood was one of deep depression, follows quite closely his model of the normal process of mourning. There too the ego is said to identify with the lost or abandoned object – 'the shadow of the object fell upon the ego' in Freud's famous formulation – and ambivalent feelings originally pertaining to the loved object are translated in to reproaches against the ego emanating from the super-ego. 'In this way,' writes Freud, 'an object-loss was transformed into an ego-loss and the conflict between the ego and the loved person into a cleavage between the critical activity of the ego and the ego as altered by identification.'[94] As with Dostoevsky, guilt plays a determinant role in Freud's effort to account for a number of the features that regularly accompany states of mourning, notably the feeling of worthlessness and blaming oneself for the person's death. The parallel with Dostoevsky can be better appreciated from a manuscript dated 31 May 1897, highly prescient since it sketches out many of his later views about mourning, in which Freud outlines how identification with the parents at their times of illness or death is a mechanism for punishing oneself for murderous, aggressive feelings directed towards them:

> Hostile impulses against the parents (a wish that they should die) . . . are repressed at times when compassion for the parents is active – at times of their illness or death. On such occasions it is a manifestation of mourning to reproach oneself for their death (what is known as melancholia) or to punish oneself in a hysterical fashion (through the medium of the idea of retribution) with the same states that they have had.[95]

We saw how Dostoevsky was punished through an hysterical identification with his father, as it were blaming himself for his father's violent death. The psychoanalyst Melanie Klein found this self-punitive trend to be borne out in clinical experience, observing in sufferers from depression both 'the dread of harbouring dying or dead objects (especially the parents) inside one and an identification of the ego with objects in this condition'.[96]

Circumscription of the ego owing to the withdrawal of cathexis from the outside world, a state akin to narcissism, is another regular concomitant of mourning and melancholia. This well describes the solipsistic isolation of the male figure in Family By the Seashore, whose pose and disposition relative to the mother and child prompts a comparison with Narcissus lying moribund in the foreground of Poussin's Echo and Narcissus (fig. 58). After the war, entire nations recoiled inwardly upon themselves and became preoccupied with distinctive national traditions, a process equivalent to the state of narcissistic withdrawal manifested by the individual mourner. Comparison with Poussin's Echo and Narcissus, a picture with which we can assume Picasso's familiarity, is instructive in other respects. Indirect support for my contention that Family By the Seashore has connotations of a lamentation over the dead Christ comes from the fact that Poussin derived his Narcissus from a Pietà by Paris Bordone (the parallel extends to the grief-stricken Echo who occupies the position of a weeping Virgin). This example affords evidence of the potential for crossover between religious and pagan subjects within French classicism. Even more unexpected is the finding on X-ray that Poussin had painted his image over two others, both of them variants on the three-figure composition, one of which is believed to represent a Rest on the Flight into Egypt. In other words, what is postulated as latent in Family by the Seashore, namely a set of allusions buried within the manifest subject matter, is in Poussin's Echo and Narcissus concretely embedded in the fabric of the work.[97]

Freud notes that in its clinical presentation melancholia is liable to alternate, or even coexist, with a manic state which is characterised by the feelings of euphoria and triumphalism noted

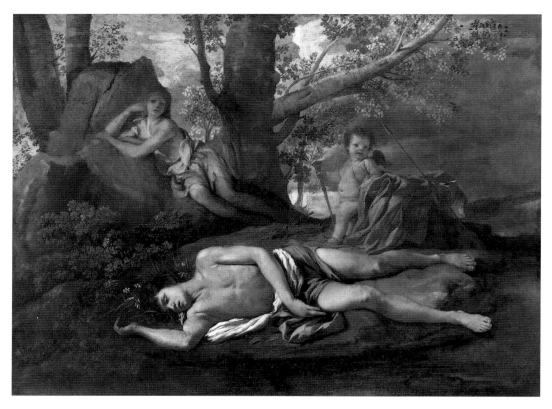

58 Nicolas Poussin. *Echo and Narcissus. c.*1629–30. Oil on canvas, 74 × 100cm. Paris: Musée du Louvre.

above.[98] Melanie Klein, who elaborates upon Freudian theory in this area, describes mania as a psychotic defence, an omnipotent denial of death, and in recognition of its link with the primal feast (where the sons devour the father after killing him) she stresses its oral canni-balistic character.[99] Freud himself compares the manic individual to 'a ravenously hungry man'[100] – a strikingly apt metaphor for Picasso's restless, eclectic consumption of past styles during the post-war period. We might also conjecture that the revival of *commedia dell'arte* subjects in the work of Picasso and other artists was linked with their utility at conveying these contradictory affects, a slightly phoney or superficial gaiety which conspicuously fails to conceal an underlying mournfulness. Brilliant detective work by Theodore Reff has disclosed beneath the frenetic rhythms and comic disguises of Picasso's *Three Musicians* (fig. 59) a pro-foundly melancholic elegy to the friends of whom the war had deprived him.[101] Of the so-called *bande à Picasso* – the band of brothers one might say – Apollinaire, as Pierrot, was now dead and Max Jacob, the figure in a monk's habit, had converted to Catholicism and was living in a monastery, leaving Picasso, in the guise of harlequin, all alone. Picasso's description of waving farewell on the train platform at Avignon to his artist comrades, Braque and Derain, both of whom enlisted at the outbreak of the war, and his laconic remark that they were never to meet again under the same carefree circumstances, is filled with poignancy reminding us that the war spared no one the experience of loss. André Derain, who, unlike Picasso, totally expunged all trace of pre-war modernism from his work, enjoyed professional and commer-cial success in the 1920s as a conservative proponent of the return to figuration, yet even he

deploys the *commedia* in a way that belies its reputation for light-hearted entertainment. The desolate landscape of his *Harlequin and Pierrot* brings to mind Freud's observation that 'in mourning it is the world which has become poor and empty'.[102] The figures themselves are devoid of any hint of merriment and their musical instruments lack strings; broken and useless, they exhibit the profound inhibition of function typically induced by melancholia. Another peculiar feature is the extremely low vantage point, a giveaway to the re-activation of a regressive infantile depressive position in the visual culture of the period. It is worth adding that the disjunctive combination of mourning and triumphalism which we earlier discerned in *Family By the Seashore* paralleled the response of people generally to the cessation of hostilities and is reflected in the iconography of monuments to the war, many of which were being erected in the early 1920s. A typology of these monuments by Antoine Prost seeks to make a distinction between those celebrating victory and others whose main purpose is to commemorate the dead, but in reality the two functions are often combined in a way that is destined to arouse contradictory emotions in the viewer.[103] And as a description of French popular culture at large in the roaring 'twenties, the notion of a mixed, fitful state of manic-depression veering between despair and denial is difficult to better.

It is a characteristic of the depressive position according to Melanie Klein that the infant reacts to its perceived destruction of the object by seeking to make amends. An important modification of Freudian orthodoxy in her theory concerns the mode of onset of guilt and its relation to the Oedipus complex. Klein locates the origins of anxiety and guilt in the infant's oral cannibalistic drives, claiming that hostile impulses aimed at the maternal breast give rise to the earliest feelings of guilt. The beginnings of a super-ego function, in other words, she claims are discernible well before the onset of the Oedipus complex.[104] The infant's attempts to undo the destruction of the good object carry over in later life into artistic creativity which, in fairly conventional terms, Klein views as synonymous with the creation of beautiful forms and idealising trends.[105] Whilst plainly such a view of the motives for artistic creation is inadequate for much of twentieth-century art, and especially so for an artist like Picasso who famously stated that 'Art is the sum of destructions', it does however shed light on the post-war turn to classicism where a reparative impulse can be discerned in the extreme idealisation of the mother and child in the work of a number of artists, Picasso included. So too, the prevalence of a grossly exaggerated stereotype of a bountiful, nurturing female body might reflect a wish to reverse the phantasised destruction of a good maternal object. Viewed in this manner, Renoir's late bathers, for example the *Grandes Baigneuses* of 1919, can be understood as spelling out the phantasmatic correlate of a post-war ideology of reconstruction. Renoir's death in 1919 was followed by a retrospective which ensured that such works were in the public eye, and they clearly afforded a model for the hypertrophied bathers who loll about like inflated liloes in works by Picasso and other artists in this period. The effort at restitution of the lost object leads to the creation of female bodies so turgid and ponderous they verge on parodying the values of stability and monumentalism they were intended to embody. Klein remarks that the infant's reparative phantasies are frequently an exact obverse of the original sadistic ones: in a futile attempt to annul the imagined consequences of its aggression, agents of destruction like urine and faeces are magically transformed in to gifts.[106] As I muse on Picasso's majestic *Three Women at a Spring* of 1921 (fig. 59), its three, cloned earth mothers set in a pictorial space awash with ochre-brown pigment, I become progressively more convinced that we are dealing here with a restorative attempt to undo the destruction and loss of the maternal good object whose survival at the level of the unconscious is assured by its magical

59 Pablo Picasso. *Three Musicians*. Fontainebleau. Summer 1921. Oil on canvas, 200.7 × 222.9cm. The Museum of Modern Art, New York. Mrs Simon Guggenheim Fund.

60 Pablo Picasso. *Three Women at the Spring*. Fontainebleau. Summer 1921. Oil on canvas, 203.9 × 174cm. The Museum of Modern Art, New York. Gift of Mr and Mrs Allan D. Emil.

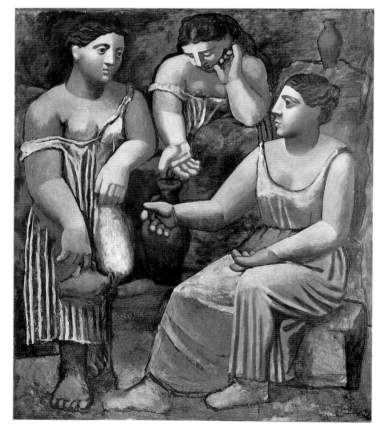

61 Georges Braque. *Guitar and Jug.* 1927. Oil on canvas, 80.9 × 116.5cm. London: Tate Gallery.

replication. This picture is the outstanding exemplar of what is sometimes referred to as Picasso's Pompeian phase, so-named because the white tunics like fluted columns and the terracotta flesh tints of the crudely drawn figures recall the painted pottery and wall paintings he might have seen on his visit to Naples and Pompei in 1919 in the company of Stravinsky. Over and beyond these stylistic references, however, one might consider the historical fate of Pompei as relevant to the imaginative associations conjured up by this body of works. The *Three Women at a Spring* mimes as an excremental phantasy the burial of the inhabitants of that city by the catastrophic eruption of Vesuvius, while its subsequent retrieval through archaeological excavation is equivalent to the reparative process which seeks to reverse the damage that has been caused — Picasso's Pompeian phantasy, shall we say, or is it mine?[107] At the very least, one can surely agree with Carl Einstein that: 'These works proclaim a titanic archaism. Picasso has carried Greekness far beyond Maillol into a realm of colossal myth.'[108]

Georges Braque's *Basket-Bearers* of 1922–23, mural-scale decorations, share the corpulent physiognomy and earthiness of *Three Women at a Spring*. Altogether a more timid figure painter than Picasso, in Braque's case we are obliged to read the recurrent still-life forms as surrogates for the absent (lost or destroyed) maternal body. Painted at greater remove from the immediacy of the war, a reparative phantasy predominates in Braque's *Guitar and Jug* of 1927 (fig. 61). It is an unusual picture, not easily reproduced, which in its complex layering, conspicuous *pentimenti* and overpainting, as well as its very sombre colour, anticipates the meditative, subjective character of Braque's later studio pictures. Spatial incongruities arising from the inconsistent overlapping of fragmentary elements of the scene suggest that these residues of perceptual reality have been shuffled or rearranged in memory to accord better with an inner psychical reality. Utilising a working procedure he adopted from Juan Gris and then employed quite consistently after the war, Braque has built up the picture starting from a dense black ground; such a literal enactment of creation *ex nihilo* invites one to read the act of painting as

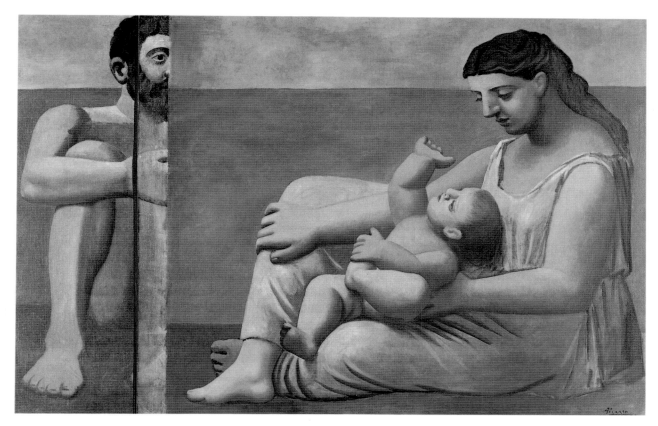

62 Pablo Picasso. *Mother and Child* (shown with tacking margin exposed) and fragment at left. Chicago: The Art Institute of Chicago. *Mother and Child*. 1921. Oil on canvas, 142.9 × 172.7cm. Mary and Leigh B. Block Charitable Foundation; restricted gift of Maymar Corporation and Mrs Maurice L. Rothschild; through prior gift of Mr and Mrs Edwin E. Hokin; Hertle fund, 1954.270. Fragment. 1921. Oil on canvas, 143.4 × 44.3cm. Gift of Pablo Picasso, 1968.100.

a reparative process linked with the depressive position. Cubist painting from before the war prepares us for an analogy of the female body with the depicted still-life objects: the flesh-tinted peaches, guitar with curvaceous waist and sound hole, and earthenware pitcher are imbued with these kinds of associations. The pitcher, as a source of nourishment, is akin to the breast or perhaps the whole body imagined as a refuge or receptacle. Or could it not also be a funeral urn into which Braque pours his sentiment? Another significant feature of *Guitar and Jug* is its oblique horizon line and landscape format, evidence possibly of Braque's debt to Cézanne whose still-life compositions not infrequently exhibit this propensity for crossover with landscape. Sanctioned by Cézanne's incorporation within a tradition of French classicism, this pictorial reference extends the set of metaphoric equivalences by linking body with physical terrain in a restorative phantasy that was doubtless prompted by the wartime destruction of large tracts of the French countryside. Even for the victors, it would seem, in the aftermath of war it was necessary to make reparations as the price of peace; it is tempting to read the sprig of leaves, though not obviously an olive branch, as bearing this symbolic meaning.

Jacques Lacan, in an early study devoted to the familial complex, refers to the father in the modern conjugal family as 'absent, humiliated, divided, or superfluous'. Linking the advent of psychoanalysis to this social decline of the paternal imago, Lacan implies that Freud's discov-

ery of the Oedipus complex, which shores up his faltering privilege by seeking to conflate the father with the Law, is to be understood as a reaction to an historically determined crisis within patriarchal culture.[109] In the context of the *rappel à l'ordre*, we have established that the classical tradition was represented as a paternal line of descent passing from antiquity via Poussin, Cézanne and Renoir, masters of *la tradition française*, down to contemporary artists. In concluding, I want to raise the possibility that veneration of their forefathers was a means for artists to disavow a crisis of legitimacy within patriarchy brought on by circumstances specific to the post-war era. The lineaments of that crisis, as well as its disavowal, can be seen as registered by Picasso's *Family by the Seashore* where the father, while incorporated into the familial triangle, is at the same time distanced from the other family members. A yet more vivid demonstration of the father's exile can be found in a closely related composition, the *Mother and Child* of 1921 (fig. 62).[110] Against a very similar Mediterranean backdrop, the seated mother and the child cradled in her hands comprise a massive pyramidal solid bounded on two sides by the edges of the canvas. There is simply no room left in this compressed pictorial space for any patriarch to muscle in on the self-containment of mother and infant. It transpires, in fact, that the canvas as it now exists has been cut down from a longer panel which did include at the left-hand extremity a bearded male, a symbolic representative of the paternal imago but strangely relegated to the margins as a forlorn onlooker.[111] Picasso's decision to crop the picture merely confirmed his exclusion from a scene where he was already in a manner absent and most definitely superfluous.

Aspects of the male figure's pose in *Family by the Seashore* are distinctly reminiscent of female sources and prototypes, at odds with the authority and dignity proper to a patriarch. This is even more apparent in a pencil study where the figure adopts a more relaxed pose with both arms wrapped around the extended head in a visual paraphrase of the sleeping Ariadne (fig. 55). The raised arm displaying the axilla in the painted version is, like the hand modestly covering the genitals, standard fare in images of the reclining Venus and had been used often by Picasso in the past as a signifier for female erotic allure. Leo Steinberg has drawn attention to the gesture of a hand touching or covering the groin in late-medieval representations of the dead Christ where its purpose, he suggests, is to signify Christ's incarnate sexuality.[112] Poussin conserves the gesture in his Narcissus where we may suspect it of an autoerotic signification, but in Picasso's adaptation of it the effect of this concealment arguably is to place a question-mark over the figure's virility. What we judge rationally to be the case, namely the potency of the man whom one presumes to have fathered the infant in the picture, is thus denied or at least rendered ambiguous. We earlier explained the feminisation of the recumbent male body in terms of the ego's masochistic self-abasement before a punitive super-ego, but in a work that purports to represent an ideal exemplar of the family it may be said to betray anxiety about the paternal function and by extension the transmission of patriarchal values and traditions.

Low birth-rates and depopulation were a perennial source of worry in France from the moment such statistics became available and, as Robert Nye has persuasively demonstrated, within medical discourse the problem tended to be posed as one of declining male potency.[113] Fears of decline and degeneration were rife in the period after the Franco-Prussian War of 1870–71, which dealt a humiliating blow to national pride, up until the First World War. That the war again rekindled concerns about male reproductive potential is revealed by pronatalist campaigns mounted during and after the wartime. The sacred duty of those who survived the slaughter was to father more sons. That sons were also potential fathers was presupposed by

this discourse and underlay fears that the depletion of the young male population had sapped the nation's strength and capacity to make good its losses.[114] Further evidence that the male sex felt itself embattled at this time comes from studies of the changing sex roles precipitated by the war which led to women making up a larger part of the civilian workforce than they had hitherto. While the situation was largely reversed after the war, indeed there seems to have been something of a male backlash, it is plausibly claimed that this disruption of the *status quo* contributed to a crisis of masculinity.[115] If *Family by the Seashore* is a scene of lamentation over a dead father, then I would suggest that masculinity *per se* is one element of what is being mourned.[116]

Taking cognisance of this crisis also helps explain the terms of approbation used by Picasso's supporters, who evoke him as a heroic progenitor of modern art possessed of almost preternatural virility.[117] Writing about Picasso's *Les Demoiselles d'Avignon* in 1921, the poet André Salmon proclaims it: 'the ever-glowing crater from which the fire of contemporary art has erupted', adding that 'Picasso has invented it all.'[118] Salmon was a staunch defender of modern art at a time of growing opposition to it, and hence his exaggerated claim that the vital strands of modern art all originate from Picasso must be understood in this light. Salmon's hyperbole, especially the metaphor of an eruption that likens artistic creativity to an ejaculatory outpouring, demands to be read alongside the widespread perception of a patriarchy in decline. Like the fetish, which Freud describes as a memorial erected in the place of a lack, the priapic cult of Picasso as omnipotent father served to console and compensate at a time of loss and insecurity; the specific psychic economy of the post-war society ensured that his genius could only be acknowledged in terms that were overtly phallic. At the end of the period I have been concerned with, Picasso conspicuously realigned himself with Breton's surrealist group in an effort perhaps to reconstitute the ties with a radical avant-garde milieu that had been severed by war. One issue that caused his relationship with surrealism to be permanently contested, however, was again the matter of paternity. If Picasso was the father of modern painting, how could he also be adopted by the surrealists? Maurice Raynal, in 'La Peinture surréaliste', plays wryly on the unnatural confusion of fathers and sons when he comments sardonically that 'The "father of cubism" has become the adopted son of the surrealists who, no doubt, consider him, for the time being at least, "their [young] lad of a father".'[119]

ii double trouble

> 'The archaic, narcissistic self, not yet demarcated by the outside world, projects out of itself what it experiences as dangerous and unpleasant in itself, making of it an alien *double*, uncanny and demoniacal.'[120]

Picasso's non-identity

In the climate of virulent xenophobia that gripped nations after the war, Picasso's stylistic heterogeneity provoked questions about national belonging and identity, as we have seen. The relationship between style and identity is again posed towards the end of the decade in a sequence of heads of harlequin which, though not strictly speaking individualised in the usual manner of a self-portrait, can be understood as portrayals of the self. Christopher Green

has shown that in the post-war revival of *commedia* subjects harlequin was routinely treated by artists as a sort of empty vessel, a cipher for themselves and their personal emotions.[121] Since this convention was well understood by the audience, we are not talking about disguise but rather a mode of self-representation that eschews the use of indexical signs as in the production of a portrait likeness. It is more akin to what linguistics calls a 'shifter': the pronoun 'I' does not belong to me alone but is a neutral vehicle through which 'I' articulate my subjectivity in language.

On his first trip to Paris in 1926, Salvador Dalí made a pilgrimage to the studio of his famous compatriot where he was shown dozens of canvases including one presumes some very recent works. His responses are clear-sighted and, as one would naturally expect of Dalí, totally irreverent.[122] *Self-Portrait Splitting in Three* (fig. 63) is a rather flippant, comical picture that departs from the harlequin heads in its use of flat, interpenetrating cubist-derived planes. As a satiric commentary on these busts it holds a certain degree of interest. First of all, Dalí seems to have been in no doubt at all about their self-reference, although like Picasso his remake shows little evidence of any effort to record a direct likeness, except in the most desultory and caricatural sense. The notion of a self-portrait splitting in three is humorous but also indicates that Dalí was alert to a fundamental mechanism (or psychical operation) in the Picassos: that of splitting, division and discontinuity. Whereas in the case of Picasso this splitting of the self yields a series of alien *doubles*, uncanny and demoniacal, Dalí obviously felt he had to go one better. A combination of three heads can, I discovered, be an allegory of prudence — not a character trait one readily associates with Dalí. Given his already nascent interest in psychoanalysis, it seems more likely that he alludes to the three mental agencies of id, ego and super-ego. By extension, Dalí permits us to see that the interlocking positive and shadowy negative planes of Picasso's heads could also be read as a potent visual analogy for the interweaving of the conscious and unconscious within the psyche.

The use of cubist devices to depict the face as a space of binary difference was pioneered by Picasso in a cluster of female heads belonging to an earlier period. These hark back to works produced in 1913 and 1914 under the inspiration of a Grebo mask which were notable for the extreme arbitrariness of their visual signs. That Picasso was also responding to the work of his newly acquired surrealist friends is evident in the way this polysemy is now put at the service of poetic ends, introducing a density of metaphorical associations into the depiction of a face.[123] In a typical case (e.g. Zervos VII, 40), the eye on the right side is like a radiant sun whilst on the profiled left side it is shaped like a lunar crescent; this vertical slit in the place of an eye doubles as a displaced image of the vagina. The mouth is depicted using signs that point in opposite directions: on one side, it has a row of teeth and looks like the buccal cavity of some very primitive organism, while on the other a V-sign like a swallow signifies lips. Two parallel sets of associations are generated by the split into left and right sides: lunar-regressive-unconscious-aggressive-sexual versus the solar-conscious-rational. The reversible interlocking planes that comprise the face ensure that these halves are not reified as a static, binary opposition; instead, they interpenetrate visually, each being infiltrated and contaminated by the other.

It was not until 1927 with the entry of harlequin that self-reference really became an issue. In two closely related versions of *Harlequin* (fig. 64) Picasso orchestrates a contrast between an extravagantly biomorphic contour and a right-angle, a geometer's set square. The latter signifies order and reason against the wildly metamorphic elements which evoke a polymorphously perverse sexuality: the mouth and nose resemble both male and female genitals. The dual

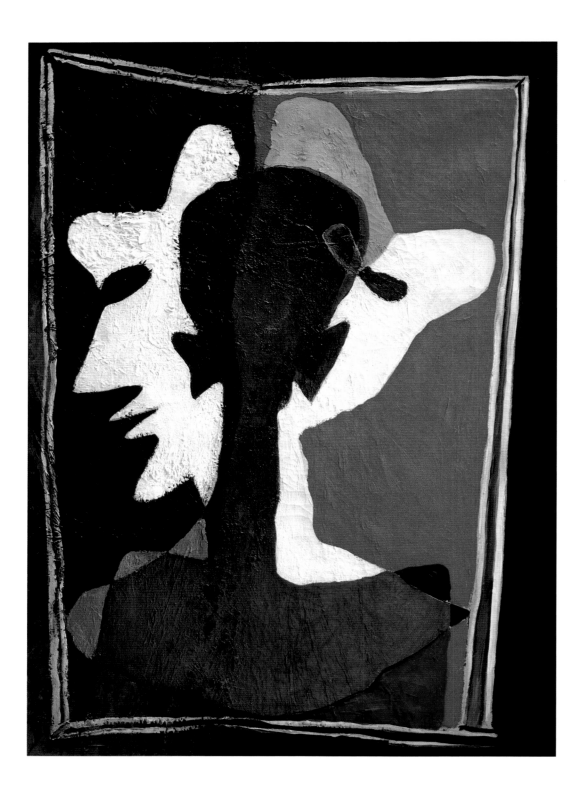

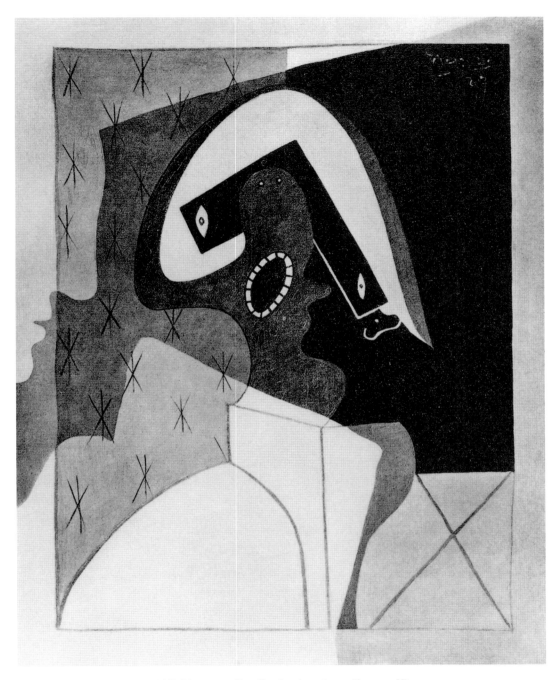

64 (*above*) Pablo Picasso. *Harlequin*. 1927. Oil on canvas, 81 × 65cm. Location unknown (Zervos VII, 80).

63 (*facing page*) Salvador Dalí. *Self-Portrait Splitting in Three*. 1927. Oil on carton, 70 × 50cm. Figueres: Museo Gala-Salvador Dalí.

nature of harlequin is reiterated in the sharp subdivision of the background into halves. In the more complex variant (illustrated here) the neck and shoulders of harlequin are like the pedestal of a sculpted bust, and the whole is surrounded by a painted frame, so that it becomes difficult to determine exactly where art crosses over into reality. Identity itself is caught up in this *mise en abyme* of representation which is complicated further by the presence of a silhouette, like a shadow of the artist either reading or engaged in the act of drawing, that falls across harlequin.[124] There is little doubt that this classical profile which recurs like an impassive observer in numerous works from this period is meant as a self-portrait but the indexical character of the self-reference is undermined by a dark–light reversal which doubly removes the 'shadow' from its ostensible source. Offsetting this lighter profile is another darker one composed of the negative space at the right lateral edge of the harlequin. 'By the polyphonic law of opposites, every form signifies itself and yet simultaneously hurls us into its antithesis' Carl Einstein remarks of this whole group of works.[125]

A photographic negative, brought to light by an exhibition of Picasso's photography at the Musée Picasso, seems to have been a source of inspiration for *Harlequin* and other related works where a shadow profile appears. In what at first appears to be a double exposure of the film, but may in fact be an elaborately set-up shot, a deeply shadowed profile of the artist is superimposed on a framed drawing which is thought to be an early (1906 or thereabouts) self-portrait.[126] Shadows, mirror reflections and photographs are all 'doubles' of the self that under certain conditions, Freud notes, reverse their benign aspect and become objects of superstition or dread, 'uncanny harbingers of death'[127] – all forms of the Negative, so to speak. Writing about Picasso in the journal *Documents*, Einstein contends that shadows are 'one of the numerous emanations of man which are dialectically opposed to him'.[128] Positivity and negativity are the metaphysical coordinates that define Picasso's subjectivity within the representational field of these paintings. Pondering the crucial role of the negative, in particular, one wonders if the same analogy did not occur to him as occurred to Freud when he reflected that:

> A rough but not inadequate analogy to this supposed relation of conscious to unconscious activity might be drawn from the field of ordinary photography. The first stage of the photograph is the 'negative'; every photographic picture has to pass through the 'negative process', and some of these negatives which have held good in examination are admitted to the 'positive process' ending in the picture.[129]

The harlequin, long-established as a surrogate for the artist, and the more recently adopted profile head, meet once again in *Head* of 1928 (fig. 65), a work scarcely mentioned in the literature on Picasso but which manages to combine a profound, quasi-philosophical reflection on the nature of identity with an astonishing, aphoristic brevity. It belongs to a group of several works that all consist of a schematic line drawing of a biomorphic figure overlaid on coloured or monochrome planes. The separation and layering of these distinct elements somewhat recalls Picabia's use of this process in his transparencies in the 1920s, and anticipates the use of layering as a combinatory principle by more-contemporary artists. In *Head* we have a harlequin, recognisable by his diamond-patterned costume, collar and cap, drawn in full-face view over a profiled head which is depicted as a flat plane. Contrasting with the classical form of the latter, the harlequin is represented in an organic metamorphic idiom that carries unmistakeable hints of atavism – notably the primitive mouth or anus which rather ambiguously occupies the place of the eye of the planar head. The two components of the image (full-face and profile views; the surreal and the classical) bear an ambiguous spatial relation to each other,

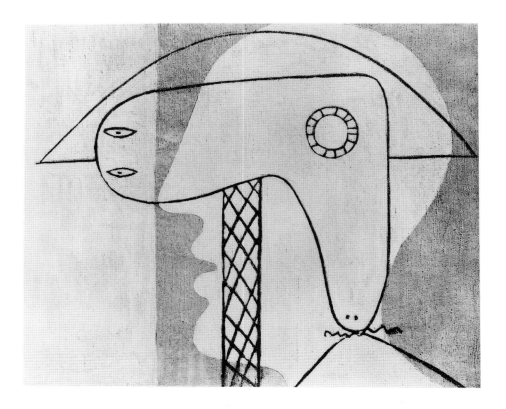

65 (above) Pablo Picasso. *Head*.
1928. Oil on canvas, 46 × 55cm.
Location unknown (Zervos VII,
126).

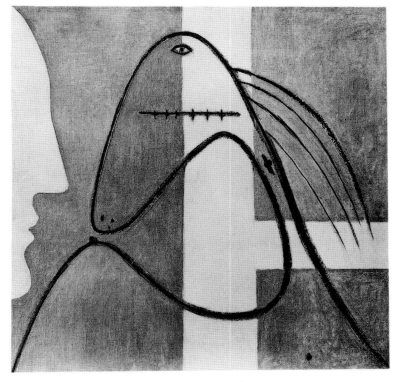

66 (left) Pablo Picasso. *Head of a
Woman*. 1928. Oil on canvas, 46 ×
46cm. Location unknown (Zervos
VII, 125).

cohering as a precarious unity without ever losing their distinctness from each other. Subjectivity is suspended between the psychological poles engendered by this bipartite structure.[130] One further detail in the image is the vertical subdivision which constitutes, in shorthand, a kind of internal framing device. The profile of the artist is depicted, in a spirit of paradox, as a picture within a picture and shown to be itself a by-product of representation, whereas the transgressive harlequin naturally eludes containment by the frame. The subject thus straddles two levels of representation, two degrees of fiction, further undermining a metaphysics of presence.

Head of a Woman (fig. 66) is a closely related image, another variation on the theme of the artist's studio as revealed again by the schematic indication of a canvas stretcher bar. The biomorphic idiom which in the former case depicted harlequin is used here to portray the head and breast of a woman. Hideously distorted, this monstrous creature is the sadistic persecutor of the male artist whose profiled features remain Apollonian in their regularity and perfection. Comparing the two images, it is apparent however that the female persecutor is interchangeable with the harlequin: in truth, she is the outwards projection of a split-off part of himself. Looking back, one cannot fail to be struck by the remarkable correspondence between the subjective terrain covered by this entire sequence of works and Melanie Klein's description of the infant's phantasy world. Klein evokes a subject overwhelmed with anxiety and a fear of annihilation at the hands of its own aggressive and destructive drives, which in the infant primarily take the form of oral cannibalistic desires. It responds to this internal danger which poses a threat to the viability of the primitive ego even before its boundaries are properly secured by splitting off and expelling the unassimilable parts of itself. Projected outwards, these destructive impulses then return as frightening and persecutory figures of which the bad breast and bad mother are the prototypes. In this to-and-fro movement between good and bad objects, external and internal sources of anxiety, self-preservation is achieved it seems only at the price of an ever-renewed splitting. As a form of defence, Freud remarks: 'it will be possible for the ego to avoid a rupture in any direction by deforming itself, by submitting to encroachments on its own unity and even perhaps by effecting a cleavage or division of itself.'[131] We noted earlier in the Picasso images indications of oral cannibalism in the form of a primitive mouth–eye–cloaca and in repeated divisions into light and shade, good and bad, which generate a proliferating multiplicity of doubles and dialectical contraries. Aggressivity is the agent of a far-reaching and radical interrogation and deconstruction of identity in these works of 1927. 'It is possible that one paints . . . with the aim of expressing things that are psychically inassimilable, and also because one is constantly separating from oneself' commented the brilliant German critic Carl Einstein, with a degree of insight that one can still admire today.[132]

Jung and Raphael: conflicting paradigms

'It seems abnormal that a single person should employ two antithetical styles. I cannot carry out the work of a psychologist and justify from a scientific point of view this troubling phenomenon' wrote the critic Waldemar George, introducing his 1926 publication of Picasso drawings in a diverse assortment of styles.[133] At the time, George brushed aside any qualms he may have had by reaffirming Picasso's heroic stature, but the psychological investigation he believed was needed to fathom this 'troubling phenomenon' was eventually forthcoming. Carl

Jung, in a new capacity of art critic, was invited by the daily newspaper *Neue Zürcher Zeitung* to put Picasso on the couch on the occasion of a massive retrospective at the Zurich Kunsthaus in 1932 which included some 225 paintings spanning all phases of Picasso's career.[134] Though a newcomer to modern art, Jung begins by assuring the reader that he has no lack of relevant experience with art by the clinically deranged, which he ranges under two broad categories as products of either neurosis or schizophrenia. Concerning the latter, Jung states that: 'From a purely formal point of view, the main characteristic is one of fragmentation, which expresses itself in the so-called "lines of fracture" – that is, a series of psychic "faults" (in the geological sense) which run right through the picture.'[135] It is to this group that Picasso belongs. Jung finds evidence of this schizophrenia in cubist fragmentation which he equates with the catastrophe that befalls reality in states of psychosis when the exterior world decomposes into 'fragments, fractures, discarded remnants, debris, shreds, and disorganised units'.[136] Jung's interpretation rests on an assumption that Picasso's art is the relatively unmediated expression of an interior drama, and that pictorial fragmentation thus corresponds to a state of psychical disintegration. Recent works such as *Girl Before a Mirror* (fig. 51) in which 'the motif of the union of opposites is seen very clearly in their direct juxtaposition' attest to Picasso's incapacity to create a 'living unity'. The paintings, like their creator, are no more than the sum of disconnected parts.[137] Having probed the fault lines, Jung pronounces his diagnosis on the most famous modern artist alive: schizophrenia.[138]

Without wishing to turn the diagnostic tables, it is difficult to avoid the impression that an anti-modern pessimism and sense of foreboding colours Jung's judgement of Picasso whom he regards, in typically Spenglerian terms, as encapsulating an era of catastrophic decline: 'Picasso and his exhibition are a sign of the times, just as much as the twenty-eight thousand people who came to look at his pictures.'[139] There is uncertainty among scholars about the extent of Jung's acquiescence in National Socialist ideology, and one can only guess how much a wider public at the time knew of his political sympathies.[140] However, his essay did prompt one reply, pugilistic in tone, from the avowedly Marxist critic Max Raphael who scoffed at the self-delusion of the soul doctor who pretends 'only he himself has been saved from the schizophrenia of the [bourgeois] class, that only he stands above it and can therefore heal it'.[141] For Jung's analysis to have possessed any validity at all, 'a backing up of the psychic by the social (of the intellectual production by the material and social circumstances) would still have been necessary' argued Raphael, whose more considered response to Jung – though expunging any explicit reference to him – was published the following year (1933) in Paris as *Proudhon, Marx, Picasso: Trois études sur la sociologie de l'art*.[142] Billed as an exercise in a Marxist sociology of art, Raphael accepts Jung's main contention that Picasso lacks a principle of unity, as evidenced by his switching between contradictory styles, but proposes an alternative explanation for it. To ascribe this fault to a weakness in Picasso's personality is, asserts Raphael with characteristic asperity, a mistake that results from the ideological misconceptions of bourgeois scholars: namely, their faith in the shibboleth of individual genius and in the autonomy of art and its history. Only by divorcing Picasso from the sociohistorical context can one 'consider the phenomenon of the inner split as a phenomenon of personality (and conclude that Picasso is mad, as some have done)'.[143]

By critics of widely differing persuasions, we have seen how Picasso was treated as an exemplary figure taken to represent the very essence of a modern artist. It is so for Raphael who describes him as 'the symbol of contemporary bourgeois society' and maintains that this class position determines the salient features of his art, which he defines as an 'excessive

multiplicity' and 'a disturbing abundance of the most unlike aspects, both simultaneously and successively – inevitable in an artist whose personality is the symbol of the bourgeois ruling class, because he himself and his epoch are experiencing the most contradictory tensions'. Raphael concludes that: 'Today a great bourgeois artist is possible only as an eclectic genius.'[144] Having lagged behind the rest of Europe in the process of modernisation, Spain still preserved elements of a feudal society during Picasso's youth when it belatedly entered upon a period of accelerated change (essentially a transformation from free-market to monopoly capitalism). The effect of this was to exacerbate the contradictory forces acting on the bourgeoisie which found itself caught between revolutionary and reactionary tendencies. Under such conditions, not only is the individual torn by conflicting forces, in bourgeois cultural production one also finds 'extremely heterogeneous conceptions [coexisting] side by side in the work of the most advanced artists, and only reconciled, if at all, in an eclectic, non-dialectical manner'.[145]

Spain was a crucible in which the contradictions and antagonisms besetting bourgeois modernity had a heightened visibility, and Raphael sought to demonstrate how Picasso as the foremost bourgeois artist of the day manifested these tensions. Riven by these schisms, Picasso exhibits a 'torn personality, devoid of any dialectical element', which leads onwards to ever-more pronounced psychic crises and changes in style.[146] The lack of synthesis is seen at all stages in Picasso's work. The incorporation of real objects into cubist collage, for example, results in the stark confrontation of a literal materialism and an abstract idealism. Subsequently, from 1915 to 1925, 'the principle of division into equivalent contrasts [abstract and classical] becomes the very motor force of Picasso's development' Raphael states.[147] Having asserted that his oeuvre lacks any integrating factor, he then rediscovers a deeper unity predicated on the unity of the total sociohistorical process. In this, the most obscure section of his essay, Raphael contends that, notwithstanding its many variations, Picasso's evolution down to the present day is incontestably unified and logical, 'but this logic is dialectical'.[148] A case of the dialectic lost and refound.

Paralleling his account of a stylistic schism in Picasso's art, Raphael also addresses the issue of his decomposition of the human body, analysing in depth the *Seated Bather* (fig. 75) of 1930.[149] Raphael identifies within the picture a number of violently contradictory elements: the pose of the figure, firmly seated on the beach with arms clasped around a bent leg, conveys an intense corporeality, yet the flesh has been stripped away leaving behind nothing but a translucent, disjointed doll. 'This bold idea of expressing the most intense life through contrast with a skeleton is already the sign of an inner split' Raphael concludes.[150] Furthermore the body does not belong to its setting; they appear detached from each other, 'as two contrary principles'. Raphael attributes this dismemberment of the classical body to a caricatural trend which he claims can be discerned in modern bourgeois art: 'Daumier was the first to invent the caricatural style, and down to this day all bourgeois art has revolved around him as a central axis. The essential characteristic of this style is that the whole no longer determines the parts, is not even the result of an accretion of homogeneous parts; the harmony of the whole has ceased to exist.'[151] Raphael contrasts this defining trait of modernist art – the art produced during the period of capitalist modernity – with a classical aesthetic in which proportion governs the relation between parts of the body, and between man and cosmos. Where the proportional relations of antique sculpture corresponded to harmonious social relations, in modern art Raphael finds only abstract mechanical analogies for the reason that 'man has been eliminated from social life having become a commodity.' Modernism's fragmentary vision is thus a reflection of the 'impossibility of a whole – whether it is the whole of a situation,

of a man or of their relations between themselves' – and Raphael closes his essay with an appeal for 'a new, integral work of art adapted to a new social order'.[152]

Despite the conflicting explanatory paradigms of Jung and Raphael, one is struck by the large measure of agreement between them. Both concur that Picasso's work is fatally riven, their negative judgement of which stems from an ethics and an aesthetic that place a higher premium on unity and identity than they do on difference and multiplicity. Our story would be incomplete, however, were we not also to mention Christian Zervos, the editor of *Cahiers d'art*, who reprinted Jung's essay in French translation.[153] Zervos was indignant at what he regarded not only as a slur on his artist–hero but also as trespass on his own professional terrain, and showed his disdain by omitting Jung's last paragraph – a muddled confection of 'ideas already expressed by the Gnostics, the neo-Pythagoricians and neo-Platonists . . . and introduced by M. Jung into psychiatry'![156] Needless to say, Zervos rejects out of hand the schizophrenia diagnosis; indeed, his projected catalogue of Picasso's complete works, begun in 1933, could be regarded as a lengthy rebuttal of it, intended to demonstrate that: 'Whatever might be insinuated there is a unity that runs throughout Picasso's entire work . . . It is the constancy of his temperament, like the return of a familiar melody, which comprises the unity of his work.'[154] Christopher Green has elegantly shown that the unity which Zervos purports merely to document in the *Cahiers d'art* editions of Picasso's work he in fact creates.[155] For our purposes, we need simply note that Zervos's desire to recuperate the transcendent unity of an author function from the dispersion and disunity of Picasso's work reveals he has more in common with Jung than he would perhaps have cared to admit.

a foreign body

Max Raphael's essay is a courageous, if unnuanced, attempt to lay the foundations for a social history of art, and is not without admirers, though it is not a path I intend to follow here.[156] One of the important insights of surrealism, and a reason for its continued relevance, is the recognition that identity itself is a contested terrain and thus a legitimate site of political struggle (a view that inevitably put the surrealists on a collision course with French Communist Party orthodoxy). My decision to focus on issues of identity and its representation will not, I trust, be mistakenly construed as a return to biography. At no stage will we be attempting to put surrealist artists on the couch, to access their individual psyches via their art – Breton warned about the pitfalls of that. The fundamental premise of biography, its assumption that art and life are a seamless unity overseen by the sovereign figure of the artist–creator, was called into question by the surrealist practice of automatic writing. Like the ego itself, which Lacanian psychoanalysis unmasks as an illusory *méconnaissance* (that is to say, as the form in which we generally misapprehend ourselves), surrealism exposes as a fiction this essentially theological construction of the authorial subject.

> There, in the bosom of their conscious mind, in the self, pillar of the world, unique rock which does not disaggregate, appeared suddenly a foreign element [*un élément étranger*] which destroyed the unity and identity of consciousness.[157]

Our starting point in this chapter was an etching which contrives an uncanny juxtaposition of a classical figure with a whimsically transgressive surrealist assemblage. What could be more homely, more familiar, than the body we inhabit? But in surrealist imagery that body is

habitually rendered strange: robotic, doubled, dismembered, deprived of sight – one's own body (corps propre) become an uncanny place, a foreign territory. Given the ideological invest-ments in the classical body as a signifier for Frenchness, of national belonging, we ascribed specific meanings to this estrangement which the familiar classical body undergoes at Picasso's hands. No doubt connected at some level with his experience as a foreigner, Picasso figures his own subjectivity in terms of an uncanny oscillation between stylistic idioms which are held in a state of perpetual non-identity. Surrealism aims to exacerbate a crisis of identity which, as Jung rightly discerned, the foremost artist of the era registers in his art; under the aegis of the marvellous, it seeks to generalise the state of self-estrangement depicted by Picasso. Again and again, one can see surrealism privilege those moments of subjective destructura-tion where the self appears haunted by another. Picasso's *Model with Surrealist Sculpture* indicates that the notion of a foreign body might be a serviceable metaphor for this fundamental theme of surrealist art and discourse, namely the haunting of the self by a foreign element which, as Octavio Paz phrases it, 'destroyed the unity and identity of consciousness'.

iii Picasso and the burlesque body

'The highest and the lowest are always closest to each other in the sphere of sexuality.'[58]

a base seduction

Bataille sets out to disconcert idealism with his base materialism. Between 1929 and 1930, when their exchanges were at their most vituperative, Bataille accused the Bretonian surreal-ists of escapism and poetic complacency in their embrace of a dream-world. Filled with disgust for their own bourgeois class, the surrealists tried to soar above it, embarking on a mistaken quest for transcendence, an Icarian revolt which was destined to betray their revolutionary ideals. It is through his attacks on Breton, curiously enough in a sequence of articles unpub-lished at the time, that Bataille sharpens and clarifies his own philosophical stance.[159] Against the grain of Bretonian surrealism, Bataille espouses a materialism whose whole direction is downwards, desublimatory; baseness (bassesse) and formlessness (informe) are the key terms of a trenchantly anti-idealist subversion.[160] In a sequence of texts published in *Documents* he elab-orates a transgressive iconography of the human body which seeks to give flesh and blood to his philosophical stance. 'Although within the body blood flows in equal quantities from high to low and from low to high, there is a bias in favour of that which elevates itself, and human life is erroneously seen as an elevation' he writes, confronting this illusion with the burlesque, ignominious, monstrous body: with the inside of a gaping mouth, with the base seduction of a stinking foot, or with 'the bellowing waves of the viscera'.[161] For the purpose of illustrating this standpoint, Picasso was of no less importance to Bataille than he had been to Breton in 1925. But whereas the entire impetus of Breton's soaring prose is upwards, aimed towards that ineffable point where all contraries are reconciled, Bataille discerns in the recent produc-tion of certain artists, Picasso most notably, a transgressive impulse – rupture, excess – and a brutally ignominious fall from the ideal:

academic painting more or less corresponded to an elevation – without excess – of the spirit. In contemporary painting, however, the search for that which most ruptures the

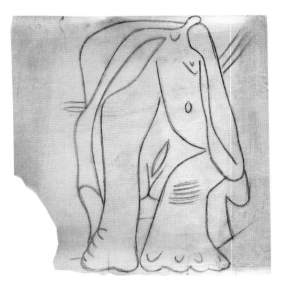

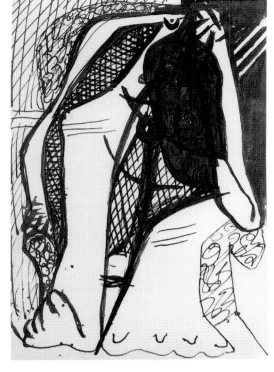

67 (*above*) Pablo Picasso. *Woman in an Armchair*. January 1927. Pencil on tracing paper, 26 × 24.7cm. Paris: Musée Picasso (MP 1022).

68 (*right*) Pablo Picasso. *Nude in an Armchair*. 1927. Pen and ink wash with scratching, 26 × 17.5cm. Paris: Musée Picasso (MP 1873/6).

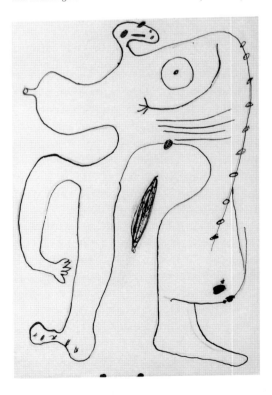

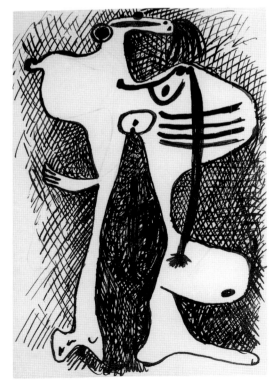

69 Pablo Picasso. *Standing Figure*. 1927. Pen and ink over pencil, 26 × 17.5cm. Paris: Musée Picasso (MP 1873/11).

70 Pablo Picasso. *Standing Figure*. 1927. Pen and ink over pencil, 26 × 17.5cm. Paris: Musée Picasso (MP 1873/13).

highest elevation, and for a blinding brilliance, has a share in the elaboration or decomposition of forms, though strictly speaking this is only noticeable in the paintings of Picasso.[162]

In accordance with this interpretation, it is those figurative works by Picasso from 1927 onwards that most overtly violate a classical canon of the body which are selected for inclusion in *Documents*, along with Jacques-André Boiffard's photographs of the big toe and a salivating mouth, as a pictorial counterpart to Bataille's base materialism. Reference to psychoanalysis, and to what Bataille identifies as a phenomenon of base seduction, enables us to clarify the status of the body within this desublimatory project; the terms of Bataille's analysis are never philosophical abstractions but are anchored in the body and its desires.[163]

We can trace a vertiginous descent from the ideal in the actual genesis of a bizarrely dysmorphic figure type which populates Picasso's imagery of the late 1920s. From a sketchbook held at the Musée Picasso in Paris it is possible to infer that Picasso undertook a stepwise decomposition of the classical nude.[164] A process of tracing not dissimilar to that described for Miró played a significant role in generating this crucial sequence of drawings, accounting for the repetition of contours, or in some cases of whole images, from one sheet to another.[165] The point of departure for the sequence is the motif of a nude seated in an armchair, recalling the monumental classical bathers of the early 1920s, but adopting a low, raking angle to produce extreme foreshortening: the head, the seat of reason and the soul, has become a shrivelled appendage while the lower body, especially the foot, is enlarged to almost elephantine proportions. Four variants of this first stage exist: figure 67, which is on a loose sheet of tracing paper, and three other drawings (figs 68, 69 and 70) on consecutive pages in the notebook. Figure 67 shares identical contours with the traced image but in terms of medium and method of execution is markedly different. It consists of a pencil underdrawing that has been worked over in black ink – the ink has been scratched at and includes a large blotched area which partly obliterates the torso. Swivelled round and splayed flat onto the page in the following sketch (not reproduced), the figure feigns modesty by clasping hands round her crossed legs. Quite a different style again is deployed in the next image (fig. 69), which appears regressive, by turns primitive or child-like, with a stick-figure drawing of an arm. All indications of modelling or perspective which in the preceding images gave clues to a rational reading of the deformations are eschewed. Unexpectedly, the right arm pressed against the leg detaches from the shoulder and becomes grafted onto the thigh – an event that unfolds according to its own logic, but which profoundly disequilibrates the harmonious interrelation of parts pertaining in the classical body. The contour of this figure is deeply involuted at several intervals and grossly ballooned out between these points, destroying the stable relationship of inside to outside that serves to bound and demarcate the unity of the classical body. Perversely, a result of deep invagination of the bounding contour, the vaginal orifice itself seems to have been extruded from the body. What has occurred becomes clearer in the ensuing drawing (fig. 70), where the entire space between the legs extending upwards to the breast has become a vagina-shaped cleft. In the next image in the sequence (fig. 71), visual rhymes link the sex and mouth and eyes, fostering a visual interchange between base and apex, high and low, cancelling the transcendence of the body that Bataille so despised. Bakhtin evokes this anti-hierarchical movement in the grotesque body: 'The entire logic of the grotesque movements of the body', he writes, 'is of a topographical nature. The system of these movements is oriented in relation to the upper and lower stratum; it is a system of flights and descents into the lower depths.'[166] The distance travelled from a classical or even naturalistic conception of the body can now be gauged when it is reinvested with three dimensions in *Metamorphosis II*

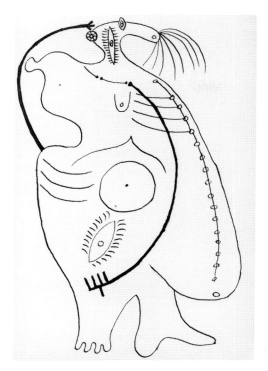
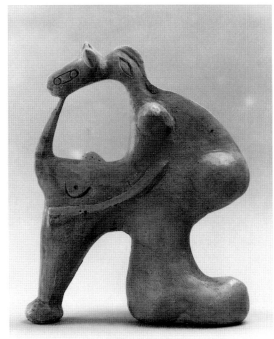

71 Pablo Picasso. *Standing Figure*. 1927. Pen and ink, 26 × 17.5cm. Paris: Musée Picasso (MP 1873/16).

72 Pablo Picasso. *Metamorphosis II*. 1928. Painted plaster, 22.6 × 18.0 × 11.5cm. Paris: Musée Picasso (MP 262).

(fig. 72) where the figure asserts its viability as an alternative in the form of statuary to the classical body as preserved and transmitted down the ages.

With Miró's use of tracing, one is struck by the breathtaking switches in subject and meaning from one image to the next, by the extraordinary fluidity and mobility of the process. Here, by contrast, the mechanical character of tracing – a whole image repeated four times in one instance – seems to betray fixation and a compulsive repetition. There is an obsessive visual focus on the figure's sex which hardly varies in position throughout the sequence, nor in the low viewpoint from which it is espied. One begins to suspect this repeatedly enacted scenario, which incidentally spawns the most transgressive of Picasso's surrealist figures from 1927 onwards, of being a compulsive restaging of an earlier, more originary one: the 'uncanny and traumatic' moment in which the male child, gazing upwards at the mother's body, first catches sight of the female genitals.[167] Recognition of the fact of sexual difference is liable to engender castration anxiety which the boy seeks to allay by disavowing its perception of a lack and putting in its place whatever object happens to be closest to hand, which is invested as a symbolic equivalent of the maternal phallus.[168] Freud writes that: 'The foot or shoe owes its preference as a fetish . . . to the circumstances that the inquisitive boy peered at the woman's genitals from below, from her legs up.'[169] Besides adopting this self-same viewpoint, it is evident that both the moment of recognition and its disavowal are reproduced in our sequence of drawings – the arm sprouting from the right leg (fig. 69) is surely a stand-in for the missing phallus.[170] It only partly reassures, however, and the feverish hatching, smudging of charcoal, blotching of ink, and aggressive scratching are all symptomatic of the 'horror of the mutilated

creature, or triumphant contempt' that, Freud claims, permanently colour the male child's view of femininity thereafter.[171]

Several quite extraordinary studies by Picasso for a Crucifixion dating from the late 1920s depict Mary Magdalen doubled backwards in an expression of extreme anguish. It is an unrepentant, profanely sexual Magdalen whose face, John Golding has pointed out, is scandalously superimposed on her genitals. Freud had speculated that the assumption of a vertical posture by humans led to the sexual instinct being deflected away from its original aim towards more elevated pursuits such as art, a process he termed sublimation. Picasso's Magdalen, on the other hand, exhibits a contrary desublimation, equivalent to the falling down of the upright man. Here, as in Les Demoiselles d'Avignon, which can be thought of as inaugurating an artistic practice of transgression, the fallen woman metaphorises a 'system of flights and descents into the lower depths'. Transgression of the classical ideal is articulated through the body of the fallen woman, the prostitute or the Magdalen, who bears a relation of sharpest contrast to the ideal of womanhood, the mother. Freud notes that what is found in the conscious mind split into a pair of opposites very often began in the unconscious as a unity.[172] The impulses which culture separates into sacred and profane love had once ambivalently attached to the mother, the first love-object. As a result of the incest prohibition, libido is detached from the mother and displaced onto other objects. All future object-choices are thus merely surrogates for the original, now barred, maternal object – this explains why desire, set in train by the 'interposition of the barrier against incest', is refractory to complete satisfaction. An additional danger is that the surrogate, because of its likeness to the original object, will revive the anxiety of castration associated with the prohibition. 'The main protective measure against such a disturbance which men have recourse to in this split in their love consists in a debasement of the sexual object, the overvaluation that normally attaches to the sexual object being reserved for the incestuous object and its representatives.' As a way of bypassing the taboo, Freud notes that the boy may in phantasy degrade the mother to a prostitute, bridging the two currents, and 'by debasing the mother to acquire her as an object of sensuality'.[173]

Susan Rubin Suleiman, in a very compelling reading of Bataille's pornographic novel Story of the Eye, observes that the transgressions of the avant-gardist are typically enacted over the body of the mother in a confrontation 'between an all-powerful father and a traumatised son'.[174] It cannot be disputed that the pattern of Picasso's artistic transgressions conforms, broadly speaking, to an Oedipal model: his violation of the norms of the classical body bears all the hallmarks of an incestuous desire for the mother and its inevitable corollary, fear of castration.[175] In the Bataillean narrative, Suleiman notes, pornographic content and a formal transgression at the level of the text mirror one another; a parallel for the latter obtains in the diverse stylistic idioms of the sequence of drawings just examined – which, in their obsessive iconographic focus, recapitulate a standard shot in the pornographer's repertoire. It behoves us, therefore, to take account of Suleiman's critique of the sexual politics at stake in a modernist literary or artistic practice premised on transgression. She rightly draws attention to the ambiguity of a transgression that derives its force from the paternal prohibition, which, in fact, depends on the latter being in place. 'The limit and transgression depend on each other for whatever density of being they possess' writes Michel Foucault.[176] As a means for channeling and dissipating potentially dangerous impulses, managed transgressions may actually maintain and strengthen the status quo; their function is a socially conservative one. Avant-garde artistic practices of transgression, as Suleiman defines them, are likewise managed and easily recuperated by the dominant order: Oedipal son topples the father, his feared and hated

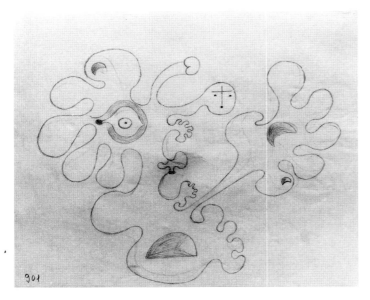

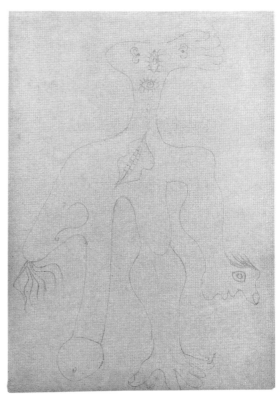

73 (*above*) Joan Miró. *Personage*. November 1930. Pencil on paper, 17.3 × 20.6cm. Barcelona: Fundació Joan Miró (FJM 901 [882–942]).

74 (*right*) Pablo Picasso. *Figure*. 1927. Pencil, 26 × 17.5cm. Paris: Musée Picasso (MP 1873/47).

rival, only to take his place at a later date within the patriarchal lineage. A dialectic of identi-fication and aggressivity is played out in Picasso's many homages to the Old Masters which, even in his old age, still bear the imprint of the son's primary rivalrous identification with the father.

A question raised by certain surrealist representations, however, is whether one is not dealing with an operation that is *meta*-transgressive with respect to the Oedipal structure – which escapes the double bind and is, literally, perverse. Joan Miró comes close to achieving this, I believe, in a cluster of figure drawings belonging to a sketchbook (FJM 854–881) that can be securely dated to November 1930 and where, in consequence, one might reasonably posit either an influence of Bataille's base materialism or at least a climate of reception sympathetic to '*this gross and deforming art*'.[177] Miró refashions the body in the form of a primitive, unicel-lular organism, all pseudopodic excrescences and invaginations (fig. 73). Inasfar as distinct human body parts are recognisable here, we seem to be in the realm of the base seduction of a very overgrown foot. If one were to invoke the idea of a corporeal schema in relation to these aberrant anatomies, it would be to the earliest stages of mental development that one would necessarily refer. Jean L'Hermitte writes: 'It suffices to see a young baby dressing a doll to be struck by the confusion of its acts; does it not take, for example, the hands for the feet, the head for a limb?'[178] Apart from turning on its head a normative adult body schema, there is a disorderly confusion of sexual anatomy with a profusion of outsized penises and vaginas, attached to the same body in some instances, creating a feeling of unbridled libidinal energy, excessive and polymorphously perverse.[179] At stake in these riotously exuberant drawings is

not so much a denial of sexual difference, since distinctly male and female sexual organs are present in abundance, as a deferral of any fixity in the assignation of gender. Of relevance here is the case Freud cites of a man whose fetish object was an athletic support belt: 'This piece of clothing covered up the genitals and entirely concealed the distinction between them' Freud writes. Or, to be more precise, it supported a whole range of hypotheses: that women were castrated or not, that men were or were not castrated.[180] The fetishist's perverse disavowal of the real, a psychical operation which Freud terms 'artful', can thus be understood as a refusal to submit to the binary oppositional terms overseen by the phallic signifier that organise sexual difference under patriarchy.[181]

Before concluding this section, I would like to return briefly to the Musée Picasso sketch-book examined above. The culmination of its metamorphic conception of the body is to be found near the end of the sketchbook in an image (fig. 74), faintly drawn and not easily reproduced, where the downward migration of the classical body is absolute. Elimination of the torso has collapsed the body's vertical orientation, causing the limbs to radiate around a central axis like spokes of a wheel. Any hierarchy that might be mapped onto the body is patently devoid of meaning now. Anarchy prevails in the domain of sexual difference as well: the mouth has become the female sex of a hermaphroditic creature which, in the manner of a drawing by a child, sprouts a phallus where normally one might expect a leg or an arm to be. Allowing for the period's ideological investments in the body, what sort of politics can be extrapolated from this anarchy of anatomical parts?[182]

transgression politics

Whilst acknowledging the limitations of modernist revolt exposed by Suleiman's incisive analysis, it is important not to lose sight of the dimension of critique implicit in avant-garde transgressions. We need to ask ourselves how Picasso's decomposition of the classical body could have signified within a highly polarised cultural and political field. It was noted in our analysis of the *rappel à l'ordre* that the postwar culture freighted classicism with associations of order and the authority of tradition. This section aims to reconstruct a discursive field within art criticism whose governing terms were those of form versus the formless. It also seeks to highlight the degree to which Picasso's work became around 1930 a focus for debate about the nature of the human and for claims about humanism; this last term, in particular, is shown to have been much contested in this period.

'Le Cheval académique' is a study of Celtic coins by Bataille, who was trained as a numismatist, though the article rapidly dispenses with any pretence to scholarly detachment.[183] It is concerned with coins bearing the image of a horse, evidently derived from Greek and Roman coins bearing the same motif, but gratuitously distorted. With an eye to the present day, Bataille remarks that the alternation in different historical epochs of academic classical forms with deviant, baroque ones is a reflection of underlying differences between the social formations that gave rise to them. Celtic civilisation, he asserts, was a veritable antithesis to the organised imperial society that gave birth to classical culture — to classical architecture and to the institutions which sustained its power. All this was foreign to the Celts 'who calculated nothing, had no conception of progress and gave a free rein to immediate impulses and to every violent emotion'.[184] The formal correlate of the anarchic social structure of the Celts, Bataille insinuates, was their dislocation of the classical horse which 'culminated finally in a frenzy of forms

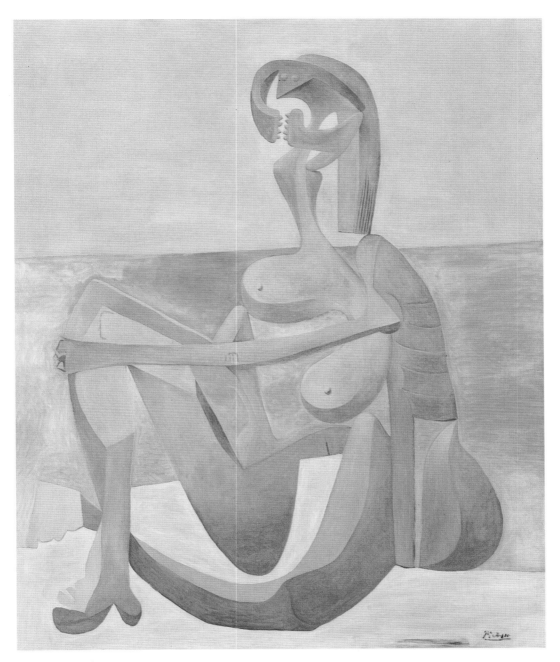

75 Pablo Picasso. *Seated Bather*. 1930. Oil on canvas, 163.2 × 129.5cm. The Museum of Modern Art, New York. Mrs Simon Guggenheim Fund.

that transgressed the rule and achieved an exact expression of the monstrous mentality of these people'. Such ugliness 'represented thus a definitive response of the human night, burlesque and hideous, to the arrogance and platitudes of idealists'.[185]

Picasso's *Seated Bather* (fig. 75) of 1930 is marked by a disparity between the subject, one of the most venerable in Western high art, and its disconcerting treatment. The hollow forms of this chimerical creature are hard and skeletal; its menacing vice-like countenance and stick arm transform the classical nude into a subhuman insect. It recalls the praying mantis whose weird anthropomorphism and capacity to perform automaton-like, even when decapitated, fascinated the surrealists. A female nude, seated against a tranquil Mediterranean backdrop redolent of classical antiquity, has been metamorphosed into a bestial and mechanistic contraption. We can characterise its relationship to a classical canon of beauty unequivocally as one of rupture, transgression, *subversion*.

That same year, 1930, Bataille gave his approbation to what he terms 'a bizarre but mortal subversion of the ideal and of the order expressed by the words classical antiquity'.[186] These remarks were made in the context of an article about the iconography of Gnostic coins but with an eye firmly fixed on contemporary trends. Indeed, Bataille's words aptly describe the *Seated Bather* which evokes memories of a classical motif but only in order to dismember it. Noting on Gnostic coins a mode of figuration in radical opposition to academic classicism, Bataille comments that 'in the same way today certain plastic representations are the expression of an intransigent materialism, of a recourse to everything that compromises the powers that be in matters of form, ridiculing the traditional entities.'[187] Who, one might ask, were the powers that be in the matter of form? One such cultural mandarin was Waldemar George, erstwhile supporter of Picasso, who as the editor of *Formes* had become by the 1930s a staunch defender of classicism, apeing in his rhetoric the worst of the reactionary Right. George championed the cause of the sculptor Aristide Maillol, of Catalan origin but a leading exponent of French classicism.[188] A marble version of Maillol's icon of classicism, *The Mediterranean*, commissioned by the state had been installed in the Louvre in 1929, and it is tantalising to imagine the *Seated Bather* as a calculated riposte to the Maillol whose pose it approximates. At any rate, the following year Picasso received a mauling in the art press from George who railed against: 'The chimeras of Pablo Picasso [which] are destined to be dumb still lifes . . . assemblages of form and colour, but not sources of energy or foci of a Mediterranean civilisation.'[189]

Formlessness (*informe*) was therefore placed at the antipodes to an aesthetic and attendant ideology of classical form as promulgated by George through *Formes*. Bataille assimilates Picasso's decomposition of the classical body to a base materialism in which the idea(l), the frock-coat that thought imposes on the world, is itself decomposed: 'when Picasso paints, the dislocation of forms leads to that of thought, in other words the immediate intellectual movement, which in other cases leads to the idea, aborts.'[190] At stake in this abortive operation within the field of representation is a conception of the human being completely at odds with the universalist humanism of Waldemar George. What has perhaps not been sufficiently recognised is the degree to which the alleged anti-humanism of Picasso became a subject of controversy around this time; the enthusiasm Michel Leiris evinces 'towards a painter who, like Picasso, dismantles under our eyes the human mechanism' was by no means universally shared.[191]

'The Dehumanisation of Art' was published in 1925 by José Ortega y Gasset who argues that the drive towards purity of formal means in modernist art entails the gradual abandonment of human elements found in Romantic or naturalistic art.[192] 'For', he writes, 'modern

art is an artistic art.' The modern artist flees the human face of reality: 'He has set himself resolutely to distort reality, break its human image, dehumanize it.'[193] Consequently, modern art is deeply unpopular with the masses who desire to see themselves and their day-to-day lives reflected in art. Allied with the fundamental tendency to dehumanise, where formerly art had ennobled man and lent dignity to humanity, Ortega discerns in modern art an ironic attitude and an avoidance of spiritual or transcendent claims. The modern artist eschews the personal and strives for impersonality (Mallarmé is the example he gives). A modern insistence on style is what dehumanises according to Ortega: 'to stylise is to distort the real, to make un-real. Stylization implies de-humanization.'[194] But the main weapon of the moderns, 'the most radical instrument of de-humanization', is metaphor: 'The lyrical weapon is turned against natural things and damages, even assassinates them'.[195] Surrealism, it appears, is the main culprit here. Ortega aims firstly to explicate, to describe what he sees as the condition of modern culture, and he does not overtly prescribe another course for art, though he does assert that a large part of the dehumanisation of and loathing for human forms arises from the modernist rupture with tradition.

Plainly, although Picasso is not explicitly mentioned by Ortega, his acknowledged role as a founder and foremost practitioner of modern art made him a target of such reproaches. Indeed, Jean Cassou in *Cahiers d'art* in 1927 observes wryly that 'For some, Picasso accomplished marvellously this "dehumanisation of art" that is prophesied almost everywhere.'[196] It has already been noted that Picasso's ironising of the classical style provoked the wrath of reactionary critics like Camille Mauclair. So too, amidst a resurgence of humanist beliefs, his perceived irreverence towards the human form became a matter of some contention.[197] Waldemar George deplores the lack of humanity, proffering his view on the occasion of Picasso's fiftieth birthday that: 'The salient feature of modern art is the death of the world considered as a huge still life [*nature mort*]. This death seems irremediable.'[198] It may be no more than a figure of speech, George's bleak evocation of a world devoid of human values, treated as stilled lives, but it emerges that Picasso had done just that in a large picture, *Musical Instruments on a Table* (now in the Galerie Beyeler, Paris) executed in the watershed year of 1926. The culmination of a series of still lifes from 1923 in which the first inklings of a realignment towards surrealism can be detected, this picture began life as a classical bather composition but was abruptly transformed in the course of being executed into a still life in a biomorphic idiom derived from Miró – that is to say, into something resolutely anti-classical. A dramatic metamorphosis of this order, from a figure-grouping into a still life, is not without a well-known precedent. The transition of *Carnival at the Bistro* of 1908 into *Bread and Fruit Dish* is no less astonishing, but in that case the final work contains no evidence of the switch in identity the composition has undergone, whereas in *Musical Instruments* vestiges of the original idea are deliberately preserved and displayed. The head and upper torso of a female nude can still be discerned peering through the opacity of a guitar body in the upper-right section of the canvas, which echoes her contour and seems virtually in the process of floating free from its origin in the figure. The question arises of why the classical nude has been left partially visible in the course of her effacement by a still life? Surely the purpose was to highlight the act of cancelling the classical nude with its concomitant values of measure – the human measure – and proportion; they are eclipsed by inanimate, *informe* shapes which seem to propose the transgression of all norms and to demand a revaluation of all values.

We may infer that Picasso's newly formed attachments to the surrealist movement helped foster an attitude of defiance towards classicism as this became overlaid with bourgeois

humanist values. Among the mainstream surrealists, René Crevel was especially outspoken on this issue. Cynical appeals to a universal humanity, he writes, are a smokescreen obscuring narrow class interests: 'it needed a prodigious and obstinate ruse by moralists and politicians in order that the word designating the whole of mankind came to signify no longer this concrete and living universality, but a qualitative abstraction . . . designed to thwart the future of humanity for the benefit of a favoured few.'[199] Crevel is doubtless in accord with Breton when he proclaims: 'from a withered humanity, surrealism resuscitated man',[200] but it is the dissident surrealism of Bataille and Michel Leiris that, unsurprisingly, affords a setting for Picasso's most trenchantly anti-humanist endeavours. *Seated Bather* makes use of metaphor much as Ortega had described, pitching the machine of analogy against the traditional nude which he demotes to a subhuman status. In 1931, the year following George's broadside against him, Picasso painted one of the most rebarbative images in his entire oeuvre, *Figures By the Sea* (*The Kiss*). An amorous embrace turns into a lethal duel between two monstrous combatants, like gulls squabbling over scraps of food except that here they devour each other. They have no eyes to see — their love is blind — and their flailing limbs, like a pile of ribs, are skeletal and deathly but spongy and turgid at the same time. In an article on the praying mantis, published in *Minotaure* in 1934, Roger Caillois comments on the reputed propensity of the female mantis for con-suming the male during coitus that the interest of this trait derives from the link it forges between Eros and death, from 'an ambivalent presentiment to find the one in the other'.[201]

Subtitled 'De la biologie à la psychanalyse' (From biology to psychoanalysis), this article attests to the impact of Freud's hypothesis of a death drive in surrealist circles following the belated translation of 'Beyond the Pleasure Principle' in 1927.[202] This influence is most evident at the point where Caillois comes to reflect on the capacity of the mantis, whose anthropomorphic aspect relates it to our human predicament, for carrying on all the vital functions of life even after being decapitated, including, 'what is truly alarming, to fall, in the face of danger or after a peripheral stimuli, into a false, cadaveric immobility: I express myself in this round-about way because language, it seems to me, has difficulty signifying, and reason comprehending, that dead, the mantis can simulate death.'[203] The aporia that Caillois defines here, that 'dead' the mantis is able to mimic death just as well as it could while still alive, short-circuits the barrier that humanist thought maintains between life and death. In a similar manner, Freud's text destabilises this binary opposition. Unable securely to locate death and repetition beyond the pleasure principle, as the essay title announces, Freud repeatedly finds them cropping up *within it* such that he is led to conclude that: 'The pleasure principle seems actually to serve the death instincts.'[204] The evocation of desire as enmeshed with aggressivity, of desire itself as a shattering, unbinding force disruptive of all unities — of the body, of thought, of self — points to another crucial distinction between Bataille and the Breton of, say, *L'Amour fou*. It is a position authorised by the Freudian corpus but one from which Freud himself takes a step back when, near the end of 'Beyond the Pleasure Principle', he endeavours once again to separate as two dualistic principles Eros, a force which binds together and creates greater unities, and Thanatos, a force of unbinding.

Writing in *Documents*, Michel Leiris asserts that the so-called perversions of the sexual instinct are closest to man's true nature: 'masochism, sadism and almost all the vices . . . are only means of feeling more human — because of a deeper and more direct rapport with the body.'[205] Disparaging the 'conventional nude of official painting — clean and combed, and in a way *dehumanised*',[206] Leiris writes in laudatory tones about Picasso's recent works in an article which

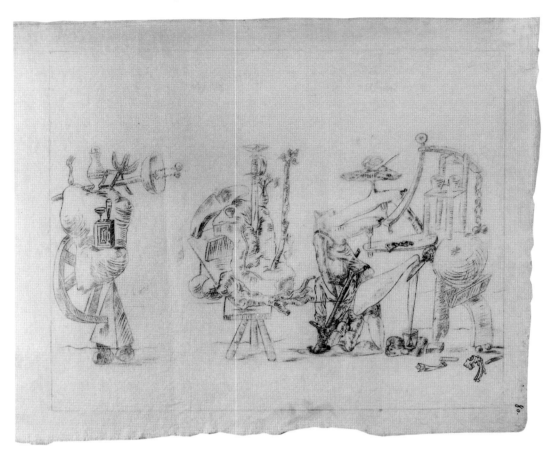

76 Pablo Picasso and Salvador Dalí. *Cadavre exquis*. 1933–4. Mixed technique, 36 × 42.5cm. Paris: Musée Picasso (MP 3253).

defends him against the charges of dehumanisation coming from Waldemar George and those of his ilk, insisting that we overlook the real significance of the work by viewing it simply as an assault on an already obsolete classical ideal: 'Under the pretext that Picasso has rebelled against academic canons, one praises him for attacking antique beauty – pale, cold and idiotic like a nymph in a square – and having invented disquieting and monstrous forms.'[207] Picasso's recent figurative works only seem fantastic and unreal to eyes grown accustomed to lies and illusions when they actually lay bare honestly, and for the first time, what really constitutes our humanity: 'never until him in the artistic domain has anyone so powerfully affirmed what makes our nature and our humanity.'[208]

In 1933, Picasso and Dalí produced an etching together in a unique collaboration (fig. 76) that seems to have been the brainchild of Dalí who was working at the time on his etchings for *Les Chants de Maldoror* at the Lacourière Press. The starting point was a Picasso etching of three surrealist figures dated 19 May 1933.[209] Employing a photographic process known as heliogravure to transfer this source image on to a new etching plate, Dalí splayed the figures apart just wide enough to make room for his own additions: a male and a female figure extracted from the *Maldoror* etchings, who link arms with a Picasso assemblage. While an

additive principle similar to the game of *cadavre exquis* underlies the procedure, one could object that it is not a truly collaborative exercise, with Picasso's role limited to, at most, giving his assent to the use of an etching. But that would be to underestimate the degree of reciprocity and dialogue shown by Picasso's inclusion in his etching of distinctively Dalinian obsessions with culinary implements, sado-masochistic eroticism and such like. Recalling that Picasso singled out 1933 as the only year in which he would concede surrealism having had any influence on him, this jointly authored plate is a kind of visual intertext attesting to the convergence of the two artists' preoccupations just at this moment.[210] It is to Dalí's *Maldoror* illustrations, the most-sustained exploration of abjection and aggressivity in surrealist visual art, that we now turn.

4 DISGUST

The centrepiece of the first issue of *Minotaure* in May 1933 was an essay by André Breton, 'Picasso in his Element', his first extended commentary on the artist since the eulogistic first instalment of 'Surrealism and Painting' in 1925.[1] It is abundantly obvious that Breton's admiration for Picasso had in no ways diminished in the intervening years; the tone of the later article is none short of laudatory and passages of intense poetic lyricism reveal that Breton continued to be inspired by that scintillating fantasy which made of Picasso, notwithstanding his independence of the movement, an ideal embodiment of the surrealist spirit. That is evident from the underlying principle that Breton extracts from a detailed survey of his recent artistic output, conspicuous amongst which were a number of collages. With a nod in the direction of Picabia, or even Miró, these works differ from the collages he and Braque had created in 1912 by their incorporation of extremely heteroclite materials — refractory, one would have supposed, to the purposes of making art. Well before Damien Hirst had thought of doing likewise, Picasso ensnared a real butterfly in a field of cream emulsion, along with a leaf and whimsical stickmen composed of a drawing pin, matchsticks and rope. His capacity to integrate these extraneous elements of reality into the field of representation without destroying it testified, in Breton's view, to a powerful unifying impulse at work, to 'the continuously dialectical progress of this thought'.[2] An avid butterfly collector (one wonders if Picasso was forearmed with this knowledge), Breton could not resist putting this work at the head of his article. More surprising, given the lofty tone of his piece, is the example with which Breton chose to conclude: a tableau, alas no longer extant, that Picasso informed him was meant to contain actual human excrement. Lacking the genuine substance — one of those rare and exquisite turds with undigested pips left behind in the countryside by children who have gorged on fresh berries — he was forced to use oil paint instead, but Picasso assures the poet that the flies needed to complete the picture would, at least, have been real. Breton prefaces his description of this work with the observation that: 'A mind so constantly and exclusively inspired is capable of turning everything into poetry, of ennobling everything.'[3] That he manages to distil from this tale, earnestly recounted, an edifying message about the sublimation of base material into art is, if nothing else, proof of Breton's incomparable skill in ratiocination. Contemplating the work, he discovers that whatever slight feeling of distaste the subject at first induced in him is quickly dissipated as he is transported to an *elsewhere* — 'where the weather was fine, life was pleasant and I was surrounded by wild flowers and morning dew . . .'[4]

For Bataille, no doubt, Breton's reflections on Picasso in this essay would have been a prime example of the poetic indulgence and escapism of which he was so scornful, and to which as we saw in the previous chapter his base materialism was resolutely opposed. The inordinate amount of space Breton devotes to discussing this slight work (which is not even reproduced in the article) suggests an anxious need on his part to recuperate it to the elevated terms

of his prose. In his attempts to do so, yet another basic point of difference between himself and Bataille, whom Breton in the *Second Manifesto of Surrealism* castigates as an 'excremental philosopher', is exposed. Breton asserts that the fundamental issue posed by Picasso's collage, which 'may well be considered the essential motivating force of artistic creation', is that of 'the very particular interest which the relationship between the unassimilated and the assimilated should arouse'.[5] If Breton's aesthetic bias is towards assimilation, we can range Bataille's anti-aesthetic, by contrast, under the sign of the unassimilable or what he himself terms the heterogeneous. Were a bodily metaphor to be invoked here, it would be that of a violent expulsion. EXCRETION and APPROPRIATION define two essential, polarised human impulses, according to Bataille.[6] The second of these impulses seeks to establish a state of homogeneity (identity) between the subject and object. It is this principle that governs systems of production, accumulation and exchange, against which Bataille pits the excremental forces of the heterogeneous. The realm he denotes as the heterogeneous corresponds to the homogeneous, everyday world of utility and rationality as the sacred does to the profane: 'The notion of the (heterogeneous) *foreign body*', Bataille avers, 'permits one to note the elementary *subjective* identity between types of excrement (sperm, menstrual blood, urine, faecal matter) and everything that can be seen as sacred, divine, or marvellous.'[7]

Bataille imports the notion of a foreign body (*corps étranger*) from pathology, where it connotes an object or substance that does not properly belong where it is found, especially something of extrinsic origin that is recognised by the body as 'foreign', i.e. non-self. The foreign body is a kind of Trojan horse that implants a kernel of heterogeneity in the body, one's own body (*corps propre*); self is contaminated by non-self, inside by outside; boundaries are breached, traduced, transgressed. A foreign body, a wooden splinter for example, in order to reach its present site, has of necessity violated the integrity of the body's surface. So our topic is one that touches upon boundaries of the self and whatever poses a real threat — a threat from the Real — to the borders or limits of a body only ever imagined as a self-contained whole.[8] To fears of dirt and defilement. As Bataille describes it, the foreign body is a focus for an eruption of excremental forces which exceed their function of simply expelling the object in order to reestablish a state of homogeneity; rather, the whole of oneself is put into a state of abjection: 'a more or less violent state of expulsion (of projection)'.

The foreign body affords Bataille a resonant metaphor for the heterogeneous, or sacred, world as whatever constitutes a definitive rupture with the principle of homogeneity governing the profane. It is, admittedly, a peculiar notion of the sacred that is being invoked here. Bataille is at pains to insist that the sacred is not only that which is elevated but also that which is base and abject; the sacred is not only that which inspires awe but also that which repels and evokes disgust. 'The identical nature, from the psychological point of view, of God and excrement, should not shock the intellect of anyone familiar with the history of religions' writes Bataille.[9] The Bataillean concept of an impure sacred stems from Emile Durkheim who stated that 'the pure is made out of the impure and reciprocally. It is in the possibility of these transmutations that the ambiguity of the sacred consists.'[10] Durkheim extrapolated this view from the ambivalent attitude evinced by primitive peoples towards dead bodies: initially perceived as a threat to the living which an elaborate system of taboos is meant to defend against, a decomposing corpse can switch in valence to become an object of cultic veneration. For Bataille, horror marks the threshold of the sacred.

No trace remains of a picture that Breton, relying largely on what Picasso had told him about it, describes in such meticulous detail. This leads William Rubin to speculate that Breton,

notoriously humourless, has been the butt of an elaborate hoax. Picasso's provocation to the poet, if that was his intention, carries more than a whiff of one of Dalí's pranks about it, and it may indeed be the case that Picasso was playing on the brouhaha caused by Dalí's *The Lugubrious Game* in 1929. Given the sensitivity of the moment – a nadir in the relations between Breton and Bataille – the shit-smeared pants of the male figure in the foreground of the picture were bound to be a source of embarrassment to Breton, something that Bataille endeavours to exploit in an article on the picture. Where Breton speaks in elevated tones of Dalí throwing wide open the mental windows, Bataille, scoffing at this 'emasculated poetic complacency', finds only 'the screaming necessity of a recourse to ignominy'.[11] Though Dalí's refusal to allow Bataille permission to reproduce the picture alongside his article – a tactical decision made for reasons of political expediency – effectively ruled out any further cooperation between them, the parallels between Dalí and Bataille on the issue of abjection are compelling, as Dawn Ades has argued.[12] One of the purposes of such a comparison, to which I shall return in considering Dalí's etchings for Lautréamont's *Les Chants de Maldoror*, is to reinstate the issue of subjectivity which has been missing from recent quasi-structural appropriations of the Bataillean formless (*informe*).[13] Subjectivity is from the start implicated in the network of concepts, which includes the heterogeneous and the abject, that Bataille elaborates around the formless.

on Dalí's abjection

The first issue of the relaunched surrealist journal, *Le Surréalisme au service de la révolution*, a sober-looking publication whose title is indicative of Breton's attempt to build bridges with the Communist Party, carried an article in 1930 by Dalí titled 'L'Ane pourri' (Rotten donkey). Two years later, the essay was republished in the surrealism special issue of *This Quarter* as 'The Stinking Ass', an imperfect translation but having the virtue of alluding to that other source of Dalí's increasing renown. The most promising new recruit to Breton's surrealist group risks heresy in this, his first theoretical statement of any consequence, by daring to ask whether the *terre de trésors* that the surrealists hankered after, namely the unconscious with its component drives, is not, after all, to be found concealed beneath 'the three great simulacra' which are blood, shit and putrefaction. Continuing in the same scabrous vein, Dalí remarks that: 'we have long ago learned to recognise the image of desire hidden behind simulacra of terror, and even the awakening of "Golden Ages" in ignominious scatological simulacra.'[14] One cannot imagine Breton drawing much comfort from sentiments such as these which were dangerously close to those of his sworn enemy, Bataille. As if to forestall criticism, Dalí alludes at several points to Breton's catalogue preface for his first solo exhibition in Paris the previous year and makes a gratuitous swipe at Bataille's 'non-dialectical' materialism. But his manifesto finishes on as uncompromising a note as it began: 'It needs to be said,' writes Dalí, 'to all art critics, artists, etc., that they need not expect from the new surrealist images anything other than disappointment, foulness and repulsion.'[15]

This chapter will be concerned primarily with the abject in Dalí. It would require another to do justice to the complex issue for art history of Dalí *as* abject, but a few remarks about this will, I hope, suffice to establish the parameters for a project that seeks to reevaluate Dalí via themes of abjection in his work. At the outset, it must be said that art critics and historians have generally reacted to Dalí with the visceral disgust that it would seem, from the above

quotation, he both invited and fully anticipated. One would be hard pressed to think of another major, avant-garde artist for whom there is such a striking correlation between their level of popular acclaim and critical disdain.[16] Dalí's stigmatisation, his abject status in art history, has much to do with the imperatives of a formalist paradigm that was dominant in the profession. In saying this, it is important to bear in mind that, as his reputation began to be established in the 1930s, Dalí soon found his most avid following in America where he had a commercial outlet with the Julien Levy Gallery. This period coincides with the formation of the Museum of Modern Art in New York, an institution with an explicit agenda to promote the cause of modernism, which for its collectors and apologists was viewed as an endangered species, attacked in the mid-1930s by left- and right-wing proponents of realism. The institution of art criticism also swung into action to defend modern art, and it is at this point that Clement Greenberg emerges as an important spokesperson for modernism.

An embattled modernism with its powerful defenders; these are the circumstances, then, that shaped initial reactions to Dalí, an unstoppable and very public phenomenon who simply could not be ignored. So many of the rhetorical tropes that in later writings about Dalí become obligatory gestures by critics eager to distance themselves from him are put in place at this time. Though Dalí was by no means blacklisted by the Museum of Modern Art, which mounted an exhibition of his work in 1941, the exhibition curator, James Thrall Soby, plainly saw him as spearheading the realist challenge to a beleaguered abstract tradition, writing that: 'it seems clear that Dalí has brought to a head the particular kind of anti-abstract revolt . . . he has helped restore representational painting in general, and objective exactitude of technique in particular, to a popular favour which they might have rewon more slowly without him.'[17] These assertions, which it appears Soby was obliged to moderate under pressure from the museum's director of painting and sculpture, Alfred H. Barr, were not unfounded. An essay by Dalí published in New York by the Julien Levy Gallery in 1935 is outspoken in its denunciation of the 'abject misery' of *Abstraction–Creation*, the French equivalent of the abstract movement in the United States.[18]

For Greenberg, writing in 1939, the German word *Kitsch* encompassed the assorted threats, ranging from socialist realism to a homespun capitalist mass culture, that he perceived modern art as having to withstand at all costs.[19] Kitsch is a debased currency, an *ersatz* culture of 'vicarious experience and faked sensations'. That Greenberg should equate kitsch with 'the debased and academicized simulacra of genuine culture' is interesting with respect to Dalí since it was he who single-handedly introduced the simulacral into surrealist discourse and art practice. Naturally, when he comes to write about Dalí, Greenberg ranges him under the sign of kitsch, to the extent of repeating almost verbatim his enumeration of its diverse forms in the 1939 essay, 'Avant-Garde and Kitsch'.[20] With reference chiefly to Dalí, he comments that the surrealists 'prize the qualities of the popular reproduction' and 'for the sake of hallucinatory vividness . . . cop[y] the effects of the calendar reproduction, postal card chromeotype and magazine illustration'.[21] A Dalí picture unashamedly feigns the look of a cheap postcard reproduction of itself: 'his work is not so much eminently reproducible as a reproduction already' observes Waldemar Januszczak.[22] The danger and the reason why it must be rejected beyond the pale of genuine art is that the simulacral risks undermining the very oppositions on which the defence of modernist culture is to be based: the distinction between original and copy, authentic and fake. Indeed, it could perhaps be shown that the problem of imitation represents something of an aporia in Greenberg's theoretical project, that is to say his attempt to distinguish between a legitimate form of imitation – for avant-garde culture is defined by

Greenberg as 'the imitation of imitating' – and imitation of a false or insidious kind in the simulacral forms of kitsch. Taking up the cudgel from Greenberg, the critic Carter Ratcliffe in an essay titled 'Swallowing Dalí' (which has the merit of revealing the visceral substrate of the intellectual operation of expulsion) would have us learn an object lesson from Dalí about the perils of postmodernism, warning direly that it is Dalí's *inauthenticity* that matters most.[23]

The abject for these modernist critics has a name. It is Dalí. He stands for everything abhorred by modernism, for what it must at all costs withstand, cast aside or abject in order to be itself. But this is exactly as Dalí intended. Whichever of his many artistic or literary endeavours one chooses, it can easily be shown that Dalí calculatedly stakes out for himself an anti-modernist position in the 1930s. 'How to become anachronistic?' begins an article by Dalí in 1934, and it is his wilfully contrived and seemingly perverse anachronism that most obviously offends against the aesthetic pieties of the day.[24] As moves were afoot to expel Dalí from the surrealist group for reactionary tendencies, a long-winded letter from him to a plainly sceptical Breton robustly defends the retrograde academicism of Meissonier, whom Dalí acknowledged as a source for his miniaturist technique, on the grounds that it objectifies in the most precise way the subtlest nuances of dreams and phantasies. While protesting his unconditional surreality, Dalí is hardly contrite and tries to persuade Breton that it is a positive virtue of his technique from the surrealist point of view that it is discredited and indefensible on aesthetic grounds:

> I dare to say and I believe it that an *academic* technique would be the most adequate and the least artistic *means* for the copying and reproduction of certain visions and irrational images which are characterised by the paroxysmal exacerbation of their concreteness, as well as for the materialisation and objectification of certain involuntary phantasies [and] dreams, all the value of which resides in the feeblest nuance of lighting or facial expression, etc. From my point of view, only an academic technique totally discredited and *indefensible from an intellectual aesthetic angle* should be taken into consideration by the surrealists and made use of in order to objectify with the maximum of *trompe l'oeil*, with the maximum of fetishistic illusionism the content of a delirious new world to which we have only just gained access and which remains for the moment incommunicable by no matter what other means.[25]

By the same token, I think one can extrapolate from this and other cases, for example his championing of the outmoded forms of art nouveau architecture, to argue that Dalí's exploration of the abject is yet another facet of a programmatic anti-modernism. As a reviewer of the Tate Gallery retrospective in 1980 has it: 'Dalí's pictures, an abbatoir of icons, are strewn with the displaced human organs abstraction has hurled away as offal.'[26]

In *Civilisation and Its Discontents*, Freud propounds a sort of evolutionary fable in which man's assumption of an upright posture leads to various fateful consequences: vision is elevated and there is a concomitant devaluation of other sensory modalities, notably olfaction.[27] The genitalia, previously hidden beneath the body, are now exposed and visible, giving rise to feelings of shame and repugnance. A wholesale organic repression of the sexual function occurs, forcing the instinct away from its immediate aim into culturally prescribed sublimations. A further consequence related to the depreciation of smell is a reversal in the attitude towards excreta, which, Freud notes, arouse no disgust in children or animals, but for the adult human are 'worthless, disgusting, abhorrent and abominable'. The resultant horror of dirt and the drive to cleanliness only later comes to be justified by considerations of hygiene. Now, the process outlined can be read as an allegory of modernism, of its quest for transcendence and

77 Catalogue of *Effluvia*, an exhibition by Helen Chadwick. Serpentine Gallery, London, 19 July–29 August 1994.

purity, of course, but also its valorisation in Greenberg's formulation of a 'purely optical experience as against optical experience modified or revised by tactile associations'.[28] The overthrow of this bodily and sensory hierarchy in recent art has seen a riotous liberation of the abject body and the invasion of the clean, white spaces of the modern art gallery by dirt and bodily effluvia, as well as all manner of obscene noises and smells. Helen Chadwick's exhibition *Effluvia* (fig. 77) is a prime example of an art-world phenomenon that provides a lead for how one might care to situate Dalí's landscape of scatological delights (fig. 78) in relation to the hegemonic modernism of the 1930s.[29] With the eclipse of modernism and the proliferation of abject art, could it even be that the abject in Dalí provides an avenue for his art-historical rehabilitation? The history of art is littered with stranger reversals in fortune.[30]

78 Salvador Dalí. *Accommodations of Desire*. 1929. Oil and collage on board, 22 × 35cm. Metropolitan Museum of Art, New York. Jacques and Natasha Gelman Collection, 1999. (1999.363.16)

i a modern Midas: Dalí's *Maldoror*

'I can scarcely enumerate for you all the things that I (a modern Midas) turn into — excrement.'[31]

A letter from Salvador Dalí to the collector Charles de Noailles of 28 January 1933 excitedly relates the 'great news' that he is about to sign a contract with Albert Skira, the Swiss-based publisher of the surrealist journal *Minotaure*, to illustrate Lautréamont's *Les Chants de Maldoror*. 'It has always seemed to me the most gripping thing to do' enthuses Dalí, who had a year in which to produce forty etchings.[32] Among the surrealists, who helped rescue it from oblivion, *Les Chants de Maldoror* was fanatically revered, so one can well understand Dalí's elation at being invited to illustrate it. It was also quite a coup for a young artist still in his twenties to have netted such a prestigious contract for an artist's book following similar ventures by Skira with Picasso and Matisse, and a sign of Dalí's growing cachet that the publisher was willing to take a gamble on its commercial success in the midst of a severe economic downturn.[33]

Though they can be ranked securely as some of Dalí's most brilliantly inventive work, spawning a number of his major paintings in the 1930s, only the slenderest of threads it seems connects the etchings with *Les Chants de Maldoror*, their ostensible pretext. Renée Reise Hubert, one of the few authors to have discussed them at any length, remarks that 'the plates rarely refer to the text in a recognisable manner' and concludes disappointedly that Dalí 'only sporadically establishes connections' with the narrative.[34] But Dalí had already protested, in a foreword for an exhibition of the completed prints at the Galerie des Quatre Chemins in Paris early in 1934, that the mere fact of illustrating a book could not be expected to restrain in the least the course of his delirious ideas. Indeed, I want to argue here that a shift of focus is required: as an exercise in paranoia-criticism, in fact its veritable *tour de force*, the etchings need to be viewed as interpretation rather than straightforward illustration. Dalí's visual imagery interprets the written text of *Maldoror* and, as will hopefully emerge, their madness contains more than a grain of truth.

We need to bear in mind the extraordinary investment of the surrealists in this book in order to gauge the stakes involved in Dalí daring to reread it. For the aspiring surrealist writer one had only to follow where Lautréamont had dared to pass. *Les Chants de Maldoror* had conferred upon it retrospectively the status of origin for an entire literary and aesthetic endeavour. It was the novel use of poetic imagery based on incongruity between the two terms of a metaphor, encapsulated in the famous *beau comme* stanza, repeated like a talisman in almost every text by or about the surrealists, then or since, that captivated André Breton and opened the way to an authentic surrealist use of language. Its discovery in 1918 was nothing short of a revelation for Breton who copied out long extracts in letters to Louis Aragon and Théodore Fraenkel. This correspondence, examined by Marguerite Bonnet, reveals a consistent bias in the selections made by Breton, who eschews those passages 'where the furies and demons of eroticism and cruelty are unleashed' and retains only those 'that touch upon the poetic experience and its expression'.[35]

Dalí's priorities were quite the reverse of Breton's. He turns by preference to those points in the text where poetic lyricism is undercut by couplings of a more bestial, degraded nature, such as the account of Maldoror making love with a shark or, more unsavoury still to Breton,

of Maldoror's sexual predations on assorted virginal youths he chances across. We might as well say Dalí reads a different text to Breton. Every bit a modern Midas like Freud, in his hands *Les Chants de Maldoror* oozes with the 'three great simulacra' – shit, blood and putrefaction.

delirium of interpretation

The execution of the *Maldoror* project coincided with Dalí's elaboration of the paranoiac-critical method and it is to that, and the matter of interpretation, that I turn to first of all. André Breton, in *What is Surrealism?* of 1934, gives a ringing endorsement to Dalí's chief contribution to surrealist theory:

> Dalí has endowed surrealism with an instrument of the first order, namely the *paranoiac-critical method*, which immediately showed itself capable of being applied with equal success to painting, to poetry, to cinema, to the construction of typical surrealist objects, to fashion, sculpture, the history of art and even, if necessary, to all manner of exegesis.[36]

The last-enumerated item is far from being the least important. Dalí packaged and promoted his paranoia–criticism as, first and foremost, a method of interpretation. Unlike Breton who prevaricated on the question of interpreting the outpourings of the unconscious, Dalí presented this as a reason for the superiority of his method over automatism and dream narratives, until then the two mainstays of a surrealist visual practice. A high-profile article by Dalí in the very first issue of *Minotaure* asserts truculently that 'the delusion assumes a tangibility which is impossible to contradict, placing it at a very opposite pole to the stereotyped character of automatism and the dream.'[37] Forced on to the defensive by Dalí's onslaught, Breton reiterates the centrality of automatism to the surrealist project, at the same time conceding its 'continuing misfortune', in 'The Automatic Message', an essay timed to appear in the following issue of *Minotaure*. The challenge to Breton was more blatant in 1935 when Dalí proffered a dictionary-style definition of paranoia as if to countermand the original definition of surrealism set down in the *Manifesto* of 1924.

> Paranoia: delirium of interpretative association entailing a systematic structure. *Paranoiac-Critical Activity: spontaneous method of irrational knowledge based upon the interpretative-critical association of delirious phenomena.*[38]

Dalí's terminology, note, is precise and surprisingly technical. Though the paranoiac-critical method was a confection of various things, the conception of paranoia upon which it relied, and especially the fundamental concept of an interpretative delirium (*délire d'interprétation*), derives in large measure from sources in French psychiatry.[39] In 1909, Sérieux and Capgras described a condition of 'chronic systematised psychosis based on delusional interpretations' (such cases would be diagnosed as paranoiacs under the taxonomy soon to be introduced by Kraepelin).[40] The core feature of the condition is interpretation, which the authors define as follows:

> a false reasoning having as point of departure a real sensation, an exact fact, which, by virtue of associations of ideas linked to tendencies, to affectivity, assumes, aided by erroneous deductions and inferences, a personal significance for the patient, compelled invincibly to relate everything to himself.[41]

It is characteristic of the delusional interpretation that it ramifies and extends, joining with other thoughts to become organised into a system; it has a markedly egocentric character and is filled with personal significance; it inspires a feeling of total conviction which defies rational argument to the contrary; and, furthermore, there is a strong inclination to act on the basis of the delusional idea ('tending towards realisation, the delusional interpretation orientates and dominates activity'). The terminology of Sérieux and Capgras and each one of the clinical features they ascribe to the condition is faithfully reproduced when Dalí puts into practice his paranoiac-critical method.

Dalí's *Minotaure* article of 1933 signals as an event of capital importance for the theoretical understanding of paranoia the recent publication of a doctoral thesis by a young psychiatrist, Dr Jacques Lacan, who straightaway contacted Dalí on learning of their shared interest.[42] Lacan's *On Paranoiac Psychosis In Its Relations to the Personality* was timely because it offered Dalí an authoritative scientific voice which broadly corroborated his own ideas. Still writing from within the institutional and discursive bounds of psychiatry, but already receptive to psychoanalysis, Lacan rejected the mechanistic approach of his mentor de Clérambault for whom the actual content of hallucinations and delusions was unimportant – at their meeting, Dalí reports, he and Lacan were pleased to find 'our views were equally opposed, and for the same reasons, to the constitutionalist theories then almost unanimously accepted.'[43] Lacan was of the opinion that the paranoiac's delirium made perfect sense when viewed in the context of the whole personality. '*Once systematised*, the delusion merits an attentive study. In the case we describe, it *signifies* in effect in a very legible fashion . . . the unconscious *conflict* which engendered it.'[44] Most crucially, Lacan's insistence that paranoiac delusions interpret the unconscious endorsed Dalí's prior claim in the essay 'L'Ane pourri' of 1930 that 'the new simulacra that paranoiac thought can cause to appear suddenly not only have their origin in the unconscious, but also the force of the paranoiac faculty will be put at its service.'[45] The relevant passage from Lacan's thesis concerning exactly what it is that a paranoiac delirium signifies, and what it interprets, is sufficiently important for Dalí to warrant quoting in full:

> This first characteristic of the delirium deserves to be noted: the evidence for the signification of the delirium. Utterly unlike the symbolic obscurity of dreams, it leads us to say that 'in the delirium the unconscious expresses itself directly in the conscious' . . . One can say that, contrary to dreams, which must *be interpreted*, the delirium is by itself an *interpretive* activity with regard to the unconscious. Thereby a completely new meaning is given to the term '*délire d'interprétation*'.[46]

Dalí paraphrases Lacan in his *Minotaure* article on paranoia, affirming that 'the paranoiac delirium constitutes in itself a form of interpretation.'[47] (Incidentally, the claim that the unconscious is expressed *directly* in the paranoiac delirium without the distortions usually found in dreams adds some credence to Breton's view that: 'It is perhaps, with Dalí, the first time the mental windows have been opened wide.')[48]

Considered as a hermeneutical method, as a form of interpretation, paranoia bears more than a passing resemblance to psychoanalysis itself. Both interpret the unconscious, claim to speak the truth of the unconscious. Freud comments that: 'Paranoia decomposes just as hysteria condenses. Or rather, paranoia resolves once more into their elements the products of the condensations and identifications which are effected in the unconscious.'[49] Paranoia is analagous, in this respect, to the work of psychoanalytic interpretation which consists in painstakingly unpicking the disguises undergone by an unconscious wish in order to bypass

80 (*above*) Detail of fig. 81.

79 (*left*) Jean-François Millet. *The Angelus*. 1858–9. Oil on canvas, 55 × 66cm. Paris: Musée d'Orsay.

the ever-vigilant censor on the road to becoming conscious. The parallels do not stop there. Just like the psychoanalyst, paranoiacs have a propensity to divine occult or secret meanings and connections in the most insignificant and unpropitious of circumstances: 'There where others see only a coincidence, they, due to their interpretive clairvoyance, know how to unravel the truth and the secret rapports among things.'[50] Thus it is possible to regard the delusions of a paranoiac as holding a mirror up to psychoanalysis – an irony not lost on Freud who, in the course of his analysis of the paranoiac Schreber, writes that: 'It remains for the future to decide whether there is more delusion in my theory than I should like to admit, or whether there is more truth in Schreber's delusion than other people are as yet prepared to believe.'[51] Apparently, Dalí was well apprised of this ambiguity since he exploits it to the full in his textual-cum-pictorial analysis of Jean-François Millet's *The Angelus* (fig. 79) which, fervently pursued over several years, is the most sustained and comprehensive attempt to implement the paranoiac-critical method as a mode of exegesis.

Dalí was able to pin-point a moment in June 1932 when the image of Millet's *Angelus* abruptly and without explanation invaded his consciousness. It was this sudden revivification of a memory trace, rather than an immediate sensory perception, which served as the nidus for an ever-expanding web of delusional associations. As a child, Dalí recalled being singularly moved by a reproduction of the *Angelus* which hung in his classroom, a sentiment he later guiltily suppressed in the face of avant-garde disapproval. However, with the onset of his retrospective delirium, this rather anodyne image of pious peasants was gradually revealed as 'the most troubling, the most enigmatic, the densest and richest in unconscious thoughts ever known'. The body of paintings and writing generated by Dalí's single-minded obsession with the picture affords the most complete illustration of how the paranoiac-critical method was meant to operate as a method of interpretation. The article that appeared first in *Minotaure* in 1933 proved to be merely the prelude to a book-length study entitled *The Tragic Myth of Millet's 'Angelus'*.[52] Although this *magnum opus* did not see the light of day until 1963, evidently because the manuscript was mislaid at the outbreak of war when Dalí was forced to beat a hasty retreat from Paris, we can be certain that the main elements of the systematised delirium it records were already in place by 1933. Thus it can be read in conjunction with an extensive body of works on the theme of Millet's picture which Dalí produced between 1932 and 1934. The one

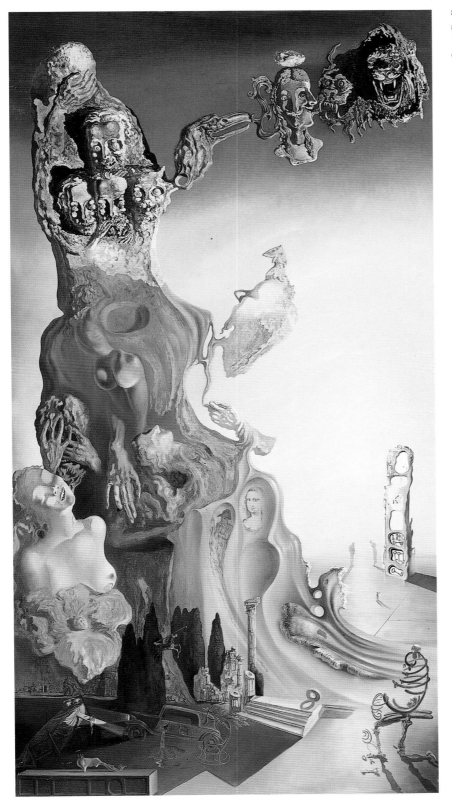

81 Salvador Dalí. *Imperial Monument to the Child-Woman*. 1929–34. Oil on canvas, 142 × 81 cm. Madrid: Museo Nacional Centro de Arte Reina Sofía.

exception, apparently, is the inclusion of the Angelus couple in the background of *Imperial Monument to the Child-Woman* (fig. 80), a picture generally assigned to 1929. On close examination, however, it is apparent that a good many of the motifs crammed into it must have been added after this date, and the picture is therefore best understood as a compilation of Dalí's obsessions loosely connected around the phantasy image of Gala, ranging from 1929 to November 1934 when it was first exhibited.[53] It follows also that the crystallisation of Dalí's ideas on the *Angelus* overlaps and, as we shall see, thoroughly permeates his work on the *Maldoror* project.

The *Tragic Myth* purports to be written from the point of view of the paranoiac and is imbued with the utter conviction and incontrovertibility that is the mark of that condition. Like the memoirs of Daniel Paul Schreber, analysed by Freud, it is essentially an autobiographical document tracing the gradual systematisation of a paranoiac-delusional belief system. Dalí's initial obsession with the *Angelus* was followed by a variety of secondary phenomena, associations and phantasies which disclose a latent content within the former that are described in clinical detail. Dalí, naturally, was eager to deny the intervention of conscious reason ('pensée dirigée') in the application of his method, a crucial prerequisite for its acceptance by the surrealists, seeking legitimacy in Lacan's insistence that the delirium presents to the conscious mind with an immediate sense of conviction and is *never* the result of any conscious deliberation. Lacan had abandoned an older conception of paranoia as a *folie raisonnante* in which the process of systematising of the delusional belief system was thought to be due to a reasoning process that originated from a false premise.[54]

Dalí's strenuous efforts to persuade the reader of the unpremeditated character of his analysis are somewhat disingenuous, as it is undoubtedly the case that this hermeneutic project was modelled if not on Freud's Schreber case then certainly on his case-study of Leonardo to which the 1933 article on the *Angelus* makes explicit reference.[55] That the cases of Millet and Leonardo were precisely analogous was confirmed *post facto* in Dalí's eyes by an incident that occurred after his essay had been written in which the *Angelus* was vandalised by a deranged assailant. Dalí learnt from Lacan who interviewed the man, a paranoiac, that he had at first prevaricated, unable to decide whether to attack the *Mona Lisa*, Watteau's *Embarkation for Cytheria*, or the *Angelus*. As Dalí proceeds to demonstrate, the paranoiac had fathomed a common element among these disparate works, Oedipal in nature, which, once revealed, no one in their right mind could deny. Dalí's and Freud's interpretations both deal with very famous paintings and use this fame as a guarantee of the general validity of the interpretations they make. The *Angelus*, Dalí notes, is one of the most widely reproduced images in France, a *petit-bourgeois* icon likely to crop up on anything from teacups to postcards. The patent overestimation of this drab, naturalist image Dalí treats as symptomatic and, like Freud with the Mona Lisa, he embarks on a search for the unconscious determinants of its otherwise enigmatic appeal. Like the paranoiac, Dalí's interpretations are full of self-reference, unlike Freud who prefers the pose of detached, scientific observer. But Dalí, no less than Freud, is anxious to persuade the reader of the concrete, verifiable truth of his reading, however irrational it might appear.

Nothing is left unscathed by Dalí's corrosive humour. His mad parody of Freud might be seen as undermining whatever claim psychoanalysis has to serious attention: as it is absorbed into Dalí's ever-expanding delirium, what is left except to affirm the paranoiac structure of *all* knowledge, as Lacan did?[56] It is on that firm understanding that I venture an interpretation of my own.

words made flesh

That the pious couple from the *Angelus* are omnipresent throughout the *Maldoror* etchings (fig. 82) ought not surprise us unduly since they were the focus for what had become, by this stage, an elaborate, highly organised, delusional system. Like the lunatic who hesitated between three pictures hanging in the Louvre, Dalí's delirium combines the *Angelus* with the *Gleaners* and, in the background, Meissonier's 1814 – all three in the Louvre.[57] 'It suffices that the delirium of interpretation should have linked together the meaning of the images of diverse pictures covering a wall for the real existence of this link to be no longer deniable' he speculated way back in 1930.[58] For the nonplussed viewer, Dalí confesses that only with hindsight did he become aware of a very precise connection between the *Angelus* couple and the text he was supposedly illustrating: uttered with the air of absolute certainty one might expect to follow from some rigorous logical proof, the preface for an exhibition of the etchings in 1934 concludes with the declaration: 'The *Angelus* of Millet, beautiful as the chance meeting on a dissecting table of a sewing machine and an umbrella!'[59] After establishing to his satisfaction that the two figures bowed in unison are a pictorial equivalent to the coupled terms of Lautréamont's metaphor, Dalí proceeds to excavate their hidden psychical resonance, and it is here that he begins to part company with Breton. From the start, Dalí had the presentiment of

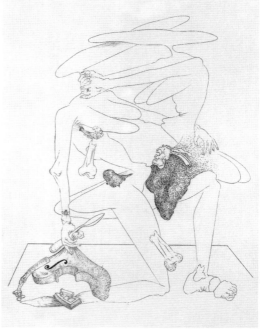

83 Salvador Dalí. Plate from Comte de Lautréamont, *Les Chants de Maldoror* (Paris: 1934). St Petersburg, Florida: The Salvador Dalí Museum.

84 Salvador Dalí. Plate from Comte de Lautréamont, *Les Chants de Maldoror* (Paris: 1934). St Petersburg, Florida: The Salvador Dalí Museum.

a savage drama brewing beneath the tranquil scene depicted by Millet, the nature of which gradually emerges from the various secondary phenomena and his interpretations of them. An innocuous display of peasant piety one might have assumed, but for Dalí it is a scenario seething with atavistic violence: the expectant poses of the figures he finds menacing; the crepuscular lighting adds to his feelings of portent. A night of unimaginable erotic fury, he is convinced, is about to descend on Millet's rural idyll. Dalí's reading of the *Angelus* also doubles as an interpretation of *Maldoror*, and he unleashes a torrent of aggressive and excremental forces which, had one relied solely on Breton's sanitised, poetical reading, would have gone unnoticed within this foundational surrealist text.

In a love poem addressed to Gala in 1930, Dalí provocatively rewrites the orthodox surrealist cult of courtly love by declaring that: 'I wish it to be known that in love I attach a high price to all that is commonly named perversion and vice.'[60] The *Maldoror* etchings bear out that credo. As we regress from words to pictures, metaphor is made flesh. The coupling of linguistic terms on a plane unfamiliar to them become paired figures on a sort of raised sculptural plinth, or dissecting table, enacting what appears to be an exhaustive set of permutations on the theme of sado-masochistic eroticism (figs 83 and 84). Dalí's use of the term 'appétit du mort' as a translation for the Freudian death drive (*Todestriebe*) provides him with the occasion for a delicious pun as lovers forage with knives and forks, hacking and tearing at their own and each other's flesh in preference to lamb cutlets and other morsels strewn about. Tireless, inexorable, the death drive goes about its grisly work (fig. 98): limbs are lopped off like lumps of dead wood, elongated feet and buttocks sliced like loaves of garlic bread. It is as though Dalí had set out to give an object lesson in the vicissitudes of the instincts, as

masochism turned outwards becomes sadism and vice versa.[61] Not by chance, four of the completed etchings were reproduced in *Minotaure* on the page facing an article by Maurice Heine, respected in surrealist circles as a de Sade scholar, which was titled 'Note sur un Classement Psycho-Biologique des Paresthésies sexuelles' (Note on a psycho-biological classification of the sexual perversions).[62]

Léon Pierre-Quint was the author of a book-length study of Lautréamont in 1928, *Le Comte de Lautréamont et Dieu*, later praised by Breton for its lucidity, which accords with Dalí's pictorial interpretation in identifying sadism as a central theme of *Les Chants de Maldoror*. On almost every page, the reader's sensitivities are assailed by acts of gratuitous cruelty, leading Gaston Bachelard to brand this subversive book a veritable 'phenomenology of aggression'.[63] Preeminent among the forms taken by sadism in the novel are themes of oral cannibalism, which of course are especially salient in Dalí's etchings as well. Gnashing, gnawing teeth are

85 Salvador Dalí. *Autumnal Cannibalism*. 1936–7. Oil on canvas, 65 × 65.2cm. London: Tate Gallery.

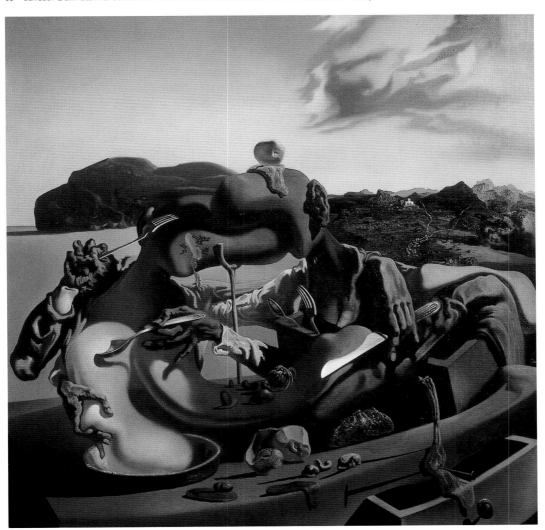

regularly employed as a murderous weapon by humans, no less than by dogs or ravenous sharks. 'During the oral stage of organisation of the libido the act of attaining erotic mastery over an object coincides with that object's destruction' writes Freud.[64] Maldoror professes his love along the lines of this regressive phantasy – 'You will rend me incessantly with both teeth and nails . . . and together we shall suffer, you through tearing me, I through being torn . . . my mouth glued to yours'[65] – a likely source not only for several etchings, but also for one of the outstanding fruits of this project, *Autumnal Cannibalism* (fig. 85) of 1936–7. Little effort was needed for Dalí to inflect this work and the closely related *Soft Construction With Baked Beans* with the significance of an allegory of the civil war in Spain. Deeply troubling, but strongly reminiscent of the way violence is portrayed in Lautréamont, is the calculatedly amoral stance Dalí adopts towards the orgy of killing and destruction triggered by the war: 'These Iberian beings mutually devouring each other correspond to the pathos of the civil war considered as a pure phenomenon of natural history' he writes.[66]

A striking parallel with Dalí's pictorial explorations is to be found in Lacan's work of the same period. His concern in the 1930s with the problem of aggressivity arose from his investigation of paranoia which had revealed aggression to be an intrinsic, quasi-structural property of the human condition.[67] Aimée, the paranoiac whose case was analysed by Lacan in his 1932 doctoral thesis, had attempted to stab an actress whom she believed was trying to persecute her. Lacan argued that since Aimée had wanted to be successful and famous like the actress she attacked, the persecutor was actually a projection of the patient's ego ideal, a double for whom she had developed a consuming, rivalrous hatred. 'The same image which represents her ideal is also the object of her hatred' he observes.[68] In response to Alexandre Kojève's lectures on Hegel which he attended along with Sartre, Raymond Queneau and others, Lacan's theorising of paranoia took on an overtly dialectical cast. According to Kojève, 'the I of Desire is an emptiness that receives a real positive content only by negating action that satisfies Desire in destroying, transforming and "assimilating" the desired non-I.'[69] What was once true only of the paranoiac, under the aegis of the mirror stage hypothesis is made a condition of subjectivity in general.[70] Dalí's *Maldoror* etchings supply us with a pictorial counterpart to this state of affairs. It is noteworthy that in figure 83 the two figures shown throttling each other are nearly identical, one the mirror-image of the other; in the light of Dalí's familiarity

86 Photograph of the Papin sisters. *Le Surréalisme au service de la révolution* n° 5 (15 May 1933): 60. 'Emerged fully armed from a *chant de Maldoror . . .*'

AVANT

APRÈS

« *Sorties tout armées d'un chant de Maldoror. . .* » (Voir page 28).

with Lacan's thesis, it might be significant as well that both are female. The case of the Papin sisters (fig. 86), two maids who murdered the mother and daughter of the household in which they were employed, could also have had a bearing on the erotic fury that Dalí purports to uncover in the *Angelus* and which he portrays as a visual accompaniment to Lautréamont. Before their Dionysiac orgy of violence was over, the two maids, normally of a meek and introverted disposition, had torn out their victims' eyes, slashed their throats, and mutilated the corpses with their bare hands. The ferocity of the seemingly unmotivated assault shocked the country and caused a sensation in the tabloid press. Based on these reports, Lacan diagnosed the sisters as suffering from paranoia in an article which appeared in *Minotaure* in December 1933.[71] Small wonder too that Paul Eluard and Benjamin Peret, who excuse the murderous rampage as a justifiable revenge for humiliations long endured as servants in a bourgeois household, describe the pair in reverential tones as 'emerged fully armed from a *chant de Maldoror*'.[72]

The relentless concentration on sadism (and yet other perverse manifestations of the sexual drive anathema to Breton) serves to align Dalí's illustrations with the views of Breton's sworn enemy, Georges Bataille. Nineteen twenty-nine, the year Dalí joined the surrealist movement, coincided with the schism that saw the formation of the dissident group centred around Bataille and the journal *Documents*. Bataille had evinced an early interest in Dalí, reproducing some of his work in the fourth issue of *Documents* in September 1929. That he responded in particular to the Sadean proclivities in Dalí's work is indicated by the initial title for an essay on the artist intended for publication in *Documents*, 'Dalí screams with Sade'.[73] It is well known that the subsequent fracas caused by Dalí's refusal to allow his picture, *The Lugubrious Game*, to be included in the article put an end to any possible cooperation between the two men, but this move, made for reasons of political expediency, ought not to blind us to what was a deeper affinity, both intellectual and temperamental, with Bataille. Though Bataille chose to remain silent on *Les Chants de Maldoror*, possibly because he regarded it as the intellectual property of the Bretonian surrealists, the effect of Dalí's desublimatory reading was to realign this proto-surrealist text more closely with Bataille's position in his polemic with Breton, a claim that becomes more convincing as we turn to the issue of abjection.[74]

Dalí with Kristeva

Recall that Dalí's manifesto, 'L'Ane pourri', had warned his readers to expect nothing from surrealist images but disappointment, foulness and repulsion. The *Maldoror* etchings make good his pledge. Lautréamont offered Dalí a veritable taxonomy of the foul to which his illustrations responded in kind. The stench of death and putrefaction is all about. Dalí does his utmost to put the cadaver back into the *cadavre exquis*: tottering monuments cobbled together from bits of bentwood furniture, bones, formless lumps of decomposing flesh, and abstracted Tanguyesque forms lean on crutches in order simply to stay upright. *Javanese Mannequin* (fig. 87), a close relative of the etchings, in its exquisitely spectral quality and disjunctively hybrid combination of animate and inanimate parts, exhibits with a spectacular theatrical flair that haunting of the subject by the death drive which it appears to have been Dalí's intention also to convey in the *Maldoror* plates themselves. The male figure in the *Angelus* couple with whom he identifies, Dalí describes as being already in the grip of death, as 'dead in advance', 'dead in a latent fashion'.[75] Luring the viewer in by means of his technical virtuosity, these images,

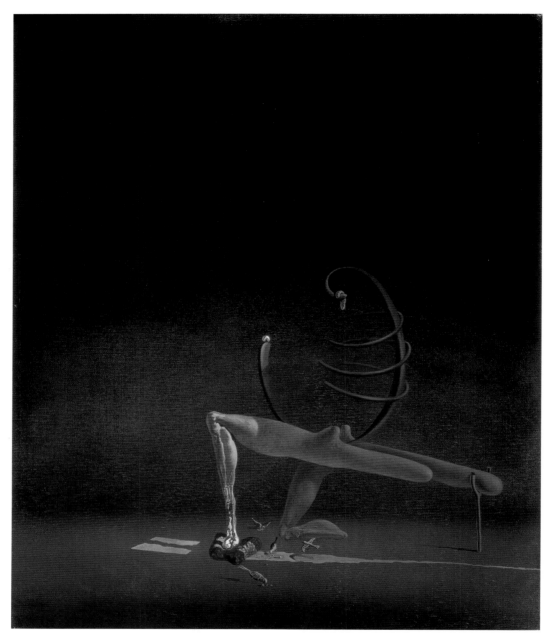

87 Salvador Dalí. *The Javanese Mannequin*. 1934. Oil on canvas, 64.8 × 54.0cm. St Petersburg, Florida: The Salvador Dalí Museum.

among the most formidable creations of his fevered imagination, show Dalí vying with Lautréamont to equal, or even outdo, in horribleness that loathsome creature described in Chant 4 who confides in the reader:

> I am filthy. Lice gnaw me. Swine, when they look at me, vomit. The scabs and sores of leprosy have scaled off my skin, which is coated with yellowish pus. I know not river water nor the clouds' dew. From my neck, as from a dungheap, an enormous toadstool with umbelliferous peduncles sprouts. Seated on a shapeless chunk of furniture, I have not moved a limb for four centuries. My feet have taken root in the soil forming a sort of perennial vegetation – not yet quite plant-life though no longer flesh – as far as my belly, and filled with vile parasites. My heart, however, is still beating. But how could it beat if the decay and effluvia of my carcass (I dare not say body) did not abundantly feed it?[76]

88 André Masson. Plate from Comte de Lautréamont, *Oeuvres complètes* (Paris: 1938). Edinburgh: Scottish National Gallery of Modern Art.

This baroque evocation of a grandiose decomposition, which Masson chose to illustrate for the 1938 surrealist edition of Lautréamont's *Complete Works* (fig. 88), brings to mind some of the bizarre delusions by which Schreber was tormented. Freud reports that at one point in the course of his illness Schreber thought he was dead and his body was starting to decompose; in his own words, Schreber recalled that 'more than once I believed I would have to rot alive' and how, due to putrefaction of the abdominal organs, a 'rotten smell escaped from my mouth in a most disgusting manner'.[77] Dalí's soft forms inevitably contain an implicit reference to death and decomposition, as well as to bodily secretions of a viscous or abject nature. By the time of the *Maldoror* etchings, a major source of his soft forms was a type of perspectival deformation known as the anamorphosis, which Dalí saw as having an intrinsic connection with death: 'the most successful anamorphoses are those which represent death concretely by a skull' Dalí affirms, no doubt referring to the most famous example of such distortion, the anamorphic skull in the foreground of Holbein's *Ambassadors*.[78] A connection between his soft forms and the anamorphosis was first made in *Documents* in September 1929 through a discerning juxtaposition of images (fig. 89)[79] with an accompanying note by Carl Einstein who observes with extraordinary prescience that the anamorphosis is no mere optical game, rather it 'partakes of a detailed symbolism linked in general to deformation'.[80] Besides the boneless, amorphous lumps of flesh that terminate truncated limbs and torsos, Dalí crams into the *Maldoror* plates a pair of anamorphic skulls bowed towards each other in a macabre tête-à-tête mimicking the poses of the peasant couple from the *Angelus*. With a nod and a wink in the direction of Holbein's flying saucer, they hover in midair like saints in a resurrection,[81] and, to avoid any disappointment for the punters, he adds a proverbial soft watch, bloated and blubbery like a beached jellyfish cast out from Lautréamont's 'kingdom of viscosity'.[82]

Saint Antoine de Padoue et l'Enfant Jésus. — Coll. Lipchitz.

Phot. Galerie Gœmans

Deux tableaux de Salvator Dali, 1. Baigneuses, 2, Nu féminin,
qui figureront à l'Exposition d'art abstrait et surréaliste, au Kunsthaus de Zurich.

89 Page from *Documents* n° 4 (September 1929): 229. *Saint Anthony of Padua with the Infant Jesus* by an unknown artist (*top*); *Bathers* by Salvador Dalí (*bottom left*); *Female Nude* by Salvador Dalí.

The parallels obtaining between Dalí's soft forms (*super-mou*) and Bataille's formless (*informe*) are many and compelling, as Dawn Ades has shown.[83] Moreover, there is a close correspondence between Dalí's arrival in Paris and the references in Bataille's writing to a thematics of putrefaction (*pourriture*). But it is not a question of who cribbed what from whom, since it emerges that both drew independently upon the same theoretical source in their speculations on disgust and abjection and, in any case, the sociological dimension of Bataille's concentration on the heterogeneous set him apart rather from Dalí's strictly psychoanalytic perspective.[84] The value of such a comparison lies in what it tells us about the nature of their shared interests, serving in particular to highlight a concern with issues of subjectivity. There exists between Dalí and Bataille a common orientation towards that asymptotic point where fascination and the most abject terror coincide, a perception that 'extreme seductiveness is probably at the boundary of horror'.[85] The slit eye episode in the opening scene of *Un Chien andalou* provides, in Bataille's opinion, our best approximation of that point by revealing 'to what extent horror becomes fascinating, and how it alone is brutal enough to break everything that stifles'.[86] What is apparent is that an affective reaction (disgust, horror) is in each case the starting point of their reflections and that they are concerned with the abject insofar as it pertains to a subject. This is made explicit in Bataille's post-war writings, which are inflected by the prevailing existentialism, but already in unpublished notes on the abject from 1930 he asserts: 'There exists a manner of being rotten, the sheer *presence* of a cadaver decomposes the living being.'[87] In Dalí's *Maldoror* etchings it is the Arcimboldesque faces (fig. 90), poised

90 Salvador Dalí. Plate from Comte de Lautréamont, *Les Chants de Maldoror* (Paris: 1934). St Petersburg, Florida: The Salvador Dalí Museum.

91 Pablo Picasso. *Head of a Woman*. 1931. Bronze, 71.5 × 41 × 33cm. Paris: Musée Picasso. On loan to Musée National d'Art Moderne, Centre Georges Pompidou.

between composure and an incipient decomposition, that most vividly dramatise the precarious condition of the subject faced by the abject. Among fellow artists, it is only Picasso who attains a comparable pitch of violence and extreme abjection: the bony, and obviously turd-like, forms of his *Head of a Woman* of 1931 (fig. 91) are the culmination of a step-wise, sadistic process of dismemberment that starts off with an idealised portrait bust of his mistress, Marie-Thérèse Walter.

Subjectivity is central to Julia Kristeva's highly influential psychoanalytic account of the abject, *Powers of Horror*, which concurs on a number of points with Dalí's analysis in a visual register. Kristeva correlates abjection with a very early, pre-Oedipal phase of differentiation from the maternal body. The abject stands in for those elements of the Real which have been repudiated, cast out by the subject in order for it to be constituted as such within the symbolic order. It is the Lacanian *objet a*, the left-over of the Real.[88] Temporally anterior to the division into subject and object, the dread associated with the abject is thus essentially objectless and unnameable. Kristeva discusses Freud's case of Little Hans, the child whose neurosis included a phobic anxiety of being bitten by a horse. Freud interprets this symptom as an expression of fears of castration with the horse a symbol for the father, whereas Kristeva sees

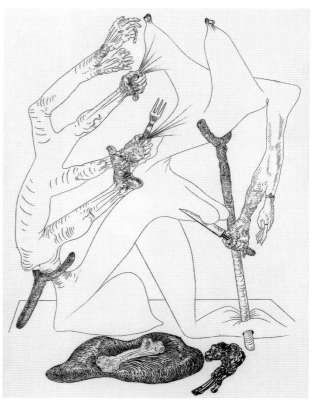

92 Henry Moore. *Mother and Child*. 1953. Bronze, 53 × 27 × 34.5cm. London: Tate Gallery.

93 Salvador Dalí. Plate from Comte de Lautréamont, *Les Chants de Maldoror* (Paris: 1934). St Petersburg, Florida: The Salvador Dalí Museum.

the phobia and associated phantasies of devouring, or being devoured, as referring to the unrepresentable maternal object.[89] Edibility (*comestibilité*) is, of course, one of the outstanding leitmotifs of Dalí's work and, as was noted, oral cannibalism is especially salient in the *Maldoror* etchings, one of which (fig. 92) it is tempting to read as depicting an infant sprouting from the mother's side, not yet able to distinguish itself from her, and tearing rapaciously at a maternal breast it is about to ingest.[90] An unexpected parallel is afforded by Henry Moore's *Mother and Child* of 1953 (fig. 93), which, uniquely for him, depicts a violent struggle between mother and infant similarly premised on an infant's destructive phantasies.

Dalí's pictorial interpretation of the *Angelus* transplants the figures to a landscape setting reminiscent of the coast of Cadaquès or the nearby plains of Ampurdan, the scene of his early childhood, thereby evoking a space of psychic regression. The frequent depiction of the pair as fossils or ruins implies the persistence of this past into the present. That is to say, the temporal structure is one of deferral in which archaic, pre-Oedipal phantasies are actualised in the present by Dalí's relationship with his Gala, who is consequently implicated as a protagonist. According to his interpretation, Dalí is identified with the male figure and Gala with the maternal imago.[91] It gradually becomes clear to Dalí that the anguish the picture produces in him emanates largely from this source, more precisely from 'the fear of being absorbed, annihilated, eaten by the mother'.[92] The bent-over woman reminds Dalí of a praying mantis.

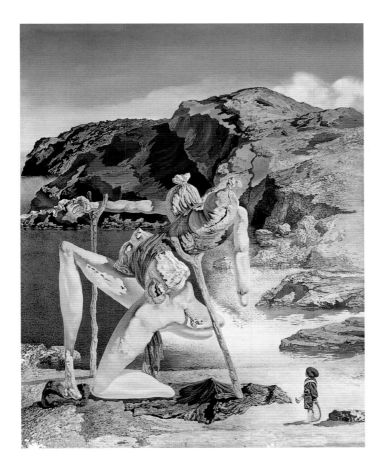

94 Salvador Dalí. *Spectre of Sex Appeal.*
1934. Oil on wood, 18 × 14cm. Figueres:
Museu Gala-Salvador Dalí.

The denouement, self-evidently, is that 'the mother devours her son'.[93] Finally, what Dalí's paranoiac interpretation uncovers in the *Angelus* as the basis for its universal appeal is: 'the maternal variant of the immense and atrocious myth of Saturn, of Abraham, of the Eternal Father with Jesus Christ and of William Tell devouring their own son'.[94] This maternal phantasm, first espied in the etchings, emerges from behind the shadow of Oedipus into brilliant, technicolour daylight in the *Spectre of Sex Appeal* (fig. 94).

By attending to the moment of primal repression (*Urverdrängung*), Kristeva's account of the genesis of the subject shifts emphasis away from the Oedipal complex with its associated castration anxiety to an occulted maternal axis. In a less rigorously academic vein, Dalí does likewise. *The Tragic Myth* comically relates a further association regarding the painting: Dalí reports that he was deeply troubled by thoughts of one half of the *Angelus* being plunged into a basin of warm milk, a prospect he found deeply unsettling. Pondering this phantasy leads him to conclude that:

> Submersion of the personage from the *Angelus*, that is to say myself, in the mother's milk, can only be interpreted (with the benefit of what has been learnt from surrealist objects functioning symbolically about the preoccupation with liquids serving as intermediaries for cannibalistic desires) as expressing the fear of being absorbed, annihilated, eaten by the mother.[95]

95 Salvador Dalí. *Scatological Object Functioning Symbolically*. 1974; reconstruction of the 1931 original which was destroyed. Assemblage of diverse objects, 48 × 28 × 14cm. Brussels: Patrick Derom Gallery.

The surrealist object referred to here is Dalí's *Scatological Object Functioning Symbolically* of 1931 (fig. 95), an assemblage with a shoe which contained warm milk as well as a substance resembling excrement. A suspended sugar cube was to be lowered into the shoe whereupon it would dissolve . . . *et voilà!* For anyone well-versed in the Kristevan abject, the multiplicity of references to the maternal body in this zany confection are obvious. Dalí's phantasy of engulfment by a maternal element would seem also to contain echoes of the episode in Chant 2, strophe 13, in which Maldoror copulates with a female shark in an ambient of frothy seawater mixed with the blood of shipwrecked sailors. Borne along by the sea current 'as in a cradle', arms with fins intertwined, they roll over and over 'towards the unknown depths of the abyss'.[96] Paul Zweig comments that 'Maldoror's love, in addition to its obvious extravagance, is also, after its fashion, an incest.'[97] Not to be outdone, Dalí pastiches this event in one of the secondary phenomena recorded in *The Tragic Myth* which concerns a visit with Gala to the Museum of Natural History in Madrid, a setting conducive to the regressive nature of the ensuing phantasy. At nightfall they find themselves in the insect gallery before a colossal sculpture of the *Angelus*. Dalí relates that: 'On leaving, I sodomised Gala in front of the very doorway to the museum which, at this hour, was deserted. This act was accomplished rapidly, in an extremely savage, enraged fashion. We slid together bathed in sweat at the asphyxiating end of a summer twilight made deafening by the frenetic sound of insects' (the other allusion is evidently to the mud-love scene in the Dalí–Buñuel film, *L'Age d'or*).[98]

The Kristevan concept of abjection has been extended in a way that is pertinent to our analysis by Judith Butler who uses it in order to explain homophobia with its attendant horror of disease and defilement.[99] The overlap with paranoia is instructive here. Freud had argued that a repressed homosexual wish lies at the base of typical paranoid delusions of persecution. The linguistic transformations that produce this are as follows: the unacceptable thought expressed by the proposition 'I love him' is first negated in the form 'I hate him'. This is then projected as 'He hates me.'[100] At its most virulent, homophobia has a similarly paranoid character with hatred and loathing of what is perceived as threatening to oneself. Paul Zweig notes accurately that 'One could make an inventory, and a long one, of scenes in which homosexuality is more or less openly evoked' in *Les Chants de Maldoror*.[101] Maldoror's narcissistic quest for 'beings who resemble me'[102] leads him to indulge in what nowadays would more than likely be labelled promiscuous gay sex. Its counterpart is guilt and anxiety, verging on homosexual panic, which animates the contemptuous tirade in Chant 5, strophe 5:

> O incomparable pederasts, not for me to hurl insults at your great degradation; not for me to cast scorn on your infundibuliform anus. It is enough that the shameful and almost incurable diseases which beset you bring with them their inevitable punishment.[103]

The negative form in which Maldoror's accusations are couched – 'not for me to . . .' – one might suspect bears the trace of an anxious disavowal. One wonders, moreover, in the light of Butler's analysis, if the kingdom of filth Lautréamont creates, a text piled high with shit, rotting corpses and pus, is not the by-product of an unavowable homoerotic desire which, far from being incidental or just another form of perverse sexuality, perhaps comprises its abject heart? Studies of *Maldoror* contemporary with Dalí's etchings all maintain a blanket silence on the homosexual theme. Certainly Breton, whose intolerance of homosexuality was notorious, could not have countenanced it. He nearly aborted an inquiry into sexual practices reported in *La Révolution surréaliste* in 1927 when the matter of pederasty was raised by one of the discussants.[104] Dalí, fully cognisant of Breton's sensitivity on this score, was able to exploit it to

advantage in his show trial in February 1934, taunting Breton ostensibly over the issue of censorship by saying that should he dream they had sex together he would happily paint it the following day sparing no details.[105] The status of homoeroticism in Dalí's work and life is complex, as David Vilaseca's judicious study of the issue has shown, and a source of contention.[106] For our purposes, it suffices to note that anal eroticism marks all of Dalí's forays into the abject, as the shit-smattered pants of *The Lugubrious Game* or the above episode with Gala well shows. Dalí's *Atmospheric Death's Head Sodomising a Grand Piano* of 1934, a direct offshoot of the *Maldoror* etchings, must have been inspired by that passage in the text where the confusion of desire and terror reaches an apocalyptic pitch:

> Oh! If instead of being a hell this universe had been but an immense celestial anus – behold the gesture I would make . . . yes, I would have plunged my prick through its blood-stained sphincter, smashing the very walls of its pelvis with my impetuous movements![107]

Where those more timid feared to tread, Dalí boldly leapt. None the less, it remains the case that Dalí colludes with the surrealists' most flagrant suppression of homoerotic content in *Les Chants de Maldoror*. That oft-quoted passage, 'beautiful as . . . the chance meeting on a dissecting table of a sewing machine and an umbrella', is excerpted from a lengthier description of an unsuspecting target of Maldoror's sexual predations, a flaxen-haired youth of sixteen years, which in actual fact begins: '*He* is as beautiful as . . .'[108] Not only is this meaning deliberately suppressed but Breton further travesties the text when he purports to interpret the image in *Les Vases communicants* of 1932.[109] Consulting the simplest key to dream symbols, Breton maintains, would straightaway compel one to admit that the umbrella could *only* be a man and the sewing machine *only* a woman. Dalí is party to a violation no less outrageous than anything perpetrated by Maldoror when he in turn allows this metaphorical coupling to become fused in his mind with the *Angelus*.

Dalí, Ducasse, Maldoror

I want to conclude this discussion with a few remarks of a more speculative nature concerning the role and significance of *Les Chants de Maldoror* for Dalí's work, and also for the persona that he constructs.

We have seen that it afforded him in 1933 a perfect opportunity to indulge his obsessions, scatological and otherwise. Given the sheer abundance of such imagery in Lautréamont, a question inevitably raised by this study is whether *Maldoror* may have given an impetus to Dalí's earliest forays into this territory. Dawn Ades has established that the 'putrefact' was used initially as a term of derision by Dalí's circle of friends in the neo-dada milieu of Madrid.[110] It then undergoes a rather startling reversal of valence, with the no longer extant picture *Honey is Sweeter than Blood* of 1927 a crucial marker for this turnabout, until, with 'L'Ane pourri', it becomes a pivotal obsession. Remarks in *The Secret Life* confirm that Dalí's first exposure to Lautréamont occurred well before he had officially joined the surrealists. He recollects: 'The shadow of Maldoror hovered over my life, and it was just at this period that for the duration of an eclipse precisely another shadow, that of Federico Garcia Lorca, came and darkened the virginal originality of my spirit and of my flesh.'[111] This auspicious confluence of events would have happened in 1925 or thereabouts. By that date, a Spanish translation of *Les Chants de Maldoror* which included a prologue by Ramòn Gómez de la Serna, a student acquaintance of Dalí's from Madrid, would have

been available to him.[112] Another possible avenue leading him to *Maldoror* was an article by Paul Dermée carried by the purist journal *L'Esprit nouveau*, avidly read by Dalí in Barcelona as his work up until 1924 testifies.

Putrefaction, entailing a transition in matter from one state to another, is closely allied with mutation and metamorphosis, themes conspicuous in Dalí's work from the period around 1927 of which *Bird . . . Fish* (fig. 96) is a typical example. This predilection for metamorphosis could conceivably also be a reflection of that decisive early encounter with Lautréamont coupled with a more indirect influence filtered through Masson's sand paintings (a number of works produced by Dalí around this time, including most notably the painting *Rotten Donkey*, incorporate sand and grit). Ceaseless metamorphoses from man to animal, from animate to inanimate, are quite the order of the day in *Les Chants de Maldoror*: 'A man or a stone or a tree is about to begin the fourth chant.'[113] Its

apotheosis in Dalí's work comes with *Autumnal Cannibalism* (fig. 85), a picture spawned by the *Maldoror* project in which the physical attributes of discrete objects are metonymically transferred in a delirious circuit from still life to figures to landscape. Abjection, Kristeva notes, does not generally reside in any one specific object but rather is a function of the mutability and disruption of borders, categories and distinctions *among* things.[114] That would seem to be critical in determining the beholder's response to this image which systematically deprives us of the usual coordinates by which we find our bearings in the object world. Autumn is the season of decay and here one has the impression that the entire visual field has gone soft – notice the gentle anamorphic curvature of the pictorial space – in a sort of universal putrefaction.[115] It is a measure of Dalí's not inconsiderable talent to have created in *Autumnal Cannibalism* a picture that is positively nauseating to look at.

'Lautréamont, we raise in your honour the epithet of madman by which they thought to insult you.'[116] Partly on account of his premature death at the age of twenty-four, which might have been suicide, but mostly prompted by the excesses of his writing, Isidore Ducasse's sanity was always a hot topic of conjecture, as Dalí would have known.[117] Gómez de la Serna's opinion that 'Ducasse is so courageous that he cultivates madness and makes use of it' could have emboldened Dalí in turn to emulate certain features of Lautréamont's writing style and even his sardonic humour. Léon Pierre-Quint included a chapter on humour in his book on Lautréamont which, no less than the one on sadism, would, one trusts, have caught Dalí's eye. An important source of the comic in *Maldoror*, according to Pierre-Quint, lies in the jarring transitions that occur when a technical, scientific vocabulary is interspersed with a more conventionally literary one. Dalí, for his part, claimed the surrealists were like sturgeons, swimming between the warm water of science and the cool water of art, and, as we have seen, delighted in couching his maddest speculations in the arcane jargon of psychiatric textbooks. In the

96 Salvador Dalí. *Bird . . . Fish.* 1927–8. Oil and sand on panel, 59 × 48cm. St Petersburg, Florida: The Salvador Dalí Museum.

98 (*above*) Film-still from *Delicatessen*. 1990. Directed by Jean-Pierre Jeunet. Constellation Productions. London: BFI Films: Stills, Posters and Designs.

97 (*left*) Salvador Dalí. Plate from Comte de Lautréamont, *Les Chants de Maldoror* (Paris: 1934). St Petersburg, Florida: The Salvador Dalí Museum.

Maldoror etchings themselves, it is the cohabitation of sadism with the comic that is so perverse and, by the same token, so redolent of Lautréamont. The Hammer Horror spectacle (fig. 97) Dalí treats us to is, in the final analysis, much closer in spirit to the popular film *Delicatessen* (fig. 98) than it is to the bleak misanthropy of Goya, their ostensible, high-art source.

While this chapter is concerned principally with the abject in Dalí, I wish to return for a moment to the issue of Dalí *as* abject. I referred at the outset to Dalí's calculation that his future lay with Breton and his brand of surrealism, and for several years his effervescence and high buffoonery stoked the fires of surrealist revolt, as Breton generously conceded.[118] But the love affair was not destined to last. Dalí's phenomenology of repugnance was a heretical version of the surrealist doctrine that immediately brought him into tension with the mainstream surrealists. When he tackles the illustration of *Les Chants de Maldoror* he exposes the limits of Breton's surrealism by confronting him, in a sense, with what is unassimilable to his vision of surreality. Dalí's eventual expulsion, i.e. abjection, from the group was prompted by his perverse fascination with the repugnant: most unnerving for Breton was his preternatural interest in 'Hitlerisme' at a time when relations between the surrealists and the Communist Party were most fraught.[119] Jean-Charles Gateau likens Dalí to a bone lodged sideways in the throats of the party faithful (one can just imagine them dry retching); the last straw was his irreligious treatment of Lenin in a portrait dispatched to the Salon d'Automne.[120] When it became too damaging for him to stay any longer, decisive action was taken to remove Dalí from the surrealist group, yet their correspondence shows that Breton continued to regard him with the kind of ambivalent fascination that is the hallmark of the abject.

Dalí also managed to fall foul of none less than George Orwell who apparently chanced upon a copy of *The Secret Life* – 'a book that stinks' in his estimation.[121] Surveying Dalí from the moral high ground, Orwell is sickened by the catalogue of aberrations (not least a 'marked excretory motif') that Dalí readily confesses to but is quite unrepentant about. Most offensive, however, is Dalí's narcissism and lack of social conscience: 'He is as antisocial as a flea', Orwell fumes indignantly.[122] Amongst a litany of indictments, he cites one occasion when Dalí claims, as a four-year-old child, to have flung a small boy off a suspension bridge; and another when, aged twenty-nine, he knocked down and trampled on a girl 'until they had to tear her, bleeding, out of my reach'. When I first read Orwell's outraged reaction to these quite improbable events, it dawned on me – suddenly and with a sense of absolute conviction that I have been unable to dispel since – that Dalí the amoral narcissist, no less than the Papin sisters, might have emerged fully armed from *Les Chants de Maldoror*. Could it be that *Maldoror* so completely infiltrated the virginal purity and originality of Dalí's spirit way back in 1925 that he refashioned his life story on the model of Lautréamont's abject anti-hero?[123] *The Secret Life /Les Chants de Maldoror* – one can envisage Orwell's concluding sentence being applied to either one of them: 'They are diseased and disgusting, and any investigation ought to start out from that fact.'

ii on [Dalí's] narcissism: an introduction

'It would in fact be very interesting to investigate analytically how a picture like this came to be painted.'[124]

When Dalí's wish to meet the founder of psychoanalysis was at last realised in 1938, the picture he chose to take with him on his pilgrimage was the *Metamorphosis of Narcissus* (fig. 100). Freud had been forced into exile by the Nazi occupation of Vienna and was living at Hampstead in north London. He was little more than a year away from death and the drawing (fig. 99) Dalí executed following the visit starkly reveals his emaciation. Despite his illness, Freud seems to have been humoured by his visitors that day and was thankful to Stefan Zweig for having introduced 'that young Spaniard with his candid fanatical eyes' (Dalí, for his part, thought Freud's head was like the turbinated shell of a snail). On the matter of his painting, Freud's letter expresses admiration for Dalí's technical mastery, although in other respects it seems they were destined not to see eye to eye. Tackling a theme central to the psychoanalytic account of subjectivity, one assumes Dalí took the *Metamorphosis of Narcissus* with him in the hope of impressing the master whom he revered,[125] but therein lay a major

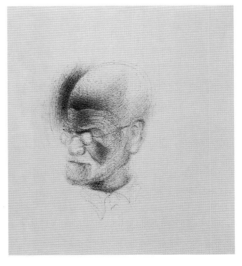

99 Salvador Dalí. *Portrait of Sigmund Freud*. 1939. Ink on blotting paper; 35 × 28.5cm. London: Freud Museum.

point of contention. Freud looked on art and literature, as indeed he looked to myth, to furnish innocent testimony to the truths about human nature unlocked by psychoanalysis. The value of Wilhelm Jensen's novel *Gradiva*, the subject of an extended analysis by Freud, is increased, not lessened, in his eyes when Freud learns that its author was ignorant of his theories, and yet managed to accord precisely with his views about the unconscious mechanisms in dreams, phantasies and neuroses.[126] With Dalí, quite obviously, any presumption of innocence would be misplaced, since none of the surrealists was better versed in the psychoanalytic corpus than he. The difficulty Freud has with Dalí's Narcissus – in mythology a self-deluded figure – is that he is, paradoxically, *too knowing*. With reference to the picture, he wrote in his letter to Zweig that: 'From the critical point of view it could still be maintained that the notion of art defies expansion as long as the quantitative proportion of unconscious material and pre-conscious treatment does not remain within definite limits.'[127]

'One of the capital discoveries of my life' was how Dalí rated his first encounter with *The Interpretation of Dreams* back in his art student days in Madrid, adding that immediately he was 'seized with a real vice of self-interpretation'.[128] That remark alone would suggest Dalí envisaged a more active role than Freud was willing to grant to the artist, one in which he would be a worthy counterpart to Freud himself when he embarked on the heroic self-analysis that, in the official version of its history, gave birth to psychoanalysis – one should recall also that *The Interpretation of Dreams* is crammed full of Freud's analyses of his own dreams. Imagine for a moment Dalí in the father's place, as he perhaps secretly wished to be, gazing unflinchingly into the abyssal depths of his psyche (only the lofty rhetoric jars slightly). Allowing free rein to his vice for self-interpretation, the *Metamorphosis of Narcissus* would be the key document of this self-analysis.

Possibly due to the exigencies of displaying modern art in the museum, it is not widely appreciated that Dalí had intended the *Metamorphosis of Narcissus* to be viewed in conjunction with a poem of the same title, written simultaneously and published in the form of an illustrated pamphlet (fig. 108).[129] Only recently has the close reciprocity in Dalí's work between writing and painting, text and image, begun to be recognised.[130] Viewing the *Metamorphosis of Narcissus* alongside the poem, a surprising picture emerges of this most accomplished Narcissus as he undertakes, in emulation of Freud, his own self-analysis. In particular, the poem alerts us to a thematics of abjection seething beneath its immaculate, airbrushed surface whose presence until now has gone unsuspected. At the risk of besmirching a much-admired work, it will be argued that the *Metamorphosis of Narcissus* culminates a decade-long preoccupation with the phenomenology of repugnance. At variance with usual perceptions of Dalí, the accent of the picture is not upon the triumphalism of His Majesty the Ego, but rather what Julia Kristeva in connection with the abject has called the 'moment of narcissistic perturbation'.[131]

the prologue

'THE FIRST POEM AND THE FIRST PAINTING OBTAINED ENTIRELY THROUGH THE INTEGRAL APPLICATION OF THE PARANOIAC-CRITICAL METHOD'[132]

Preceding the poem, a single page of text adjoins a high-quality colour reproduction of the picture, a prologue that serves to establish a framework for viewing and interpreting the visual

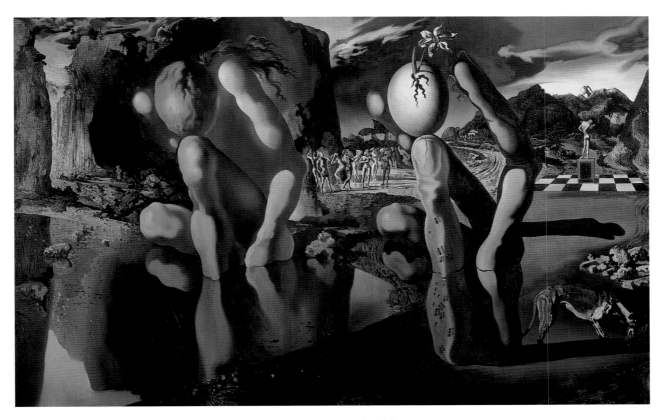

100 Salvador Dalí. *Metamorphosis of Narcissus*. 1937. Oil on canvas, 51.1 × 78.1 cm. London: Tate Gallery.

image. Strategically recycled is a quotation from an essay by André Breton from 1934 which is fulsome in its praise for Dalí's paranoiac-critical method. Appropriately, the passage chosen draws attention to the sheer versatility of Dalí's creative endeavour and by the simple expedient of omitting the date it appears as if Breton is conferring his blessing on the *Metamorphosis of Narcissus*. Indeed, the intention seems to have been to place the exercise firmly under the aegis of surrealism, since the poem was published by Editions Surréalistes and dedicated to Paul Eluard, one of surrealism's most esteemed poets. The exact equivalence of poetry and painting that Dalí was aiming to achieve certainly conforms to the surrealist ideal of a *peinture – poésie*. Another factor prompting him to experiment with this hybrid genre may have been his enthusiasm for the pre-Raphaelites, recently attested to in an article in 1936 for *Minotaure*. Dante Gabriel Rossetti's practice of exhibiting paintings and poems of the same title side by side is a notable precedent for Dalí's undertaking. It may be that the Narcissus theme is especially amenable to this sort of treatment, since one has available both an established visual iconography and a distinguished poetic lineage from Ovid through to Paul Valéry.[133] The resultant symbiosis of word and image runs strongly counter to modernism's insistence on the autonomy of visual experience, thus reconfirming an aesthetic stance in violent opposition to formalist modernism that Dalí consistently stakes out during the 1930s. For the reader or viewer, an overriding impression created by the combination of image and text is of a duplication of one by the other – the first of many instances of doubling that are connected at a fundamental level with the Narcissus theme.

A didactic set of instructions about how the tableau should be viewed follow: a 'mode of observing . . . the process of metamorphosis of Narcissus represented in the painting

opposite'. Dalí had long been in the habit of supplying diagrams setting out the constituent elements of his double and multiple images. The need for these supplements to the painted image must have increased as the visual pyrotechnics became ever more complex, and as his audience expanded to include people unfamiliar with the protocols of viewing art. Dalí recommends that the viewer gaze in a state of 'distracted fixity' whereupon the blurred figure of Narcissus gradually disappears. Is there not a deliberate analogy here between the kind of intent scrutiny Dalí requires of the viewer and that engaged in by the 'hypnotically immobile' Narcissus, absorbed in the contemplation of his reflection? Philostratus, in the Imagines, plays wittily on the ambiguous doubling and redoubling of illusion (and delusion) permitted by this transaction between viewer and depicted subject: 'As for you Narcissus, it is no painting that has deceived you, nor are you engrossed in a thing of pigments and wax; but you do not realise that the water represents you exactly as you are when you gaze upon it, nor do you see through the artifice of the pool'.[134] Painted with all the trompe l'oeil resources Dalí could muster, the Metamorphosis of Narcissus aims to replicate for the viewer the predicament of Narcissus himself; both are taken in by the power of an illusion.[135] Over and beyond merely illustrating the Narcissus myth, then, Dalí's task was, more ambitiously, to interpellate the beholder into a viewing structure that is intrinsically narcissistic.

Finally, the prologue hints at an autobiographical framework for interpreting the poem. It does so by means of a comical exchange between two Port Lligat fishermen, one of whom asks: 'What's up with that boy who looks at himself all day long in a mirror?' The other replies in hushed tones, lest they be overheard, that he has 'a bulb [oignon] in his head' – this we are told is a Catalan idiom corresponding very exactly to the psychoanalytic notion of a complex! There can be little doubt in the reader's mind that the self-infatuated youth referred to is Dalí himself. This literary conceit thus establishes at the outset that Narcissus is primarily a self-referential guise for Dalí, something the end of the poem reasserts, and which is no doubt also pertinent to some of the more recondite intervening details.

excremental cries of minerals

> On the highest mountain,
> the god of the snow,
> his dazzling head bent over the dizzy space of reflections,
> starts melting with desire
> in the vertical cataracts of the thaw
> annihilating himself noisily among the excremental cries of minerals[136]

The poem begins with a description of the landscape that forms a spectacular backdrop to Narcissus in the foreground. Dalí was holidaying at Zürs in the Austrian Alps in April 1937 when the work was painted, and the surrounding mountains provided his immediate source of inspiration. Edward James, who stayed with him for part of the time, recalls that it being springtime the snow was melting and narcissi were everywhere in bloom. Complicating the picture is the fact that the setting is also strikingly reminiscent of the precipitous landscape seen looking back from the beach near Cap Creus towards the Pyrenees which on their lower slopes are lined with olive groves. Since this stretch of coastline was the scene of some of Dalí's earliest childhood memories, the picture can be understood as referring not only to the present but also to the remote past. Potentially recapitulated within a single, unified space are all the

decisive moments of Dalí's personal history, ranging from infantile experience through to adolescence and adulthood.

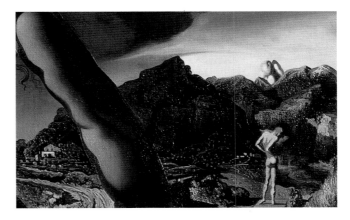

101 Detail of fig. 100.

The section of the poem given over to evoking the landscape is like an Old Testament prefiguration in which the melting snow and germinating narcissus flowers rehearse the eventual disappearance of Narcissus, his melting away and ensuing metamorphosis. Similarly, in the painting the landscape setting acts as a mirror for his predicament: at the top right, one can just catch a glimpse of the snow god, like a miniature version, or morphological echo, of Narcissus perched at the water's edge. His inner psychological drama is consequently writ large in the landscape behind him. The stems of the narcissi rise up 'straight, tender, and hard', a virile force of new life, whereas the snow god melts away and is 'annihilated noisily among the excremental cries of minerals'. There is a blatant anthropomorphism behind this contrasting set of images which represent as an event in nature, a cycle of the seasons, the conflict of Eros and the death drive.

One of the more disputed aspects of Freudian theory, the notion of a death drive (*Todestriebe*) was introduced by Freud in the essay 'Beyond the Pleasure Principle' in order to account for the existence of mental phenomena that seemed not to obey the pleasure principle, which until then he had assumed to govern all of unconscious mental life.[137] As Freud describes it, the death drive is essentially a tendency inherent in organic life to seek the restoration of an earlier, ultimately inanimate, state of things; it is 'a kind of organic elasticity . . . the expression of the inertia inherent in organic life'. Death makes its presence everywhere felt in the *Metamorphosis of Narcissus*, but for the moment let us simply note as one of the basic manifestations of the death drive what Freud defines as a compulsion to repeat. Dalí's use of a proleptic device, whereby the first section of the poem concerning the landscape setting anticipates the subsequent description of Narcissus, sets in train a process of repetition within the poem that I would venture to associate with the insistence of the death drive. The deceptively picturesque image of narcissi flowering beneath a spring sky presupposes that Narcissus has already died. Narcissus, we can say, is dead in advance of his dying; death resides within him as a kind of latency.

That which incites disgust, the disgusting, is another one of the presentations of the death drive. More consistently than any other artist of the period, and in a way that chimes with the preoccupations of a good many contemporary artists, Dalí's work of the 1930s explores the terrain of the abject: bodily effluvia, secretions and excreta, putrefaction and so forth. On more than one occasion, he acknowledges as a vital theoretical support for his speculations in this area an essay on the phenomenology of repugnance by the Hungarian author Aurel Kolnai, first published in German in 1929.[138] A brief outline of Kolnai's main arguments will suffice, I hope, to demonstrate its relevance to how the issue of abjection and subjectivity is represented in the *Metamorphosis of Narcissus*.

The list of disgusting things enumerated by Kolnai reads like an inventory of Dalinian obsessions. Chief amongst them is putrefaction, the most fundamental source and object of disgust according to Kolnai. He refers to the disgusting character of excrements, and states that tactile

sensations linked to viscous materials, and simply 'the soft', are all liable to incite disgust.[139] Of interest to us is Kolnai's explanation of disgust as one of a series of so-called reactions of defence. Noting that disgust is often accompanied by a macabre seduction, seeming to comprise an integral part of the affect, he asserts that 'the invitation actualises the defence.' On this point, Dalí virtually paraphrases Kolnai, writing that: 'One exhibits repugnance and disgust for that which at root one desires to approach and from this arises an irresistible "morbid" attraction, translated often by incomprehensible curiosity for that which appears as repugnant.'[140] Kolnai proceeds to argue in a key section of his essay, 'The Relation of Disgust to Life and Death', that our psychic ambivalence regarding death lies behind most reactions of disgust (presumably this is why he considers putrefaction a fundamental cause). Once again, Dalí accurately conveys the bones of Kolnai's argument when he suggests that repugnance is 'a symbolic defence against the vertigo of the death drive [les vertiges du désir de mort].'[141]

'Everything disgusting "sticks" in some manner to the subject, surrounding it by its proximity, by its emanation' writes Kolnai. It could be said of the rocky outcrop behind Narcissus that it surrounds and, so to speak, adheres to him. In support of this reading, which would posit a connection with the scatological landscape depicted way back in 1929 in *Accommodations of Desire*, the poem states that Narcissus is assailed by the 'excremental cries of minerals'. Kolnai claims that the disaggregation of living matter is what primarily accounts for the feelings of disgust aroused by faeces. At certain points in Dalí's picture, notably where the chocolatey brown earth abuts the knuckles of the terrifying fossil hand (fig. 102), the painterly illusion verges on decomposing into its constituent pigment and we are compelled to think of paint as a material equivalent of excrement. More repellent still is the shadowy stretch of beach in the foreground, its sickly greenish-grey hue unmistakeably that of decaying flesh. One of the more novel aspects of Kolnai's account is his evocation of a sort of 'vital exuberance', a paradoxical intensification of life in the midst of rankness. He speaks of an éclat and tumultuous excess in decomposition where even colours are more vivid than usual. Dalí, for his part, recalls seeing a decaying donkey swarming with ants and blowflies which he mistook for sparkling gemstones, and it is tempting to connect the lightning flash atmosphere and intense, saturated colour of the *Metamorphosis of Narcissus* with this abrupt short-circuiting of life. Similarly, the textual evocation of the setting contains a surfeit of adjectives —

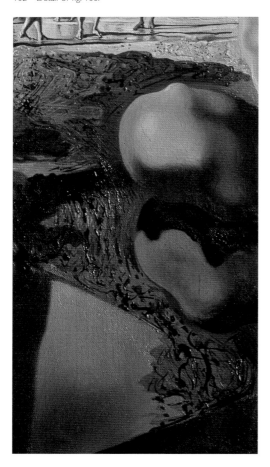

102 Detail of fig. 100.

'swarming', 'inconsolable silence', 'the deafening armies of germinating narcissi' – inducing in the reader a feeling of over-ingestion bordering on the nauseous.[142]

The relationship living beings have to the space that surrounds and envelops them was the theme of an article by Roger Caillois which appeared in *Minotaure* in 1935.[143] Caillois discusses the phenomenon of mimicry in which insects and other organisms come to resemble closely aspects of their non-living ambient. Rejecting the usual explanation of mimicry as a form of camouflage that protects animals from their predators, for Caillois space itself assumes the properties of a predator, encroaching on living beings he imagines as ensnared within it and devouring them. Mimicry, he says, erases distinctions between the living and the inorganic. It does not enhance life, but invariably diminishes it. Drawing upon the entropic dimension of the Freudian death drive, Caillois writes that assimilation by space 'is necessarily accompanied by a decline in the feeling of personality and life . . . *Life takes a step backward*.'[144] It emerges that Caillois's primary concern is with human subjectivity and its capture (*captation*) by space for which mimicry provides a convenient metaphor. Moving from the realm of biology, Caillois claims to discern a similar impulse at work in Dalí's imagery which he maintains is 'less the expression of ambiguities or of paranoiac "plurivocities" than of mimetic assimilations of the animate to the inanimate'.[145] It seems possible that such ideas had some bearing on Dalí's portrayal of Narcissus whose blurred contour is proof that he is already well on the road to merging with the inanimate. Prey to what Caillois defines as 'a real *temptation by space*', Narcissus is according to Dalí 'absorbed by his reflection with the digestive slowness of carnivorous plants'. A scrawny greyhound at the right-hand side of the picture scavenging on an animal carcass is a visual counterpart to such images of devouring space with which the poem is replete. Evidently a late addition to the picture, the dog is unmentioned in the poem, however Dalí's letter to James remarks that it looks 'very good in front of this ferocious countryside under an orb which seems to reclaim vegetation'.[146]

the heterosexual group

> Already, the heterosexual group, in the famous poses of preliminary / expectation, ponder conscientiously the imminent libidinal cataclysm, / carnivorous flowering of their latent morphological atavisms.[147]

The poem proceeds from a description of the landscape to what is termed the 'heterosexual group' in the middle distance. Clearly, these figures are meant primarily as a foil to Narcissus, whose isolation from them is stressed, though beyond that their significance is more than a little obscure.[148] In the poem, Dalí takes the trouble to specify each individual as a distinct ethnic or national type – they comprise a veritable League of Nations, and given the ominous situation in Europe in April 1937 it may be that they are supposed to allegorise these background political events.

More plausible, in my view, is the suggestion that they depict the assorted suitors, male and female, whose amorous designs Narcissus obstinately resisted. Ovid avers that 'many men, many girls desired him; / but (there was in his delicate beauty so stiff a pride) / no men, no

girls affected him.'[149] Most famous of these unlucky admirers was the nymph Echo who pined away in despair until her voice was all that remained of her. An earlier version of the myth tells of a young man called Ameinias who was smitten with love for Narcissus but he too is spurned and so kills himself. Nowadays, Narcissus would probably be diagnosed as suffering from a phobic anxiety about physical contact with others. Julia Kristeva evokes his solipsistic withdrawal in terms that have special resonance for Dalí, remarking that Narcissus is 'indifferent to love, withdrawn in the pleasure that a provisionally reassuring diving-suit gives him'.[150] As an adolescent, Dalí reports in *The Secret Life* that he craved only the 'imperialist sentiment of utter solitude', and the chapters of his confessional autobiography that precede his fateful meeting with Gala are littered with frustrated admirers whose torments alone are a source of vicarious pleasure for him. A painted version of Narcissus attributed to Tintoretto has a group of figures in the middle ground who Stephen Bann argues are the exasperated *amores* in pursuit of their elusive quarry, and such an interpretation best accounts for the element of sexual threat emanating from the similarly placed group in Dalí's picture.[151] They strut about, aggressively flaunting their sexual attributes like lethal weapons; using a phrase Dalí first coined to describe the female praying mantis about to devour its mate during the act of copulation, they adopt the 'famous poses of preliminary expectation'. The prominence given to the heterosexual group by the poem is hence inversely proportional to their diminutive scale in the painting, where a bright red cloth girding the loins of a male near the centre of the group is the only giveaway to the intense psychical accent placed upon them.

Whether or not these figures are identifiable people from Dalí's past we can only surmise. What is indisputable, however, is that they are a club from which he is firmly excluded. That Dalí is implicated in a narcissistic and by inference *homo*sexual relation in the foreground is a hypothesis we shall come back to.

narcissus and his double

> Narcissus annihilates himself in the cosmic vertigo
> in the deepest depths of which
> sings
> the cold and dionysiac siren of his own image.
> The body of Narcissus flows out and is lost
> in the abyss of his reflection[152]

At last, following the dress rehearsal, comes Narcissus. This section of the poem, which describes in detail the individual components of the double image to which the picture owes its immense popular appeal, also holds the key to Dalí's understanding of the Narcissus myth. While a consensus among recent commentators on the picture has it that the *Metamorphosis of Narcissus* illustrates, or at best affords a visual parallel to, Jacques Lacan's mirror stage hypothesis, I believe this to be misleading as well as detracting rather unfairly from the novelty of Dalí's conception.[153] Against such an interpretation, it should be noted that whilst Lacan presented his paper on the mirror stage at a congress at Marienbad in August 1936, it does not appear to have been published until considerably later and only in a revised form. Hence it is questionable whether Dalí would have known about it, and anyway the main ingredients of the picture had demonstrably coalesced in his imagination well before this date. In an essay

103　Giorgio de Chirico. *Self-Portrait*. c.1922. Oil on canvas, 38.4 × 51.1cm. Toledo, Ohio: The Toledo Museum of Art. Purchased with funds from the Libbey Endowment, Gift of Edward Drummond Libbey.

from the winter of 1934–5, Dalí writes of the *Spinario* (a Roman bronze which depicts a seated youth extracting a thorn from his foot): 'Observe him, bent over his thorn, with the same fossil immobility of Narcissus, he, too, bent over the silvery comedo of his own death.'[154] Instances of actual mirroring in the *Metamorphosis of Narcissus* are relatively few and it is more correct in the case of the double image itself to speak of a simulacral replication rather than reflection as such. Consistent with my reading so far, I would argue that the role of the double image is essentially to dramatise the ambivalent attitudes that attach to symbolic representatives of the death drive. Aurel Kolnai's axiom that 'the invitation activates the defence' succinctly defines the relationship between these parts.

There are reasons for thinking that Dalí was looking hard at de Chirico in 1937, and that he was a source for not only the configuration of the double but also the approach to myth as a vehicle for self-representation. A symmetrical arrangement comparable to Dalí's is found in a self-portrait of 1922 (fig. 103), one of several painted by de Chirico at this time which incorporate an uncanny, Medusa-like petrification of the subject. While the Narcissus myth is not explicitly invoked, the relationship to the mirror image is foregrounded in a number of these works: another shows the artist reaching towards the front plane of the picture as though he were trying to touch his reflection, like Narcissus, in the course of painting it. Whilst it is difficult to establish with any certainty that Dalí knew examples of these works, all of which date from after de Chirico's return to Italy, he undoubtedly would have been familiar with the

earlier *Portrait of Apollinaire* where a marble bust in the foreground acts as a 'double' to a profile portrait of the poet behind. Apart from the example of his painting, de Chirico's parallel literary output afforded another valuable model for Dalí. This side of his creativity was greeted with enthusiasm by the surrealists, who published several of these texts, generally in a poetic vein and conjuring the sorts of enigmatic scenarios depicted in his painting. Despite a very public, acrimonious row with Breton over issues of classicism and tradition, his attempt at a novel, *Hebdomeros*, was likewise unreservedly praised by the surrealists. In the manner of a *roman-à-clef*, an obscure personal mythology serves as a neutral vehicle for autobiography – a tactic, also evident in de Chirico's adoption of the myth of the Dioscuri to represent himself and his brother Alberto Savinio, that we may consider germane to Dalí's self-mythologising via the figure of Narcissus. That Dalí had by 1937 made the decision to 'become classical', as he put it, and evinced a growing interest in the Italian Renaissance may have disposed him to respond sympathetically to the strains of classical myth in de Chirico's post-war output of which the surrealists officially strongly disapproved (by contrast, it would seem that Breton most certainly had in mind the proto-surrealist works of de Chirico's earlier metaphysical period when he spoke in 1922 in laudatory tones of 'a new mythology in formation').

Let us now take a closer look at the constituent elements of the double image which are illustrated in the pamphlet with enlarged details. On the left, is the naked body of Narcissus who embodies that desire for annihilation normally concealed behind simulacra of terror. Poised above the abyss of his own reflection, Narcissus is half in love with an easeful death, only too ready to answer its hypnotic siren call. In the poem 'L'Amour' from *La Femme visible*, a text that adumbrates a number of the important themes in the *Metamorphosis of Narcissus*, Dalí had insisted that self-annihilation is one of our most violent and tumultuous desires. A sequence of images narrates the stepwise dissolution of Narcissus as a bounded and unified self until he attains at the end a pleasantly narcotised state of oblivion: 'incurable sleep, vegetal, atavistic, slow'.[155] The inexorable drag of the death drive manifests as a diminution of life force – 'Narcissus, you're so immobile / one would think you were asleep'[156] Dalí remonstrates with an unresponsive *alter ego* – and as an extreme regression that sees narcissism equated with the world of infantile autoeroticism. Dalí assuredly had read in Freud's *Introductory Lectures on Psychoanalysis* that:

> Sleep is a state in which all object-cathexes, libidinal as well as egoistic, are given up and withdrawn into the ego . . . The picture of the blissful isolation of intra-uterine life which a sleeper conjures up once more before us every night is in this way completed on its psychical side as well. In a sleeper the primal state of distribution of the libido is restored – total narcissism, in which libido and ego-interest, still united and indistinguishable, dwell in the self-sufficing ego.[157]

Narcissus yearns to recreate the blissful solitude of life *in utero*. Crouching down in what can best be described as a foetal position he is bathed in a warm ethereal glow. When Dalí came to write a chapter of *The Secret Life* about his improbably vivid memories of life in the womb it is something quite similar to this that he recalls: 'The intra-uterine paradise was the colour of hell, that is to say, red, orange, yellow and bluish, the color of flames, of fire; above all, it was soft, immobile, warm, symmetrical, double, gluey.'[158] In *Birth of Liquid Desires* of 1932 (fig. 104), the putative son, another Narcissus, immerses his hand in a fountain contained within a cavernous, overtly uterine space. That this motif, with its connotations of a wished-for return to prenatal existence, carries over to the *Metamorphosis of Narcissus* is shown by one of the studies

104 Salvador Dalí. *The Birth of Liquid Desires*. 1931–2. Oil and collage on canvas, 96.1 × 112.3cm. Venice: Peggy Guggenheim Collection.

for it. Following a line of argument from 'L'Ane pourri' it appears that Dalí seeks to represent in this manner 'the dream of a "Golden Age" concealed behind the ignominious scatological simulacra'. Compounding this set of associations, in the completed picture the space that cocoons Narcissus basically recapitulates the shape of his head which the poem describes as being like a chrysalis; consequently, it is a tomb in which he dies and becomes invisible, but also a womb-like place where he is preserved in order to be later reborn.

If the figure of Narcissus encapsulates the seductive enticements of the death drive, the converse is true of the colossal stony hand at the right of the picture. Such exquisite details as a crack running the length of the thumbnail, over which Dalí has laboured with seemingly perverse delight, cause us to recoil in horror. The rationale for this outreaching hand comes from Ovid who extracts remarkable poignancy from the reciprocal exchange of glances and gestures as Narcissus, entranced by his own reflection, moves in unison with a partner who mimes his every move: 'when I stretch my arms to you, you stretch yours back in return.'[159] But the way Dalí visualises the gesture is devoid of the gentle lyricism that suffuses the Ovidian verse. The hand that reaches out towards me, my hand, has become a dreadful, alien thing:

> His head supported by the tips of the water's fingers,
> at the tips of the fingers
> of the insensate hand,
> of the terrible hand,
> of the coprophagic hand,
> of the mortal hand
> of his own reflection.[160]

The Secret Life recounts an incident that must have occurred only a matter of a few months before these lines were written while Dalí stayed at Cortina d'Ampezzo in the Dolomites on

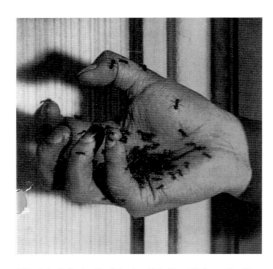

105 Luis Buñuel with Salvador Dalí. Film-still from *Un Chien andalou*. 1929. Directed by Luis Buñuel and co-written with Salvador Dalí. London: BFI Films: Stills, Posters and Designs.

his first trip to Italy. Over several days he had noticed with growing fascination a dried glob of mucus adhering to the lavatory wall. When curiosity finally got the better of him and he tried to peel it off, it became lodged under a fingernail of his right hand. An infection set in soon afterwards causing the hand to become swollen and enlarged. As Dalí lay alone on his hotel bed, Gala having departed temporarily for Paris, the diseased part appeared to detach from the rest of his body and confronted him in the shape of an offensive, over-sized *memento mori*: 'I imagined my hand already separated from my arm, a prey to the livid first symptoms of decomposition.'[161] Like the death's-head that Kolnai says grimaces at us from the place of the abject, this cadaveric hand was a chilling reminder of the death (drive) that infects life.

The image of a hand holding an egg from which sprouts a narcissus flower is without doubt one of the most startlingly original products of Dalí's feverish imagination. While in general terms this configuration is reminiscent of the hand in Max Ernst's *Oedipus Rex*, the emotional tenor plainly is not. Within Dalí's work, of course, it harks back to the scene of a severed hand swarming with ants in *Un Chien andalou* (fig. 105), the main difference being that the hand is now ossified. Inspiration for what the poem refers to as 'the limestone sculpture of the hand, the fossil hand' may have come partly from Ovid who employs a metaphorics of the petrified and statuesque to describe Narcissus, spellbound by his reflection, as 'like a statue carved from Parian marble'.[162] By transforming living flesh in to a stony cast, Dalí makes palpable the work of the death drive which, as we noted before, is a conservative force seeking to return the living organism to an inorganic state. But, as it does elsewhere in his work, notably in *The Lugubrious Game*, the enlarged hand could refer as well to the act of masturbation; such a reading is supported by the onanistic repetition in this section of the poem as it rises towards its awful crescendo, in conjunction with which the line 'The seed of your head has just fallen into the water' might possibly describe an ejaculation. An evocation of a sterile, autoerotic pleasure disengaged from the object in the external world and directed narcissistically towards the subject's own body becomes more obviously relevant later on as an unexpected twist occurs in the final stanza.

The hand which incites only disgust and terror corresponds to a part of the self that has been expelled, literally abjected, only to return in magnified form as a frightening hallucination. I want to raise here a possible link between the allusion to homosexuality (noted earlier) in the poem and the mechanism of paranoiac projection involved in the creation of this persecutory double. It stems from the same anxious need to disavow that impels Dalí to declare with unexpected vehemence: 'I am *not* a homosexual.'[163] From his reading of the Leonardo case-study we can assume that Dalí was cognisant of the link Freud makes between narcissism and homosexuality. That aside, the homoerotic content of the Narcissus myth is inescapable, a fact that may account for its scarcity in surrealist art and literature. As he lay beside the water's

edge, 'admiring all the features for which he was himself admired', Narcissus failed initially to realise that the youth whose beauty aroused his ardent desire was in fact himself. Works by Cellini and Caravaggio, which are among the best-known artistic representations of Narcissus, revel unashamedly in the homoerotic desire that the subject invites. Had Dalí availed himself of the chance to see their works at first hand on his trip to Italy he surely would have noticed in Caravaggio's *Narcissus* (fig. 106) a double image worthy of himself: that curiously inept depiction of the right knee, which Stephen Bann describes as phallic but is perhaps more like a buttock. Dalí goes one better, twinning the flexed knee with its reflection so that both buttocks are visible together. The same analogy of knees and buttocks occurs later in a passage from *The Secret Life* which recounts Dalí's plainly homoerotic infatuation with a schoolboy nicknamed Buchaques, and it is revealing of its significance for him that Dalí chose to project this precise detail in a lecture he gave at the Sorbonne in 1955. One can regard it as symptomatic that the poem seeks to disguise the true nature of the phantasy by displacing it on to a male figure in the heterosexual group, a blond German with 'brown mists / of mathematics / in the dimples of his cloudy knees'.[164] At one point in his text, Kolnai claims that an attempt at homosexual seduction – an unwelcome touch, for example – arouses feelings of disgust in a normal man. The homophobic sentiments that lie behind this unsupported remark are distasteful, but bearing in mind that disgust is a form of defence against an underlying attraction, it sheds some light on the nature of the desire that the prehensile hand in Dalí's image phobically repels. Interpreters of the *Metamorphosis of Narcissus* who have broached the issue of a disavowed homosexuality have tended to point the finger of suspicion at Dalí's intense friendship with the poet Federico García Lorca which reached a high-point when they holidayed together at Cadaqués in the summer of 1927 (fig. 107).[165] Another possible candidate for our suicidal Narcissus in the grip of the death drive is the writer René Crevel, who stayed with Dalí and Gala at Port Lligat several times in the early 1930s and was his most loyal supporter in the surrealist camp. Crevel's tragic death in 1935, like that of the homosexual protagonist

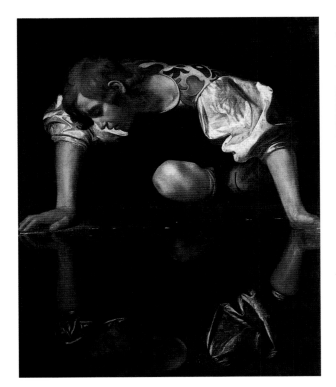

106 (*left*) Michelangelo Merisi da Caravaggio. *Narcissus.* c.1600. Rome: Galleria Nazionale d'Arte Antica.

107 (*below*) Salvador Dalí with Federico García Lorca in Cadaqués. 1927. Madrid: Fundacíon Federico García Lorca.

of his novel *Difficult Death*, is said to have deeply distressed Dalí at the time, though he later tried to make light of it. That the figure of Narcissus could be infused with memories of him does not contradict its essentially self-referential character.

the metamorphosis of narcissus

> When this head splits
> When this head cracks
> When this head shatters
> it will be the flower,
> the new Narcissus,
> Gala –
> my narcissus.[166]

Just as the poem reaches its terrible finale, the death foretold by the Ovidian myth, and that we now expectantly await, is miraculously averted. In what appears almost a sleight of hand, Eros – life, immortality – snatches Dalí back from the grasp of the death drive. Edward James, who was responsible for making a translation of the poem, had misgivings about the ending which he thought was rather unsatisfactorily tacked on, commenting that: 'Dalí ends by turning the poem with his last lines into a tribute to his wife; but, graceful though this is, it seems to me out of place in the context and dragged in "*par quatre épingles*".'[167]

So love triumphs in the end. Dalí recounts a similar tale in *The Secret Life*, portraying Gala as the intercessor whose love enables him to conquer the alarming miscellany of neurotic tics and obsessions that were a source of consternation to all around him. They met when she and Paul Eluard, along with the dealer Camille Goemans, René Magritte and his wife, descended on Cadaqués to holiday with Dalí in August 1929. It is only appropriate that the flames of their love were kindled in the very setting of the *Metamorphosis of Narcissus*. In terms of the poetic narrative, this event functions to domesticate Dalí's wayward desire by rechannelling it in the direction of a normative heterosexuality. Narcissism is thus safely reinscribed as a transitional phase in a developmental schema that reaches its socially acceptable terminus in mature object-love. After the concerns voiced by the fishermen of Port Lligat about the self-infatuated youth in their midst, one is prepared to believe that this denouement happily coincides with Dalí's cure.

It may not be coincidental that Breton opened the Galerie Gradiva in 1937, named in homage to a novel by Wilhelm Jensen which might never have come to the attention of the surrealists had it not been a subject of Freud's celebrated study.[168] It is the story of a young archaeologist, Norbert Hanold, who succumbs to a delusional phantasy about a girl represented on a Roman relief whom he names Gradiva. He believes she is real and after dreaming that she was buried in the eruption of Vesuvius sets off to Pompei in search of her. It transpires that the source of his delusion is the repressed memory of a childhood sweetheart, Zoe Bertgang, who he encounters as if by chance whilst wandering the streets of Pompei. Realising the nature of his disturbance, Zoe initially acquiesces in the delusion by pretending to be Gradiva; transferring his love from the phantasised object back on to herself, she effects his cure. Freud marvelled at her skill in a role which he compared to that of the analyst, while the surrealists were enchanted by this touching vignette because of the redemptive power of

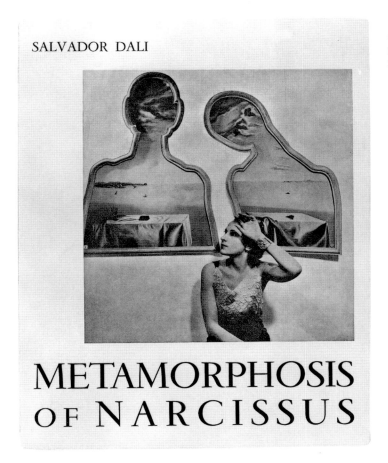

SALVADOR DALI

METAMORPHOSIS OF NARCISSUS

108 English edition of *Metamorphosis of Narcissus* (New York: 1937). Cover photograph by Cecil Beaton. Edinburgh: Scottish National Gallery of Modern Art.

love it revealed. If, indeed, it had been Dalí's intention to place the *Metamorphosis of Narcissus* under a surrealist banner, he could not have done so more unequivocally than by endorsing this article of the surrealist faith.

And yet, the trite conventionality of the ending sows doubts about its sincerity. A closer look in fact reveals that the reform of Narcissus is less complete than it had at first appeared: as 'my narcissus' Gala is surreptitiously enlisted into the class of Dalí's narcissistic love-objects (fig. 108). From the extreme idealisation of her, it can be inferred that she is an externalised portion of Dalí's ego – an ego ideal in which capacity she affords a roundabout way of satisfying his narcissism. We conclude, with Freud, that: 'What he projects before him as his ideal is the substitute for the lost narcissism of his childhood in which he was his own ideal.'[169] Of relevance to this state of affairs, a late variation of the Narcissus myth is recorded in which Narcissus, enamoured of his reflection in the water, mistakenly imagines it is the face of a beloved twin sister who had died. Dalí is a more knowing Narcissus, fully aware that it is really himself whom he loves in the guise of another when he christens Gala 'the new Narcissus'. His infatuation with her, because it is such a perfect embodiment of the Bretonian surrealist ideal of *amour fou*, in fact discloses its true face. Narcissus is nowhere to be seen in surrealism because narcissism is everywhere disguised and projected onto *la femme aimée*. A further point, going back to our observation about surrealism and homophobia, concerns the status of

erotomania as a disavowed homosexual wish. Dalí's uxorious devotion to his wife, Gala, supplanting and obscuring his former passionate attachment to Lorca, would seem to derive its intensity in part from a vigorous effort at disavowal. Inasfar as their relationship is an exemplary instance of surrealist *amour fou*, it permits us to recognise that Breton's notorious homophobia was not incidental, an unexamined prejudice on his part, but instead a necessary counterpart of the surrealist doctrine of love.

'Narcissus knows one cannot go beyond narcissism' writes Julia Kristeva.[170] Exceeding the parameters of an affliction from which Dalí might expect to be delivered, maybe the picture and accompanying poem ought to be retitled the *persistence* of narcissism. But what of the insistence of the death drive? Does the ending succeed in bringing that to an end? 'Now the great mystery draws near / the great metamorphosis is about to take place' – in terms that are perhaps meant to evoke the mystical doctrine of the transubstantiation (Salvador = Saviour), we are told that the metamorphosis of Narcissus is imminent.[171] The next stanza of the poem describes the complete disappearance of his corporeal body, to be resurrected as the flower that springs from his blood and whose annual rebirth is an assurance of his immortality. In the final lines, Dalí supplies the reader with an updated, psychologised form of this myth, namely the creation of a narcissistic double of himself in Gala. Freud, quoting Otto Rank, writes that the double: 'was originally an insurance against the destruction of the ego, an "energetic denial of the power of death"'.[172] In Ovid's poem as in Dalí's, Narcissus both dies and becomes immortal, i.e. does not die. Narcissism is cured yet persists, death is denied yet it too insists. The *Metamorphosis of Narcissus* occupies a uniquely important place in Dalí's oeuvre but the work of self-analysis it embarks upon would prove to be an analysis interminable.

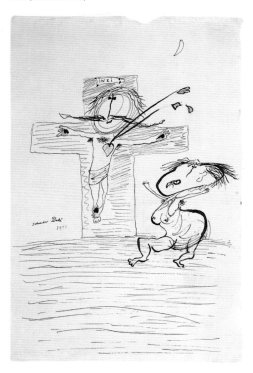

109 Salvador Dalí. *Crucifixion: Self-Portrait*. 1933. Pen, indian ink and coloured crayon, 20 × 13cm. Sotheby's, London, July 1992. Lot n° 239. (See note 171.)

5 MAKING FACES

'Our topic deals with the giving and taking away of faces, with face and deface, *figure*, figuration and disfiguration.'[1]

To speak of portraiture as a transaction is to insist upon the constitutive role of an intersubjective relation of self and other in generating the portrait image. In the usual event that a person pays another to produce a likeness one can readily appreciate that, in addition to the financial transaction that takes place, artist and sitter are implicated in a transaction of a more subjective character which may have an effect on how the person is represented. But in the case of a self-portrait, both artist and depicted subject are one and the same person and such considerations would seem not to apply. Drawing upon a psychoanalytic model of subjectivity, I want to extend the notion of a portrait transaction to include self-portraiture which, I will argue, must be thought of as a dialectic of self and other. To claim, as psychoanalysis does, that otherness is from the outset inscribed within the self is to assert that the subject ($) is divided – is not, in other words, in-*dividual*. The subject is neither identical with itself nor with the portrait each one of us paints of ourselves, that consoling fiction of an autonomous ego invested with 'attributes of permanence, identity, and substantiality'.[2]

Self-portraiture is premised on a belief that the subject is capable of being reflected and, by extension, re-presented. The same condition of specularity which underwrites the self-portrait is also an essential correlate of reflexive consciousness – the Cartesian subject *is* the subject of representation. The unconscious, on the other hand, designates a region that is accessible neither to reflection nor to representation, except indirectly. Posing as spokesperson for the unconscious, Lacan calls into question all the certainties of the Cartesian *cogito* which claims to apprehend itself in thought (reflection, speculation), declaring parodically: 'I think where I am not, therefore I am where I do not think.'[3] We saw how Max Ernst in a photocollage (fig. 1) that served as an invitation to an exhibition in 1935 shattered the coherence of himself as a subject in the Imaginary. Textual fragments – speech, language – emanating from the nether regions of the unconscious well up between the broken shards of what he exposes as a merely illusory façade. Ernst resituates himself as a subject in that other scene which Lacan calls simply 'the field of the Other'.[4] In a similar fashion to Ernst, psychoanalysis shatters the presumed transparency of the subject to self-reflexion; as Lacan puts it, 'it is a question of recentring the subject as speaking in the very lacunae of that in which, at first sight, it presents itself as speaking.' That is because 'the subject in question is not that of reflexive consciousness, but that of [unconscious] desire.'[5] For surrealism the subject in question most definitely is not that of reflexive consciousness either.

On the margins of the surrealist group and nurtured by its intellectual milieu in the 1930s, Lacan does little more than formalise their haphazard intuitions when he stipulates that: 'the condition of the subject S . . . is dependent on what unfolds in the Other O. What is being

unfolded there is articulated like a discourse (the unconscious is the discourse of the Other), whose syntax Freud first sought to define.'[6] The remainder of this chapter will explore how that abstract schema might translate into an art-historical approach to the portrait image. In the case of three very remarkable self-portraits produced by Joan Miró in the years 1937 to 1942, my intention is to analyse the face as the site, or space, of a transaction between self and other. In addition to the majestic *Self-Portrait 1*, the centrepiece of this chapter, the etched *Portrait of Miró* created jointly with Louis Marcoussis will be discussed in section iii, raising questions about intersubjectivity. A further dozen or so self-portrait drawings from this period exist, executed in some instances on mere scraps of paper and never exhibited during the years of Franco's rule because of the republican sympathies they evince. *Self-Portrait on an Envelope*, dealt with in section iv, persuades me that in spite of their cursory look these images reward careful attention. Whilst attempting to bring psychoanalysis to bear upon the dynamics of self-representation, this chapter also seeks to pin-point some of the cultural and political factors that impinged on how Miró portrayed himself which might contribute to an explanation of why it was that he turned so assiduously to self-portraiture at this moment. What kind of rapprochement between psychoanalytic and sociopolitical accounts of identity is it possible to envisage? The vast, cataclysmic upheavals on the world stage in the late 1930s had repercussions in the narrower arena of cultural politics which compelled even well-established painters to take stock of where they stood, to examine closely and redefine themselves. We may surmise that the act of self-representation was imbued with such great urgency for Miró because his identity as an artist could no longer be taken for granted. Between 1937 and 1942, Miró not only reinvents the nearly moribund genre of self-portraiture, he also reinvents himself.

i becoming other: Miró's *Self-Portrait 1*

'I come in Self-annihilation & the grandeur of Inspiration!'[7]

Unable to return to Spain because of the civil war, Miró had been stranded in Paris for more than a year when he announced to his New York dealer, Pierre Matisse, in a letter dated 3 November 1937 that he had embarked several weeks earlier on a self-portrait bust 'three times larger than natural size'.[8] The scale of his ambition was evidently equal to this as he confidently assures the dealer to whom the picture would later be consigned for sale that 'it will be the most sensational thing I have ever done.'[9] Throughout the winter of 1937/8, as Miró laboured at this herculean task a steady flow of correspondence kept Matisse abreast of each new development.[10] By February 1938, after several false starts, Miró confides that he is at last on the right track and promises to send a photograph. The following month he is so pleased with the image that in order to preserve it he decides to have a tracing made, enabling him to continue work on the traced copy should he wish to. *Self-Portrait 1* as it now stands is a mainly monochrome drawing in pencil and crayon with touches of oil colour (fig. 110). A strictly frontal head with pursed lips and intent, riveting stare nearly fills the large canvas. The eyes are like blazing stars and the whole face is consumed by flames. With Europe itself on the verge of conflagration, Miró condenses in this sombre, apocalyptic image the 'portrait' of

110 Joan Miró. *Self-Portrait I*. October 1937–March 1938. Pencil, crayon and oil on canvas, 146.1 × 97.2cm. The Museum of Modern Art, New York. James Thrall Soby Bequest.

his entire epoch. One could scarcely dispute the assessment of James Thrall Soby, one-time owner of the picture, that 'this beyond question is one of the major portraits of our time.'[11]

It might be added that it is one of the strangest, most eccentric of self-portraits too – even by Miró's standards. A need to inspect and record his features with utmost precision at a time of dislocation and uncertainty for him caused Miró to take the highly unusual step of employing a concave shaving mirror as he worked on *Self-Portrait 1*.[12] The magnified, distorted image this produces could, as Soby has suggested, account for some of the oddities of the resultant self-portrait. Miró's head looms before us so abruptly foreshortened that hairs on the tip of his nose are hugely enlarged (the one comical note in the picture). Aberrations around the edge of the mirror reflection have also been incorporated, creating a striking impression of centrifugal rupture of the facial contour. In an essay on Leonardo's *Last Supper* of which Miró was probably unaware, Goethe alerts us to the disconcerting aspect of a face viewed in this manner. Asserting that the human countenance only appears as beautiful when contained within strict parameters of size, Goethe instructs the reader: 'Make the experiment, and look at yourself, in a concave mirror, and you will be terrified at the inanimate, unmeaning monstrosity, which, like a Medusa, meets your eye. Something similar is experienced by the artist, by whose hands a colossal face is to be formed.'[13] Something similar, one could imagine, was experienced by Miró at whose hands a self-portrait three times natural size was to be formed. If, as Miró reports, it was a desire to apprehend (etymologically, 'to lay hold of') himself, warts and all, that drove him to use a concave mirror, the net effect of doing so was quite the reverse: it was to place him, at least momentarily, beyond the grasp of recognition. For an uncanny instant, it was as though he were someone – or something – other, an exorbitant movement in which he was propelled outside himself. *Self-Portrait 1* stands as a record of that putative moment of rupture and self-estrangement. A self-portrait, it is a portrait of the self as other.

Quite a contrary effect was achieved by Parmigianino in his celebrated *Self-Portrait in a Convex Mirror* of 1524, which one might otherwise be tempted to look upon as an art-historical precedent. The optical distortions created in that instance with the aid of a convex mirror plainly do nothing to disturb the composure of the juvenile Parmigianino whose air of absolute self-possession is underscored by the left hand with which he embraces himself. So too, a very different mode of address was recorded by Miró in his youthful *Self-Portrait* of 1919 (fig. 111). At the time, Miró was jockeying for position at the forefront of the avant-garde in Barcelona and the disjunctive styles that are combined within the picture reflect fashions current in those circles. The cubist facets of the shirt, left conspicuously unfinished, announce Miró's modernity and international outlook, whilst the stylised head, treated in a manner indebted to newly rediscovered Catalan Romanesque murals, aligns him with a

111 Joan Miró. *Self-Portrait*. 1919. Oil on canvas, 85.4 × 73cm. Paris: Musée Picasso.

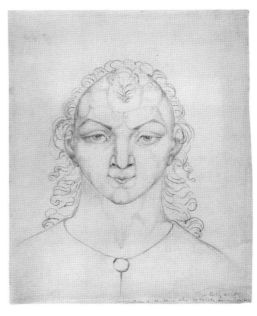

112 (*above*) André Masson. *Visionary Portrait of Heraclitus*. 1939. Illustration to Georges Bataille, 'Les Mangeurs d'étoiles', in J.L. Barrault et al., *André Masson* (Rouen: 1940): 25.

113 (*right*) William Blake. *The Man Who Taught Blake Painting in His Dreams* (Replica). c.1819. Pencil on paper, 26 × 20.6cm. London: Tate Gallery.

resurgent tide of Catalan nationalism.[14] Painted on the eve of his departure for Paris, it is an image that speaks, on every level, of artistic ambition. Accordingly, in the exaggerated curves of the small globular face and open neckline are reiterated heart shapes that betray a narcissistic investment in an idealised image of what Miró himself would like to be. As a common expression has it, the likeness captures the subject.[15] In *Self-Portrait 1*, on the other hand, that intimacy with one's self that the term 'identity' presupposes has irretrievably broken down, and along with it the boundedness of the self-image. A ghostly shadow of his former self, *Self-Portrait 1* has none of the earthy solidity and presence of the earlier self-portrait in which a large, furrowed expanse of shirt in a fiery terracotta colour literally anchors him in the Catalan landscape.

whom do I haunt?

Freud, in the essay 'The "Uncanny"', recounts an incident on a train journey when he caught sight of his face reflected in a swinging glass door and momentarily failed to recognise it as his own. Indeed, he recalls having felt a hearty distaste for the bearded stranger lurching towards him and wonders now if his reaction was not 'a vestigial trace of the archaic reaction which feels the "double" to be something uncanny'.[16] Some insight into the no-less-uncanny character of *Self-Portrait 1* can be had from a note jotted down in 1942 or thereabouts as Miró contemplated resuming work on the picture — referring in all likelihood to the traced copy which by that stage we can safely assume had been made. 'Think about William Blake when doing the self-portrait' he writes.[17] By that date, André Masson, a long-standing acquaintance of Miró's, had already commenced a series of visionary portraits which took their cue from William Blake who, at the behest of John Varley, his patron, had *circa* 1820 transcribed visions of historical, or in some cases wholly fictional, personages. An ink drawing by Masson of the pre-Socratic philosopher Heraclitus (fig. 112) whose hair is in flames is obviously close in

conception to Miró's self-portrait. Masson came to Heraclitus via Nietzsche and, like him, felt a strong affinity for a system that affirms 'perishability and destruction . . . everything which is combat and contrast' as he wrote in a letter of 1936.[18] His image is, in consequence, a partial self-portrait as comparison with other self-portraits from the period reveals. The flaming hair that Masson's drawing obviously has in common with Miró's in the former alludes to the crucial role of fire as an agent of flux and transmutation in Heraclitus's cosmology.[19] While it is possible that Masson had seen *Self-Portrait 1* in his friend's studio, another explanation for the family resemblance is that both images derive from a common ancestor. *The Man Who Taught Blake Painting in His Dreams* of 1819 (fig. 113) is one of the most renowned of Blake's visionary portraits and, since Blake was self-taught as an artist, is generally presumed to be a self-portrait, the orientalized features notwithstanding. With a wiry, incisive line, Blake depicts the head full-face to maximise the impact of his piercing stare. What appear to be flames, of inspiration maybe, rise from the forehead and merge with contiguous locks of hair. Miró had an opportunity to see this very singular image at first hand early in 1937 at an exhibition of Blake and Turner held at the Bibliothèque Nationale in Paris,[20] and the visual evidence alone persuades one that quite independently of Masson, and well before him, he struck upon the idea of representing himself in the guise of Blake, a much-venerated surrealist precursor. It could have been just after a visit to the exhibition that Miró wrote to Matisse setting out in unmistakeably Blakean terms his aims in a picture, the *Still Life With Old Shoe* (Museum of Modern Art, New York), which he was working on at the time: 'To look nature in the face and dominate it . . . It's as though by the strength of your eyes you bring down a panther at your feet in the middle of the jungle.'[21] And his comment soon after in an interview with Georges Duthuit that 'each grain of dust contains the soul of something marvellous'[22] is again highly redolent of Blake, whose name was very often invoked by the surrealists, especially in the wake of the International Exhibition of Surrealism in London in 1936.

Consider for a moment the mental note: 'Think about William Blake when doing the self-portrait.' Such a mask doubtless struck Miró as the most economical way of signalling his identity as a visionary artist. As a painter–poet, Blake would have had a special appeal for Miró who in his own work sought to achieve a synthesis of painting and poetry (indeed he later made use of a technique of relief-etching pioneered by Blake for the very purpose of enabling images and handwritten text to be combined).[23] The remark is perplexing, however, because it poses the question of whose self is being represented. What does it mean to paint a self-portrait with another artist in mind? It is as if, in the words of the poet Arthur Rimbaud, the 'I' were an other.

It transpires that yet another ghost haunts the space of *Self-Portrait 1*. Van Gogh, an ego ideal dating from Miró's earliest days as a painter, is paid a reverent homage in *Still Life With Old Shoe*, painted in Paris between January and May 1937. Strident expressionist colours and a discarded boot alongside the rudiments of a peasant repast clearly allude to the Dutch painter, as Miró confirmed in an interview many years later.[24] In *Self-Portrait 1*, which followed close on its heels, Miró (speaking figuratively now) steps into the boots of Van Gogh: the sunflower on his lapel is a token of this identification.[25] Held within the precincts of the 1937 Paris World's Fair was a blockbuster exhibition of Van Gogh which opened in June and ran until October. The catalogue for the event was published as a special issue of the popular art magazine, *L'Amour de l'art*, and contained an essay by René Huyghe, curator of paintings at the Louvre, who predictably dwelt at considerable length on Van Gogh's tragic persona. A caption to one of the numerous self-portraits (fig. 114) comments on a background of flame-shaped

arabesques that can be imagined as embroiling the artist's head, and in his catalogue essay Huyghe powerfully evokes 'torches of fire, into which trees, houses, rocks, are metamorphosed and ascend to the sky rejoining fires of neighbouring worlds'.[26] As it has been established that Miró commenced work on *Self-Portrait 1* in the month of October, it would seem reasonable to infer that the Van Gogh exhibition gave him the initial spark.

Miró Prometheus

Matters prove to be more complicated, however, with Miró writing to his dealer on 5 February 1938 that, having *destroyed* his portrait several times, 'I now feel that I am on the right track. It will be drawn in a few days, and then I will have it photographed and send you a print.'[27] It therefore seems likely that while *Self-Portrait 1* was begun in October 1937 it underwent considerable revision and only assumed its present shape in the new year. Adding weight to this hypothesis is a caricatural drawing of 21 September 1937 inscribed on the reverse side 'Study for a portrait – self-portrait'. If, as seems probable, this is an early study for *Self-Portrait 1* then as it evolved Miró plainly jettisoned its comical spirit in favour of a much graver conception. A decisive factor in this radical volte-face was the publication in December 1937 of an essay by Georges Bataille entitled 'Van Gogh Prometheus' which appeared in the first issue of *Verve*, a new avant-garde art review. Short and pithy, but incendiary in tone, it takes

the form of an avowedly idiosyncratic review of the recently closed Van Gogh exhibition (several lithographs by Miró were included in the same issue of *Verve*, adding to the likelihood that he encountered the essay there). In the exhibition catalogue Van Gogh was reported as having once said that: 'There are circumstances in which it is worth more to be the vanquished than the victor, better Prometheus than Jupiter.'[28] This furnishes Bataille with a title, and a pretext to take up on his hobby-horse, the topic of sacrifice, first broached in connection with Van Gogh in an essay of 1930 which bears the rather lugubrious title 'Sacrificial Mutilation and the Severed Ear of Vincent Van Gogh'. That article had been published in *Documents*, a journal Bataille edited, which owed its unique character to the involvement not only of artists and writers (many of whom were disaffected former surrealists) but also of ethnologists.[29] This orientation is reflected in Bataille's essay which marshals evidence from a broad range of ethnographic as well as psychiatric sources to demonstrate that Van Gogh's self-mutilation, in spite of its apparent basis in mental illness, was no less the expression of 'a veritable social function, of an institution as clearly defined, as generally human as sacrifice'. The act of slicing off an ear Bataille compares to the mutilations carried out in initiatory and other rites. Both spring from a desire to rupture limited being, from 'the necessity of throwing oneself or part of oneself *out of oneself*' which 'in certain instances can have no other end than death'.[30]

The valorisation of loss over and against the norms of utility and conservation is a theme Bataille returns to time and again in the 1930s.[31] Existence is impoverished, Bataille asserts, by the dominance of our self-preservative instincts which shore up the defensive ramparts of the ego only to confine and imprison us. With the bourgeois individual clearly in his sights, Bataille refers contemptuously to 'all that confers on (many) faces the repugnant aspect of defensive closure'. Life only reaches an incandescent intensity when it risks itself, burns and consumes itself. The sun wastefully expending its energy is a potent symbol for the unconditional, sovereign loss of self which alone is capable of redeeming the habitual emptiness of our existence. This, says Bataille, is the reason why the sun is so central to sacrificial myths and rituals, as well as being the source of Van Gogh's abiding obsession with it. Resuming this argument in 'Van Gogh Prometheus', he contends that Van Gogh went so far as to identify himself with the sun:

> Van Gogh, who decided by 1882 that it was better to be Prometheus than Jupiter, tore from within himself rather than an ear, nothing less than a SUN . . . Van Gogh began to give to the sun a meaning which it had not yet had. He did not introduce it into his canvases as part of a decor, but rather like the sorcerer whose dance slowly rouses the crowd, transporting it in its movement. At that moment all of his painting finally became *radiation*, *explosion*, *flame*, and himself, lost in ecstasy before a source of radiant life, *exploding*, *inflamed* [*en flammes*].[32]

Self-Portrait 1 renders this sovereign moment as the artist (Van Gogh–Miró) 'lost in ecstasy before a source of *radiant* life' becomes himself explosive, inflamed. Miró translates into visual form Bataille's recasting of a Promethean myth of the artist in terms of self-sacrifice. The flames kindled on the forehead of Blake, the Romantic poet, have grown into a self-immolating fire.

Supposed differences of temperament, and a somewhat dismissive attitude towards Miró's intellectual achievement, have made historians reluctant to admit of any link between him and Bataille.[33] In fact, it would be highly surprising, given his close acquaintance with Michel Leiris and André Masson, if Miró was not familiar with the concerns that animated Bataille's group. In the 1930s, Masson in particular worked in a close and reciprocal intellectual partnership

with Bataille, and a brief resumé of his work of this period reveals a number of parallels with *Self-Portrait 1* that assist in elucidating its pictorial meanings. In 1936, Masson and Bataille published an album titled *Sacrifices* consisting of a written preface by Bataille and five illustrations by Masson, the latter loosely based on the third part of Sir James Frazer's *The Golden Bough* which describes myths of the death of God. This collaborative venture reflects their ethnographic interest in the subject of sacrifice, an overriding preoccupation of both men in this decade.[34] One of Masson's plates for the album depicts the Egyptian corn deity Osiris suspended in midair (fig. 115), his head fused with the sun, prefiguring the central motif of 'Van Gogh Prometheus'. This same motif, with the connotations of rupture and self-sacrifice, resurfaces as the frontispiece to Masson's *Mythologies* and in numerous other images by him in the 1930s. It appears that Masson and Bataille also shared a passion for the work of William Blake and at one point even envisaged publishing a monograph on him, which never

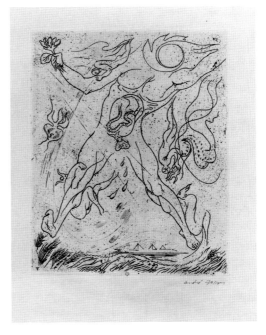

115 André Masson. *Osiris*. 1936 [1933]. Etching, 30.9 × 24.5cm. Published in *Sacrifices* (Paris: 1936), an album of five etchings by André Masson with text by Georges Bataille.

came to fruition but indicates none the less the depth of their interest. A pen-and-ink portrait of Blake by Masson from 1938, aside from the orgasmic eroticism which is a virtual trademark of his work at this juncture, can be likened to Miró's self-portrait in a number of respects: flaming hair, explosive rupture of boundaries, and metaphoric rapports of eyes and stars convey in both the impression of a figure imprinted on cosmic space.[35] An event that gave a vital impetus to the themes of ecstatic fusion with the cosmos, underlining its derivation from an aesthetic discourse of the sublime, was the epiphany Masson underwent during the night in January 1935 when he was lost in the mountains of Montserrat near to Barcelona. It will be recalled that two paintings inspired by the event and a poem by the artist were carried in the journal *Minotaure* in June 1936 with a commentary by Bataille, who writes expansively: 'No limit, no measure can be given to the violence of those who are liberated by the vertigo felt before the vault of the sky.'[36] The dizzying centrifugal expansion in *Self-Portrait 1* certainly brings to mind this account, though an antecedent for the idea of projection of a figure onto cosmic space can be found within Miró's previous artistic production in the four variants of the *Head of a Catalan Peasant* of 1925.

In the context of Masson's work, Bataille further elaborates this distinctive spatial metaphor in two essays of the late 1930s, 'Celestial Bodies' and 'Eaters of Stars' ('Mangeurs d'étoiles').[37] The first of these was illustrated by Masson with a spiralling astral vortex (fig. 25), whilst in the second Bataille lavishes praise on Masson's recent figure drawings such as *Portrait of Heraclitus* which is reproduced at the head of the article – 'the property of these figures is not to gather themselves inwardly, but to explode and lose themselves in space.'[38] Being renounces its claim to a static, fixed identity: 'the visages drawn by Masson have on the contrary invaded

the clouds or the sky. In a sort of ecstasy, which is none other than their precipitous exaltation, they annihilate themselves.'[39] A more accurate or evocative description than this of Miró's anguished, exalted self-portrait could scarcely be imagined but, disappointingly, Bataille does not seem to have known about the picture since his article makes just a single, disparaging reference to Miró (there is no firm evidence that *Self-Portrait 1* was ever exhibited publicly in Paris before being dispatched to New York).[40]

All the salient features of *Self-Portrait 1* outlined thus far – rupture of ego boundaries, sacrifice of oneself, becoming 'other' – are consistent with descriptions of the visionary experience, both secular and religious, that were available to Miró.[41] Typically, stories of religious conversion entail the death and rebirth of the individual, a process of self-transformation that, carried across to the Romantic idea of the poet, culminates in Rimbaud's famous declaration, '*Je est un autre*', which he makes in the '*Lettre du Voyant*' (Letter of a seer). Miró, we have observed, in his rebirth as a visionary, becomes literally other by virtue of his projective identifications with Blake and Van Gogh, both of whom embody, albeit in different ways, the visionary ideal.[42] Another aspect of visionary experience that derives from religion is the portrayal of the moment of revelation itself as an inner Apocalypse. M.H. Abrams, in his classic study *Natural Supernaturalism*, traces within Christian theological traditions a gradual internalisation of the biblical Apocalypse, 'transferring the theatre of events from the outer earth and heaven to the spirit of the single believer'.[43] This trend is exemplified in the work of William Blake for whom themes of the Apocalypse and Last Judgement were closely allied to his conception of the artist as a man of vision, a revealer of eternal truths as opposed to the contingent truths peddled by science. Blake combined the biblical sense of the Last Judgement as a universal, eschatological event with a notion of an equivalent event in the mind of the individual. There are several painted versions of the Last Judgement by Blake which were studies for a much larger composition intended, David Bindman states, 'as a summation of all Blake's visionary ideas'.[44] Among the works listed in the catalogue as being on display at the Bibliothèque Nationale in 1937 was the first of Blake's watercolour versions (now at Pollock House, Glasgow) of the subject, an image with a strangely anthropomorphic appearance. Comparing it with *Self-Portrait 1* yields, in addition to the obvious thematic link, tantalizing parallels of a formal and compositional nature which invite one to speculate that Blake may have provided Miró with yet another of his visual models.[45]

apocalypse now

Miró's internalisation of the Apocalypse in *Self-Portrait 1* serves to align his own personal fate with that of Spain in the throes of a destructive civil war.[46] The flames that engulf him would surely have been linked by contemporary viewers with the graphic news footage of ransacked and burning villages relayed daily to Paris. That such an association was fully intended is borne out by the notes Miró wrote in 1942 when he thought to undertake further work on the picture: 'see to it that . . . the whole thing resembles a landscape' he wrote as a reminder to himself.[47] The implicit message of resistance carried by Miró's symbolic alliance with the sufferings of the peasantry is further strengthened by clear-cut references in *Self-Portrait 1* to Catalan Romanesque art. William Rubin was the first to observe that the stylisation of the face derives from such a source; moreover, he notes that the Apocalypse is a theme commonly found in early medieval art.[48] Catalonia, Miró's birthplace, fiercely maintained its separation

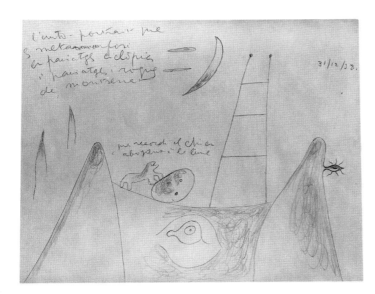

116 Joan Miró. *Self-Portrait Metamorphosed into Rocks of Montserrat.* 1938. Pencil on paper, 17 × 22cm. Barcelona: Fundació Joan Miró.

from Castilian Spain and became a natural stronghold of opposition to the nationalist Franco. Included among the programme of cultural events sponsored by the Republican government aimed at promoting international awareness of their cause was an exhibition, *L'Art Catalan du Xᵉ au XVᵉ Siècle*, held at the Jeu de Paume and the Château de Maisons-Laffitte in Paris from March to April of 1937. Picasso was on the steering committee for that event and in *Guernica*, shown subsequently in the Republican Pavilion at the Paris World's Fair, he makes conspicuous iconographic allusions to the beasts of the Apocalypse. Christian Zervos, in a book published on the occasion of the Catalan art exhibition, rehearses the myth of an organic tie uniting the Catalan people with their soil, the basis of their proud independence:

> In the face of all the monuments of this art, we know that its substance is peculiar to itself, that the very temperament of the Catalans and the earth which bears them are its source and that man and earth are all of one piece. This communion of earth, man and work which it conveys is imprinted strongly in the Catalan style and explains the spiritual autonomy of the people of this part of the Iberian peninsula.[49]

This myth of attachment to the landscape is deployed in a highly strategic fashion by Miró in a sequence of drawings based on the terrain of Montserrat, a place of utmost spiritual and symbolic importance for Catalans, which he made towards the end of 1938 as Nationalist forces were poised to overrun Barcelona (they entered the city on 26 January 1939).[50] The Benedictine monastery at Montserrat houses an ancient wooden statue of the Virgin Mary whose body seems to have permeated the landscape of Miró's drawings: the rocky outcrops which are a striking feature of the mountains have become her nurturing breasts, and a sign for the female genitals occupies the space between them. In the penultimate drawing (fig. 116), dated 31 December 1937, the female sex has been replaced by a Cyclopean eye, that of the artist; a written inscription on this astonishing drawing informs the viewer that it is a 'self-portrait' metamorphosed in to the rocks of Montserrat! Unlike the works produced several years earlier by Masson inspired by the same locality, here the quasi-mystical fusion with landscape carries an unmistakeable message of political solidarity.

Speculating about the motives that lay behind Masson's recourse to self-portraiture during his wartime exile from occupied France, Michel Leiris wrote that: 'In the midst of this total debacle . . . what seemed to Masson the most effective way of finding his feet again was an objective self-examination, self-definition by means of portraiture.'[51] A similar motivation can surely be ascribed to Miró for whom the circumstances of his exile from his native Catalonia brought a feeling of profound dislocation. No less momentous for artists than these cataclysms on the world stage were upheavals which occurred in the narrower arena of cultural politics, and it may be that the somewhat melodramatic accent on the loss of self in *Self-Portrait 1* is related to the predicament in which Miró found himself, as an artist, in 1937. Once accused by Breton of cherishing the sole desire 'of abandoning himself to painting, and only to paint-ing',[52] Miró began to echo the rhetoric of the Left which was vocal in denouncing such an artistic stance. He speaks piously of wanting 'to go beyond easel painting . . . and to bring myself closer . . . to the human masses I have never stopped thinking about',[53] and in recorded interviews is at pains to make known his fervent wish to 'plunge into the reality of things', the motive for which is obscure unless it be viewed as his concession to a social realist agenda that demanded not just a politically engaged art, but one that was accessible and in touch with reality. That Miró turned his hand to overtly propagandist art for the first time in 1937, car-rying out a mural commission for the Spanish Republican Pavilion at the Paris World's Fair (*The Reaper*, which is now lost), is further evidence that he was compelled to shift ground in response to new political exigencies.

A comprehensive study of mural painting in the interwar period in France is long overdue, but a few remarks here may be helpful in situating Miró's project. Numerous artists of widely differing ideological and aesthetic persuasions had ambitions to paint on a mural scale at this time. This was reflected in the case of some artists by a preference for art of the pre-Renaissance; Albert Gleizes proposed a version of the French tradition that bypassed the Renais-sance and embraced the spirituality and populism of Gothic art, declaring in an essay of 1923, 'Art and Religion', that: 'We don't doubt ourselves that our researches will lead us to the dis-covery of the principles which command popular painting, that of murals, and which founds the secret of the religious tradition.'[54] In the context of the realism debates of the mid-1930s, mural painting moved on to the avant-garde agenda. Easel painting, originating in the Renais-sance and 'destined socially to satisfy bourgeois individualism', was viewed now with suspi-cion by artists who wanted to reach out to a working-class audience: 'we wish to make and renew a modern collective and popular mural art form' insisted Fernand Léger.[55] In keeping with the ethos of the Popular Front, medieval wall painting offered a model for an art form that was the product of a collective will. The panels executed by Léger for the 1937 World's Fair are, however, more obviously indebted to the example of Soviet Agitprop in their use of montage than to earlier styles of art. Miró's attraction to Catalan Romanesque wall painting is well documented and certainly pre-dates the 1930s. While holding views about art and spir-ituality not dissimilar to Gleizes, much of what he says at this time contains clear echoes of the discourse on the Left around mural painting. In his interview with Georges Duthuit, for example, Miró denounces individualism as a sign of decadence and states his preference for anonymous art forms: 'In great epochs the individual and community marches together' he affirms.[56] Like Miró, and for much the same reasons, Picasso executed a mural-sized painting, *Guernica*, for the Republican Pavilion.

The Left-sponsored realism debates in Paris in the mid-1930s demonstrate that portraiture too was drawn into the political fray, with the alleged neglect of this traditional, humanist

genre by modernism being wielded as a stick to beat it with. Louis Aragon, an erstwhile surrealist but now one of the staunchest advocates of socialist realism, gave voice to the new orthodoxy: 'The portrait is an essentially realist genre, and can scarcely be accommodated by modern theories which condemn realism. I would simply say of these theories that it suffices to condemn them to note that they are incapable of doing justice to a human phenomenon like the existence of the *portrait*.'[57] That Aragon's address, 'Socialist Realism and French Realism', was made in October 1937 could indicate that Miró's turn to self-portraiture at precisely this moment was not unconnected with this sea-change. The most spectacular case of an avant-garde artist reviving portraiture as part of a return to realism was that of another former sur-realist, Alberto Giacometti, who did so in a Cézannist portrait of his mother in 1937.[58] It is, moreover, fascinating to consider that as work proceeded on *Self-Portrait 1* through the winter of 1937/8, Miró posed with his daughter Dolorès for a portrait by the artist Balthus (fig. 117). Wearing the same suit and tie as in his self-portrait, Miró is seated nearly square on, one arm extended rigidly to his knee while the other supports the waist of his daughter who leans nonchalantly against his thigh, her right hand resting on top of his. Their intimacy seems as unaffected as the stylistic idiom, a sobre naturalism Aragon might well have approved of.[59] Balthus captures a sense of the disquiet of the epoch, a trait for which the new figuration was much praised, by isolating the wistful father and daughter in a setting that is unrelieved in its drabness.[60] Sitting for this portrait would have given Miró ample time to reflect upon his own artistic stance, and while it is obvious that he did not meekly submit to the dictates of

the prevailing realism, neither could he blithely switch off from the political demands now being made on artists. Miró was assuredly not alone in being under considerable strain at this juncture; similar pressures had certainly precipitated Picasso's much-talked-about cessation of painting during 1935. World events aside, for artists of a modernist persuasion this really was the apocalyptic end of an era. *Self-Portrait 1* vividly registers this dissolution (fading, evaporation) of a once solid and secure artistic identity.

• • •

Before ceasing work on *Self-Portrait 1*, in February of 1938 Miró painted a small gouache, *Woman in Revolt* (fig. 118), possibly the most rebarbative image in his entire oeuvre. Its subject, a peasant woman defiantly brandishing a sickle as she flees a burning village, was a stock one in realist painting of the time, but the disturbing incongruity of a phallus stretched across the picture plane in effect shifts the register of Miró's image away from external reality to the plane of psychical reality.[61] We can compare this grotesquely deformed organ which floats free of its normal anatomical moorings to the elongated, anamorphic skull which occupies a similar place in the foreground of Holbein's *The Ambassadors*. Jacques Lacan, in a richly suggestive reading of it, cheekily dubs this odd *memento mori* the phallic ghost (*fantôme phallique*) on account

118 Joan Miró. *Woman in Revolt*. February 1938. Watercolour, pencil and charcoal on paper, 57.4 × 74.3cm. Paris: Musée National d'Art Moderne, Centre Georges Pompidou.

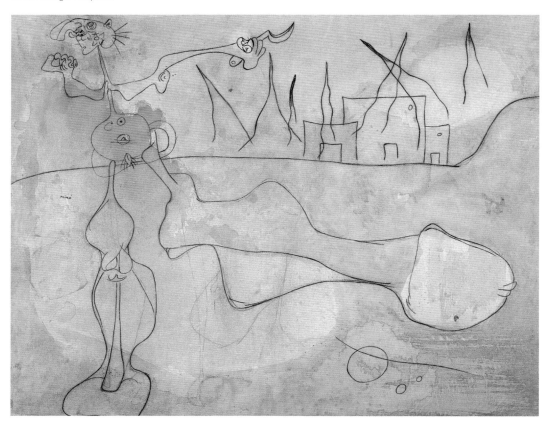

of its elongated morphology and asserts that it introduces a spectre of lack, i.e. castration, into a scene otherwise dominated by the nearly palpable presence of people and their possessions. 'Holbein makes visible for us here something that is simply the subject as annihilated', Lacan writes, 'annihilated in the form that is, properly speaking, the imaged embodiment of . . . castration.'[62] Similarly, in *Woman in Revolt*, our eye oscillates between the diminutive sickle at the top of the picture and the giant phallus at the bottom, between the alternatives of castration and disavowal.[63] A quota of castration anxiety no doubt also lurks within *Self-Portrait 1*, inasmuch as the distorted mirror reflection used by Miró has, as Goethe reminded us, a terrifying Medusan aspect. For Freud, the terror of the Medusa is none other than a fear of castration, and such a fear is liable to be provoked whenever the subject is threatened with the loss of its illusory wholeness and integrity.

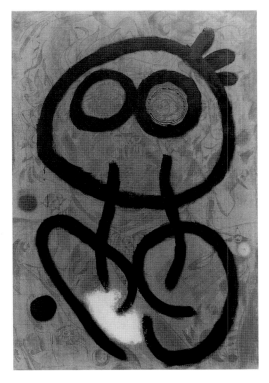

119 Joan Miró. *Self-Portrait*. 1937–60. Oil and pencil on canvas, 146.5 × 96.9cm. Barcelona: Fundació Joan Miró.

Miró wrote to his dealer early in March 1938, saying 'my portrait is already drawn . . . I have now turned the canvas against the wall and will leave it there for several days so that I can begin painting with fresh eyes. I think this will be the most important work of my life. I might do a tracing to preserve the drawing, which in itself is something of considerable breadth.'[64] When he did finally return to the traced copy of *Self-Portrait 1* in 1960 (fig. 119), Miró literally defaced it with daubed graffiti. His comical over-painting delicately mocks the grandiose pretensions of the earlier self-portrait seen peering out from underneath, at the same time defusing and recuperating an alien image of himself that was, I have argued, in more than one respect, out of character. *Self-Portrait 1* marks a moment of rapprochement with Georges Bataille during a phase of the latter's work that culminated with his book *L'Expérience intérieure* where the poetic is equated with the uncanny: it is the 'familiar dissolving into the strange, and ourselves with it'.[65]

ii transactions with the other: *Portrait of Miró* by Miró and Louis Marcoussis

The surrealists indulged in collective games like the creation of *cadavre exquis* (fig. 120) as a form of diversion.[66] They were just meant to be fun; their paradoxical use-value lay in their character of idleness, not work. Yet, as André Breton was ready to concede, this explanation is far from exhausting either the motives for, or meanings to be inferred from, their indefatigable game-play.

From daily meetings presided over by Breton, to manifestos which bound them to a common cause, to group exhibitions in which individual talents were subsumed, a strongly collective ethos impinged on every aspect of the life of surrealism. It determines the way they chose to

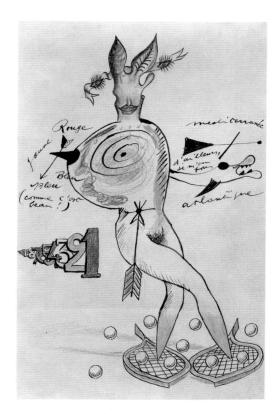

120 Yves Tanguy, Joan Miró, Max Morise and Man Ray. *Cadavre exquis*. 1926–7. Composite drawing: pen and ink, pencil and coloured crayon on paper, 36.2 × 22.9cm. The Museum of Modern Art, New York. Purchase.

121 'I do not see the [woman] hidden in the forest.' *La Révolution surréaliste* n° 12 (15 December 1929): 73.

represent themselves (fig. 121): the male surrealists huddle round the body of a woman, solipsistically isolated within their individual frames but united by a common desire for *la femme aimée*. Man Ray's photocollage permits us to see that one of the essential functions of femininity was as the glue that assured the group's cohesion. Games, too, had this as their purpose: 'straightaway, they showed themselves capable of strengthening the links which united us, favouring an awareness of the desires we had in common.'[67] The emphasis upon communal effort sprang in part from ideological sources: across the board, avant-garde spokespersons at the time had nothing but scorn for the individual. Jean Gorin's optimistic prediction spoke for them all: 'The individual is dead. The art of the twentieth century will be profoundly universal and collective. The machine age will revolutionise completely the life of man, paving the way for a classless society of the future.'[68] Sentiments like this become palpably stronger in André Breton's thinking from the mid-decade as he absorbed the ideals of the burgeoning Front Populaire, though an egalitarian impulse had long been part of the surrealist platform, epitomised in the catch-cry 'Poetry must be made by all, not by one.' Part of the appeal of the *cadavre exquis* was that even the artistically maladroit like Breton could play the game; not least of its virtues was, moreover, 'the conviction that, at the very least, these composite productions carried the mark of that which could not be engendered by a single brain'.[69]

Such considerations had an important bearing on the way automatic writing was practised and help to account for its place at the very heart of Breton's definition of the surreal.[70] Language reclaims its rights; the author is demoted to the status of a mere passive conduit for the automatic message. That much is widely understood. None the less, the crucial role of collaboration in the production of automatic texts has been generally ignored, despite Breton's eloquent pleas. 'The forms of surrealist language adapt themselves best to dialogue' he asserts in the *Manifesto of Surrealism*, continuing:

> Poetic surrealism, to which I devote this study, has applied itself to reestablishing dialogue in its absolute truth, by freeing both interlocutors from any obligation of politeness . . . The words, the images are only so many springboards for the mind of the listener. In *Les Champs magnétiques*, the first purely surrealist work, this is the way in which the pages grouped together under the title 'Barrières' must be conceived of – pages wherein Soupault and I show ourselves to be impartial interlocutors.[71]

The ubiquitous presence of an interlocutor – as occurred also in the conduct of the trance sessions – and the centrality of dialogue, both of which Breton emphasises, point to alternative ways of understanding surrealist automatism than as the outpouring of an individual unconscious.[72] Coming a full decade after *Les Champs magnétiques*, the texts that comprise 'Les Possessions' were also jointly authored, this time by Breton and Paul Eluard. In the preface to a Japanese translation of the texts in 1935 Eluard remarks that the task of collaboration was made easier by the close personal rapport that already existed between them. Eluard's 'Note à propos d'une collaboration', reprinted in *Cahiers d'art*, reflects in a lyrical vein upon what was at stake for them in the creative process: 'To be two to destroy, to construct, to live, is to be already everyone, to be the other to infinity and no longer oneself.'[73] To be other to the end and no longer oneself – this aspiration, raised to the level of an ethical injunction, was surely a powerful motivation for Breton's abiding attachment to automatic writing even in the face of its continuing misfortune.

Maurice Blanchot has written that we need to abandon as misleading the commonplace view of surrealism as a collective on the model of a religious sect or political cell. What Blanchot claims distinguishes it from all other such groupings is that surrealism, largely because of the experience of language and the novel conception of communication which it proposes ('dialogue in its absolute truth'), constituted a space of difference and otherness that defies unification. 'Let us say of surrealism, it is not a collective affirmation, but rather plural or multiple.'[74] The subject in surrealism is defined by the coordinates of a space of multiplicity, realised as a dialogue or transaction with the O/other.

inscribing alterity

Miró's experience of sitting for a portrait by Balthus at the same time as he painted his own self-portrait was in a manner recapitulated in the etched *Portrait of Miró* (figs 122–25) begun in March 1938 and finished in September of that year. The product of a collaboration between Miró and Louis Marcoussis, the former cubist painter whose printmaking studio Miró shared, this image quite intriguingly straddles the usually separable genres of portrait and self-portrait. More than just a minor footnote to *Self-Portrait 1*, the *Portrait of Miró* is a radical visualisation of the self as decentred within an intersubjective field.

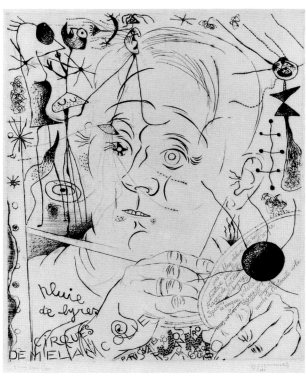

122 Joan Miró and Louis Marcoussis. *Portrait of Miró* (second state). March and November 1938. Etching and drypoint, 45 × 33cm. Barcelona: Fundació Joan Miró.

123 Joan Miró and Louis Marcoussis. *Portrait of Miró* (thirteenth state). March and November 1938. Etching and drypoint, 45 × 33cm. Barcelona: Fundació Joan Miró.

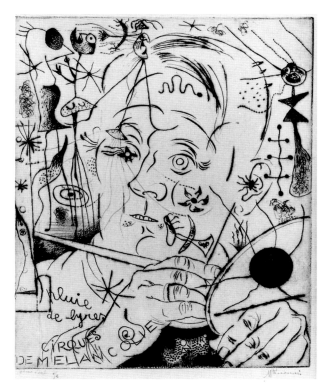

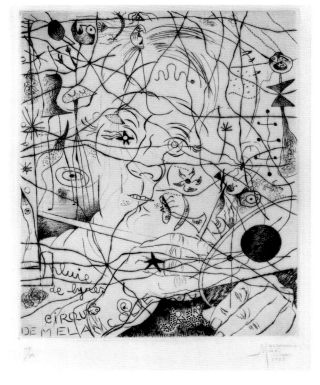

124 Joan Miró and Louis Marcoussis. *Portrait of Miró* (eighteenth state). March and November 1938. Etching and drypoint, 45 × 33cm. Barcelona: Fundació Joan Miró.

125 Joan Miró and Louis Marcoussis. *Portrait of Miró* (final state). March and November 1938. Etching and drypoint, 45 × 33cm. Barcelona: Fundació Joan Miró.

Miró was introduced to Marcoussis by Tristan Tzara in 1932. Following this date up until 1939, the majority of Miró's printmaking was carried out at Marcoussis' studio with assistance from the printers of the Lacourière Press. A painter with respectable avant-garde credentials in the pre-war years, Marcoussis opted for a more accommodating School of Paris version of the cubist style in the 1920s. In keeping with the altered climate of *les années folles*, his biographer Jean Lafranchis reports that much of his effort was devoted to hob-nobbing with aristocrats such as Helena Rubenstein who the former Polish *emigré* was able to count among his admirers (the surrealists, it must be admitted, received much of their patronage from the same quarters).[75] Yet his acceptance into the *beau monde* of Paris was not matched by an equivalent commercial flourishing and in the ensuing decade Marcoussis' activity as a painter was eclipsed by his printmaking. Hoping perhaps for a repeat of the success of his best-known print, the *Portrait of Guillaume Apollinaire* (fig. 126) which attests to his former association with the cubist circle, in 1932 he began engraving stylish portraits of fellow artists, writers and aristocrats, making about one hundred in all. Exhibiting the direct linear quality of drypoint for which Marcoussis expresses his preference in an essay from

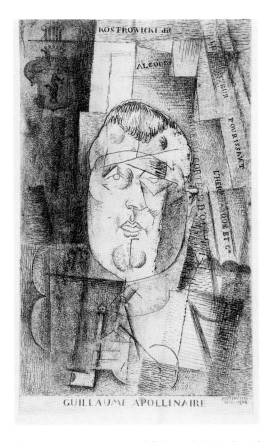

126 Louis Marcoussis. *Portrait of Guillaume Apollinaire* (second version). 1912–20. Etching and drypoint, 49.7 × 27.8cm. The Museum of Modern Art, New York. Given anonymously.

1937, these images – a portrait of the surrealist leader is typical of them – have all the spare elegance of Picasso's Ingresque line drawings from the early 1920s. Marcoussis also undertook several projects for book illustration: in 1928 he made etchings for *Indicateur des chemins de coeur* by Tristan Tzara; in 1930 engravings for *Aurélia* by Gérard de Nerval, an author the surrealists claimed as a precursor; and, in 1934, thirty-six etchings for a new edition of Apollinaire's *Alcools*. One can well imagine Marcoussis and Miró conversing at length about Apollinaire as they worked side by side in the studio, since he was Miró's favourite poet and the major inspiration for his aesthetic of *peinture-poésie*.[76]

In the 1930s Miró was also included in group exhibitions of work from S.W. Hayter's printmaking studio, *Atelier 17*, indicating that he was active there as well. Besides his important technical innovations in the field of colour etching, a major contribution of Hayter's was his promotion of the pre-modern idea of the studio as workshop. Hayter saw virtue in the fact that printmaking brought artists together in a common environment where they were reliant on shared equipment and technical expertise. The two portfolios of prints produced by artists working at the *Atelier 17* in support of the Republican war effort in Spain are an embodiment of the collective attitude he sought to encourage and it is significant that Miró contributed to

both of these.[77] One can appreciate Miró's attraction to the artisanal side of printmaking in the light of his remark to Georges Duthuit that 'Without doubt, individualism is a sign of decadence . . . In the great epochs individual and community march together' and his proclaimed sympathy with anonymous forms of artistic creativity.[78] Because it is by nature a reproductive technology which often involves a division of labour, printmaking is not encumbered with the auratic connotations of painting or drawing and, for this reason, may be inherently more amenable to the sort of cooperative venture seen in the *Portrait of Miró*.[79] A degree of unpredictability about the final look of an etching owing to the technical manipulations in each step of the etching process doubtless also recommended it as a surrealist medium to Miró, whose extraordinary receptivity, shown by a readiness to incorporate chance incidents into his work, we have seen examples of already.

A substantive precedent for this genre of activity was the *cadavre exquis* created jointly by Dalí and Picasso, but that was a private affair and it is doubtful whether Miró or Marcoussis would have known of its existence. A similar *modus operandi* lay behind the creation of *Portrait of Miró*, each artist working sequentially on the plate in a sort of medley, but whereas the *Cadavre exquis* attests to the compatability of its makers' interests, in Miró's and Marcoussis's case we witness a dialogue of contrasting visual idioms. The earliest states (fig. 122) portray Miró in the guise of an *artiste-peintre* armed with the tools of his trade in front of a canvas. A sleight of hand was involved here, since the visual conventions are those of a self-portrait but it was Marcoussis who was solely responsible for this first stage. Using his likeness as a springboard for his imagination, Miró then set to work (figs 123 and 124) covering the plate in a quasi-automatist fashion with a profusion of graffiti-like marks, some of which are plainly reminiscent of *Self-Portrait 1*: flames, stars and so forth. Comic-book creatures which go on to populate the slightly later *Constellation* series appear to leap out from Miró's head and inhabit the space around him. Interwoven with this visual iconography are several written inscriptions: the artists' names at the bottom of the plate in fancy lettering rather like the stencilled words on Marcoussis' etching of Apollinaire;[80] wistfully romantic lines '*pluie de lyres* / CIRQUES DE MELANCOLIE' which might almost have been penned by Apollinaire himself; and an automatic poem about colours that appears fleetingly on the artist's palette in the eleventh to thirteenth states (fig. 123) only to disappear again.[81] Miró implies that words are interchangeable with pigment as raw material for the creation of his works, rather in the manner of Apollinaire's *Calligrammes*, though the use of verbal imagery to evoke colours suggests that he possibly had Rimbaud's poem 'Voyelles' in mind. Thereafter, a spider's web of lines slowly radiates outwards from several nodal points to produce in the final state (fig. 125) a densely crisscrossed mesh. A final irony too since it is Miró's contribution that nearly effaces his portrait.

For the surrealists, we noted above, the significance of collaborative exercises such as this far exceeded any simple curiosity value. Let us recall that Breton, reflecting upon the writing of surrealism's ur-text, *Les Champs magnétiques*, had come to the opinion that dialogue creates the most propitious conditions for a surrealist use of language and, furthermore, that surrealist poets had dedicated all their efforts to reestablishing dialogue in its absolute truth.[82] This view of surrealist automatism as true dialogue, freed from any obligation to communicate, concurs remarkably with Lacan's later insistence upon the essentially dialogical character of psychoanalysis. Elisabeth Roudinesco, Lacan's biographer, reminds us that 'the surrealist experience brought to light, for the first time in France, a conjuncture of the Freudian unconscious, language and the decentring of the subject, which would very largely inspire the formation of the young Lacan.' In the essay 'Intervention on transference', Lacan states that: 'What happens

in an analysis is that the subject is, strictly speaking, constituted through a discourse, to which the mere presence of the psychoanalyst brings, before any intervention, the dimension of dialogue.'[83]

Lacan's view of psychoanalysis, that 'it proceeds entirely in this relationship of subject to subject', is revised quite significantly as he comes under the sway of Saussurean linguistics in the 1950s, causing him to give far greater weight to language as an independent factor in the equation.[84] Psychoanalysis, observes Shoshana Felman, 'is not a dialogue between two egos, it is not reducible to a dual relationship between two terms, but is constituted by a third term that is the meeting point in language'.[85] Lacan introduces a new term, the Other (O), to denote the field of language and the unconscious, which he is at pains to distinguish from the one-to-one relationship of analyst and analysand in the therapeutic encounter.[86] This all-important distinction is displayed in the form of a diagram by the intersecting axes of Lacan's L-*schema*. The first axis (o-o') corresponds to the dual relation between two subjects; situated in the register of the Imaginary, it subsumes what had earlier been described under the mirror stage, namely those identifications which constitute the ego.[87] A second axis, the Symbolic, set at a tangent to the first, joins the subject (S) – which explicitly does not coincide with the ego – with the Other (O). Whereas the Imaginary other (o') is the source of all the subject's self-deceptions, its *méconnaissance*, the Symbolic Other (O) is 'the locus from where the question of his existence [truth, desire] may be posed to him'.[88]

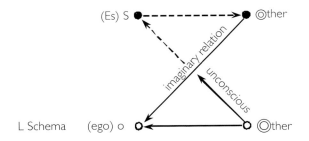

Turning now to the *Portrait of Miró*, one can readily appreciate that the distinctive contribution of each artist has created a clash of spaces and stylistic registers that corresponds neatly to the intersecting axes of the L-*schema*. Marcoussis' vibrantly naturalistic likeness of Miró, which portrays him as though gazing at himself in a mirror – as the coherent, specular subject – belongs to the Lacanian order of the Imaginary. Seen in isolation, the image appears lifelike and highly animated, but when all twenty states were shown together at the Galerie Jeanne Bucher in Paris in June of 1939 that initial impression would have been annulled by sheer repetition.[89] Rather like a row of Marilyns by Andy Warhol, it must then have looked more akin to a death-mask. Indeed, Lacan contends that 'formal stagnation' marks *all* portraits (images, representations) which the subject produces of itself in the Imaginary.[90] The analyst's task is to erase these false icons, 'to suspend the subject's certainties until their last mirages have been consumed', and thereby to free up desire.[91] The dense network of visual and linguistic signs that Miró added to the plate comprises a grid interposed between us and the illusionistic mirror-image of him. This, equivalent to the Symbolic axis, is set at a tangent to the Imaginary axis and cuts across it, in effect effacing that which we mistakenly took for the subject. Ensnared in the web of signifiers, Miró's subjectivity manifests as a playful procession

127 Joan Miró. *Composition (Head)*. 1930. Oil on canvas, 230.2 × 165.5cm. Grenoble: Musée du Grenoble.

(défile) of signs from one provisional state of his portrait to the next. Because desire is always a function of lack (or loss), this dance in the face of death is destined to be, just as the caption says, 'une cirque de mélancholie'.

The status of erasure, as evidenced in the suppression of the automatic poem from the palette for example, and effacement as an impetus for Miró's graffiti-like doodling, deserves to be underscored. Undoubtedly, this looks forward to the reworked version of *Self-Portrait 1*, described above; its sources, on the other hand, can be traced back to the highly unusual *Composition (Head)* of 1930 (fig. 127), a large picture of a profile face that has literally been cancelled – as is done with an etching-plate to destroy it at the end of a series – by scribbling across the canvas, dramatically defacing and excoriating its surface. Blots and stains partially occlude a perfunctory child-like drawing. Miró gives vent here to a destructive impulse in which the very act of drawing is a willful obliteration of the material support of representation. Soon after it was painted, the image was reproduced in Bataille's *Documents* which provides a context for viewing its violent de-facement. Of interest to Miró at this time would have been Bataille's review of a book by Georges-Henri Luquet on primitive art in which he disputes Luquet's central hypothesis that the figural distortions in primitive art are due to the artist recording mental, not perceptual, images. Bataille ascribes these deformations rather to a sadistic, destructive impulse: 'Art, since art there is here incontestably, proceeds in the sense of successive destructions. Inasfar as it liberates libidinal instincts, these instincts are sadistic.'[92] Another work from this period displaying the same iconoclastic violence is Miró's portrait of the poet Georges Auric which consists of an opaque sheet of tar paper with a torn-out hole for the head. Usual relations of figure to ground are inverted – turned on their head, so to speak – as Miró would later do in the gouache *Head of a Man* of 1937. 'Our topic deals with the giving and taking away of faces, with face and deface, figure, figuration and disfiguration' – what Paul de Man wrote of the autobiographic enterprise applies *a fortiori* to Miró's conjuring with the human face.

Lacan consigns portraiture to the realm of the Imaginary, and refers to it only as a regrettable instance of those static *imagos* in which the subject seeks to alienate its desire. The art of the portraitist and the art of the analyst are thus construed as at loggerheads with one another. While pitting them against each other served Lacan well in his campaign against ego psychology,[93] the notion of portraiture as a transaction implies a parallel with the psychoanalytic situation of the transference that may be no less fruitful or valid. The presence of a subterranean link is hinted at, in fact, by an *Oxford English Dictionary* definition of 'transaction', one qualified as obsolete but possibly needing to be exhumed, namely: 'the action of passing or making over a thing from one person, thing, or state to another; transference'. The transaction–transference analogy alerts us to the web of desires that are etched across every face and to the speech that whispers in the folds and interstices of the portrait image. It diverts attention away from his majesty the ego, resplendant and whole, to the fainter traces of a subject in process.

Analysis of the *Portrait of Miró* has revealed that the subject 'Miró' subsists in a radically dependent relation to the O/other: to Marcoussis as an other; to the unconscious as Other; and to the signifying chain of language in and through which he is constituted as a subject of desire. Self and other are so thoroughly intermingled that we are at a loss to say whether this is a portrait or a self-portrait. Once previously, in 1933, Marcoussis's etching studio had been the setting for some surrealist games played this time with Man Ray as photographer and

128 Man Ray. *Veiled Eroticism (Portrait of Meret Oppenheim)*. 1933. Photograph, 17.2 × 13cm. Private collection.

Meret Oppenheim in the role of surrealist muse.[94] The best known of these photographs (fig. 128) shows Oppenheim posed naked beside the etching press, her inked forearm and palm raised, one can imagine, as if to imprint directly on the photographic plate. 'La femme keeps always . . . in her hand the lifeline of her lover' writes Breton.[95] The body of the surrealist muse is present in the capacity of a mere pretext for the male surrealist to read his own desire; femininity is the reflective mirror in which he narcissistically apprehends himself. The entire logic of the Man Ray photograph – black ink on white skin, the phallic handle of the printing press obscuring the sex of the female subject – is a logic of the Same which disavows difference and otherness. It is a salutary reminder, if one were needed, that claims that are valid in one situation we should be wary of extending to surrealism in general.

iii post-face: Miró's *Self-Portrait on an Envelope*

Underscoring the subject's dependency on the signifying chain of language, its status not as the origin but as the recipient of a message whose source is in the field of the Other, the

129 Joan Miró. *Self-Portrait on an Envelope*. 1942. Pencil on envelope, 12.4 × 17.5cm. Barcelona: Fundació Joan Miró.

punning connection that Jacques Lacan makes between the words *lettre* (letter), *l'être* (being), and *l'Autre* (the Other), is germane to the last self-portrait (fig. 129) that I wish to discuss.[95] Deceptively cursory in appearance, it is drawn on a ragged envelope addressed to Miró at 4 Pasage del Credito in Barcelona – his birthplace and where, in a sort of return to origins, he had again taken up a studio. *Self-Portrait on an Envelope* has a mournful, elegaic character which can be ascribed to the circumstances under which Miró was now living. It belongs to a cluster of self-portrait drawings that were made in 1942 after the unexpectedly rapid capitulation of France had forced his hasty return to Catalonia, itself once proudly independent but now firmly under the yoke of Francoist Spain.

More akin to a written autobiography than to a painted self-portrait, it is an image composed almost entirely in the past tense. A mood of retrospection is evident in the way it harks back repeatedly to the motifs and sign language found in his work of the early 1920s. Quoted, almost to the letter, is one of his best-loved pictures from that period of a dog barking at the moon, whilst an appended inscription tells us that the grooves of the postal mark symbolise a tilled field, a reference to his landmark picture of 1923. Superimposed over this Catalan landscape is the undulating contour of the artist's torso with which it is metaphorically conjoined, something that was implicit way back in the *Self-Portrait* of 1919 but which, by 1942, had assumed far greater poignancy. During the reign of terror that followed the civil war, when it is estimated that upwards of four thousand people were summarily executed, any public expression of Catalanness was brutally suppressed; even to be heard speaking in Catalan, Emma Kaplan has shown, was a punishable offence.

One could be excused for feeling short-changed by Miró who in a work such as this conspicuously fails to deliver the value for money of an Old Master like Holbein. But on this occasion the portrait transaction, so to speak, works to our advantage as two heads are offered for the price of one: in addition to the portrait of the artist there is another of General Franco in the form of a stamp. Miró makes plain his opposition to the regime by tipping the envelope upside down, a deliberate gesture that sets his own features against those of the dictator (the political sentiments expressed in these drawings may explain why they remained for years in Miró's possession and were never exhibited in his lifetime).[97] Though it is a far cry from the form of political engagement demanded by Louis Aragon, that seems not to have diminished in the least its passionate eloquence.

It could indeed be argued that a politics of resistance informs all the self-portraits executed by Miró between 1937 and 1942. This is true of the visionary persona itself. At the heart of visionary experience is the negation (or refusal) of phenomenological reality and at the same time imaginative access to an invisible realm of transcendence: the light of sense goes out but with a flash that has revealed the invisible world. That André Breton foresaw a political use-value in this dialectical negation of an existing reality is evident from the first instalment of 'Surrealism and Painting', in which he states that: 'In order to respond to the necessity, upon which all serious minds now agree, for a total revision of real values, the plastic work of art will either refer to a purely internal model or will cease to exist.'[98] Refusing to bow to the dictates of socialist realism, Miró maintained that his role as an artist was to offer humanity a glimpse of something beyond a discredited reality. In the *Still Life With Old Shoe*, a picture he hoped would measure up *against* a good still life by Velásquez,[99] that reality lies in tatters, and its visionary negation is to be glimpsed in the gaping black tears that open up within the fabric of the real. In reply to a *Cahiers d'art* questionnaire in 1939, Miró reiterated his belief that the forms chosen by the artist 'must reveal the movement of a soul trying to escape the reality of the present, which is particularly ignoble today, in order to approach new realities, to offer other men the possibility of rising above the present.'[100] The task confronting a painter, as Miró saw it, was not to portray the reality of the present – ignoble, as life under Franco undoubtedly was for an ardent Catalan – but to negate it by trying to envision a new and better reality. A yearning for transcendence is a guiding impulse in Miró's work throughout the war years: it is evident in the ladder motif found in all the 1942 self-portrait drawings, as well as in the *Flight of a Bird Over the Plain* and the *Constellation* series. At root, this may be nothing more than a heartfelt protest against conditions Miró found intolerable; the *Constellations*, Breton wrote memorably, 'emanate the same note of pathos as the passionate negation of the hunter in the grouse's love-song'.[101]

That Catalan identity was, publicly at least, dead and buried may have some bearing on a marginal detail of the composition that we have yet to address: the black border on the envelope, used traditionally to notify someone of a death. With a deft economy of means Miró utilises this border as a makeshift frame. But it also means that his own self-portrait is addressed to him from the place of the Other (l'*Autre*) in the form, bizarrely, of a death notice (*lettre*). The margin is therefore central to the signification of Miró's image which acknowledges his dependence as a subject on a limit or horizon that envelops him.[102] With less ostentation than Holbein, but more conviction perhaps, he affirms that being (l'*être*) is permeated to its very core by the heterogeneity of death and absence. Miró succeeds in re-presenting a void (*manque-à-être*) which it has always been the task of the portraitist to mask with an illusion of self-presence.

With his customary mix of flamboyance and incisiveness, Lacan once spoke of surrealism as 'a tornado on the edge of an atmospheric depression where the norms of humanist individualism founder'.[103] What the foregoing analysis of self-portraits by Joan Miró has sought to demonstrate is that, at certain moments anyway, surrealism entered into an open transaction with the O/other, the full cost of which for a humanist conception of the self has yet to be counted.

EPILOGUE

'Who knows whether we may not thus be preparing to escape one day from the principle of identity?'[1]

Breton's well-aimed question resonates across the entire surrealist project. With the passage of time, it seems ever more prophetic as the identity crisis of which surrealism proved such a reliable weathervane has grown and become exacerbated in our day. My return to the subject of surrealism is informed and justified by a current politicisation of identity which has submitted our culture's most entrenched assumptions about identity to far-reaching critique and contestation. In the discipline of art history, this reconfiguration of the terrain of politics has seen the traditional concerns of social art history displaced by questions of ethnicity, gender and sexuality – a process in which psychoanalysis has played a significant, albeit equivocal, role.

Of course, it is no coincidence if surrealism at times seems peculiarly in tune with cultural theory now. It is increasingly recognised that Lacanian psychoanalysis, a major reference point for poststructuralism, has the imprimatur of surrealism indelibly stamped upon it.[2] Julia Kristeva's influential theorisation of abjection, once again a psychoanalytically-grounded discussion, involving Bataille and Dalí among others, has found a place in contemporary cultural debate. One could point, in addition, to any number of current practitioners in the visual arts to show the consonance of surrealist concerns with ours. We are the legitimate heirs to its intellectual ferment.

The issues addressed and the questions put to surrealism in these pages have obviously been shaped by our present-day concerns. It would be anachronistic, however, simply to assimilate surrealism to the terms of a contemporary discourse about subjectivity, or to suggest that it holds the answers to our dilemmas. My intention has not been to press surrealism into the service of postmodernism; it has been to recover as far as possible an historicised awareness of the crisis surrealism confronted, employing textual and visual evidence as a route to such an understanding, and from the vantage-point of the present to probe the tensions, ambiguities and limitations of the surrealist project.[3] History, like psychoanalysis, is a transferential process in which we redefine ourselves in the course of renegotiating our relation to the past. It is an analysis interminable. 'Fin et continuation' – the final words of Ernst's collage novel *La Femme 100 têtes* can equally well be mine.

NOTES

acknowledgements

1. T.S. Eliot, 'The Love Song of J. Alfred Prufrock', in *Collected Poems, 1909–1935* (London, 1936), 12.

introduction

1. André Breton, 'For Dada' (1920), in *What is Surrealism? Selected Writings*, edited by Franklin Rosemount (New York: Monad Press, 1978), 7. Since many surrealist texts are now widely available both in French and in English translation, I have been selective about including untranslated quotes in endnotes. Generally, I have done so only where the translation is mine and the source is not readily accessible or where I have chosen to differ significantly from an existing English translation.

2. André Breton, *Nadja*, translated by Richard Howard (New York: Grove Press, 1960 [1928]), 24.

3. Jacques Lacan, 'Agency of the letter in the unconscious or reason since Freud', in *Ecrits: A Selection*, translated by Alan Sheridan (London: Tavistock, 1977), 171.

4. Breton, *Nadja*, 11.

5. 'romanciers experts à fouiller le coeur de l'homme'. Louis Lapicque, statement in *Le Disque vert* (Paris-Brussels), special issue: 'Freud et la psychanalyse' (1924): 185.

6. Apropos of French resistances to psychoanalysis, we can take note of Freud's observation that: 'A negative judgement is the intellectual substitute for repression; its "no" is the hallmark of repression, a certificate of origin – like, let us say, "Made in Germany".' Sigmund Freud, 'Negation' (1925), *Pelican Freud Library*, 15 vols (Harmondsworth, Middlesex: Penguin Books, 1973–87), 11: 438. An essay by Dr René Laforgue, 'Les causes psychologiques des résistances qui s'opposent à la diffusion des idées psychanalytiques', appeared in the special issue of *Le Disque vert*.

7. 'Ainsi, la mère qui ne fut jamais amante et qui a reporté sur son fils toute la tendresse éperdue et contenue de son âme vierge, mais passionné, est, pour Freud, incestueuse.' Dr Hesnard, 'L'Opinion scientifique française et la psychanalyse', *Le Disque vert*, 'Freud et la psychanalyse' issue: 7–8. Mysticism was perceived as a northern, Germanic – or, perhaps in Freud's case, Semitic – trait by contrast with the supposed Cartesian rationalism of the French. Those elements of Freud judged most likely to offend, such as the theory of infantile sexuality, tended to be expunged from the bowdlerised secondary accounts available to a French audience.

8. 'dont la doctrine est beaucoup plus semblables qu'on ne le croit en France à celle de Freud, laquelle lui est

postérieure et en dérive'. Hesnard, 'Opinion scientifique française', 11.

9. The issue of a 'French' Freud purged of the most objectionable elements of the theory is dealt with by Elisabeth Roudinesco in her meticulously researched history of the psychoanalytic movement in France, *La Bataille de cent ans: Histoire de la psychanalyse en France*, vol. 1 (Paris: Seuil, 1986).

10. On this question, see Bertrand Ogilvie, *Lacan: La Formation du concept du sujet, 1932–1949* (Paris: Presses Universitaires de France, 1987).

11. Another circumstance beyond the scope of this study but which clearly affected the surrealists' reception of psychoanalysis is their no less fervent attachment to Marxism. Jean Frois-Wittmann expressed a misplaced optimism which Breton also shared for a time, writing that: 'Despite present misunderstandings, I believe there is a real affinity between the proletarian movement, modern art and psychoanalysis, which comes from the attempt of all three to comprehend and to liberate the authentic individual paralysed by capitalist civilisation' ('Malgré les malentendus actuels, je crois qu'il y a entre le mouvement prolétarien, l'art moderne et la psychanalyse une vraie affinité, qui vient de ce qu'ils tentent tous trois de comprendre et de libérer l'individu authentique paralysé par la civilisation capitaliste'). Jean Frois-Wittmann, 'L'Art moderne et le principe du plaisir', *Minotaure* n° 3–4 (12 December 1933): 80.

12. On the internecine politics of French psychoanalysis in the period, see Roudinesco, *La Bataille de cent ans*, 269–431.

13. Sigmund Freud, 'La Question de l'analyse par les non-médecins', *La Révolution surréaliste* n° 9–10 (1 October 1927): 25–32.

14. Freud makes much of his marginal position vis-à-vis institutional psychiatry, alternately bemoaning his exclusion or citing it as a strength of his movement: 'Nor is it perhaps entirely a matter of chance that the first advocate of psychoanalysis was a Jew. To profess belief in this new theory called for a certain degree of readiness to accept a situation of solitary opposition – a situation with which no one is more familiar than a Jew.' Sigmund Freud, 'The Resistances to Psycho-Analysis' (1925), *The Standard Edition of the Complete Psychological Works of Sigmund Freud*, ed. James Strachey, 24 vols (London: Hogarth Press, 1953–74), 19: 222. One suspects that Breton would have empathised with such views and been encouraged by them to view psychoanalysis as a subversive instrument with which to oppose medical orthodoxy.

15. André Breton, *Manifesto of Surrealism* (1924), in *Manifestoes of Surrealism*, translated by Richard Seaver and Helen Lane (Ann Arbor: University of Michigan Press, 1972), 10.

16. Georges Bataille, 'The Surrealist Religion' (1948), in *The Absence of Myth: Writings on Surrealism*, edited and translated by Michael Richardson (London and New York: Verso, 1994), 72 (translations taken from this source have in some cases been slightly modified).

17. 'Il y a plus de vérité psychanalytique dans les oeuvres d'art venues avant Freud que dans celles executées selon la connaissance et le respect de ses théories.' Eugène Tériade, 'Documentaire sur la jeune peinture IV. – La réaction littéraire', *Cahiers d'art* 5, n° 2 (1930): 69–77.

18. 'nul plus que lui n'est féru de psychanalyse mais, s'il s'en sert, c'est pour entretenir jalousement ses complexes, les porter à l'exubérance.' André Breton, *Entretiens* (1913–1952) (Paris: Gallimard, 1969), 161–2.

19. André Breton, *Communicating Vessels*, translated by Mary Ann Caws and Geoffrey T. Harris (Lincoln and London: University of Nebraska Press, 1990), 55.

20. Freud, letter to Stefan Zweig, in *Letters of Sigmund Freud, 1873–1939*, translated by Tania and James Stern and edited by Ernst Freud (London: Hogarth Press, 1961), 444.

21. 'Le reproche que je ferais à S. Dalí, comme à Breughel et à Bosch n'est pas d'exposer leurs "mesquines" préoccupations, mais de préciser tellement leurs phantasmes qu'il ne reste guère plus de place chez le spectateur pour d'autres associations que celles-là. Ce sont des Meissonniers de l'Inconscient.' Frois-Wittmann, 'Art moderne et le principe du plaisir', 80. For a concise, fascinating overview of the career of Frois-Wittmann, who was Pierre Janet's first cousin, see Anthony James, 'Un Psychanalyste defenseur du surréalisme', *Mélusine* n° 13 (1992): 193–206.

22. See Elizabeth Legge, *Max Ernst: The Psychoanalytic Sources* (Ann Arbor, Michigan, and London: UMI Research Press, 1989); Charlotte Stokes, 'Collage as Jokework: Freud's Theories of Wit as the Foundation for the Collages of Max Ernst', *Leonardo* 15 (1982): 199–204.

23. Max Morise, 'Les Yeux enchantés', *La Révolution surréaliste* n° 1 (December 1924): 26–7.

24. Emmanuel Berl, 'Conformismes freudiens', *Formes* n° 5 (May 1930): 3–4.

25. 'L'académisme du subconscient provoque et dénote la faillite du subconscient dans les arts.' Ibid.

26. Robert Desnos, 'Faillite de l'inconscient?' *Documents* n° 1 (1930): 45; Georges Bataille, review of 'Conformismes freudiens' by Emmanuel Berl, *Documents* n° 5 (1930): 310.

27. 'Les éléments d'un rêve ou d'une hallucination sont des transpositions; l'utilisation poétique du rêve revient à une consécration de la censure inconsciente, c'est-à-dire de la honte secrète et des lâchetés.' Georges Bataille, 'Dalí hurle avec Sade', in *Oeuvres complètes*, vol. 2 (Paris: Gallimard, 1970), 113. Hal Foster's notion of desublimated desire is germane to this issue, though his concern is not with Dalí. See Hal Foster, *Compulsive Beauty* (Cambridge, Mass. and London: MIT Press, 1993).

28. 'Symptoms are formed in part at the cost of *abnormal sexuality; neuroses are, so to say, the negative of perversions*' writes Freud; the unconscious phantasies of hysterics occur as conscious phantasies in the pervert. Sigmund Freud, 'Three Essays on the Theory of Sexuality', *Pelican Freud Library*, 7: 80.

29. 'La réduction du refoulement et l'élimination relative du symbolisme ne sont évidemment pas favorables à une littérature d'esthètes décadents, entièrement privés même d'une possibilité de contact avec les basses couches sociales.' Bataille, review of 'Conformismes freudiens', *Oeuvres complètes*, 1: 242.

30. 'les vrais fétiches, c'est-à-dire ceux qui nous ressemblent et sont la forme objectivée de notre désir'. Michel Leiris, 'Giacometti', *Documents* n° 4 (1929): 210.

31. 'la psychanalyse n'avait plus de secret pour les peintres et les poètes surréalistes dès leur départ, de sorte qu'à mainte occasion ils ont *joué consciemment* de la symbolique sexuelle qui s'y rattache.' André Breton, *Entretiens*, 305.

32. Sigmund Freud to André Breton, 8 December 1937. This letter appears untranslated from German in the literary review *Cahiers GLM* n° 7 (March 1938), special issue: 'Le Trajectoire du rêve' (Trajectory of the dream), edited by André Breton. The translation is by Axel Lapp. The exchanges between Freud and Breton sometimes have the character of a dialogue of the deaf. In a letter of 26 December 1932, published in *Le Surréalisme au service de la révolution* n° 5 (15 May 1933): 10–11, Freud confesses in an exasperated tone: 'I am unable to form a clear idea of what surrealism is and what it wants' ('je ne suis pas en état de me rendre clair ce qu'est et ce que veut le surréalisme').

33. 'Le surréalisme, surmontant toute préoccupation de pittoresque, passera bientôt, j'espère, à l'interprétation des textes automatiques, poèmes ou autres, qu'il couvre de son nom et dont l'apparente bizarrerie ne saura, selon moi, résister à cette épreuve.' André Breton, 'Lettre à A. Rolland de Renéville' (1932), in *Point du jour* (Paris: Gallimard, 1970), 97. Much the same sentiments are expressed in the *Manifesto of Surrealism*. See Breton, *Manifestoes of Surrealism*, 10.

34. Salvador Dalí, 'Interprétation paranoïaque-critique de l'image obsédante "L'Angélus" de Millet', *Minotaure* n° 1 (May 1933): 65–6. Dalí writes of these methods that 'they cease to be unknown images, for in falling into the domain of psycho-analysis they are easily reduced to ordinary logical language'. Salvador Dalí, *Conquest of the Irrational* (1935), reprinted in *The Secret Life of Salvador Dalí*, translated by Haakon M. Chevalier (London: Vision, 1981 [1948]), 435.

35. In thinking about the seeming paradox of a resistance to psychoanalysis within surrealism, I have been encouraged by Jacques Derrida's essay, *Resistances of Psychoanalysis*, translated by Peggy Kamuf et al. (Stanford, Calif.: Stanford University Press, 1998).

36. 'le délire paranoïaque constitue déjà en lui-même une forme d'interprétation.' Dalí, 'Interprétation paranoïaque-critique', 66.

37. 'A ce sujet, comment se refuser à envisager des sciences telles que la psychanalyse comme étant des "délires génialement systématisés" (sans naturellement, pour cela, que l'idée de délire entraîne en ce cas de notion péjorative).' Salvador Dalí, *Le Mythe tragique de l'Angélus de Millet* (Paris: Jean-Jacques Pauvert, 1978 [1963]), 149.

38. These issues are thoughtfully addressed in relation to surrealism by James Elkins in a review of Hal Foster's *Compulsive Beauty*. The uncanny is proposed by Foster as a meta-concept to translate a whole gamut of Bretonian terms: it

'comprehends' surrealism, he argues, 'not as a sundry collection of idiosyncratic visions but as a related set of complex practices', so that it is a 'principle of order that clarifies the disorder of surrealism' (xvii, xviii). Elkins cautions that one risks effacing thereby the specificity of what the surrealist terms stood for. The marvellous, to take an example, would seem to differ from the uncanny in terms of the affective reaction associated with it – surprise or wonderment rather than dread or fright. James Elkins, review of *Compulsive Beauty*, *Art Bulletin* 76 n° 3 (September 1994): 546–8. See also: *Critical Inquiry* n° 13 (winter 1987), special issue: 'The Trial(s) of Psychoanalysis' and *Yale French Studies* n° 55–6 (1977), special issue: 'Literature and Psychoanalysis; The Question of Reading: Otherwise.'

39. Theodor Adorno, 'Looking Back on Surrealism', in *Literary Modernism*, edited by Irving Howe (Greenwich, Conn.: Fawcett Publications, 1967), 220–24.

40. Jean Laplanche, 'Psychoanalysis as Anti-hermeneutics', *Radical Philosophy* 79 (September–October 1996): 7–12.

I traces of the unconscious

1. 'Plus personne n'ignore qu'il n'y a pas de peinture surréaliste'; 'Ni les traits du crayon livré au hasard des gestes, ni l'image retraçant les figures de rêve, ni les fantaisies imaginatives, c'est bien entendu, ne peuvent être ainsi qualifiées.' Pierre Naville, 'Beaux-Arts', *La Révolution surréaliste* n° 3 (15 April 1925): 27.

2. These events are recounted by Robert Desnos in 'Surréalisme', *Cahiers d'art* n° 8 (October 1926): 213 and by others subsequently; see Jean-Charles Gateau, *Paul Eluard et la peinture surréaliste, 1910–1939* (Geneva: Librairie Droz, 1982), 111–14.

3. Breton, 'Max Ernst' (1920), in *What is Surrealism? Selected Writings*, edited by Franklin Rosemount (New York: Monad Press, 1978), 7.

4. See Rosalind Krauss, 'The Photographic Conditions of Surrealism', in *The Originality of the Avant-Garde and Other Modernist Myths* (Cambridge, Mass. and London: MIT Press, 1986).

5. See Pierre Janet, *The Mental State of Hystericals: A Study of Mental Stigmata and Mental Accidents*, translated by Caroline R. Corson (New York and London: G P Putnam's Sons, 1901), 307: 'The automatic writing, obtained while awake by a process of distraction, allowed us to obtain a manifestation of these subconscious phenomena.'

6. Sigmund Freud, 'An Outline of Psycho-Analysis' (1940 [1938]) *The Standard Edition of the Complete Psychological Works of Sigmund Freud*, ed. James Strachey, 24 vols (London: Hogarth Press, 1953–74), 23: 196–7.

7. 'The unconscious is not, as we know, a hidden, virtual, or potential self-presence' writes Derrida in Jacques Derrida, *Margins of Philosophy*, translated with notes by Alan Bass (Brighton: Harvester Press, 1982), 20.

8. Sigmund Freud, 'The Unconscious' (1915), *Pelican Freud Library*, 15 vols (Harmondsworth, Middlesex: Penguin Books, 1973–87), 11: 190–91.

9. 'One cannot think the trace – and therefore, *différance*

– on the basis of the present, or of the presence of the present'. Derrida, *Margins of Philosophy*, 21.

10. Jacques Derrida, *The Postcard: From Socrates to Freud and Beyond*, translated by Alan Bass (Chicago and London: University of Chicago Press, 1987), 389.

11. Jacques Derrida, 'Freud and the Scene of Writing', in *Writing and Difference*, translated by Alan Bass (London: Routledge, 1978), 230.

12. Dominick LaCapra, 'History and Psychoanalysis', *Critical Inquiry* (winter 1987): 222–51.

13. Sigmund Freud, 'From the History of an Infantile Neurosis (The "Wolf Man")' (1918 [1914]), *Pelican Freud Library*, 9: 284.

14. Derrida, *Margins of Philosophy*, 21. See Yve-Alain Bois, 'Painting as Trauma', *Art in America* (June 1988) for a very suggestive account of *Les Demoiselles d'Avignon* in terms of the primal scene. Bois does not, however, seek to deconstruct the plainly phantasmatic status of the picture as the origin of modern art. In modernist art histories, these founding moments of decisive innovation and originality are opposed to allegedly inauthentic postmodern repetitions. It is worth noting here that Breton is supposed to have dubbed Miró's *The Birth of the World* 'the *Demoiselles d'Avignon* of the "informel"', thus ascribing to it a similarly originary status. In William Rubin, *Miró in the Collection of the Museum of Modern Art* (New York: Museum of Modern Art, 1973), 32.

15. 'I call such phantasies – of the observation of sexual intercourse between the parents, of seduction, of castration, and others – "primal phantasies".' Freud, 'A Case of Paranoia Running Counter to the Psycho-Analytic Theory of the Disease' (1915), *Pelican Freud Library*, 10: 154.

16. Jean Laplanche and J.B. Pontalis, *The Language of Psychoanalysis* (London: Karnac and the Institute of Psycho-Analysis, 1988), 332. See also, by the same authors, 'Fantasy and the Origins of Sexuality', in Victor Burgin, James Donald and Cora Kaplan (eds), *Formations of Fantasy* (London: Methuen, 1986), 5–34.

17. 'l'indice de l'enfant et de la préhistoire, la ligne numéro un, la seule ligne de son commencement, l'oeuf.' Georges Hugnet, 'Joan Miró, ou l'enfance de l'art', *Cahiers d'art* 6 n° 7–8 (1931): 335–40.

18. André Breton, 'Artistic Genesis and Perspective of Surrealism' (1941), in *Surrealism and Painting*, translated by Simon Watson Taylor (London: MacDonald and Co., 1972), 70.

19. 'Il faut remonter à l'origine.' Preface by the editor, Christian Zervos, to Hans Mühlestein, 'Des origines de l'art et de la culture', *Cahiers d'art* 5 (1930): 57. Sidra Stich has extensively documented the avant-garde interest in prehistory and its pertinence to Miró. See Sidra Stich, *Joan Miró: The Development of a Sign Language*, exhibition catalogue (St Louis, Miss.: Washington University Gallery of Art, 1980).

20. On the basis of conversations with the artist, William Rubin reports that either André Breton or Paul Eluard gave this name to the picture. How far subsequent readings have been swayed by a title applied *post facto* by someone other than the artist is an intriguing question to ponder. Rubin, *Miró in the Museum of Modern Art*, 33.

21. Rubin states succinctly: 'The marriage of method and metaphor in *The Birth of the World* is total, for the imagery recapitulates poetically the process of its own creation.' Ibid., 33.

22. Sigmund Freud, 'On the Sexual Theories of Children', *Pelican Freud Library*, 7: 187–204.

23. Reprinted in *Joan Miró: Selected Writings and Interviews*, edited by Margit Rowell (London: Thames and Hudson, 1986), 209. As well as serving to romanticise his early days as a painter, as Clement Greenberg suggested, this anecdote had the more important function of installing Miró as the worthy successor to a venerable Spanish lineage of mystics and visionaries.

24. André Breton, *Manifestoes of Surrealism*, translated by Richard Seaver and Helen Lane (Ann Arbor: University of Michigan Press, 1972), 22 (translation modified). In a subsequent essay on Max Ernst, Breton affirms that 'revelation is the daughter of refusal'. One is led to conclude that the birth of the automatic text entails the attrition – 'death' – of the author. On the inverse relationship between writing and eating, see the slim but provocative volume by Maud Ellmann, *The Hunger Artists: Starving, Writing and Imprisonment* (London: Virago, 1993).

25. Gaëtan Picon, *Joan Miró: Carnets catalans* (Geneva: Editions Albert Skira, 1976).

26. Christopher Green, *Cubism and Its Enemies: Modern Movements and Reaction in French Art, 1916–1928* (New Haven and London: Yale University Press, 1987), 267–71. We can discount the possibility that the drawings followed after the paintings, as a record of them. As Green notes, were that the case one would not find any particular links between adjacent images.

27. Rosa Maria Malet et al., *Obra de Joan Miró* (Barcelona: Fundació Joan Miró, 1988) reproduces many of these drawings (FJM 697–743). Unfortunately, the catalogue does not adhere to the order in which drawings appear in the notebooks (the sequence outlined below can, however, be checked against the FJM accession numbers). Another extended automatic sequence from the same note-pad is analysed in Green, *Cubism and Its Enemies*, 318 n.75.

28. 'Je ne progresse pas, je saute d'une chose à l'autre.' Quoted in Picon, *Carnets catalans*, 14.

In light of events that have transpired since, the basis for conclusions outlined in the preceding paragraph should be set out at greater length. Among the events held to mark the centenary of Miró's birth in 1993 was a magisterial retrospective exhibition at the Museum of Modern Art in New York. The main catalogue essay by Caroline Lanchner is an intensive study of Miró's working methods in which is reproduced the sequence of drawings presented here – but in reverse order, from front to back in the sketchbook. See Carolyn Lanchner, 'Peinture–Poésie, Its Logics and Logistics', in *Joan Miró*, exhibition catalogue (New York: Museum of Modern Art, 1994), 15–82. Looking back to notes made at the time of examining the sketchbook in March 1991, it was clear that I had entertained Lanchner's alternative reading of the sequence but was persuaded to order them as I did for the reasons outlined above. Apart from the ease with which it is possible to see through the notebook pages, the quite tentative character of lines in the intermediate images, FJM 703 and 702a, I judged more consistent with tracing over an underlying drawing. Furthermore, one more readily imagines Miró proceeding from the concrete, figurative imagery of FJM 704 and 703 to the openly ambiguous pictographic

signs of FJM 702 and 701, rather than conversely. Allowing that in principle they could have been done in either direction, however, one would be forced to accept the judgement of *non liquet* that Freud passes on the Wolf Man's primal scene were it not that the element of reality that proved elusive in his case was, in mine, forthcoming. Using a raking light and magnification to look for the tell-tale imprints that are invariably present in other sequences where pressings through were used, none was found, adding extra weight to the conclusion that FJM 704 came first in the sequence and that the overall direction of the sequence was from FJM 704 to FJM 701. These observations were made initially by Christopher Green and I have since been able to confirm them myself. An examination of this crucial sketchbook reveals other clusters of drawings where tracing using a soft crayon or pencil (rather than imprinting) was used, without any shadow of doubt. The evidence is thus incontrovertible that Miró worked in a more haphazard and unpredictable way than Carolyn Lanchner implies. Less certain in the light of Lanchner's research is where FJM 702b belongs since she presents evidence to show that quite often the blank reverse sides of sheets were only filled in by Miró at a later date. It also now seems possible that the other truly intermediate image, FJM 702a, may contain elements of both tracing and imprinting (the latter perhaps being responsible for the triangular flame shape), but lacking any concrete evidence that he did so in this case justifies leaving the following narrative unmodified, though the provisional status it shares with any historical reconstruction deserves to be borne in mind.

29. FJM 632 *Idée de deguisement*. 'Jaquette / Pantalon blanc / Chaussures and chaussettes id. / Grand faux-col / grande canne / [grande] fleur à la boutonnière / oiseau empaillé à la tête comme chapeau / gants blanc / Joues maquillés en blanc / Front [maquillés] en bleu / [diagram] / cravate une mince ficelle à soie' (*Idea for a Disguise*: Jacket / White trousers / Shoes and socks [identical] / Large false collar / large cane / [large] buttonhole flower / stuffed bird worn like a hat / white gloves / Cheeks made-up with white / Forehead [made up] with blue / [drawing of lips?] / narrow silk string for a tie).

30. It may be a complete coincidence that Max Morise sings the praises of madmen and mediums whose drawings, he says, consist of rudimentary signs jotted down according to the random dictates of the mind – a tree and a funny man (*un arbre, un bonhomme*) are the examples he uses. Morise, 'Les Yeux enchantés', *La Révolution surréaliste* n° 1 (December 1924): 27.

31. From 1924 up until the opening of the new Museu Nacional d'Art de Catalunya in 1934 the murals were displayed in the former Museu de Belles Arts de Barcelona.

32. See Hermann Schadt, *Die Darstellungen der Arbores Consanguinitatis und der Arbores Affinitatis* (Tübingen: Wasmuth, 1982).

33. Jacques Dupin, *Joan Miró: Life and Work* (London: Thames and Hudson, 1962).

34. Rosalind Krauss, 'Magnetic Fields: The Structure', in *Joan Miró: Magnetic Fields*, exhibition catalogue (New York: Solomon R. Guggenheim Museum, 1972).

35. Robert Rosenblum, paper presented to a conference, 'Mood Disorders and Spirituality in Twentieth-Century Artists', Fundació Joan Miró, Barcelona, 6–7 May 1993.

36. See Rubin, *Miró, in the Collection of the Museum of Modern Art*, 116 n.1. Carolyn Lanchner concludes that all the dream paintings of 1925 were executed in Montroig. Lanchner, 'Peinture–Poésie', 40. Robert Lubar has established that Miró's invention of a language of visual signs, as exemplified in the dream paintings, coincided with the political rebirth of Catalan nationalism and corresponding efforts to promote the Catalan language – an argument that has important implications for an historicised reading of *The Birth of the World*. Robert Lubar, 'Miró's Linguistic Nationalism', paper presented at the University of Barcelona, 19 April 1993 (forthcoming). I wish to thank Robert for generously allowing me to read his script.

37. My source for this information is Anne Umland, 'Joan Miró's *Collage* of Summer 1929. "La Peinture au défi"?', in *Studies of Modern Art*, vol. 2 (New York: Museum of Modern Art, 1993), 75 n.82. Although the situation is evidently more complicated with *The Birth of the World*, the same basic rule applies.

38. This was the focus of an exhibition at the Museu Nacional d'Art de Catalunya. See *El Descubrimiento de la pintura mural románica catalana: La colección de reproducciones del MNAC*, (Barcelona: Museu Nacional d'Art de Catalunya, 1993).

39. Letter to E.C. Ricart, 27 October 1827, reprinted in *Miró: Selected Writings and Interviews*, 58.

40. Breton, 'Surrealism and Painting' (1928), in *Surrealism and Painting*, 36.

41. Ibid., 40.

42. 'l'élément direct et simple que constitue la touche du pinceau sur la toile porte sens intrinsèquement . . . un trait de crayon est l'équivalent d'un mot.' Max Morise, 'Les Yeux enchantés', 27.

43. Freud sometimes maintained that a daemonic, machine-like compulsion to repeat is a fundamental characteristic of unconscious, 'id' impulses.

44. 'Muni d'un crayon et d'une feuille blanche, les yeux fermés, il me serait facile d'en suivre les contours. C'est que là encore il ne s'agit pas de dessiner, *il ne s'agit que de calquer*.' André Breton, *Oeuvres complètes*, vol. 1 (Paris: Gallimard, 1988), 325. Cf. *Manifestoes of Surrealism*, 20. Breton uses the same analogy in 'Le Message automatique', referring to mediums who reproduce 'as if they were tracing [*comme en calquant*]' written inscriptions or other shapes. *Minotaure* n° 3–4 (12 December 1933): 59.

45. See Lanchner, *Joan Miró*, 42–5. Louis Aragon seems to have been first to detect this oddity which attests to the remarkable openness to chance (*disponibilité*) that defines Miró's pictorial imagination, commenting in 'The Challenge to Painting' (La peinture au défi) in 1930: 'A funny guy, Miró . . . He purposely draws a trace of the stretcher on the painting, as if the stretcher had pressed inadvertently into the canvas.' In Pontus Hulten (ed.), *The Surrealists Look at Art*, translated by Michael Palmer and Norma Cole (Venice, Calif.: Lapis Press, 1990), 69.

46. Ibid., 22.

47. Sigmund Freud, *The Interpretation of Dreams* (1900), *Pelican Freud Library*, 4: 687.

48. Sigmund Freud, letter 52, 6 December 1896, in 'Extracts from the Fliess Papers', *Standard Edition*, 1: 233–4.

49. Derrida, 'Freud and the Scene of Writing', 199.

50. Sigmund Freud, 'A Note Upon the "Mystic Writing-Pad" ' (1925 [1924]), *Pelican Freud Library*, 11: 429–34.

51. Revising this text on my computer, and transferring it from RAM to ROM and on to floppy disc to be stored beside other, earlier versions of the same piece (thesis, thesis', thesis") leads me to suspect that had Freud been writing today his essay would have borne a more prosaic title and we should have been denied the comparison that presents itself between Miró's drawings and the mystic writing-pad.

52. Freud uses the term 'translation' to describe the passage from one psychical system to another; 'A failure of translation – this is what is known clinically as "repression".' Freud, letter 52 in 'Extracts from the Fliess Papers', 235.

53. One should note in passing the association with children's play in each case.

54. Of course, the analogy also holds in cases such as FJM 738–40 where pressings through from one sheet to the next were used.

55. Michel Foucault, 'What is an Author?', in *Language, Counter-Memory, Practice: Selected Essays and Interviews*, translated by Donald F. Bouchard and Sherry Simon (Oxford: Blackwell, 1977), 115.

56. Donald Preziosi, *Rethinking Art History: Meditations on a Coy Science* (New Haven and London: Yale University Press, 1989), 31.

57. Jacques Derrida, *Of Grammatology*, translated by G. Spivak (Baltimore and London: Johns Hopkins University Press, 1976), 61.

58. Derrida, 'Freud and the Scene of Writing', 230. For a discussion of the arche-trace that relates to the description of automatic writing as an experience of alterity, see Rudolphe Gasché, *The Tain of the Mirror: Derrida and the Philosophy of Reflection* (Cambridge, Mass. and London: Harvard University Press, 1986), 186–94.

59. Roland Barthes acknowledges somewhat grudgingly the role of surrealism in debunking the figure of the author in his classic essay 'The Death of the Author'. As a corollary to their avant-garde critique of the ideology of authorship, talent and genius are ritually denounced by the surrealists. Interestingly, since it poses the question of how far Jung was taken seriously by the group, in the 1930s both Ernst and Breton have recourse to the idea of symbols that are collective, i.e. impersonal and not for individual copyright. 'Concrete psychology' (La psychologie concrète), Ernst writes:

> has demonstrated that the individual subconscious finds itself surrounded by a collective subconscious. The issue of artistic ownership is thus modified. The vanity of the creator is revealed in all its ridiculousness . . . and justice is done to so many other notions that together constitute the myth of *the artist*.
>
> Max Ernst, *Écritures* (Paris: Gallimard, 1970), 401–02.

One rather suspects that it was easier for writers to have a clear conscience on this matter than surrealist painters who, if they were to succeed in the market-place, had unavoidably to pander to its sustaining illusions.

60. Similarly for Jacques Lacan, the symbolic structure of language precedes the subject, literally pre-existing it. In order to become a subject one must take up a position that language itself has already assigned; the subject is constituted by language rather than constitutive of it. 'Language and its structure exist prior to the moment at which each subject at a certain point in his mental development makes his entry into it.' Lacan, Ecrits: A Selection, translated by Alan Sheridan (London: Tavistock, 1977), 148. Concerning Lacan's critique of the constitutive subject, see Charles Larmore, 'The Concept of a Constitutive Subject', in The Talking Cure: Essays in Psychoanalysis and Language, edited by Colin MacCabe (Basingstoke: Macmillan, 1981), 108–31.

61. 'Je m'arrache difficilement à la contemplation . . . A l'apparence humaine qui dissémine.' I owe this quote and the point itself to an illuminating analysis of André Breton's Claire de terre by Michael Sheringham. See Sheringham, 'Breton and the Language of Automatism: Alterity, Allegory, Desire', in Surrealism and Language: Seven Essays, edited by Ian Higgins (Edinburgh: Scottish Academic Press, 1986).

62. As I see it, the relationship of Miró as subject to the unfolding sequence of images examined here approximates to Emile Benveniste's assertion that: 'It is in and by means of language that man is constituted as a subject; because only language founds in reality, in its reality which is that of being, the concept of the "ego".' Emile Benveniste, 'De la subjectivité en langage', chapter 29 in Problèmes de linguistique générale (Paris: Gallimard, 1966), 259. One could parenthetically note the degree to which the ostensible origin of the sequence in Miró is actually undermined. The comic absurdity of 'Moi' surely deflates an exalted ideal of the artist, but the quest for an authorial presence at the birth of artistic creation is also more subtly thwarted since the inclusion of both label and image on the sheet, each of them equally prominent, casts a shadow of uncertainty over them: Do they refer to each other? To single or to doubled referents outside the sheet? This factor of division and reduplication in what one presumes to be a self-portrait undermines the expectation of an integral self.

63. See Breton's recollection in Manifestoes of Surrealism, 22–3. Apart from this familiar passage and another in Breton, Entretiens (1913–1952) (Paris: Gallimard, 1969), 36–7, see also Marguerite Bonnet: André Breton: Naissance de l'aventure surréaliste (Paris: Librairie Corti, 1975), 98–114. Bonnet cites from Breton's letters to Théodore Fraenkel in 1916 which convey very vividly his excitement at the results obtained from his use of free association on soldiers whose madness was a consequence of their traumatising experiences at the front.

64. André Breton, 'Entrée des médiums' (1922), in Oeuvres complètes, 1: 274.

65. In 1923 Max Ernst produced a curious little drawing titled Leçon d'écriture automatique (Lesson in automatic writing) (fig. 32). Reading this image one is more or less constrained by the long horizontal format to proceed across the page taking in its disjointed images sequentially. Ernst it seems has taken a lesson from automatic writing – taken a page, so to speak, from Les Champs magnétiques. Similar hybrid forms are to be found in the work of other surrealist artists. André Masson, in an unusual sheet titled Dessin écriture (n.d.) (sold

Christie's, London, 29 November 1989, lot 586), mixes writing and drawing in a manner that recalls certain examples of Miró's peinture–poésie.

66. Was Ernst aware of the absence of a theoretical rationale for automatism in the sphere of visual art? Commenting, 'At the start, it did not appear simple for painters and sculptors to find a procedure analogous to "l'écriture automatique"', he adds that 'all the available theoretical research could not, in the circumstances, be of any help to them.' Ernst, Ecritures, 229.

67. A list of the dates of relevant French translations may be found in Elisabeth Roudinesco, La Bataille de cent ans: Histoire de psychanalyse en France, vol. 1 (Paris: Seuil, 1986), 477–9.

68. John Forrester, Language and the Origins of Psychoanalysis (London: Macmillan, 1985), chapters 1 and 2.

69. Freud, Standard Edition, 1: 365.

70. Freud, Pelican Freud Library, 11: 207.

71. 'A presentation which is not put into words, or a psychical act which is not hypercathected, remains thereafter in the Ucs. in a state of repression.' Ibid.

72. Forrester, Language and the Origins of Psychoanalysis, 31.

73. Ibid. The disjuncture between word and image typically found in Max Ernst's collage novels, equivalent to the severing of a connection between a 'word presentation' and the corresponding 'thing presentation', could be described as hysterical – an issue we shall take up in chapter 2.

74. André Breton, 'The Political Position of Surrealism', delivered as a lecture in Prague, 1 April 1935, reproduced in Breton, Manifestoes of Surrealism, 229–30. That Breton was absorbed with creating poème–objets from the mid-1930s may also have contributed to his interest in this passage since the relationship of word-presentation to object-associations was obviously crucial to that activity as well.

75. Freud, 'The Ego and the Id' (1923), Pelican Freud Library, 11: 358–9.

76. Breton, Manifestoes of Surrealism, 230.

77. Freud, 'The Ego and the Id', 359.

78. Roman Jakobson, 'Two Aspects of Language and Two Types of Aphasic Disturbances', in Fundamentals of Language (The Hague: Mouton, 1956), 76–82.

79. This is the object of an informative study by Jean Cazaux, Surréalisme et psychologie: Endophasie et écriture automatique (Paris: Librarie José Corti, 1938).

80. 'la succession des images, la fuite des idées sont une condition fondamentale de toute manifestation surréaliste.' Morise, 'Les Yeux enchantés': 26–7.

81. The association with automatism is underscored by Breton's remark that this unique image was soon followed by a scarcely interrupted succession of phrases. Breton, Manifestoes of Surrealism, 22. The actual content of the image as a representation of the split subject – of Breton himself at the moment of this intrusion into the field of his consciousness – is analysed in chapter 2, section i.

82. Breton, What is Surrealism? Selected Writings, edited by Franklin Rosemount (New York: Monad Press, 1978), 108.

83. 'Quelques personnes voient mentalement comme imprimé chaque mot quelles prononcent. Elles se servent de l'équivalent visuel et non de l'équivalent auditif du mot. Et, en parlant, elles lisent les mots, comme s'ils étaient imprimés

sur une de ces longues bandes de papier, dont on se sert dans les transmissions télégraphiques.' Cazaux, *Surréalisme et psychologie*, 13.

84. Breton, *What is Surrealism?* 108. Breton might have adopted this terminology from his reading of the psychologist Théodore Flournoy who employs it to describe the various automatist manifestations of the medium Hélène Smith (which is discussed in chapter 2, section i).

85. André Breton, *Manifestoes of Surrealism*, 21. I have departed here significantly from the translation, which unfortunately elides the key phrase 'les yeux fermés'.

86. 'Il ne faut donc pas s'étonner de voir le surréalisme se situer tout d'abord presque uniquement sur le plan du langage.' André Breton, *Qu'est-ce que le surréalisme?* (Brussels: René Henriquez, 1934), 22.

87. This view of psychotic art was sanctioned by psychiatry where the orthodox view, expressed by Marcel Réja, was that: 'Their productions are the fruit of a more or less pure psychological automatism ['un automatisme psychologique à peu près pur'].' In Réja, *L'Art chez les fous: Le dessin, la prose, la poésie* (Paris: Mercure de France, 1907), 168. As regards the inclusion of cubist painting, we can see this as consistent with the comprehensive rereading of cubism undertaken by André Breton (see chapter 3).

88. 'En effet, les processus psychiques inconscients sont intemporels, hors de la catégorie du temps; et ce qui frappe dans un tableau où prédomine l'expression du rêve, c'est que les formes qui le composent, se manifestent dans un espace et une durée qui leur sont propres.' André Masson, *Le Rebelle du surréalisme: Ecrits*, edited by Françoise Will-Levaillant (Paris: Hermann, 1976), 22.

89. Derrida remarks that: 'The timelessness of the unconscious is no doubt determined only in opposition to a common concept of time, a traditional concept, the metaphysical concept: the time of mechanics or the time of consciousness.' Derrida, 'Freud and the Scene of Writing', 215.

90. Sigmund Freud, 'The "Uncanny"' (1919), *Pelican Freud Library*, 14: 360.

91. The *Oxford English Dictionary* defines automatism as an 'involuntary action; [an] action performed unconsciously or subconsciously, or a mental state accompanying such actions.' Excluding some Orwellian interference from on high, it is probable that the aberration in my title was due to an involuntary action, a simple error of transcription. In other words the automatism which had been abolished at the level of manifest content had recurred uncannily as a symptomatic act. A title, no longer mine, was in the grip of a compulsion to repeat.

92. 'L'ECONOMIE c'est la loi de la sélection naturelle.' Amédée Ozenfant and Charles-Edouard Jeanneret, 'Le Purisme', *L'Esprit nouveau* n° 4 (January 1921): 374.

93. 'Une peinture est l'association d'éléments épurés, associés, architecturés'. Ibid., 379. One could contrast the ideal of architectural composition espoused here with a Bataillean aesthetic of decomposition (see chapter 4).

94. This issue is comprehensively treated by Mary McLeod in '"Architecture or Revolution": Taylorism, Technocracy, and Social Change', *Art Journal* 43 (summer 1983): 132–47.

95. The purists' mechanistic conception of the tableau encompassed the effects it was meant to produce in the beholder. In 'Sur la plastique' they claim to have conducted experimental research into 'THE MECHANICAL ORIGIN OF THE PLASTIC SENSATION (and consequently on the mechanical origin of plastic beauty)' and to have discovered that 'THE SAME PLASTIC ELEMENTS TRIGGER THE SAME SUBJECTIVE REACTIONS' – so guaranteeing 'the universality of plastic language', *L'Esprit nouveau* n° 1 (15 October 1920).

96. 'L'instinct, le tâtonnement, l'empirisme sont remplacés par les principes scientifiques de l'analyse, par l'organisation et la classification'; 'Jamais depuis Périclès, la pensée n'avait été aussi lucide.' Amédée Ozenfant and Charles-Edouard Jeanneret, *Après le cubisme* (After cubism) (Paris, 1918), 27.

97. Concerning the notion of instrumental or purposive rationality (Zweckrationalität), see Richard Bernstein (ed.), *Habermas and Modernity* (Cambridge: Polity Press, 1985).

98. Georges Bataille, 'Surrealism and How It Differs from Existentialism' (1947), in *The Absence of Myth: Writings on Surrealism*, edited and translated by Michael Richardson (London and New York: Verso, 1994), 65–6. For a comparison of Bataille's position with the Frankfurt School's critique of purposive rationality see Annette Michelson, 'Heterology and the Critique of Instrumental Reason', *October* 36 (spring 1986): 111–27.

99. For an overview of the notion of automatism in psychiatry see Renaud Urvoy de Portzampac, 'La Notion d'automatisme en psychiatrie', unpublished medical thesis, University of Paris-Ouest, 1979. It should be noted, parenthetically, that 'écriture mécanique', a term used by Breton in the *Manifesto*, was part of the self-description of mediums, and has no connection with positivist psychology.

100. Bataille, *The Absence of Myth*, 66. In a rather similar manner, Jean Cazaux spoke of automatic writing as prioritising a lived present (his term is 'présentification du vécu') unlike consciously directed forms of writing or thinking where, he says, 'the temporal connection is replaced by one of logic' ('le lien temporel est remplacé par un lien logique'). Cazaux, *Surréalisme et psychologie*, 20.

101. Bataille, 'The Surrealist Religion' (1948), in *The Absence of Myth*, 76. Tristan Tzara, in 'Essai sur la situation de la poésie', *Surréalisme au service de la révolution* n° 4 (1933): 18, employs a dichotomy of *pensée dirigé* versus *pensée non-dirigé* borrowed from Jung to make a similar point to Bataille.

102. See Briony Fer, 'The Language of Construction', in Briony Fer et al., *Realism, Rationalism, Surrealism: Art Between the Wars* (New Haven and London: Yale University Press, 1993), 162–4. The quotation is from Max Weber, *The Protestant Ethic and the Spirit of Capitalism*, translated by Talcott Parsons (London: G. Allen and Unwin, 1930).

103. On the body as the site of anxious repression in purist discourse, see Tag Gronberg's subtle analysis of the type-object as a fetish whose purpose is to conceal lack. Tag Gronberg, 'Speaking Volumes: The *Pavillon de l'Esprit nouveau*', *Oxford Art Journal* 15, n° 2 (1992): 58–69.

104. 'Le corps va réapparaître nu sous le soleil, douché, musclé, souple.' Dr Winter, 'Le Corps nouveau', *L'Esprit nouveau* n° 15: 1755–8.

105. Michel Leiris, 'L'Homme et son intérieur', *Documents* n° 5 (1930): 261–6.

106. An obsession with *ordre* (order) being an anxious disavowal of the horror and fascination exerted by *ordure* (dirt). Bataille says as much in his essay 'L'Esprit moderne et le jeu des transpositions' (The modern spirit and the game of transpositions) (1930). Of the 'grandiose' image of decomposition, he writes, the modern spirit retains only its negative image: 'soap, toothbrushes, and all the pharmaceutical products the accumulation of which permits us to escape painfully each day from filth and death.' Bataille, *Oeuvres complètes*, vol. 1 (Paris: Gallimard, 1992 [1970]), 273.

107. 'Les images presque toujours labyrinthiques présentaient des corps éventrés mettant à nu les organes digestifs. Cette obsession viscérale était parfois voilée par le remplacement symbolique d'un fruit ouvert, quand il s'agissait de figures féminines. Masculines, elles n'étaient jamais exemptes de plaies, de blessures, de mutilations.' Masson, *Ecrits*, 33.

108. 'Il se refusent à la représentation non seulement du rêve, mais des instincts qui sont à la racine de l'être: la faim, l'amour et la violence.' Masson, *Ecrits*, 21.

109. 'je ne pouvais me défendre d'un mouvement de honte – d'un indescriptible malaise – joint à une exultation vengeresse. Comme d'une victoire remportée sur je ne sais quelle puissance oppressive.' Masson, *Ecrits*, 32–3.

110. Forthright comments by Masson in a letter to D.H. Kahnweiler validate the construction I am putting on his work. He declares: 'I will hate forever the Horrors of the "industrial age" and the hideous pretensions of *mécanos* of all kinds from the inventor of lethal rayon through to Monsieur Le Corbusier who thinks of making everyone (those left after the exploits of his savant colleague) live in these colombariums – (to each his own.)' André Masson, *Les Années surréalistes: Correspondance, 1916–42*, edited by Françoise Levaillant (Paris: La Manufacture, 1990), 157. The letter is dated 1 January [1935].

111. 'ce rêve d'une architecture souterraine, disproportionnée dans ses dimensions et ses multiplications'; 'elle vise au seul effet et à mener l'homme à un malaise, à un état – ridicule ou sublime – de vertige.' Henry-Charles Puech, 'Les "Prisons" de Jean-Baptiste Piranèse', *Documents* 4 (1930): 199–204.

112. Sigmund Freud, 'New Introductory Lectures on Psychoanalysis' (1933 [1932]), *Pelican Freud Library*, 2: 54. The French translation of these essays would have coincided quite nicely with Masson's creation of the *acéphale* whose belly is the labyrinth.

113. Sigmund Freud, 'The Interpretation of Dreams', 671. This passage is the subject of an extended reading by Derrida, *Resistances of Psychoanalysis*, translated by Peggy Kamuf et al. (Stanford, Calif.: Stanford University Press, 1998), 10–16.

114. Masson, *Ecrits*, 37.

115. Sigmund Freud, 'Beyond the Pleasure Principle', *Pelican Freud Library*, 11: 306.

116. Masson, *Ecrits*, 38.

117. Figure 13 from Sigmund Freud, 'Project For a Scientific Psychology', *Standard Edition*, 1: 314.

118. Sigmund Freud, 'On the Universal Tendency to Debasement in the Sphere of Love', *Pelican Freud Library*, 7: 258.

119. Freud, 'Beyond the Pleasure Principle', 283–6; 284.

120. Freud applauds 'the child's great cultural achievement – the instinctual renunciation (that is, the renunciation of instinctual satisfaction) which he had made in allowing his mother to go away without protesting.' Ibid., 285.

121. Ibid., 284 n.1.

122. Mikkel Borch-Jacobsen, *Lacan: The Absolute Master*, translated by Douglas Brick (Stanford, Calif.: Stanford University Press, 1991), 227–39. Cf. Lacan: 'It is here that I propose that the interest the subject takes in his own split is bound up with that which determines it – namely, a privileged object, which has emerged from some primal separation, from some self-mutilation induced by the very approach of the real, whose name, in our algebra, is the *objet a*.' Jacques Lacan, *The Four Fundamental Concepts of Psycho-Analysis*, translated by Alan Sheridan (Harmondsworth, Middlesex: Penguin Books, 1977), 83.

123. Freud, 'The Dissolution of the Oedipus Complex' (1924), *Pelican Freud Library*, 7: 317. Lacan's list of *objets a* is more extensive and includes, in addition to those mentioned, the voice and the gaze.

124. I find it difficult to resist comparing this state of affairs with Malcolm Bowie's remark that 'the way of looking at things that Lacan . . . prefers is one that places lack and interdiction at the centre of the picture and has the drives circulating round them.' Malcolm Bowie, *Lacan* (London: Fontana, 1991), 162. I would also want to contrast it emphatically with the metaphysics of presence that informs Breton's notion of psychic automatism.

125. Binding and unbinding as key metaphors in Freud's model of the psychical apparatus are richly analysed by Derrida in *The Postcard*, 389–95.

126. Sigmund Freud, *An Outline of Psycho-Analysis* (1940 [1938]), *Standard Edition*, 23: 148.

127. André Masson, *La Mémoire du monde* (Geneva: Editions Albert Skira, 1974). For a wide-ranging treatment of issues explored in this section, see also Sidra Stich, *Anxious Visions: Surrealist Art*, exhibition catalogue (Berkeley: University Art Museum, University of California, 1990) and Romy Golan, *Modernity and Nostalgia: Art and Politics in France Between the Wars* (New Haven and London: Yale University Press, 1995).

128. The only notable exception being an extended review of *Mémoire du monde* by Yve-Alain Bois, 'André Masson: De la Guerre aux "Massacres"', *Critique* 342 (November 1975): 1127–35. On the theme of metamorphosis, see the publications of Christa Lichtenstein on this topic, including *André Masson und die Métamorphose: Blatter und Bilder, 1923–1945*, exhibition catalogue (Berlin: Galerie Brusberg, 1985).

129. For a definitive statement of this viewpoint, see William Rubin, 'Notes on Masson and Pollock', *Arts* 34 (November 1959): 36–43.

130. Masson, *Ecrits*, 33.

131. Georges Charbonnier, *Entretiens avec André Masson*, with a preface by Georges Limbour (Paris: Ryôan-ji, 1985 [1957]), 25.

132. Walter Benjamin, 'The Storyteller', in *Illuminations*, translated by Harry Zohn (New York: Schocken Books, 1969), 84. There may, of course, be other perfectly legitimate explanations for Masson remaining tight-lipped about his works and only in old age divulging their secrets.

133. The hand-to-hand fighting of trench warfare is erotised and recurs as a battle of the sexes whose misogynistic character Masson acknowledged but was at a loss to explain. A somewhat comparable instance is the depiction of sex-murder (*Lustmord*) scenes by George Grosz in Weimar Germany. Based on lurid newspaper reports at the time of a serial killer who mutilated and dismembered his victims, these works can very readily be viewed as the transposition of recollected scenes of trench warfare. On a related subject, see Brigid Doherty, ' "See: We Are All Neurasthenics!" or, The Trauma of Dada Montage', *Critical Inquiry* 24 (autumn 1997): 82–132.

134. Laurie Monahan, 'A Knife Halfway Into Dreams: André Masson, Massacres and Surrealism of the 1930s', unpublished doctoral thesis, Harvard University, 1997. My thanks to William Jeffett for bringing to my attention this superb study of Masson's work.

135. Carl Einstein, 'André Masson, étude ethnologique', *Documents* n° 5 (May 1929): 93–102.

136. Leiris's essay, 'André Masson: Le Peintre-Matador', extends the analogy to the painter himself in envisaging the blank canvas as a sort of sacrificial arena. In Louis Barrault et al., *André Masson* (Rouen: Wolf, 1940), 99–100.

137. Georges Bataille, *Inner Experience*, translated by Leslie Anne Boldt (Albany: State University of New York Press, 1988), 153.

138 Masson, *Memoire du monde*, 84.

139. See the discussion of trauma and the real as a missed encounter in *Four Fundamental Concepts of Psycho-Analysis*, 55. Lacan asks: 'Is it not remarkable that, at the origin of the analytic experience, the real should have presented itself in the form of that which is *unassimilable* in it – in the form of the trauma, determining all that follows, and imposing on it an apparently accidental origin?' For a valuable exegesis and commentary, see also John Forrester's essay, 'Dead on Time: Lacan's Theory of Temporality', in *The Seductions of Psychoanalysis: Freud, Lacan and Derrida* (Cambridge: Cambridge University Press, 1989), 168–218.

140. Jay Winter, *Sites of Memory, Sites of Mourning: The Great War in European Cultural History* (Cambridge: Cambridge University Press, 1995).

141. For an incisive discussion of the status of memory in debates about the treatment of shellshock see Ruth Leys, 'Traumatic Cures: Shell Shock, Janet, and the Question of Memory', *Critical Inquiry* 20 (summer 1994): 623–62.

142. John 5. 25–29. The general resurrection of the dead is prefigured by the Old Testament prophet Ezekiel whose attribute is accordingly the double wheel. See Ezek. 37. 1–10.

143. Georges Limbour, 'L'Homme plume' (1924) in *André Masson and His Universe*, edited by Michel Leiris and Georges Limbour (Geneva and Paris: Editions des Trois Collines, 1947), 26.

144. 'la métamorphose n'oublie rien: si aérien que soit le geste, on voit la chair blessée qu'il emporte.' In Masson, *Mémoire du monde*, 10.

145. Freud points to a link at the level of the unconscious between the respective phantasies. 'To some people,' he writes, 'the idea of being buried alive is the most uncanny thing of all. And yet psycho-analysis has taught us that this terrifying phantasy is only a transformation of another phantasy which originally had nothing terrifying about it at all, but was qualified by a certain lasciviousness – the phantasy, I mean, of intra-uterine existence.' Sigmund Freud, 'The "Uncanny" ', 366–7.

146. Reported in Jean-Paul Clébert, *Mythologie d'André Masson* (Geneva: Pierre Cailler, 1971), 49–51.

147. Masson, *Mémoire du monde*, 86.

148. Bataille, 'The Practice of Joy in the Face of Death' (1939), in *Visions of Excess*, translated by Allan Stoekl (Minneapolis: University of Minnesota Press, 1985), 239.

149. The first quote is from Nietzsche's *Thus Spoke Zarathustra*, translated by R.J. Hollingdale (Harmondsworth, Middlesex: Penguin, 1985), 161; the second from the commentary in his *Ecce Homo*, translated by R.J. Hollingdale (Harmondsworth, Middlesex: Penguin, 1983), 99.

150. It needs to be borne in mind that Masson's disclosure of these events in the 1970s postdates the return to Nietzsche in French philosophy during the 1960s. The eternal recurrence was crucial for Gilles Deleuze in *Nietzsche et la philosophie* (Paris: Presses Universitaires de France, 1962) and also for Pierre Klossowski in a succession of writings. That Masson was cognisant of this literature is shown by his remark in *Mémoire du monde*, in 1974, that 'After nearly a century the myth of Dionysos has regained vigour, and also that of the Eternal Return' (p.124). How much was actually new for him in what has been called 'the new Nietzsche' is debatable since many of its themes are adumbrated by himself and Bataille in the 1930s. Especially prescient with regard to the subsequent engagement with Nietzsche is the way the eternal return is marshalled in the service of a critique of Hegelianism. On this issue, see Denis Hollier, 'De l'au-delà de Hegel à l'absence de Nietzsche', in *Bataille*, edited by Philippe Sollers (Cerisy: Centre Culturel de Cerisy La Salle, 1972), 75–96.

151. *Minotaure* n° 8 (June 1936): 50–52. It would seem that this publication was orchestrated to coincide with the first issue of *Acéphale* in which the Nietzschean proclivities of the pair would be very much in evidence.

152. The image of nature convulsed in a state of orgasmic *jouissance*, signified by the erupting volcano, features in Masson's illustrations for *Acéphale*. The source for this motif is Sade's *Juliette*, in which, according to Masson, one finds 'the summit of the imagination of the divine marquis: grand Italian decors in front of a volcano, in eruption, emblazoned with blood'. In Masson, *Ecrits*, 69.

153. Cited in Pierre Klossowski, 'Nietzsche's Experience of the Eternal Return,' in *The New Nietzsche: Contemporary Styles of Interpretation*, edited by David Allison (Cambridge, Mass. and London: MIT Press, 1985), 107–20. The theme of vertigo in its relation to the Eternal Return figures interestingly in Klossowski's text.

154. Deprived of the ground beneath its feet, Being is 'suspended in a realised void' writes Bataille in the text of *Sacrifices* (Paris: Editions GLM, 1936). Masson in the 1930s repeatedly depicts the figure projected into the sky, as in his

etching of Osiris (fig. 115) for the *Sacrifices* album, or in a state of free fall. Nietzsche, whose radical questioning of all foundations fuelled this metaphysics of vertigo, asks: 'Are we not perpetually falling? Backward, sideward, forward, in all directions? Is there any up or down left? Are we not straying through an empty nothing?' Friedrich Nietzsche, *The Gay Science*, translated by Walter Kaufman (New York: Random House, 1974), 125.

155. Whether intentionally or not, Bataille provides a resumé of Masson's iconography of the antecedent two decades when he writes that: 'Ecstatic time can only find itself in the vision of things that puerile chance causes brusquely to appear: cadavers, nudity, explosions, spilled blood, abysses, sunbursts, and thunder.' In Bataille, *Visions of Excess*, 200.

156. '[The female sex] for Masson evokes neither fecundity nor sexual availability . . . It figures discord, a gaping, the explosive dislocation of a body . . . the crayon of Masson so often transforms it into a wound.' Jean-Paul Sartre, introduction to *André Masson: Vingt-deux dessins sur le thème du désir* (Paris: F. Mourlot, 1962); reprinted as 'Masson' in *Situations IV* (Paris: Gallimard, 1964), 387–407.

157. See Denis Hollier, 'Mimesis and Castration', *October* (winter 1984): 3–15 and Susan Suleiman, 'Bataille in the Street: The Search for Virility in the 1930s', in *Bataille: Writing the Sacred*, edited by Carolyn Gill (London: Routledge, 1995), 26–45.

158. Charbonnier, *Entretiens avec André Masson*, 25. Of his own experience, Masson remarked: 'My melancholy was unfathomable . . . It took many months before "I got back to *myself*", giving to this expression its full plenitude. This *self* had been ravaged. Forever.' Masson, *Mémoire du monde*, 100.

159. Absolutely germane to this issue is the article by Max Morise written in the wake of Breton's *Manifesto of Surrealism*. As we noted previously, Morise stipulates that 'the succession of images, the flight of ideas is a fundamental condition of every surrealist manifestation.' From this point of view, the static nature of the image is cited as a major drawback, nevertheless Morise does allow that a painting 'concretises an ensemble of ideational representations . . . [hence] one can attribute to it a curve [*une courbe*] comparable to the curve of thought.' Morise, 'Les Yeux enchantés', 26–7.

160. Georges Limbour, 'La Discorde,' in *André Masson and His Universe*, 149–56.

161. Morise, interestingly, entertains the idea that cinema through its synthesis of time with the image might offer a solution to the problem he addresses.

162. Sartre, 'Masson', 393 and 400.

163. A caption in *Mythologies* reads: 'When the arrow of existence attains its goal: life.' Another says: 'Become yourself: you are the arrow and the bow.' André Masson, *Mythologies* (Paris: Editions de la Revue Fontaine, 1946), n.p.

164. Reported in Michel Leiris, 'Eléments pour une biographie', in Barrault et al., *André Masson*, 11.

165. Michel Leiris, *Journal, 1922–1989*, edited by Jean Jamin (Paris: Gallimard, 1992), 160–61.

166. Masson explained his aims as follows: 'to fuse the body with its environment in order to create a space where, as far as possible, following the hermetic definition, there is

neither top nor bottom; where what is within is also without . . . the secret is the penetration of diverse elements' (Clébert, *Mythologie*, 32). It is a space in which we lose our bearings – lose ourselves, as Breton would have us do – in view of which, the error that resulted in the drawing which accompanied Morise's article 'Les Yeux enchantés' being reproduced upside down is hardly surprising.

167. For a study of the meanings of the vortex in William Blake and romanticism that has relevance to Masson, see WJT Mitchell, 'Metamorphoses of the Vortex: Hogarth, Turner, and Blake', in *Articulate Images: The Sister Arts from Hogarth to Tennyson*, edited by R. Wendorf (Minneapolis: University of Minnesota Press, 1968), 125–68. The configuration of the spiral or vortex, Mitchell notes, is linked in the natural world to fluids and gases – whirlpools and whirlwinds. Hence its connection in romanticism with 'scenes of destruction, flux, and dissolution, literally in natural disasters, metaphorically in the "whirlwinds" of political revolution or psychological disorientation.' The unboundedness of the spiral, its expansiveness, makes it both a literary and artistic figure for the sublime.

168. André Masson, 'Mouvement et métamorphose', *Les Temps modernes* 5 n° 48 (October 1949): 655.

169. The quote is taken from an unpublished tract on sacrifice from the late 1930s translated in *October* 36 (spring 1986): 61–74. Space here does not permit an analysis of rotation as a figure in Bataille's *L'Anus solaire*, written in 1927 and published with illustrations by Masson in 1931 (Paris: Editions de la Galerie Simon, 1931).

170. Nietzsche, *Thus Spoke Zarathustra*, 234.

171. Nietzsche, *Ecce Homo*, 81.

172. Drawing attention to the salience of pursuit and capture as subjects in Masson's work of the early 1930s – the Massacres, Rapes and Abductions – Jean-Paul Clébert astutely remarks that these pursuits are of their nature unending: 'They are rotations ['tournoiements'], up to and including stars which rotate, without possible resolution ['sans issue possible'].' Jean-Paul Clébert, 'Georges Bataille et André Masson', *Les Lettres nouvelles* (May 1971): 57–80.

173. 'Montrer la chose sans commencement ni fin'. Leiris, 'Eléments pour une biographie', 13.

174. Bataille, *Visions of Excess*, 238. I am indebted to Simon Elmer for pointing out to me that Bataille produced a drawing c.1926 which he titled *Eternal Recurrence* to accompany the manuscript of *WC*.

175. Again, it is instructive to turn to Bataille who writes in a piece titled 'Heraclitean Meditation': 'I imagine myself . . . transfigured and in agreement with the world, both as prey and as a jaw of TIME, which ceaselessly kills and is killed.' Bataille, *Visions of Excess*, 239.

176. It also occupies the forehead of the closely related *Portrait of the Poet Kleist* reproduced on p.34 of *Memoire du monde*.

177. Masson, *Ecrits*, 72. See also Denis Hollier, *Against Architecture: The Writings of Georges Bataille*, translated by Betsy Wing (Cambridge, Mass. and London: MIT Press, 1989).

178. Masson, *Ecrits*, 33.

179. Wittgenstein accuses psychoanalysis of conforming to this mythic style of narration: 'It has the attraction

which mythological explanations have, explanations which say that this is all a repetition of something that has happened before.' Ludwig Wittgenstein, 'Conversations on Freud; excerpt from 1932/3 lectures', in *Philosophical Essays on Freud*, edited by Richard Wollheim and James Hopkins (Cambridge: Cambridge University Press, 1982), 2 and 9. Quite possibly Masson would have agreed that psychoanalysis is a 'powerful mythology' but he would not have perceived that as a defect.

180. On this matter, several passages from Karl Jasper's epic study, *Nietzsche: Einführung in Das Verständnis Seines Philosophierens* (Berlin: Walter de Gruyter, 1936), are cited in *Acéphale* which underscore the cardinal role of the labyrinth in Nietzsche's thought.

181. Freud, 'The "Uncanny"', 359. The involuntary repetition of an occurence 'forces upon us the idea of something fateful and inescapable when otherwise we should have spoken only of "chance"' Freud writes.

182. It may not be coincidental that the picture *Ariadne's Thread* was owned by Lacan.

183. Masson, *Mémoire du monde*, 63.

184. Ibid., 83.

185. Cited in Leiris, 'Eléments pour une biographie', 17. There is a rich vein to be explored in the relationship between Masson's oeuvre, organised by repetition, and the autobiographical project of Michel Leiris which, dispensing with chronological narrative, circles back repeatedly to favoured nodal points: 'these nodes of facts, of feelings, of ideas are grouped around an experience more coloured than others and playing the role of a sign' ('ces noeuds de faits, de sentiments, de notions se groupant autour d'une expérience plus colorée que les autres et jouant le rôle d'un signe'). Michel Leiris, *Biffures* (Paris: Gallimard, 1948), 259. That individual words as well as events serve Leiris in this capacity strongly recalls the role of *mots soutiens* in Masson's artistic practice, discussed above. On Leiris and Masson, see Julia Alexandra Kelly, 'The Autobiographer as Critic: The Art Writings of Michel Leiris, c.1922–1989', unpublished PhD dissertation, Courtauld Institute of Art, London, 1998, chapter 3.

186. Freud, 'The Unconscious', 191. Masson paraphrases this passage, writing that: 'les processus psychiques inconscients sont *intemporels*, hors de la catégorie du temps.' Masson, *Ecrits*, 22.

187. Gilles Deleuze, *Nietzsche and Philosophy*, translated by Hugh Tomlinson (London: Athlone Press, 1983), 188.

2 seductions of hysteria

1. Salvador Dalí, 'Review of Anti-Artistic Tendencies' (1929), in *The Collected Writings of Salvador Dalí*, edited and translated by Haim Finkelstein (Cambridge: Cambridge University Press, 1998), 103 (translations from this source have in some cases been significantly modified).

2. Louis Aragon and André Breton, 'Le Cinquantenaire de l'hystérie, 1878–1928', *La Révolution surréaliste* n° 11 (15 March 1928): 20–22; in Breton, *What is Surrealism? Selected Writings*, edited by Franklin Rosemount (New York: Monad Press, 1978), 320–21.

3. It ought to be noted, as a background to publication of this article, that 1925 was the centenary of Charcot's birth and though the recent vicissitudes of the hysteria diagnosis had dented his reputation, glowing tributes appeared in the medical press to mark the occasion. From the psychoanalytic camp, see for instance R. Laforgue and H. Codet, 'Centenaire de Charcot et 25ᵉ anniversaire de la Société de Neurologie', *Revue neurologique* 32 n° 6 (1925) and, by the same authors, 'L'Influence de Charcot sur Freud', *Le Progrès médicale* 22 (30 May 1925).

4. Borrowed from Janet, the term 'hysterical mental state' ('état mental hystérique') first crops up in a text by Breton in 1920 where he also refers to hysteria as 'one of the most beautiful poetic discoveries of our epoch'. Breton, Review of *Gaspard de la Nuit* by Louis Bertrand, *Oeuvres complètes*, vol. 1 (Paris: Gallimard, 1988), 243.

5. André Breton, *What is Surrealism? Selected Writings*, edited by Franklin Rosemount (New York: Monad Press, 1978), 321. For a detailed exegesis of this very compacted text, and a survey of references to Charcotian hysteria in the writings of André Breton, see Alain Chevrier's essay in Marcel Gauchet and Gladys Swain, *Le Vrai Charcot: Les chemins imprévus de l'inconscient* (Paris: Calman-Lévy, 1997), 231–82.

6. Susan Rubin Suleiman, *Subversive Intent: Gender, Politics, and the Avant-Garde* (Cambridge, Mass. and London: Harvard University Press, 1990), 106.

7. Salvador Dalí, 'Le Phénomène de l'extase', *Minotaure* n° 3–4 (12 December 1933): 76–7; *Collected Writings*, 201.

8. Salvador Dalí, 'De la beauté terrifiante et comestible de l'architecture modern style', *Minotaure* n° 3–4 (12 December 1933): 69–76; *Collected Writings*, 193–200.

9. The source is Alphonse Bertillon: *Identification anthropométrique: Instructions signalétiques* (Melun: Impr. administrative, 1893).

10. Dianne Hunter (ed.), *Seduction and Theory: Readings of Gender, Representation and Rhetoric* (Urbana: University of Illinois Press, 1989), 1.

11. See Sigmund Freud, 'On the History of the Psycho-Analytic Movement' (1914), *The Standard Edition of the Complete Psychological Works of Sigmund Freud*, ed. James Strachey, 24 vols (London: Hogarth Press, 1953–74), 16: 17–18. In fact, Freud's retraction of the seduction theory was nowhere near as clear-cut as he asserts; in the *Introductory Lectures on Psychoanalysis* of 1917, for example, he writes: 'Phantasies of being seduced are of particular interest, because so often they are not phantasies but real memories.' Nicholas Rand and Maria Torok show conclusively that Freud continued to prevaricate indefinitely as to whether these tales were fictive or not. See Rand and Torok, 'Questions to Freudian Psychoanalysis: Dream Interpretation, Reality, Fantasy', *Critical Inquiry* 19 n° 3 (spring 1993): 567–94. Since the early 1980s, the controversy surrounding recovered memories of childhood abuse have refocussed attention on Freud's seduction theory and allied concepts of repression and the return of the repressed. It has been claimed that recovered memories are generally the product of suggestion by the therapist. For a trenchant overview of this divisive issue, see the series of articles by Frederick Crews in the *New York Review of Books* 18 November 1993; 17 November 1994; 1 December 1994; and 12 January 1995.

12. Jean Laplanche and J.B. Pontalis, *The Language of Psychoanalysis* (London: Karnac and the Institute of Psycho-Analysis, 1988), 318.

13. Jean Baudrillard, *Seduction*, translated by Brian Singer (New York: St Martin's Press, 1990).

14. John Forrester, 'Rape, Seduction, Psychoanalysis', in *The Seductions of Psychoanalysis: Freud, Lacan and Derrida* (Cambridge: Cambridge University Press, 1989), 85.

15. Andrew Ross, 'Baudrillard's Bad Attitude', in Hunter (ed.), *Seduction and Theory*, 214–25.

16. Max Ernst's wife at the time was Marie-Berthe Aurenche, some sixteen years his junior, whom he wedded as a minor in 1927. The details are in Patrick Waldberg, *Max Ernst* (Paris: Jean-Jacques Pauvert, 1958), 259–66.

17. Forrester, 'Rape, Seduction, Psychoanalysis', 85.

18. For a parallel argument in nineteenth-century France concerning Baudelaire and Flaubert, not strictly analogous for the reason that hysteria as a disease concept evolved in the course of the century, see Jan Goldstein, 'The Uses of Male Hysteria: Medical and Literary Discourse in Nineteenth-Century France', *Representations* 34 (spring 1991): 134–65.

19. 'De l'unité de corps on s'est beaucoup trop pressé de conclure à l'unité de l'âme, alors que nous abritons peut-être plusieurs consciences.' André Breton, 'Les Chants de Maldoror' (1920); *Oeuvres complètes*, 1: 234.

20. André Breton, 'Le Message automatique' (The automatic message), *Minotaure* n° 3–4 (12 December 1933): 55; *What is Surrealism? Selected Writings*, 97.

21. Théodore Flournoy, *From India to the Planet Mars: A Case of Multiple Personality with Imaginary Languages*, edited and introduced by Sonu Shamdasani (Princeton, N.J.: Princeton University Press, 1994); originally published as *Des Indes à la planète Mars. Etude sur un cas de somnambulisme avec glossolalie* (Geneva: Atar, 1900).

22. Ibid., 101. It is remarkable that Flournoy seems quite oblivious to the power of suggestion resulting from his leading questions, neither is he aware that his simply being present may play a role in inducing these bizarrely implausible happenings.

23. Breton, 'Le Message automatique', 181; *What is Surrealism? Selected Writings*, 104–05.

24. André Breton and Paul Eluard, *L'Immaculée Conception* (Paris: Editions surréalistes, 1930); reprinted in Breton, *Oeuvres complètes*, 1: 848–63.

25. In the order that they appear: 'débilité mentale' – mental deficiency; 'manie aiguë' – acute mania; 'paralysie générale' – general paralysis of the insane (the form of insanity caused by syphilis); 'délire d'interprétation' – delirium of interpretation, or paranoia; 'démence précoce' – dementia praecox, or schizophrenia. Not least of the difficulties for a translator of the texts is that older and more recent nosographic classifications are not strictly comparable. In the case of *délire d'interprétation*, for instance, Breton relied upon the older category of 'folie raisonnante' rather than the newer one of paranoia.

26. Contemporary reactions are excerpted in Paul Eluard, *Oeuvres complètes*, vol. 1 (Paris: Gallimard, 1979), 1424–7. See, in addition, Alain Rauzy, 'A propos de "L'Immaculée Conception" d'André Breton et Paul Eluard. Contribution à l'étude des rapports du surréalisme et de la

psychiatrie', unpublished medical thesis, Faculty of Medicine, University of Paris, 1970; Jacqueline Chénieux-Gendron, 'Toward a New Definition of Automatism: L'Immaculée Conception', *Dada/Surrealism* n° 17 (1988): 74–90; and the notes by Marguerite Bonnet and Etienne-Alain Hubert in Breton, *Oeuvres complètes*, 1: 1629–52.

27. Cited in Eluard, *Oeuvres complètes*, vol. 1, 1425.

28. Rolland de Renéville, 'Dernier état de la poésie surréaliste', *Nouvelle revue française* (1 January 1932): 285–91; reprinted in Eluard, *Oeuvres complètes*, 1: 1426–7.

29. *Hegel's Philosophy of Mind*, translated by William Wallace (Oxford: Clarendon Press, 1971), 124–5. 'To the madman, his purely subjective world is quite as real as the objective world' (p.128). Breton many times described this state of mind as the ideal towards which surrealism tended.

30. Reprinted in Breton, *Oeuvres complètes*, 1: 1632. That Jacques Lacan, who attended Alexandre Kojève's lectures on Hegel in the 1930s, was also fundamentally Hegelian in his views is shown by his assertion that: 'the being of man not only cannot be comprehended without madness, but he would not be a human being if he did not carry within him madness as the limit of his freedom' ('Et l'être de l'homme, non seulement ne peut être compris sans la folie, mais il ne serait pas l'être de l'homme s'il ne portait en lui la folie comme la limite de sa liberté'). Jacques Lacan, *Ecrits* (Paris: Seuil, 1966), 176.

31. Cited in Bernard-Paul Robert, 'Breton, Hegel et le surréel', *Revue de l'Université d'Ottawa* 44 n° 1 (January–March 1974): 44–8.

32. André Breton, *Manifestoes of Surrealism*, translated by Richard Seaver and Helen Lane (Ann Arbor: University of Michigan Press, 1972), 14 (translation modified).

33. Following a lead indicated by Breton in the *Entretiens*, Bernard-Paul Robert points to a source in chapter one of Benadetto Croce's *Ce qui est vivant et ce qui est mort de la philosophie de Hegel*, entitled 'La Dialectique ou la synthèse des contraires' (The dialectic or the synthesis of contraries). Bernard-Paul Robert, *Le Surréalisme désocculté: Manifeste du surréalisme, 1924* (Ottawa: Editions de l'Université d'Ottawa, 1975), 37–45.

34. Breton, *What is Surrealism? Selected Writings*, 105.

35. Walter Benjamin, 'Surrealism: Last Snapshot of the European Intelligentsia', in *Reflections*, translated by Edmund Jephcott (New York: Schocken Books, 1978), 180.

36. 'Even our person, as much as we can account for it, is a simulation' ('Même notre personne, en tant que nous en tenant compte, est une simulation') writes Paul Valéry astutely. See his 'Difficulté de définir la simulation', *La Nouvelle revue française* 28 (1927): 612–21.

37. Unusual, but not unheard of: Hans Prinzhorn refers to the case of Johann Knüpfer who was subject to a delusional identification with birds. Eluard was certainly acquainted with Prinzhorn's extremely influential book, *Bildnerei der Geisteskranken* (Berlin and Heidelburg: Springer–Verlag, 1922). Translated as *Artistry of the Mentally Ill* (Berlin and Heidelburg: Springer–Verlag, 1972).

38. Robert Desnos, 'Le Génie sans miroir', *Les Feuilles libres* n° 35 (January–February 1924): 301–08.

39. 'Lettre aux médecins-chefs des asiles de fous', *La Révolution surréaliste* n° 3 (15 April 1925): 29.

40. See the *Annales médico-psychologiques* (November 1929): 289–92 and 358–61. Pierre Janet's opinion that 'the works of the surrealists are above all the confessions of obsessives and doubters' was typical of the views expressed.

41. André Breton, 'La Médecine mentale devant le surréalisme', *Le Surréalisme au service de la révolution* n° 2 (October 1930): 29–32.

42. Max Ernst, *Ecritures* (Paris: Gallimard, 1970), 20. His interest is attested to by a small over-painted postcard titled *Schizophrenia* (fig. 29) omitted from the Spies oeuvre catalogue, but datable to c.1923.

43. Francis Picabia, 'La Fosse des anges', *Orbes* n° 2 (spring 1929): 81–3; reprinted in Picabia, *Ecrits, 1921–1953 et posthumes* (Paris: Pierre Belfond, 1978), 212.

44. *Catalogue des oeuvres d'art morbide*, exhibition catalogue (Paris: Max Bine, 1929).

45. The literature in this area tends to cite just a few well-known examples. Among recent studies of this subject, see Roger Cardinal, 'Surrealism and the Paradigm of the Creative Subject', in Maurice Tuchman (ed.), *Parallel Visions: Modern Artists and Outsider Art* (Princeton, NJ: Princeton University Press, 1992), 94–119; and John MacGregor, *The Discovery of the Art of the Insane* (Princeton, NJ: Princeton University Press, 1989).

46. Rolland de Renéville, 'Dernier état de la poésie surréaliste', 1426–7.

47. Breton, *Oeuvres complètes*, 1: 863; cf. the brave attempt at translation in Breton and Eluard, *The Immaculate Conception*, translated by Jon Graham (London: Atlas Press, 1990), 76–7. The preceding quote from the *Manifesto* appears in Breton, *Manifestoes of Surrealism*, 5.

48. 'Lettre aux médecins-chefs', 29. The term 'word salad' (*salade de mots*) is used to refer to aberrant speech or language like that reproduced by Breton and Eluard above, but Artaud seems to imply that for psychiatry all the linguistic productions of the insane are regarded as meaningless nonsense.

49. The burgeoning interest among medical psychiatrists in visual productions of the insane and the status accorded them is documented in Françoise Will-Levaillant, 'L'Analyse des dessins d'aliénés et de médiums en France avant le surréalisme', *Revue de l'art* 50 (1980): 24–36.

50. Marcel Réja, *L'Art chez les fous: Le Dessin, la prose, la poésie* (Paris: Mercure de France, 1907). See also Alphonse Maeder, 'La Langue d'un aliéné: Analyse d'un cas de glossolalie', *Archives de psychologie* 9 (1910): 208–16. The patient suffered from dementia praecox and spoke in an invented language, however Maeder is circumspect about using terms such as *salade de mots*, claiming that 'one discovers a meaning hidden behind the gibberish.' Strikingly reminiscent of Breton is his conjecture that the psychotic 'lives in a fantasy world which must furnish a *compensation* for the mundane ['terre-à-terre'] existence he has had to lead until now'.

51. See Michel Thévoz, 'Marcel Réja: découvreur de "l'Art des fous" ', *Gazette des beaux-arts* 107 (May–June 1986): 200–08.

52. Jacques Lacan's involvement with the surrealists interestingly causes him to straddle this divide. Whilst still operating notionally within the framework of medical psychiatry, Lacan is willing to ascribe a positive value to psy-

chosis. His doctoral thesis, a study of a case of paranoiac psychosis, describes 'fecund moments' in the clinical course of the illness and notes with irony that the patient's cure also put an end to her quite remarkable writing: 'La chute de la psychose semble avoir par ailleurs entraîné la stérilité de sa plume.' Jacques Lacan, *De la psychose paranoïaque dans ses rapports avec la personnalité* (Paris: Seuil, 1980), 288–9.

53. Katia Samaltanos, *Apollinaire: Catalyst for Primitivism, Picabia and Duchamp* (Ann Arbor: UMI Research Press, 1984).

54. Sigmund Freud, 'The Unconscious' (1915), *Pelican Freud Library*, 15 vols (Harmondsworth, Middlesex: Penguin Books, 1973–87), 11: 206–09. Whereas organic psychiatrists tended to dismiss the language disturbances in schizophrenia as a mere epiphenomenon, they were central to Freud's theorising about psychosis and especially to his views regarding the 'loss of reality' in psychosis. The schizophrenic, writes Freud, is 'obliged to be content with words instead of things': instinctual cathexis is withdrawn from the Ucs. object-presentation, while the associated word-presentation receives a more intense cathexis. On this score, the dreamer is little different to the schizophrenic: 'Words are often treated as things in dreams and thus undergo the same operations as thing presentations.' Freud, 'A Metapsychological Supplement to the Theory of Dreams' (1917 [1915]), *Pelican Freud Library*, 11: 237.

55. Rhyme, assonance and the pun are employed to join together their phrases rather than common sense or logic, according to Réja: 'they think with words, but with words considered more as sounds than as a support for ideas or images' ('ils pensent avec des mots, mais avec des mots considérées en tant que sons et non en tant que support des idées ou des images'). Réja, *L'Art chez les fous*, 114.

56. 'When I bestow from top to toe to be the beech, the forename, the countername, the intername and the Parthename my prayer and I say NO and Canon.' Breton, *Oeuvres complètes*, 1: 863.

57. Ibid., 860–61.

58. André Breton (ed.), *L'Art magique* (Paris: Club Français du Livre, 1957), 223. There is no reason to suspect that the patient 'dont la psychasthénie aboutit d'une part au négativisme absolu, d'autre part à une brève et magnifique floraison picturale', was a Magritte scholar.

59. Breton, *Oeuvres complètes*, 1: 661. Breton's preface to the exhibition, *Le Surréalisme en 1947*, which he and Marcel Duchamp co-curated, explores at greater length the significant figures connected with this 'alchemy of the verb'. He cites, in addition to the writers mentioned, the 'phonetic cabbalism' of Jean-Pierre Brisset and Raymond Roussel's extraordinary book, *Comment j'ai écrit certains de mes livres* (Paris, 1935).

60. Robert Desnos, 'Le Génie sans miroir', 301–08. See Juliet Ireland, 'Psychopathology and Surrealism: Some Perceptions of the Relationship Between Art Production and Insanity in France, c.1919–1924', unpublished MA report, Courtauld Institute of Art, London, 1994.

61. Breton uses the expression 'hors de tout pastiche' in countering the criticisms levelled by Rolland de Renéville. André Breton, 'Lettre à A. Rolland de Renéville', in *Point du jour* (Paris: Gallimard, 1970 [1934]), 97.

62. Réja, *L'Art chez les fous*, 168.

63. Breton suspected that he and Desnos had telepathic links of which he gives an illustration in the *Second Manifesto*, adding that 'This is not the first time that something of this kind has happened to Desnos and me.' Breton, *Manifestoes of Surrealism*, 174.

64. 'Wireless telegraphy, wireless telephony, wireless imagination, they say . . .'. André Breton, 'Introduction au discours sur le peu de réalité' (1924), in *Point du jour*, 7.

65. The fact that Breton had some first-hand experience of the depredations wrought by insanity may explain why he is more circumspect than either Dalí or Eluard about celebrating madness. See his remarks in *Entretiens* (1913–1952) (Paris: Gallimard, 1969), 38.

66. Georges Bataille, 'La Folie de Nietzsche' (1939), *Oeuvres complètes*, vol. 1 (Paris: Gallimard, 1970), 548. Bataille, of course, also writes about Van Gogh of whom there was a spate of psychiatric studies in the period under discussion. See, for example, V. Doiteau and E. Leroy, *La Folie de Vincent Van Gogh* (Paris: Editions Aesculape, 1928). His case reinvigorated a debate which has been ongoing since at least Antiquity about the relationship between insanity, genius and artistic creativity.

67. Breton, *Oeuvres complètes*, 1: 848. 'As for experiencing along the way the corresponding state of mind, this we never claimed.' Breton, 'Lettre à A. Rolland de Renéville', 95. Is not the fact that Breton and Eluard can emulate the linguistic foibles of the insane *without* submitting to the mental states entailed by such derangements enough to invalidate the Hegelian interpretation?

68. Breton, *Oeuvres complètes*, 1: 861.

69. 'En un mot, la distraction semble scinder le champ de la conscience en deux parties: l'un qui reste conscient, l'autre qui semble ignorée par le sujet.' Pierre Janet, *L'Automatisme psychologique* (Paris: Editions Félix Alcan, 1889), 245. The view that states of automatism are invariably accompanied by a *scission du moi* was strongly endorsed by the psychiatrist Gaëtan Gatian de Clérambault in the 1920s, though in every other respect the mechanistic concept of *automatisme mentale* which he subscribed to wouldn't have been in the least bit congenial to the surrealists.

70. ' "Il y a un homme coupé en deux par le fenêtre" '; '[une] phrase oserai-je dire *qui cognait à la vitre*.' Breton, *Oeuvres complètes* 1: 325 and 324. Not dissimilar to Breton's memorable image, Janet relates the case of Madame D., who, during a session of automatic writing, responded to a question by writing: 'Je me suis coupée avec du verre.' Pierre Janet, *L'Etat mental des hysteriques* (Paris: Editions Félix Alcan, 1911), 89.

71. Breton, *Oeuvres complètes*, 1: 234.

72. Ian Hacking, 'The Invention of Split Personalities', in Alan Donagan et al. (eds), *Human Nature and Natural Knowledge* (Dordrecht: Lancaster Reidel, 1986). See also Ian Hacking, 'Two Souls in One Body', *Critical Inquiry* 17 (summer 1991): 838–67.

73. Hippolyte Taine, *De l'Intelligence* (Paris: Hatchette et Cie, 1870). Bernard-Paul Robert details the extent of Breton's borrowings from Taine's *De l'Intelligence* which was of huge importance for Breton's concept of the imagination as well as his understanding of hallucination. See Robert, *Le Surréalisme désoccultée*.

74. Taine, *De l'Intelligence*, 373.

75. Theodule Ribot, *Les Maladies de la personnalité* (Paris: Editions Félix Alcan, 1885), 1.

76. Ibid., 165.

77. Ibid., 145 and 147.

78. Janet, *L'Automatisme psychologique*, 442. Henri Ellenberger, *The Discovery of the Unconscious: The History and Evolution of Dynamic Psychiatry* (New York: Basic Books, 1970), 358–64 provides an indispensible account of Janet's psychological automatism. See also Lecture IV: 'Double Personalities', in Pierre Janet, *The Major Symptoms of Hysteria*, 2nd edition (New York: Macmillan Co., 1920), 66–92, which includes an account of the renowned Lady of Mac Nish.

79. Janet, *L'Automatisme psychologique*, 86–91.

80. It is worth considering how studies of multiple personality were inflected by a gender bias – an issue not addressed by Hacking. Overwhelmingly an affliction of female subjects, multiple personality disorder was opposed to a normative integrated, and implicitly male, subjectivity. The medical observer was thereby exempted from the psychic fragmentation posited in the subject being studied. The discourse of double and multiple personality was part and parcel of a reactive construction of sexual difference which displaced lack on to femininity, permitting the male subject to persist in the belief that he, at least, was 'un, parfaitement un'. The question one has to ask of 'Les Possessions', however, is what consequences follow when the dissemination of the self in multiple personality is made general.

81. On this issue, see my 'Paranoia as Paradigm: A Study of Dalí's Paranoiac-Critical Method', unpublished MA report, Courtauld Institute of Art, London, 1987, 37–8. Or, more recently, Alain Chevrier, 'Une source secrète de l' *Immaculée Conception*', *Mélusine* 13 (1992): 67–8.

82. Breton, 'Message automatique', 170, *What is Surrealism? Selected Writings*, 100.

83. Jean Starobinski, 'Freud, Breton, Myers', *L'Arc* 34 (1968): 87–96.

84. Frederick Myers, *Human Personality and Its Survival of Bodily Death*, vol. 1 (London: Longmans and Co., 1903), 16.

85. J.P. Williams, 'Psychical Research and Psychiatry in Late Victorian Britain: Trance as Ecstasy or Trance as Insanity', in William Bynum, Roy Porter and Michael Shepherd (eds). *The Anatomy of Madness*, vol. 1 (London: Tavistock, 1985), 233–54. See also Jean-Louis Houdebine, 'Méconnaissance de la psychanalyse dans le discourse surréaliste', *Tel Quel* (summer 1971).

86. This is not an isolated claim. Breton reiterates it in 1934, maintaining that surrealism has taken 'a decisive step towards unification of the personality, of this personality which it found heading to a more and more profound dissociation' ('un pas décisif à l'unification de la personnalité, de cette personnalité qu'il avait trouvée en voie de plus en plus profonde dissociation'). Breton, *Qu'est-ce que le surréalisme?* (Brussels: René Henriquez, 1934), 27.

87. Breton, *Manifestoes of Surrealism*, 178.

88. That said, Breton's use of the term 'écriture mécanique' at one point in the *Manifesto of Surrealism* is definitely borrowed from the world of mediumism. Concerning

Breton's interest in the work of Myers, see the editor's note in Breton, *Oeuvres complètes*, vol. 1, 1124.

89. Breton, *Manifestoes of Surrealism*, 179. In the same note, Breton declares: 'I think there would be every interest in us carrying out a serious exploration of sciences which for various reasons are nowadays completely discredited, such as astrology, among the oldest of these sciences, [and] metapsychics (especially as it concerns the study of cryptaesthesia)'. Ibid., 178 (translation modified).

90. Breton, 'The Exquisite Corpse, Its Exaltation' (1948), in *Surrealism and Painting*, translated by Simon Watson Taylor (London: MacDonald and Co., 1972), 290. Of interest in connection with these remarks is Freud's observation that: 'It is a remarkable thing that the *Ucs.* of one human being can react upon that of another, without passing through the *Cs.*' Freud, 'The Unconscious', 198. But more about Freud and telepathy hereunder.

91. Jean-Louis Houdebine, 'Méconnaissance de la psychanalyse dans le discours surréaliste', 67–82. Houdebine's use of the word *méconnaissance* is not fortuitous, but rather serves to situate his own discourse in relation to that 'French' Freud stemming from Lacan and taken up by Louis Althusser in a belated attempt by the Left in France to heal the rift with psychoanalysis. See Althusser, 'Freud and Lacan' (1969 [1964]), in *Lenin and Philosophy*, translated by Ben Brewer (London: NLB, 1971), 181–201.

92. Whether Freud does not, despite his own caveats, treat the unconscious in the manner of a second consciousness with its own appetites and intentions is disputable. On this question, see Jacques Bouveresse, *Wittgenstein Reads Freud: The Myth of the Unconscious*, translated by Carol Cosman (Princeton, NJ: Princeton University Press, 1995), chapter 2: 'The Problem of the Reality of the Unconscious'.

93. John Forrester, 'Psychoanalysis: Gossip, Telepathy and/or Science?', in *Seductions of Psychoanalysis: Freud, Lacan and Derrida* (Cambridge: Cambridge University Press, 1989), 252.

94. Cited in Mikkel Borch-Jacobsen, 'Hypnosis in Psychoanalysis', in *The Emotional Tie: Psychoanalysis, Mimesis, and Affect* (Stanford, Calif.: Stanford University Press, 1992), 39.

95. 'Tout cela trouve à se lier, à se conjuger avec mes autres façons de voir à la faveur de l'admiration enthousiaste que je porte à Freud et dont je ne me départirai pas par la suite.' Breton, *Entretiens*, 82.

96. Dawn Ades, in one of the few commentaries on Ernst's *Lesson in Automatic Writing*, relates its gauche, untutored look to drawings done under hypnosis by Robert Desnos as well as to schizophrenic art. See Dawn Ades, 'Between Dada and Surrealism: Painting in the *Mouvement flou*', in *The Mind's Eye: Dada and Surrealism*, exhibition catalogue (Chicago: Museum of Contemporary Art, 1984), 23–41. Desnos evidently had some direct input into Ernst's *Castor and Pollution*, a picture of 1923.

97. Anne Harrington, 'Metals and Magnets in Medicine: Hysteria, Hypnosis and Medical Culture in *fin-de-siècle* Paris', *Psychological Medicine* 18 (1988): 21–38.

98. Ibid., 23.

99. Ibid., 27.

100. 'Au fond de l'Inconnu pour trouver du *nouveau*!' Charles Baudelaire, 'Le Voyage', in *Baudelaire: The Complete Verse*,

vol. 1, translated by Francis Scarfe (London: Anvil Press, 1986), 247.

101. Rolland de Renéville, 'Dernier état de la poésie surréaliste', in Eluard, *Oeuvres complètes*, 1: 1427.

102. Breton, 'Lettre à A. Rolland de Renéville', 94–101.

103. J. Lévy-Valensi, Pierre Migault and Jacques Lacan, 'Ecrits "inspirés": Schizographie', *Annales médico-psychologiques* 11 (December 1931): 508–22.

104. Breton, 'Message automatique', 58; *What is Surrealism? Selected Writings*, 101–02.

105. Benjamin, 'Surrealism', 179.

106. 'On se demande s'ils dormaient vraiment . . . L'idée de la simulation est remise en jeu. Pour moi, je n'ai jamais pu me faire une idée claire de cette idée. Simuler une chose, est-ce autre chose que la penser? Et ce qui est pensée, est.' Louis Aragon, *Une Vague de rêves* (Paris: Seghers, 1990 [1924]), 19.

107. Joseph Babinski, 'Démembrement de l'hystérie traditionnelle: Pithiatisme', *La Semaine médicale* 29 n° 1 (6 January 1909): 4. For a fascinating study of hysteria's disappearance from the taxonomic systems of psychiatric medicine, see Mark Micale, 'On the "Disappearance" of Hysteria: A Study in the Clinical Deconstruction of a Diagnosis', *Isis* 84 (1993): 496–526.

108. G. Parcheminey, 'Le Problème de l'hystérie', *Revue française de psychanalyse* 8 (1935): 13.

109. From January to September 1917, Breton was attached as a medical student to the Centre Neurologique de la Pitié in Paris in the service of Dr Babinski – see Marguerite Bonnet, *André Breton: Naissance de l'aventure surréaliste* (Paris: Librairie Corti, 1975), 70 n.13. That he was cognisant of the implications of Babinski's dismantling of a disease category championed by Charcot is shown by statements made as early as 1920 in which Charcot is described as 'the man with a prodigious imagination who invented rather than discovered hysteria.' Elsewhere, Breton remarks that: 'Charcot had not counted on the gift for simulation of his subjects.' Breton, *Oeuvres complètes*, vol. 1, 618 and 243.

110. Breton, *Oeuvres complètes*, 1: 849.

111. See Joseph Babinski and J. Froment, *Hystérie-pithiatisme et troubles nerveux d'ordre réflexe en neurologie de guerre* (Paris: Masson, 1917). A copy of this book with a dedication from the authors was in André Breton's library. See the note in Breton, *Oeuvres complètes*, 1: 1729–30.

112. In a British context, see the discussion of malingering in Joanna Bourke, *Dismembering the Male: Men's Bodies, Britain, and the Great War* (London: Reaktion, 1996), chapter 2.

113. In 1916, when any mention of hysteria would have referred implicitly to the war neuroses, Dr Henry Meige observes that the patient is cured when they declare themselves vanquished ('quand le patient s'avoue vaincu – c'est-à-dire guéri'). His quasi-military terminology opposing doctor and patient as combatants might be taken to indicate that the therapeutic alliance, so to speak, was not in a healthy state. Meige was a discussant of a paper delivered by Dr Clovis Vincent at the Société de Neurologie. See Vincent, 'Au sujet de l'hystérie et de la simulation', *Revue Neurologique* 29 n° 7 (July 1916): 104–07. For some valuable reminiscences concerning Breton and Clovis Vincent, see René Held, *L'Oeil*

du psychanalyste: Surréalisme et surréalité (Paris: Payot, 1973). Around 1915, just before being mobilised, it appears that Held and Breton were in the service of Babinski whose first assistant, Clovis Vincent, was experimenting with a rather brutal treatment for incapacitated soldiers returned from the front which consisted in the local application of painful electric currents of up to eighty volts. Held adds: 'It is still of interest to note that it was a case of sick men, and that these patients, without any doubt, were hysterics, contrary to the etymology of the word.'

114. On this issue, see Marc Oliver Roudebush, 'A Battle of Nerves: Hysteria and Its Treatment in France during World War I', unpublished PhD thesis, University of California at Berkeley, 1995.

115. Breton, Entretiens, 162.

116. Jean Baudrillard, Simulations (New York: Sémiotext(e), 1983), 5. Dalí, for his part, confides: 'I am in this constant interrogation: I don't know when I begin simulating or when I actually tell the truth.'

117. I am paraphrasing Breton's statement in the Second Manifesto: 'Everything tends to make us believe that there exists a certain point of the mind at which life and death, the real and the imagined, past and future, the communicable and the incommunicable, high and low cease to be perceived as contradictions. Now, search as one may one will never find any other motivating force in the activities of the surrealists than the hope of finding and fixing this point.' Breton, Manifestoes of Surrealism, 123–4.

118. The issues broached here are to be developed more comprehensively in a forthcoming monograph by myself and Jeremy Stubbs on the subject of surrealism and simulation.

119. Chénieux-Gendron stresses the collaborative nature of 'Les Possessions' as well as their markedly intertextual character – see 'Toward a New Definition of Automatism: L'Immaculée Conception'. The connection with Ernst and Dalí, but not the points concerning simulation and hysteria, is made by Marguerite Bonnet and Etienne-Alain Hubert in Breton, Oeuvres complètes, 1: 1631.

120. 'Ma mère est une toupie dont mon père est le fouet.' Breton, Oeuvres complètes, 1: 843.

121. 'Il fait tourner le contenu du vase en y remuant son gros crayon de plus en plus vite. Le vase même finit par tourner et devient toupie. Le crayon devient fouet.' Max Ernst, 'Visions de demi-sommeil', La Révolution surréaliste n° 9–10 (1 October 1927): 7.

122. Freud, 'Extracts from the Fleiss Papers (Draft L)', Standard Edition, 1: 249.

123. Sigmund Freud, Letter 71, 15 October 1897, 'Extracts from the Fleiss Papers', 264.

124. Breton, What is Surrealism? 100.

125. In connection with this picture, see Nadine Simon-Dhouailly (ed.), La Leçon de Charcot: Voyage dans une toile, exhibition catalogue, (Paris: Musée de l'Assistance Publique de Paris, 1986).

126. Malcolm Gee, Ernst: Pietà, or Revolution by Night (London: Tate Gallery Publications, 1986), 21.

127. Sigmund Freud, 'The Ego and the Id' (1923), Pelican Freud Library, 11: 372.

128. Ades, 'Between Dada and Surrealism', 23–41.

129. 'Identification', writes Freud, 'is most frequently used in hysteria to express a common sexual element.' Ernst's identification with the hysteric would thus express a wish to seduce the father – and thereby subvert his phallic authority. The relationship of seduction to subversion will be argued hereunder.

130. Max Ernst, Rêve d'une petite fille qui voulut entrer au Carmel (Paris: Editions du Carrefour, 1930); translated as A Little Girl Dreams of Taking the Veil by Dorothea Tanning (New York: George Braziller, 1982).

131. Sigmund Freud, Letter 101, Extracts from the Fleiss Papers, 276.

132. Josef Breuer and Sigmund Freud, 'On the Psychical Mechanism of Hysterical Phenomena: Preliminary communication' (1893), Pelican Freud Library, 3: 64. Like the hysterical woman, Ernst too was prone to embroider phantasies, as in Above the Clouds Midnight is Walking of 1920.

133. 'When the work of interpretation has been completed, we perceive that a dream is the fulfilment of a wish.' Sigmund Freud, The Interpretation of Dreams (1900), Pelican Freud Library, 4: 199.

134. Ibid., 700.

135. Sigmund Freud, Letter 61, Extracts from the Fleiss Papers, 247.

136. Freud, The Interpretation of Dreams, 696–7.

137. The preamble relates in a matter-of-fact tone how at the age of seven Marceline-Marie was violated by an ignoble individual who, 'not content with having forced her to submit to these ignominies, broke all her teeth with an incredible ferocity and by means of a large stone'. This incident, smacking of a savage initiatory rite, is presented as a precondition for the girl's first Holy Communion. Ernst's incorporation of aspects of a primitive ritual into the seduction theme would be consistent with Freud's speculation that primal phantasies, because of the nature of their content and universality, belong to the phylogenetic inheritance of the species: 'all the things that are told to us today in analysis as phantasy . . . were once real occurrences in the primaeval times of the human family.' Sigmund Freud, Introductory Lectures on Psychoanalysis (1916–17), Pelican Freud Library, 1: 418.

138. Ernst, Ecritures, 11. On this matter, see Elizabeth Legge, Max Ernst: The Psychoanalytic Sources (Ann Arbor, Michigan and London: UMI Research Press, 1989), 5–10 and chapter 3.

139. The character of this event as primal scene is unequivocally shown by Ernst's added remark that, at the age of puberty, whilst contemplating the conduct of his father on the night of his conception, 'the very precise memory of this hypnagogic vision which I had forgotten welled up inside me.' Ernst, Ecritures, 238. This account has received extensive commentary from Malcolm Gee, Ernst; Rosalind Krauss, 'The Master's Bedroom', Representations 28 (fall 1989): 55–76; and Hal Foster, 'Convulsive Identity', October 57 (summer 1991): 19–54.

140. I agree with Elizabeth Legge that this almost certainly alludes to the glove and stocking anaesthesias typically found in hysteria (see the discussion of Ernst's One Must Not See Reality Such as I Am below). Legge, Max Ernst, 207 n.41. Is the hysteric perhaps also present as the accomplice to whom

the parricidal son displays his grisly trophy in *Max Ernst Showing A Young Woman the Head of His Father* of 1927?

141. Jacques Lacan saw the emergence of psycho-analysis itself as historically connected with a crisis in the patriarchal structure of authority – 'a social decline of the paternal imago'. Lacan, 'La Famille', in *Encyclopédie française* 8° (40): 16. Ernst, plainly, is anxious to hasten the father's demise.

142. Jan Goldstein, 'The Hysteria Diagnosis and the Politics of Anti-Clericalism in Late Nineteenth-Century France', *Journal of Modern History* 54 (June 1982): 209–39.

143. See Max Ernst, *Une semaine de bonté, ou, les septs éléments capitaux* (One week of kindness) (Paris: Editions Jeanne Bucher, 1934), plate 174; reproduced in Werner Spies, *Max Ernst Collages: The Invention of the Surrealist Universe* (London: Thames and Hudson, 1991), fig. 509.

144. Goldstein writes that 'the redefinition of the supernatural as the natural-pathological . . . had the effect of debunking religion; it was consonant with the frenetic crusade for laicization that marked republican politics in this era.' The mix of anti-clericalism and republican politics, she argues, worked to the benefit of the emergent psychiatric profession allowing it to colonise new territory, the neuroses, of which hysteria was far and away the most significant. For his part, Charcot was rewarded by the creation of a new chair of clinical diseases of the nervous system in 1882, the direct result, according to Goldstein, of an initiative by his friend Leon Gambetta, President of the Council of Ministers who obtained from parliament a credit of 200,000 francs for the post. Jan Goldstein, *Console and Classify: The French Psychiatric Profession in the Nineteenth Century* (Cambridge: Cambridge University Press, 1987), 371.

145. Charlotte Stokes and Fiona Bradley have both established that Ernst's *Dream* is a sustained satire of *Histoire d'une âme*, the autobiography of St Theresa of Lisieux published in 1898, and contains precise references to many of the episodes recounted in it, including the spiritual training for her entry into the ascetic Carmelite order. St Theresa's touching piety and the mawkish sentimentality of *Histoire d'une âme* made her a figure of immense popular veneration among the French middle classes after she was canonised in 1925, and a ready butt for Ernst's anti-Catholicism. See Fiona Bradley, 'An Oxymoronic Encounter of Surrealism and Catholicism', unpublished PhD thesis, Courtauld Institute of Art, London, 1995.

146. Freud: 'It might be said that the wild beasts are used to represent the libido, a force dreaded by the ego and combated by means of repression.' Freud, *The Interpretation of Dreams*, 536.

147. 'Love is the great enemy of Christian morality' Ernst writes in 'Danger of Pollution', a text in which he gives vent to a vehement anti-Catholicism and can thus usefully be read in conjunction with *Dream*. Max Ernst, 'Danger de pollution', *Le Surréalisme au service de la révolution* n° 3 (1931); reprinted in *Ecritures*, 174–85.

148. Alternatively, Freud states that, in dreams, 'being plagued with vermin is often a sign of pregnancy' – an expression, no doubt, of Marceline-Marie's wish to marry Christ, i.e. to have a child by him. Freud, *The Interpretation of Dreams*, 474.

149. Ibid., 232.

150. Sigmund Freud, 'Hysterical Phantasies and Their Relation to Bisexuality' (1908), *Pelican Freud Library*, 10: 94.

151. Sigmund Freud, 'The Ego and the Id', 370.

152. That Ernst had previously cast himself and Eluard as the mythical twins Castor and Pollux, offspring of the union between Jupiter and Leda, justifies our consideration of the image as the staging of a primal scene. He does so in the picture *Castor and Pollution* of 1923.

153. A further example of Ernst's knowing and witty adaptation of source material relevant to the theme of suspension is a collage from *La Femme 100 têtes* (fig. 40) based on an article in the popular science magazine *La Nature* concerning a treatment for ataxia – disorders of limb control and locomotion – pioneered at the Salpêtrière which entailed suspending the patient in mid-air using a leather harness and pulleys.

154. Parveen Adams, 'Of Female Bondage', in Teresa Brennan (ed.), *Between Feminism and Psychoanalysis* (London and New York: Routledge, 1989), 250–54.

155. On this question, see in addition Kaja Silverman, 'Masochism and Male Subjectivity', *camera obscura* 17 (May 1988): 31–67 (33). Silverman (p.33) cites Janine Chasseguet-Smirgel to the effect that 'the pervert is trying to free himself from the paternal universe and the constraints of the law. He wants to dethrone God the Father.'

156. Freud argues that the Wolf Man was able to express a passive feminine attitude by means of his Christ identification: 'His knowledge of the sacred story now gave him a chance of sublimating his predominant masochistic attitude towards his father. He became Christ – which was made especially easy for him on account of their having the same birthday . . . If he was Christ, then his father was God.' Ernst refers his own Christ identification back to a portrait painted by his father, an amateur painter, of his son as the Christ-child. The *Virgin Spanking the Infant Jesus in Front of Witnesses: André Breton, Paul Eluard and Max Ernst* of 1926, another picture that mobilises jokingly this identification, derives from a hysterical beating-phantasy which Freud traces back once again to a repressed, 'feminine' (masochistic) attitude in the boy towards the father. See Legge, *Max Ernst*, 72–3 and Suleiman, *Subversive Intent*, 153ff.

157. Disavowal (*Verlugnung*) as a fundamental psychical mechanism of the perversions is discussed by Gilles Deleuze, *Masochism: An Interpretation of Coldness and Cruelty*, translated by Jean McNeil (New York: Zone, 1971). One might also cite in connection with the theme of masochism the many instances of gratuitous cruelty in the collage novels.

158. Dianne Hunter, 'Hysteria, Psychoanalysis, and Feminism: The Case of Anna O', *Feminist Studies* 9 n° 3 (fall 1983): 465–88.

159. My suspicion of an intertextual allusion to 'Les Possessions', with which it is more or less contemporary, in this neologistic speech is reinforced by another phrase uttered by Marceline-Marie: 'Hidden in the folds of my sombre prison multicoloured groups represent the various peoples of the world.'

160. Cited in Margaret Iversen, 'Vicissitudes of the Visual Sign', *Word and Image* 6 n° 3 (July–September 1990): 214.

161. Sigmund Freud and Joseph Breuer, 'On the Psychical Mechanism of Hysterical Phenomena', 63.

162. See Anne Harrington, *Medicine, Mind, and the Double Brain: A Study in Nineteenth-Century Thought* (Princeton, NJ: Princeton University Press, 1987).

163. Legge, *Max Ernst*, 207 n.40. Of possible relevance to the Ernstian riddle of one person being concealed behind another, we might conjecture, are Freud's observations regarding the processes of identification and self-representation in dreams; 'Whenever my own ego does not appear in the context of a dream, but only some extraneous person, I may safely assume that my own ego lies concealed by identification, behind this other person.' These remarks apply even more so, I would suggest, to the situation of Ernst's *Dream*. Freud, *The Interpretation of Dreams*, 434.

164. Duchamp's reemergence as a conspicuous presence in the 1930s, together with Tristan Tzara and other veterans of dada, is confirmed by Breton's pangyric in 1934, 'La Phare de la Mariée'. Aragon's authoritative essay, 'The Challenge to Painting', published in the same year as Ernst's *Dream*, pinpoints the crucial reorientation owing to the Duchampian personality of choice (*personnalité du choix*) and locates him, alongside Ernst, at the foundation of a specifically surrealist visual aesthetic. Ernst, in 'Beyond Painting', would simply add a further twist to Aragon's phrase by the playful manipulation of his own personality. A study of the many fascinating and compelling parallels between Ernst and Duchamp has been made by David Hopkins in *Marcel Duchamp and Max Ernst: The Bride Shared* (Oxford: Clarendon Press, 1998).

165. Ernst, *Beyond Painting*, edited by Robert Motherwell (New York: Wittenborn, Schultz, 1948), 28–9. The constitutive function of an autobiographical narrative which mingles factual events with myth and phantasy, and where this history is subject to continual revision and reworking (*Nachträglich*), owing to which there exist not one authorised version but several, each slightly different from the others, is strikingly close to what happens in psychoanalysis. As Emile Benveniste writes, 'empirical events have reality for the analyst only in and by "discourse" which confers on them the authenticity of experience, without regard for their historical reality, and even (one must say: above all) if the discourse evades, transposes or invents the biography the subject gives of themself.' Emile Benveniste, 'Remarques sur la fonction du langage dans la découverte freudienne', chapter 7 in *Problèmes de linguistique générale* (Paris: Gallimard, 1966), 77.

166. Sigmund Freud, 'Group Psychology and the Analysis of the Ego' (1921), *Pelican Freud Library*, 12: 138.

167. Ibid.

168. We should note in this context Ernst's probable interest in Jung – see Elizabeth Legge, 'Jungian Influences on Ernst's Work of the 1920s', unpublished MA report, The Courtauld Institute, London, 1979.

169. Freud, 'Totem and Taboo' (1913), *Pelican Freud Library*, 13: 190. The Ernst account presents another point of congruence with the case of Little Hans. 'I had predicted to his father,' Freud confides, 'that it would be possible to trace back Hans' phobia to thoughts and wishes occasioned by the birth of his baby sister.'

170. Freud, 'Totem and Taboo', 190–91.

171. '*Vogelfrei*, a German adjective, which means "free like a bird", is often by error employed by braggards who boast of being independent, but in reality it is a juridical term dating from the Thirty Years War: one who is declared "vogelfrei" by custom, is a prey "free" to be killed by whoever without further judgement.' Ernst, *Ecritures*, 418.

172. Freud, *The Interpretation of Dreams*, 518.

173. 'Birds . . . as a symbol of an absolute liberty. They don't seem to be submitted to the same laws of gravity as us.' Ibid.

174. Georges Bataille, 'Max Ernst philosophe!', foreword to *Max Ernst* (Paris, 1959). The essential achievement of Ernst, according to Bataille, is to rupture with the world of work. 'He who recognises the powerlessness of work, on the contrary is dazzled, fascinated by play, which serves no purpose.'

175. The *Iconographie photographique de la Salpêtrière* appeared in three volumes between 1876 and 1880; the *Nouvelle Iconographie de la Salpêtrière* from 1888.

176. See Charlotte Stokes, 'The Scientific Methods of Max Ernst: His Use of Scientific Subjects from La Nature', *Art Bulletin* 62 n° 3 (1980): 453–65.

177. On hospital-based diagnostic medicine as an instance of a museological practice, see John Pickstone, 'Museological Science? The Place of the Analytical / Comparative in Nineteenth-Century Science, Technology and Medicine', *History of Science* 32 (1994): 111–38.

178. Sigmund Freud, 'Charcot' (1893) *Standard Edition*, 3: 11–23 (12).

179. Charcot informs us that: 'This great asylum . . . housed a population of more than five thousand people, among whom figured a large number deemed incurable who were admitted for life, subjects of all ages afflicted by chronic diseases of every kind, but in particular those based in the nervous system . . . We are, in other terms, in possession of a sort of museum of living pathology of which the resources are considerable.' Cited in Simon-Dhouailly (ed.), *La Leçon de Charcot*, 24.

180. Freud, 'Charcot', 13.

181. Paul Richer and J-M Charcot, 'Note sur l'anatomie morphologique de la région lombaire: Sillon lombaire médian', *Nouvelle Iconographie de la Salpêtrière* 1 (1888): 13. Cited in Deborah Silverman, *Art Nouveau in Fin-de-Siècle France: Politics, Psychology, and Style* (Berkeley and London: University of California Press, 1989), 94.

182. Apropos Charcot as an artist, see Silverman, *Art Nouveau in Fin-de-Siècle France*, 75–106.

183. Martha Evans, *Fits and Starts: A Genealogy of Hysteria in Modern France* (Ithaca and London: Cornell University Press, 1991).

184. Cited in Georges Didi-Huberman, *Invention de l'hystérie: Charcot et L'Iconographie photographique de la Salpêtrière* (Paris: Macula, 1982), 32. See also Elaine Showalter, *The Female Malady: Women, Madness and English Culture, 1830–1980* (London: Virago, 1987), chapter 6: 'Feminism and Hysteria: The Daughter's Disease'.

185. The significance of Dora's dream in which the father stands beside the bed and wakes the child is discussed by Freud in terms that are applicable here. See Freud, 'Fragment of an Analysis of a Case of Hysteria', *Pelican Freud Library*, 8: 99ff. In a seminar class, Samantha Lackey noted the simi-

larity between this plate and Ernst's account in 'Vision du démi-sommeil' of a dark, threatening and vaguely obscene man, his father, who appears before his bed. Her interpretation places the image in a series with those other bedroom scenes, such as *The Master's Bedroom*, and further underscores the interchangeability of Ernst and the hysteric.

186. Aragon and Breton in 'Le Cinquanténaire de l'hystérie' infer that the transference love between the hysterics and their attending physicians did not always go unrequited: 'Does Freud, who owes so much to Charcot, remember the time when, according to survivors, the interns at the Salpêtrière mixed up their professional duties with their amorous tastes, and when at dusk the patients either met the doctors outside the hospital or admitted them to their own beds?' The source of their information may have been Arsène-Jules Clarétie's fictionalised memoir, *Les Amours d'un interne* (Paris: Editions E. Dentu, 1881).

187. John Forrester, 'Rape, Seduction and Psychoanalysis', 81.

188. Baudrillard, *Seduction*, 53.

189. Ernst plundered the section of *The Interpretation of Dreams* dealing with typical dream symbols for all of his collage novels. A number of these borrowings are enumerated by Evan Maurer, 'Images of Dream and Desire: The Prints and Collage Novels of Max Ernst', in *Max Ernst: Beyond Surrealism, A Retrospective of the Artist's Books and Prints*, edited by Robert Rainwater (New York and Oxford: New York Public Library and Oxford University Press, 1986), 37–93.

190. Breton, *Entretiens*, 304.

191. For a suggestive exegesis of the uncanny in terms that are pertinent here, see Nicholas Rand and Maria Torok, 'The Sandman Looks at "The Uncanny" ', in *Speculations After Freud: Psychoanalysis, Philosophy and Culture*, edited by Sonu Shamdasani and Michael Münchow (London: Routledge, 1994), 186–203. Their reading focusses on the ambiguous meanings of *heimlich* as 'homely' and as 'secret' in order to open up as a problem for psychoanalysis the whole area of the dark, family secret – seduction (abuse) would be one such. Rand and Torok remark that 'Injured, blinded or lifeless eyes are omnipresent in *The Sandman*,' but where Freud ascribes this to the castration complex they argue that 'they symbolize the sheer inability to see [a familial secret] – nothing else' (p.200).

192. Werner Spies, 'An Open-ended Oeuvre', preface to William Camfield, *Max Ernst: Dada and the Dawn of Surrealism* (Munich: Prestel, 1993). The hostility to interpretation calls for some analysis in its own right. As a leading authority on Ernst, and compiler of the Ernst oeuvre catalogue, Werner Spies is authorised to pronounce on what is, and is not, a genuine Ernst. But to legislate, this time in the name of supposed fidelity to Ernst's intentions, on what is and is not a legitimate meaning betrays an anxiety about the proliferation of meaning. Spies' assertion that the pictures do not signify at all is thus an extreme attempt to *restrict* meaning in the face of perceived challenges to his interpretative authority.

193. Violette Nozière, an eighteen-year-old girl who poisoned her stepfather and afterwards claimed he had been raping her repeatedly over a long period of time, became a *cause célèbre* among the surrealists, who in 1933 published a collection of poems and illustrations extolling her as the slayer of a monstrous patriarch. It is clear that they were inclined to accept as literal truth the girl's accusations against the father – which, incidentally, she later retracted in 1937 after deciding to take vows. The collage that Ernst contributed to this pamphlet harks back to the bird symbolism and the associated theme of sexual menace in *Two Children are Threatened by a Nightingale* of 1924. Elizabeth Legge's subtle analysis of the latter, with reference to the case of Dora, establishes that the threatening nightingale is a father substitute, and that the threat he poses is one of rape. See Legge, *Max Ernst*, 76–84. André Breton et al., *Violette Nozières* (Brussels: Nicolas Flamel, 1933).

194. Freud, in 'The "Uncanny" ', cites approvingly Schelling: ' "Unheimlich" [the uncanny] is the name for everything that ought to have remained . . . secret and hidden but has come to light.' *Pelican Freud Library*, 14: 345.

195. Freud, 'The Moses of Michelangelo', *Pelican Freud Library*, 14: 254.

3 uncanny doubles

1. Louis Aragon, 'The Challenge to Painting' (La peinture au défi) (1930), in Pontus Hulten (ed.), *The Surrealists Look at Art*, translated by Michael Palmer and Norma Cole (Venice, Calif.: Lapis Press, 1990), 47–72.

2. Aragon, 'The Challenge to Painting', 48. A parallel with psychosis certainly obtains with regard to the attitude towards the real. See, for example, Sigmund Freud, 'The loss of reality in neurosis and psychosis' (1924), *Pelican Freud Library*, 15 vols (Harmondsworth, Middlesex: Penguin Books, 1973–87), 10: 221–6.

3. Julia Kristeva, *Strangers to Ourselves*, translated by Leon S. Roudiez (New York and London: Harvester Wheatsheaf, 1991), 188.

4. There is now an abundant literature on surrealism and the uncanny, see, *inter alia*: Elizabeth Wright, 'The Uncanny and Surrealism', in Peter Collier and Judy Davies (eds), *Modernism and the European Unconscious* (Cambridge: Polity Press, 1990); Margaret Cohen, *Profane Illumination: Walter Benjamin and the Paris of Surrealist Revolution* (Berkeley, Calif.: University of California Press, 1993); Briony Fer, 'Surrealism, Myth and Psychoanalysis', in Briony Fer, David Batchelor and Paul Wood, *Realism, Rationalism, Surrealism: Art Between the Wars* (New Haven and London: Yale University Press, 1993); Hal Foster, *Compulsive Beauty* (Cambridge, Mass. and London: MIT Press, 1993).

5. Freud, 'The "Uncanny" ' (1919), *Pelican Freud Library*, 14: 339–76.

6. Ibid., 344.

7. Ibid., 363–4.

8. Ibid., 368.

9. Ibid.

10. Ibid., 345.

11. I have resisted the renaming of this work as *Marie-Thérèse Considering Her Sculpted Surrealist Effigy* for the reason that it bestows a coherent, unitary identity on an image that I see as radically destabilising such notions.

12. Freud, 'The "Uncanny" ', 373.

13. Freud, 'The "Uncanny"', 347. Freud is citing from an article by Jentsch on the uncanny. E. Jeutsch, 'Zur Psychologie das Unheimlichen', *Psychiatrisch–Neurologische Wochenschrift* 8(1906): 195.

14. Kristeva, *Strangers to Ourselves*, 188.

15. The other obvious reference point of this assemblage is the mobile sculptures of Giacometti, such as *Suspended Ball* of 1930–31, which similarly oscillates perpetually between male and female genders. We shall be returning to this 'uncanny and traumatic' point in section iii of this chapter which examines a sequence of drawings by Picasso of the female nude.

16. Ibid., 183.

17. André Breton, 'Picasso dans son élément', *Minotaure* n° 1 (1 June 1933): 20–21; reprinted in Breton, *Surrealism and Painting*, translated by Simon Watson Taylor (London: MacDonald and Co., 1972), 112.

18. The *Vollard Suite* portrays the studio as a quasi-sacred place. The hybrid character of the Minotaur and its mythic associations with sacrifice, both derived from more primitive, totemic beliefs and practices, serve to reinforce this sacredness – with which the theme of an encounter with the other, of the self as other, is wholly consonant. According to Emile Durkheim, whose notion of the sacred is largely adopted by Bataille and Leiris (the latter a close confidant of Picasso throughout this period), the sacred and profane comprise 'two heterogeneous and incompatible worlds'. Whilst passage can occur from a profane world to a sacred one, to do so presupposes a complete metamorphosis of the person – in effect, their death and rebirth. 'It is said that at this moment the young man dies, that the person that he was ceases to exist, and that another is instantly substituted for it.' Emile Durkheim, *The Elementary Forms of Religious Life*, translated by Joseph Ward Swain (London: Allen and Unwin, 1976 [1915]), 38–9.

19. Elza Adamowicz, 'Monsters in Surrealism: Hunting the Human-Headed Bombyx', in *Modernism and the European Unconscious*, 299. Bataille defines the sacred as precisely the *tout Autre*.

20. Julia Kristeva sees an equivalence between the foreign (*étrange*) and the foreigner (*étranger*). Given the ideological investments in the classical body as a signifier for Frenchness, of national belonging, what meanings can be ascribed to the *dépaysement* which the classical body undergoes at Picasso's hands? How does his status as a foreigner inform this artistic strategy?

21. Christopher Green, in an unpublished lecture, suggested that it may have been based on a Dogon mask reproduced in the *Minotaure* special issue (n° 2 [1 June 1933]) devoted to the Dakar–Djibouti expedition. Anita Costello believes that a mask in Picasso's collection was the source. Anita Coles Costello, *Picasso's 'Vollard Suite'* (New York and London: Garland, 1979), 145 n.7.

22. Eunice Lipton notes this as an obsessive topos in Picasso criticism. 'The relationship between Picasso and surrealism,' she writes, 'was, and remains, an ambiguous one. The ambiguity is a result of traditional attempts to see Picasso as either surrealist or not.' Eunice Lipton, *Picasso Criticism, 1901–1939: The Making of an Artist–Hero* (New York and London: Garland, 1977), 289.

23. William Rubin, *Dada and Surrealist Art* (New York: H.N. Abrams, 1968), 281.

24. Ibid., 281.

25. Ibid., 290.

26. 'parmi les grossières, mais pernicieuses erreurs qui, dans le courant de ces dernières années, ont été propagées sur le compte de Picasso, celle qui vient au premier plan est celle qui tendait à confondre plus ou moins avec les surréalistes, somme toute à faire de lui une sorte de homme en révolte, ou bien plutôt en fuite . . . devant la réalité.' Michel Leiris, 'Toiles récentes de Picasso', *Documents* n° 2 (1930): 62.

27. 'le réel est alors éclairé par tous ses pores, on le pénètre, il devient alors pour la première fois et *réellement* une REALITE.' Ibid.

28. He writes: 'In order to respond to the necessity, upon which all serious minds now agree, for a total revision of real values, the plastic work of art will either refer to a purely internal model or will cease to exist' ('L'oeuvre plastique, pour répondre à la nécessité de révision absolue des valeurs réelles sur laquelle tous les esprits aujourd'hui s'accordent, se référera donc à un modèle purement intérieur, ou ne sera pas'). Breton, 'Le Surréalisme et la peinture', *La Révolution surréaliste* n° 4 (15 July 1925): 28; Breton, *Surrealism and Painting*, 4.

29. Reality, so-called, 'is only one rapport among others . . . the mind can grasp other rapports than the real' affirms Louis Aragon. Aragon, *Une Vague de rêves* (Paris: Seghers, 1990 [1924]), 11.

30. Surrealism aims at achieving a reconciliation of psychical reality and exterior reality, two principles that in the present state of society, they maintain, are in contradiction with each other: 'at the limits, I say, we have attempted to present interior reality and exterior reality as two elements in a process of unification, of finally *becoming one*' ('à la limite, dis-je, nous avons tendu à donner la réalité intérieure et la réalité extérieure comme deux éléments en puissance diunification, en voie de *devenir commun*'). Breton, *Qu'est-ce que le surréalisme?* (Brussels: Editions René Henriquez, 1934), 11. Ironically, in this crucial text Breton defines the aims of surrealism in very similar terms to those that are alleged to disqualify Picasso from inclusion in its ranks. The prefix 'sur', meaning 'above', in the word *surréalisme* appears to connote a transcendence of reality, when in point of fact: 'it expresses . . . a desire to deepen the foundations of the real, to bring about an ever clearer and at the same time ever more passionate consciousness of the world perceived by the senses' ('il exprime . . . une volonté d'approfondissement du réel, de prise de conscience toujours plus nette en même temps que toujours plus passionnée du monde sensible'). Ibid.

31. As reported by William Rubin in *Picasso in the Collection of the Museum of Modern Art* (New York: Museum of Modern Art, 1972), 72.

32. Breton, 'Le Surréalisme et la peinture', 30; *Surrealism and Painting*, 7.

33. Elizabeth Cowling, '"Proudly We Claim Him as One of Us": Breton, Picasso, and the Surrealist Movement'. *Art History* 8 n° 1 (March 1985): 82–104.

34. Breton, *Qu'est-ce que le surréalisme?* 16.

35. Breton, '80 carats . . . With a Single Flaw' (1961), in *Surrealism and Painting*, 117. Breton's responses to cubism are

comprehensively treated in Dawn Ades, 'Visions de la matière: Breton, le "cubisme" et le surréalisme', *Pleine marge* n° 13 (1991): 23–37.

36. Maurice Jardot, *Picasso: Peintures, 1900–1955*, exhibition catalogue (Paris: Musée des arts décoratifs, 1955).

37. Waldemar George, *Picasso: Dessins* (Paris: Editions des Quatre Chemins, 1926).

38. Cited in Pablo Picasso, *Picasso on Art: A Selection of Views*, edited by Dore Ashton (London: Thames and Hudson, 1972), 95–6.

39. Robert Goldwater, 'Picasso: Forty Years of His Art', *Art in America* (January 1940): 43–4.

40. Sigmund Freud, 'Splitting of the Ego in the Process of Defence' (1938), *Pelican Freud Library*, 11: 462. Octave Mannoni cites an expression of a patient of his, 'Je sais bien . . . mais quand même', as typical of the equivocal attitude resulting from this split. Something of this equivocation has been discerned in some of the texts already referred to, notably in the ambiguous situation of Picasso on, and in *Dada and Surrealist Art*. Octave Mannoni, ' "Je sais bien . . . mais quand même": La Croyance', *Les Temps modernes* 212 (1964): 1262–86.

41. Carl Einstein, 'Picasso: The Last Decade' (1928), in *A Picasso Anthology: Documents, Criticism, Reminiscences*, edited by Marilyn McCully (London: Arts Council, 1981), 166–70. The notion of a polyphony of styles is adopted from this source.

42. Kenneth Silver, *Esprits de Corps: The Art of the Parisian Avant-Garde and the First World War, 1914–1925* (London: Thames and Hudson, 1989).

43. Ibid., 135.

44. Ibid.

45. One might ask why the internationalist character of modernism should be endorsed without qualification when it is, after all, none other than a manifestation in the cultural superstructure of the logic of capital? As Marx reminds us in the *Communist Manifesto*, 'The bourgeoisie has through its exploitation of the world-market given a cosmopolitan character to production and consumption in every country . . . And as in material, so in intellectual production . . . from the numerous national and local literatures, there arises a world literature'. Karl Marx, *Selected Writings*, compiled by David McLellan (Oxford: Oxford University Press, 1977), 224–5.

46. Recent judgements on the *rappel à l'ordre* have been too much predicated on views about the cultural scene in the 1980s. Benjamin Buchloh, who also brands the whole process reactionary, has one eye fixed on the 1980s return to figuration in which he discerns an explicitly nostalgic, anti-modernist agenda. In my case, it is the preoccupation of a growing number of artists and theorists – most definitely not aligned with neo-conservatism – with issues of individual and collective memory that has conditioned my return to the postwar visual culture. My main objection to the readings of Buchloh and Silver is that anyone in the period who engages with the past, in whatever fashion, is seen as ideologically tarred with the same brush as Charles Maurras and his ilk. See Benjamin Buchloh, 'Figures of Authority, Ciphers of Regression: Notes on the Return of Representation in European Painting', *October* n° 16 (spring 1981): 39–68.

47. Julia Kristeva has said that: 'Subjectively, the issue of the "national" is that indistinct domain of the psychic and historical experience which transforms identity into belonging: "I am" becomes "I am one of them", to "be" becomes to "belong".' In the era of Jean-Marie Le Pen, the French version of Hamlet's question, Kristeva notes wryly, still remains: ' "To belong or not to belong." ' Julia Kristeva, 'Proust: Issues of Identity' (lecture at University College London, 1995), in Tamar Garb and Linda Nochlin (eds), *The Jew in the Text: Modernity and the Construction of Identity* (London: Thames and Hudson, 1995), 140–55.

48. It may be that this trait is a reflection of Picasso's attempt to negotiate his way in a climate of suspicion towards foreigners where the approval of influential critics was contingent on being accepted as an honorary Frenchman. The German dealer Wilhelm Uhde had some penetrating insights into these matters. See Wilhelm Uhde, *Picasso et la tradition française: Notes sur la peinture actuelle* (Paris: Editions des Quatre Chemins, 1928), 55–6.

49. Mikhail Bakhtin, *The Dialogic Imagination: Four Essays by M.M. Bakhtin*, edited by Michael Holquist (Austin, Tex.: University of Texas Press, 1981), 738.

50. Michael Holquist explains that: 'A word, discourse, language or culture undergoes "dialogization" when it becomes relativized, de-privileged, or aware of competing definitions for the same things', whereas 'Undialogized language is authoritative or absolute.' Ibid., glossary of terms.

51. Breton, *Surrealism and Painting*, 6. Breton's comments tally with what Bakhtin has to say about parodic stylisation in which the aim is an exposé or destruction of the represented language.

52. 'Constamment les deux tendances luttent en lui et dominent alternativement sans réussir à s'allier assez intimement pour faire un tout. Cette perpetuelle oscillation qui est la faiblesse de Picasso devient aussi sa force . . . Toute son oeuvre est un combat d'où il sort chaque fois vaincu et grandi.' Roger Bissière, 'L'Exposition Picasso', *L'Amour de l'art* 2 (1921): 209–12, cited in Eunice Lipton, *Picasso Criticism*, 145.

53. Waldemar George, 'Fair Play: The Passion of Picasso', *Formes* n° 4 (1930): 8.

54. Romy Golan, 'The "Ecole Français" vs. the "Ecole de Paris": The Debate About the Status of Jewish Artists in Paris Between the Wars', in Kenneth Silver (ed.), *The Circle of Montparnasse: Jewish Artists in Paris, 1905–1945*, exhibition catalogue (New York: Jewish Museum, 1985).

55. Sander Gilman uses the term 'Jewish self-hatred' to describe this identification with the aggressor, something that is quite familiar to us as a psychological defence. Sander Gilman, *Jewish Self-Hatred: Anti-Semitism and the Hidden Language of the Jews* (Baltimore and London: Johns Hopkins University Press, 1986).

56. Waldemar George, 'Aut Caesar Aut Nihil (Reflections on the Picasso exhibition at the Georges Petit Galleries)', *Formes* n° 25 (May 1932): 268.

57. George, 'Fair Play', 8.

58. Camille Mauclair, *La Crise de l'art moderne* (Paris: Editions CEA, 1944). 'Waldemar George, juif polonais manager du demi-juif Picasso, et dont le charabia amusait son equipe elle-même . . .'

59. Adolphe Basler, 'Y a-t-il une peinture juive?' *Mercure de France* (15 November 1925): 11–18; cited in Golan, 'The "Ecole Français" vs. the "Ecole de Paris" '.

60. 'une sorte de nomadisme intérieur qui le condamne à se fuir lui-même sans cesse . . . toute sa vie n'avoir cherché qu'un alibi perpétuel pour fuir cet horrible sentiment de vide intérieur qui l'oppresse.' Germain Bazin, 'Le Cubisme lyrique: Pablo Picasso', in René Huyghe (ed.), *Histoire de l'art contemporain: La Peinture* (Paris, 1935); cited in Lipton, *Picasso Criticism*, 284.

61. George, 'Aut Caesar Aut Nihil', 270.

62. *Gertrude Stein on Picasso*, edited by Edward Burns (New York: Liveright, published in cooperation with the Museum of Modern Art, 1970), 47.

63. Ibid., 97.

64. Ibid., 38.

65. Lipton, *Picasso Criticism*, 266.

66. *Gertrude Stein on Picasso*, 35.

67. Robert Delaunay, Letter to Albert Gleizes (undated); reprinted in Silver, *Esprits de Corps*, 148 and 431.

68. 'Statement by Picasso: 1923', in Alfred Barr, *Picasso: Fifty Years of His Art* (London: Secker and Warburg, 1975), 270.

69. Christopher Green, *Cubism and Its Enemies: Modern Movements and Reaction in French Art, 1916–1928* (New Haven and London: Yale University Press, 1987), 175. Alexandra Parigoris discusses the issue of sincerity as it concerns pastiche, especially Picasso's use of it, in 'Pastiche and the Uses of Tradition, 1917–1922', in Elizabeth Cowling and Jennifer Mundy (eds), *On Classic Ground: Picasso, Léger, de Chirico and the New Classicism, 1910–1930*, exhibition catalogue (London: Tate Gallery, 1990), 296–308.

70. On this question, see Christopher Green, *Léger and the Avant-Garde* (New Haven and London: Yale University Press, 1976), 217ff.

71. On masculinity as a masquerade, see Andrew Perchuk and Helaine Posner (eds), *The Masculine Masquerade: Masculinity and Representation* (Cambridge, Mass. and London: MIT Press, 1995). Eugenie Lemoine-Luccioni writes: 'if the penis were the phallus, men would have no need of feathers or ties or medals . . . Display ['parade'], just like the masquerade, thus betrays a flaw: no one has the phallus.'

72. 'Je le tiens pour un jongleur capable de tout imiter, un homme qui court après soi-même et ne se rattrapera jamais, impersonnel à un tel degré qu'il en peut sembler original, et caméléonesque dans "le genre génie", comme disait Degas.' Camille Mauclair, statement in *Documents* n° 3 (1930), special issue: 'Hommage à Picasso', 178.

73. F.T. Marinetti, 'The Foundation and Manifesto of Futurism' (1908), in Herschel B. Chipp (ed.), *Theories of Modern Art* (Berkeley, Los Angeles and London: University of California Press, 1968), 287.

74. Rosalind Krauss, *The Picasso Papers* (London: Thames and Hudson, 1998).

75. Michael Raeburn (ed.), *Picasso's Picassos*, exhibition catalogue (London: Hayward Gallery, 1981), 54.

76. The recurrent topos of a sleeping figure with another watching over it is treated by Leo Steinberg in 'Picasso's Sleepwatchers', in Steinburg, *Other Criteria: Confrontations with Twentieth-Century Art* (New York: Oxford University Press, 1972), 93–114.

77. In so doing, Gentileschi unwittingly portrays the scene from the viewpoint of the Oedipal infant who wishes to be rid of the father and enjoy the sole attention of the mother.

78. Sigmund Freud, 'Dostoevsky and Parricide' (1928 [1927]), *Pelican Freud Library*, 14: 441–60.

79. Ibid., 447.

80. Ibid., 450.

81. Ibid., 451.

82. Sigmund Freud, 'Civilisation and Its Discontents' (1930 [1929]), *Pelican Freud Library*, 12: 324.

83. Freud, 'Dostoevsky and Parricide', 448.

84. It transpires that guilt is basically a form of anxiety arising from the ego's fear of this tyrannical super-ego: 'the sense of guilt is at bottom nothing else but a topographical variety of anxiety; in its later phases it coincides completely with *fear of the super-ego*.' Freud, 'Civilisation and Its Discontents', 328.

85. Sigmund Freud, *New Introductory Lectures on Psycho-Analysis* (1933 [1932]), *Pelican Freud Library*, 2: 99.

86. T.S. Eliot, 'Tradition and the Individual Talent' (1919), in *Selected Essays* (London: Faber and Faber, 1972), 14.

87. Freud, 'Dostoevsky and Parricide', 450. Elsewhere, in the 'Wolf Man' case study, Freud observes that his identification with Christ on account of their common birthday enabled the Wolf Man to express a masochistic attitude towards his father. Sigmund Freud, 'From the History of an Infantile Neurosis (The 'Wolf-Man')' (1918 [1914]), *Pelican Freud Library*, 9: 300.

88. Melanie Klein applies this schema to the circumstance that directly concerns us, noting that in wartime internal and external danger-situations reinforce one another: 'External experiences which rouse anxiety at once activate even in normal persons anxiety derived from intrapsychic sources.' Melanie Klein, 'On the Theory of Anxiety and Guilt' (1948), in *Envy and Gratitude and Other Works, 1946–1963* (London: Virago, 1988), 40.

89. Freud, 'Dostoevsky and Parricide', 451.

90. As Freud's disciple Ernest Jones put it, in wartime 'all sorts of previously forbidden and buried impulses, cruel, sadistic, murderous and so on, are stirred to greater activity.' Ernest Jones, 'War Shock and Freud's Theory of the Neuroses', in Sandor Ferenczi et al., *Psycho-Analysis and the War Neuroses* (London, Vienna, New York: The International Psycho-Analytic Press, 1921), 47.

91. Nicola Lambourne, 'Production versus Destruction: Art, World War I and Art History', *Art History* 22 n° 3 (September 1999): 347–63.

92. Freud adds: 'We have divined just such a sequence of triumph and mourning, of festive joy and mourning, in the brothers of the primal horde who murdered their father, and we find it repeated in the ceremony of the totem meal.' Freud, 'Dostoevsky and Parricide', 451.

93. Winter, *Sites of Memory, Sites of Mourning: The Great War in European Cultural History* (Cambridge: Cambridge University Press, 1995), chapter 4.

94. Sigmund Freud, 'Mourning and Melancholia', *Pelican Freud Library*, 11: 251–68 (258).

95. Cited in the editor's note to 'Mourning and Melancholia', 248. Significantly, it is in this manuscript, dated 31

May 1897, that the notion of the Oedipus complex is also foreshadowed.

96. Melanie Klein, 'A Contribution to the Psychogenesis of Manic-Depressive States' (1935), in Love, Guilt and Reparation and Other Works, 1921–1945 (London: Virago, 1988), 266.

97. This information comes from a catalogue entry in Richard Verdi, Nicholas Poussin, 1594–1665, (London: Royal Academy of Arts, 1995), 172–3.

98. Freud, 'Mourning and Melancholia', 262ff.

99. Hannah Segal writes: 'The object is devoured and identified with and no loss or guilt for it is experienced.' Hanna Segal, Introduction to the Work of Melanie Klein (London: Karnac Books, 1988), 86.

100. Freud, 'Mourning and Melancholia', 264.

101. Theodore Reff, 'Picasso's Three Musicians: Maskers, Artists and Friends', Art in America 68 n° 10 (December 1980): 124–42.

102. Freud, 'Mourning and Melancholia', 254.

103. Antoine Prost, 'Monuments to the Dead', in Pierre Nora (ed.), Realms of Memory: The Construction of the French Past, vol. 2 (New York: Columbia University Press, 1997), 307–30.

104. Melanie Klein, 'On the Theory of Anxiety and Guilt', 33.

105. Klein, 'A Contribution to the Psychogenesis of Manic-Depressive States', 270.

106. Melanie Klein, 'The Oedipus Complex in the Light of Early Anxieties' (1945), in Love, Guilt and Reparation and Other Works, 410.

107. On this matter, see Sigmund Freud, 'Delusions and Dreams in Jensen's Gradiva', Pelican Freud Library, 14: 33–118. Freud employs the fate of Pompei, its burial and later excavation, as an allegory of psychoanalysis. What I am proposing is that this scenario is susceptible to a Kleinian rereading.

108. Einstein, 'Picasso: The Last Decade', 169.

109. Jacques Lacan, 'Le complexe, facteur concret de la psychologie familiale' (1938), part I of a two-part article on the family, L'Encyclopédie française (Larousse) n° 8(40): 16. All citations are taken from the section entitled 'Déclin de l'imago paternelle'.

110. Unpublished MA research by Katharine Peever on representations of the orphan in First World War imagery has established that where children are depicted either alone or with the mother on posters, commemorative memorials and elsewhere, in many cases they can be presumed to be orphaned (i.e. fatherless). Katherine Peever, 'The Representation of the Child and Orphan in the Visual Culture of the First World War', MA thesis, University of Manchester, 1999.

111. I am very thankful to Elizabeth Cowling for bringing this fact to my attention.

112. Leo Steinberg, The Sexuality of Christ in Renaissance Art and in Modern Oblivion (Chicago and London: University of Chicago Press, 1996 [1983]). Of relevance to our subject, Caroline Bynum has demonstrated that the body of Christ could equally carry symbolic associations with femininity. Medieval authors, she remarks, 'spoke of Jesus as a mother who lactates and gives birth'. Visually, the link was made through a correspondence between images of the lactating Virgin and Christ with blood spurting from his side, the wound figured as nurturing and breast-like. See Caroline Walker Bynum, 'The Body of Christ in the Later Middle Ages: A Reply to Leo Steinberg', in her Fragmentation and Redemption: Essays on Gender and the Human Body in Medieval Religion (New York: Zone Books, 1991), 79–117.

113. Robert Nye, Masculinity and Male Codes of Honour in Modern France (Oxford and New York: Oxford University Press, 1993).

114. Another dimension to this problem was the occurrence of shellshock in epidemic proportions among combatants. The recognised association of this condition with female hysteria called in to question traditional militaristic stereotypes of manly valour and so contributed to a broader crisis of gender definition. See Marc Oliver Roudebush, 'A Battle of Nerves: Hysteria and Its Treatment in World War I', unpublished PhD thesis, University of California at Berkeley, 1995.

115. See Margaret Higonnet et al., Behind the Lines: Gender and the Two World Wars (New Haven and London: Yale University Press, 1987) and Mary Louise Roberts, Civilisation Without Sexes: Reconstructing Gender in Post-War France, 1917–1927 (Chicago and London: Chicago University Press, 1994).

116. Freud avers that mourning can be a response not only to the loss of a loved person, but also 'to the loss of some abstraction which has taken the place of one, such as one's country, liberty, an ideal, and so on.' Freud, 'Mourning and Melancholia', 252. On this matter, see also Daniel Sherman, 'Monuments, Mourning and Masculinity in France after World War I', Gender and History 8 n° 1 (April 1996): 82–107.

117. Germane to our argument is what Freud has to say about biographers 'devot[ing] their energies to a task of idealization, aimed at enrolling the great man among the class of their infantile models – at reviving in him, perhaps, the child's idea of his father'. Sigmund Freud, 'Leonardo da Vinci and a Memory of His Childhood' (1910), Pelican Freud Library, 14: 223.

118. André Salmon, 'Picasso', L'Esprit nouveau n° 1 (May 1920): 64 and 67.

119. Maurice Raynal, 'La Peinture surréaliste', L'Intransigeant, 1 December 1925. I am grateful to Christopher Green for this very choice quotation.

120. Kristeva, Strangers to Ourselves, 183.

121. This indisputably was the case with Picasso. Christopher Green, Juan Gris, exhibition catalogue (London: Whitechapel Art Gallery, 1992), 134.

122. The grotesquely bloated, classical bathers Dalí produced following his visit are a case in point. For his account of the visit, see Dalí, The Secret Life of Salvador Dalí, translated by Haakon Chevalier (London: Vision, 1948), 206.

123. Picasso may have been influenced in this direction by Miró who, more than any other surrealist artist, exploits the metaphoricity of ambiguous visual signs. Miró's Head of a Catalan Peasant of approximately the same date as the Picasso images (1926–7) plays a similar game of substitutions. Apropos the visual signifier in cubism, see Yve-Alain Bois, 'Kahnweiler's Lesson', Representations 18 (spring 1987): 33–68.

124. A closely related ink drawing, evidently preparatory to this painting, is found in a sketchbook in the Musée Picasso, Paris (MP 1873) used by Picasso between December

1926 and May 1927 (the sequence of figure drawings discussed in section iii below are found in the same sketchbook). The only significant respect in which the drawing differs is the absence of the shadow, suggesting that it was incorporated at a late stage in the conception of the work. See Brigitte Léal (ed.), *Carnets: Catalogue des dessins*, vol. 2. (Paris: Musée Picasso, 1995), 73 (cat. 34, 45r°).

125. Einstein, 'Picasso: The Last Decade', 169–70.

126. See Anne Baldassari (ed.), *Picasso photographe, 1901–1916*, exhibition catalogue (Paris: Musée Picasso, 1994), figs 57–8. Of course, in the photographic negative where tonal contrasts are the reverse of a developed print, the shadow would show as brighter than the rest of the image, just as it does in the related paintings.

127. Freud, 'The "Uncanny"', 356–7. Sidra Stich raises the possibility that Picasso was acquainted with Otto Rank's book, *The Double*, which is also the main source of Freud's information on this subject. See Sidra Stich, 'Toward a Modern Mythology: Picasso and Surrealism', unpublished PhD thesis, University of California at Berkeley, 1977, 129ff.

128. 'L'ombre elle-même n'est pas un double, mais une des nombreuses émanations de l'homme qui lui sont dialectiquement contraires. C'est un antagoniste, et Janus n'est plus le reflet du Moi mais un signe de contradiction et de métamorphose.' Carl Einstein, 'Picasso', *Documents* n° 3 (1930), special issue: 'Hommage à Picasso', 156. These remarks may refer specifically to *Harlequin* which is reproduced on page 132 of the journal.

129. Sigmund Freud, 'A Note on the Unconscious' (1912), *Pelican Freud Library*, 11: 55.

130. Einstein, once again, proves our astutest commentator: 'Ses tableaux sont tendus entre deux pôles psychologiques et on peut parler à leur propos d'une dialectique intérieure, d'une construction à plusieurs plans psychiques' he writes. Einstein, 'Picasso', 157.

131. Sigmund Freud, 'Neurosis and Psychosis' (1924 [1923]), *Pelican Freud Library*, 10: 217.

132. 'Il est possible qu'on peigne tableaux . . . dans le but d'exprimer des choses psychiquement inassimilables, et aussi parce que constamment on se sépare de soi-même.' Ibid.

133. 'Il semble anormal qu'un seul homme emploie deux styles antinomiques. Je ne puis faire oeuvre de psychologue et justifier d'un point de vue scientifique ce troublant phénomène.' George, *Picasso: Dessins*, 15.

134. *Picasso*, Kunsthaus Zurich, 11 September–30 October 1932. The bulk of the works, which included many items from Picasso's personal collection, had been exhibited from 16 June to 30 July at the Galeries Georges Petit in Paris. See Carl Jung, 'Picasso', *Neue Zürcher Zeitung* (Zurich) 153 n° 2 (13 November 1932), reprinted in McCully (ed.), *A Picasso Anthology*, 182–6.

135. Ibid., 183.

136. Ibid., 184.

137. Ibid., 186. It may well have been the *Girl Before a Mirror*, reproduced in the catalogue of the Zurich exhibition as plate 21, of which Jung remarks that 'one painting (although traversed by numerous lines of fracture) even contains the conjunction of the light and dark anima.' See also Carla Gottlieb, 'Picasso's *Girl Before a Mirror*', *Journal of Aesthetics and Art Criticism* 24 (summer 1966): 509–17.

138. The term 'schizophrenia', first coined by the Swiss psychiatrist Eugen Bleuler in 1911, means literally a split mind and refers to the dissociation of mental faculties which Bleuler believed to be the essential feature of the psychotic state. The self-disturbance in schizophrenia, so defined, comprises the pathologised other to a culturally and historically specifiable notion of the subject (to cite the anthropologist Clifford Geertz: 'the Western conception of the person as a bounded, unique, more or less integrated motivational and cognitive universe, a dynamic center of awareness, emotion, judgement, and action organised into a distinctive whole and set contrastively both against other such wholes and against its social and natural background'). Jung, in his essay on Picasso, evokes the normative ideal of a *homo totus*. See Clifford Geertz, *Local Knowledge* (New York: Basic Books, 1983), 59.

139. Ibid. The diagnosis of a schizophrenic state of culture finds Jung keeping odd company with Frederic Jameson who employs the term ironically to describe the fragmented and dispersed subject of postmodernity; arch-modernist Picasso stands accused of the same pathology by anti-modernist Jung as does the postmodern subject by Jameson. See Frederic Jameson, 'Postmodernism, or the Cultural Logic of Late Capitalism', *New Left Review* 146 (July–August 1984): 53–91.

140. For a balanced appraisal from inside the Jungian camp, see Andrew Samuels, *The Political Psyche* (London: Routledge, 1993), chapter 12: 'Jung, Anti-Semitism and the Nazis'.

141. Max Raphael, 'C.G. Jung vergreift sich an Picasso' (C.G. Jung misinterprets Picasso), *Information* (Zurich edition) (6 December 1932): 4–7. Written in response to Carl Jung's article on Picasso commissioned by the *Neue Zürcher Zeitung* at the time of the retrospective exhibition at the Zurich Kunsthaus in 1932, the ideas adumbrated here clearly formed the basis of Max Raphael's better-known essay (see n.145 below) on Picasso of the following year which, however, omits all mention of Jung. The translation is by Suzanne Walters and the article in its entirety can be found as Appendix B in Lomas, 'The Haunted Self: Surrealism, Psychoanalysis, Subjectivity', PhD dissertation, Courtauld Institute, London, 1997, 266–9.

142. Max Raphael, *Proudhon, Marx, Picasso: Three Essays in Marxist Aesthetics*, translated by Inge Marcuse (London: Lawrence and Wishart, 1981). The reaction to Raphael's book in the French press was uniformly hostile: see reviews by Michel Leiris in *La Critique sociale* n° 9 (September 1933): 147 and Louise Perier in *Commune* n° 5–6 (January–February 1934): 649–53.

143. Raphael, *Proudhon, Marx, Picasso*, 135.

144. Ibid., 143.

145. Ibid., 117.

146. Ibid., 133.

147. Ibid.

148. Ibid., 142.

149. The work that Raphael refers to as *Bathing Woman* can be positively identified from his description as the *Seated Bather*. I have been able to ascertain recently that this picture was definitely included in the Picasso exhibition at the

Zurich Kunsthaus in 1932 (reproduced in the catalogue as plate 19). As noted above, this exhibition was crucial as a source for the reflections of both Jung and Raphael.

150. Raphael, *Proudhon, Marx, Picasso*, 133.

151. Ibid., 129.

152. Ibid., 145.

153. 'idées déjà énoncées par les gnostiques, les néopythagoriciens et les néo-platoniciens, Plotin, Porphyre et Jamblique et introduite par M. Jung dans la psychiatrie': Christian Zervos, 'Picasso étudié par le Dr Jung', *Cahiers d'art* n° 8–10 (1932): 352–4.

154. 'Quoi que l'on veuille insinuer il y a une grande unité tout le long de l'oeuvre de Picasso . . . C'est la constance du tempérament, comme le retour d'une mélodie caractéristique, qui fait l'unité de son oeuvre.' Christian Zervos, 'Picasso à Dinard: Eté 1928', *Cahiers d'art* n° 4 (1929): 5–11.

155. Christopher Green, 'Zervos, Picasso and Brassaï, Ethnographers in the Field: A Critical Collaboration', in Malcolm Gee (ed.), *Art Criticism, 1900–1990* (Manchester: Manchester University Press, 1993), 116–39.

156. John Berger dedicates *The Success and Failure of Picasso* (London: Writers' and Readers' Publishing Cooperative, 1980 [1965]) to Max Raphael, 'a forgotten but great critic'. My thanks to Alex Parigoris for introducing me to it.

157. 'Là, au sein de leur conscience, dans le moi, pilier du monde, unique rocher qui ne se désagrège pas, apparaissait soudain un élément étranger qui détruisait l'unité et l'identité de la conscience.' Octavio Paz, statement in André Breton (ed.), *L'Art magique* (Paris: Club Français du Livre, 1957), 311.

158. Sigmund Freud, 'Three Essays on the Theory of Sexuality', *Pelican Freud Library*, 7: 75.

159. See Georges Bataille, 'The "Old Mole" and the Prefix *Sur* in the Words *Surhomme* [Superman] and *Surrealist*' and 'The Use Value of D.A.F. de Sade', in *Visions of Excess*, translated by Alan Stoekl (Minneapolis: University of Minnesota Press, 1985), 32–44; 91–102.

160. 'Intellectual despair results in neither weakness nor dreams, but in violence' Bataille writes in 'Le "Jeu Lugubre"', *Documents* n° 7 (December 1929): 297; translated as 'The "Lugubrious Game"' in *Visions of Excess*, 24. Growing disillusionment among intellectuals on the Left with mainstream Marxism and its dream of world revolution can be counted as one of the sources of Bataille's intellectual despair. Whilst initially it is possible to regard him as a heterodox Marxist, as the 1930s progress this is surely no longer the case; Bataille's faith in myth and the sacred as a basis for community places him firmly at odds with Marx's rationalism. Highly revealing in this respect is a letter from André Masson to Bataille in 1935: 'one is obliged *first of all to detest marxism* because its bases are uniquely rationalist and utilitarian and it obstinately rejects everything which is not'. André Masson, *Le Rebelle du surréalisme: Ecrits*, edited by François Will-Levaillant (Paris: Hermann, 1976), 284. This broader sociopolitical context needs to be borne in mind in assessing both the reasons for Bataille's anti-idealism – his hostility to the dream, for instance – as well as its revival post-1968 with the failure of revolutionary aspirations then.

161. Georges Bataille, 'Le Gros orteil' (The big toe), *Documents* n° 6 (November 1929): 297–302; reprinted in Bataille, *Visions of Excess*, 20–23.

162. Georges Bataille, 'Soleil pourri', *Documents* n° 3 (1930): 174; reprinted in *Visions of Excess*, 57–8.

163. Desublimation as a description of Bataille's discourse has the virtue of situating it within a psychoanalytic problematic. The term – not one that Bataille himself uses – originates with Hal Foster.

164. The sketchbook (Musée Picasso, Paris: MP 1873), which is dated December 1926–8 May 1927, is reproduced in its entirety in *Pablo Picasso, Carnets: Catalogue des dessins*, ed. Brigitte Léal (Paris: Musée Picasso, 1996) vol. 2, 65–73.

165. Tracing had been incorporated into Picasso's drawing practice from at least 1913, being a source of the metamorphic propensity in his late cubism, so we need not infer any direct debt to Miró.

166. Mikhail Bakhtin, *Rabelais and His World*, translated by Helen Iswolsky (Cambridge, Mass. and London: MIT Press, 1968), 353. On 11 May 1929, Michel Leiris committed to his diary the following: 'Vu Picasso. Parlé du burlesque et de son équivalence avec le merveilleux (Reich). Actuellement, il n'y a plus moyen de faire passer une chose pour laide ou répugnante. La merde même est jolie.' Michel Leiris, *Journal, 1922–1989*, edited by Jean Jamin (Paris: Gallimard, 1992), 154.

167. Freud, 'Some Psychical Consequences of the Anatomical Distinction Between the Sexes', *Pelican Freud Library*, 7: 335–6. See the points above concerning the uncanniness of the female genitals.

168. Freud, 'Fetishism', 352.

169. Ibid., 354.

170. Reading backwards to the more naturalistic images in the sequence, it can be appreciated that the space defined by the inner contours of the legs and abdomen defines a vaginal shape, surrounded by long snaking arms – in toto, an image of the petrifying Medusa's head.

171. Freud, 'Some Psychical Consequences of the Distinction Between the Sexes', 336.

172. Sigmund Freud, 'A Special Type of Object-Choice Made By Men' (1910), *Pelican Freud Library*, 7: 237.

173. Sigmund Freud, 'On the Universal Tendency to Debasement in the Sphere of Love' (1912), *Pelican Freud Library*, 7: 247–60 (251–2).

174. Susan Rubin Suleiman, 'Pornography, Transgression, and the Avant-Garde: Bataille's Story of the Eye', in Nancy K. Miller (ed.), *The Poetics of Gender* (New York and Guildford: Columbia University Press, 1986), 132.

175. That desire is the motive force behind his transgression of the classical body is shown by Picasso's statement reported by Christian Zervos in 1935 that: 'The beauties of the Parthenon, Venuses, Nymphs, Narcisseses, are so many lies. Art is not the application of a canon of beauty but what the instinct and the brain can conceive beyond any canon. When we love a woman we don't start measuring her limbs.' 'Statement by Picasso: 1935', in Alfred Barr, *Picasso: Fifty Years of His Art*, 273.

176. Michel Foucault, 'A Preface to Transgression', in *Language, Counter-Memory, Practice: Selected Essays and Interviews*, translated by Donald F. Bouchard and Sherry Simon (Oxford: Blackwell, 1977), 34.

177. 'cet art grossier et déformant'. Bataille, 'L'Art primitif' (1930), *Oeuvres complètes* 1: 251. In support of a claim that

the Bataillean context is relevant to the conditions of production as well as reception of Miró's work, it could be noted that, towards the end of the 1920s, when he turns to collage and assemblage, matter – base matter – as well as process becomes of concern to him. The intrusion of shoddily cut-and-pasted discs of paper, abrasive sandpaper and so forth, destroys the equanimity of painting. Whereas Carolyn Lanchner is reluctant to allow more than a minor role to Bataille in explaining this new stance, one hostile to representation as such, it might be argued that his conception of base materialism prompted Miró's choice of such intransigent materials. Lanchner, *Joan Miró*, exhibition catalogue (New York: Museum of Modern Art, 1994), 57.

178. Jean L'Hermitte, *L'Image de notre corps* (Paris: Editions de la Nouvelle Revue Critique, 1937), 20. There were a number of pioneering studies of children's drawings in the period. See, in particular, Georges Henri Luquet, *Les Dessins d'un enfant (Simonne Luquet): Etude psychologique* (Paris: Editions Félix Alcan, 1913) and *Le Dessin enfantin* (Paris: Editions Félix Alcan, 1927). Luquet proposed the existence of a *modèle interne*, a sort of virtual image (*dessin virtuel*) which the child in effect copies whenever it makes a drawing. The *modèle interne* is a reconstruction of perceived reality according to a hierarchy of value which the child attaches to each part – generally of the human body to begin with. By studying their drawings we gain access, Luquet says, to 'a childish metaphysics ['une métaphysique enfantine'] which produces without doubt many a surprise'. The capricious attitude towards anatomical proportions evinced by Miró, one might surmise, is regulated by precisely such a childish metaphysics.

179. Freud often draws an analogy between the ego and the body of an amoeba. He compares our libidinal attachments to objects to the pseudopodia which extend outwards from the main protoplasmic mass surrounding the organism's nucleus. See the 'Introductory Lectures on Psycho-Analysis', *Pelican Freud Library*, 1: 465–6.

180. As noted before, Picasso registers a similar uncanny oscillation and ambiguity in the surrealist assemblage in his etching *Model with Surrealist Sculpture* (fig. 49). Visual uncertainty is maximal at the very point where one feels identity *ought* to be most secure: the sex of this hybrid creature is a reversing image that switches back and forth uncannily between representations of male and female genitalia. Ironically, the prototype for this sexual indeterminacy, Freud points out, is the fig-leaf on classical statues.

181. Gilles Deleuze states that: 'Disavowal should perhaps be understood as the point of departure of an operation that consists neither in negating nor even destroying, but rather in radically contesting the validity of that which is: it suspends belief in and neutralises the given in such a way that a new horizon opens up beyond the given and in place of it.' Understood in these terms, fetishistic disavowal is absolutely pivotal to the surrealist project. Deleuze allows one to account for the ubiquity of fetishism in surrealist visual art – of which Dalí's *Scatological Object* (fig. 93) is a spectacular instance – in terms more sympathetic to the surrealists' objectives than has tended to be the case in literature dealing with this issue. See Gilles Deleuze, 'Masochism: An Interpretation of Coldness and Cruelty', introduction to

Leopold von Sacher-Masoch, *Venus in Furs* (New York: Zone Books, 1989). For a nuanced discussion of the fetish within surrealist discourse and art practices which argues for a need to differentiate the surrealist viewpoint from a strictly Freudian conception, see Dawn Ades, 'Surrealism: Fetishism's Job', in Anthony Sheldon (ed.), *Fetishism: Visualising Power and Desire*, exhibition catalogue (London and Brighton: South Bank Centre and the Royal Pavilion, Art Gallery and Museums, 1995), 67–87.

182. There can be no absolute certainty that these images are not later additions to the sketchbook. In fact, a series of paintings of *Swimmers* and *Acrobats* that employ a similar formula for depicting the body correspond closely in date to the Miró drawings. Acrobats are an archetypal embodiment of classical virtues of balance and equilibrium. It may be pertinent to Picasso's subversive revival of a subject familiar from his Rose period that, at this moment, acrobatic displays on a mass scale offering the spectacle of an ordered and regimented populace were being organised by authoritarian regimes across Europe.

183. Bataille, 'Le Cheval académique' (1929), *Oeuvres complètes*, vol. 1, 159–63.

184. 'qui ne calculaient rien, ne concevant aucun progrès et laissant libre cours aux suggestions immédiates et à tout sentiment violent.' Ibid., 160.

185. 'parvenue en dernier lieu à la frénésie des formes, transgressa la règle et réussit à réaliser l'expression exacte de la mentalité monstrueuse de ces peuples'; 'représentèrent ainsi une réponse définitive de la nuit humaine, burlesque et affreuse, aux platitudes et aux arrogances des idéalistes.' Ibid., 161–2, 162.

186. Bataille, *Visions of Excess*, 46.

187. Ibid., 225.

188. On George and Maillol, see Christopher Green, 'Classicisms of Transcendance and of Transience: Maillol, Picasso and de Chirico', in *On Classic Ground*, 267–82.

189. Waldemar George, 'Fifty Years of Picasso and the Death of the Still Life', *Formes* n° 14 (April 1931): 56.

190. Bataille, 'The "Lugubrious Game"', 24.

191. Michel Leiris, 'Toiles récentes de Picasso', *Documents* n° 2 (1930): 57–70.

192. José Ortega y Gasset, *Velasquez, Goya, and the Dehumanisation of Art*, translated by Alexis Brown (London: Studio Vista, 1972), 65–83.

193. Ibid., 71.

194. Ibid., 73.

195. Ibid., 77.

196. 'Pour les uns, Picasso accomplit merveilleusement cette "déshumanisation de l'art" qu'on prophétise un peu partout.' Jean Cassou, 'Derniers dessins de Picasso', *Cahiers d'art* 2 (1927): 49–54.

197. Serge Fauchereau notes that critics with leftist sympathies were voicing humanist sentiments at this time. He cites Gaston Diehl who writes favourably of the Forces Nouvelles artists: 'Surtout, ce qui me plait en eux, c'est retour à l'humanisme et à la nature. Visages condensés, simplifiés, prêts à crier leur sourde détresse.' See Serge Fauchereau (ed.), *Le Querelle du réalisme* (Paris: Cercle d'Art, 1987), 20–23. By the same token, he notes the emergence of a Catholic humanism on the right of the political spectrum (Ibid., 22

and 23). Waldemar George was at the forefront of those advocating neo-humanism – see his 'Le Néo-humanisme', *L'Amour de l'Art* (1934): 359–61.

198. George, 'Fifty Years of Picasso and the Death of the Still Life', 56.

199. 'Il a fallu la ruse prodigieuse et obstinée des moralistes et politiciens pour que le mot désignant l'ensemble des hommes en vienne à signifier non plus cette universalité concrète et vivante, mais une abstraction qualitative dont la tartuferie couvre ses méfaits, et ne cesse d'arguer, pour contrarier, au profit du petit nombre favorisé, le devenir de l'humanité.' René Crevel, 'Le Clavecin de Diderot'; reprinted in *L'Esprit contre la raison* (Paris: Pauvert, 1986), 161. In 'Notes en vue d'une psycho-dialectique', *Surréalisme au service de la révolution* n° 5 (15 May 1933) Crevel observes: 'il faut ne jamais oublier que l'humanitarisme sentimental cache, à l'ombre de généralités bêlantes, un individualisme dont les appétits sournois décident des ruses oratoires du masque.'

200. 'de l'humain desséché, le surréalisme ressuscitait l'homme.'

201. 'un pressentiment ambivalent de trouver l'une dans l'autre.' Roger Caillois, 'La Mante religieuse: De la biologie à la psychanalyse', *Minotaure* n° 5 (May 1934): 23–6.

202. In a French context, the surrealists were clearly quite prescient in this regard, since it was not until about 1938, according to Elizabeth Roudinesco, that the psychoanalytic establishment began to debate the concept. See her *La Bataille de cent ans: Histoire de Psychanalyse en France*, vol. 1 (Paris: Seuil, 1986), 387.

203. 'ce qui est proprement affolant, tomber, en face d'un danger ou à la suite d'une excitation périphérique, dans une fausse immobilité cadavérique: je m'exprime exprès de cette façon indirecte tant le langage, me semble-t-il, a peine à signifier, et la raison à comprendre, que morte, la mante puisse simuler la mort.' Ibid., 26.

204. Sigmund Freud, 'Beyond the Pleasure Principle' (1920), *Pelican Freud Library*, 11: 338.

205. 'le masochisme, le sadisme et presque tous les vices . . . ne sont que des moyens de se sentir plus humain – parce qu'en rapports plus profonds et plus abrupts avec les corps.' Michel Leiris, 'L'Homme et son intérieur', *Documents* n° 5 (1930): 261–6 (264).

206. Ibid., 261.

207. 'Sous prétexte que Picasso s'est insurgé contre les canons académiques, on le loue de s'être attaqué à l'antique beauté, fade, froide et idiote comme une nymphe de square, et d'avoir inventé des formes inquiétantes et monstrueuses.' Michel Leiris, 'Toiles récentes de Picasso': 57–70 (64).

208. 'jamais jusqu'à lui l'homme n'avait aussi fortement affirmé, dans le domaine artistique, ce qui fait sa nature et son humanité.' Ibid., 70. Christian Zervos, more moderate, adopts a similar tack in his defence of Picasso in *Cahiers d'art* 10 n°1 (1935), writing that: 'This humanity . . . has nothing in common with the neohumanism of today. Human, in this sense, means common. We expect nothing good of this humanity, but we count a great deal on a very complete humanity, where the sentiments, the anxieties, the dramas, the emotions, the constraints, the conflicts of instincts are found condensed' ('Cette humanité . . . n'a rien à voir avec le néohumanisme d'aujourd'hui. Human, dans ce sens, veut

dire commun. Nous n'attendons rien de bon de cette humanité, mais nous comptons beaucoup sur une humanité très complète, ou les sentiments, les inquiétudes, les drames, les emotions, les contraintes, les conflits des instincts se trouve condensés').

209. See B. Geiser, *Picasso: Peintre–Graveur*, vol. 2 (Berne, 1968), n° 353.

210. Reportedly, it was Picasso who arranged Dalí's introduction to Skira and suggested to the latter that he might undertake a project for illustrating a book.

4 disgust

1. André Breton, 'Picasso dans son élément', *Minotaure* n° 1–2 (1 June 1933): 10–22; André Breton, *Surrealism and Painting*, translated by Simon Watson Taylor (London: MacDonald and Co., 1972), 101–14.

2. Ibid., 110 (translation modified).

3. Ibid., 113.

4. Ibid., 114.

5. Ibid.

6. Georges Bataille, 'Use Value of D.A.F. de Sade', in *Visions of Excess*, translated by Alan Stoekl (Minneapolis: University of Minnesota Press, 1985), 94.

7. Ibid. Regarding the status of the heterogeneous in Bataille see, albeit from a critical vantage point, Jurgen Habermas, 'The French Path to Postmodernity: Bataille Between Eroticism and General Economics', *New German Critique* 33 (fall 1984): 79–102.

8. My concern is with interrelations between mind and body, i.e. the body as a figure for the self. For Freud, the ego, interposed between the unconscious and the exterior world, can be understood as a projection of the body surface analogous to the cortical homunculus of the anatomists: 'The ego is first and foremost a bodily ego; it is not merely a surface entity, but is itself the projection of a surface.' Freud, 'The Ego and the Id' (1923), *Pelican Freud Library*, 15 vols (Harmondsworth, Middlesex: Penguin Books, 1953–87), 11: 364.

9. Bataille, 'Use Value of D.A.F. de Sade', 102 n.1.

10. Emile Durkheim, *The Elementary Forms of Religious Life*, translated by Joseph Ward Swain (London: Allen and Unwin, 1976), 410.

11. Bataille, *Visions of Excess*, 29–30 n.1.

12. Dalí's pariah status for the dissident surrealists following this episode is attested to by André Masson's remark in his correspondence with Michel Leiris: 'But *Dalí is taboo* and not only for Bataille' ('Mais *Dalí est tabou* et pas seulement pour Bataille'). André Masson, *Les Années surréalistes: Correspondance, 1916–42*, edited by Françoise Levaillant (Paris: La Manufacture, 1990), 260.

13. I am referring here to the exhibition curated by Yve-Alain Bois and Rosalind Krauss, *L'informe: Mode d'emploi*, at the Centre Georges Pompidou in Paris in 1996. This justifiably celebrated show was premised on a selective application of the formless, which was deployed for the purpose of a critique of modernist formalism, in part through the presentation of an alternative historical lineage to that championed by modernism, but also by revalorising in terms of the

formless a number of canonical modernist artworks. It would be unreasonable to demand that such a project be bound by fidelity to the original Bataillean concept, though as others have remarked it wound up oddly mirroring the formalism it meant to deconstruct — evident especially in the bias towards non-figurative art and hostility towards abject art, so-called, as well as to the Kristevan concept of abjection. In these respects, Rosalind Krauss's position can be fruitfully compared with that of Robert Morris who in the late 1960s espoused the notion of anti-form, and it is not coincidental that his work occupied pride of place at the Pompidou. See the round-table discussion reported in *October* 67 (winter 1994): 3–21.

14. Dalí, 'L'Ane pourri' (Rotten donkey), *Le Surréalisme au service de la révolution* nº 1 (July 1930): 9–12; *The Collected Writings of Salvador Dalí*, edited and translated by Haim Finkelstein (Cambridge: Cambridge University Press, 1998), 223–36 (translations from this source have in some cases been significantly modified).

15. Ibid., 226.

16. When one enquires into the matter, it is surprising how often an earlier infatuation with Dalí has been overcome *en route* to becoming a reputable critic or historian. This puts into a rather different perspective Ian Gibson's morality tale of a shameful life. For how many such detractors is Dalí their guilty secret? See Ian Gibson, *The Shameful Life of Salvador Dalí* (London: Faber and Faber, 1997).

17. James Thrall Soby, *Salvador Dalí*, revised edition (New York: Museum of Modern Art, 1946), 26. Soby had worked under A. Everett ('Chick') Austin at the Wadsworth Atheneum which in 1931 mounted the first ever surrealist exhibition in the United States and went on to amass one of the most important surrealist collections in the country. He was appointed to the Museum of Modern Art in November 1940 and succeeded Alfred Barr as director of painting and sculpture in 1943.

18. One can only guess at the exact nature of Barr's objections, but Soby's reply dated 17 October 1941 sets out at greater length his own position. 'I've toned down the section about Dalí as the leader of anti-abstraction,' he writes. 'First, I called it "a particular kind of anti-abstract revolt", which still leaves room for Derain and the Germans. Then, I later put in "vanguard" in front of favor, because I do think Dalí has converted the *avant-garde* in a way that Hopper and such people never did. It also seems to me that Dalí's disavowal of abstract art is more conscious than that of Americans like Hopper who were never really in the middle of the Paris excitement. Hope this paragraph will do as in; I don't like to make it too dispassionate.' Museum of Modern Art Archives, James Thrall Soby Papers, 1.10. My presumption is that because Barr wished to assimilate surrealism to mainstream modernism he was therefore anxious to downplay as far as possible Dalí's polemical opposition.

19. Clement Greenberg, 'Avant-Garde and Kitsch', *Partisan Review* 6 nº 5 (fall 1939): 34–49; reproduced in Francis Frascina (ed.) *Pollock and After: The Critical Debate* (London: Harper and Row, 1985), 21–33.

20. 'Kitsch: popular, commercial art and literature with their chromeotypes, magazine covers, illustrations, ads, slick and pulp fiction, comics, Tin Pan Alley music, tap dancing, Hollywood movies, etc., etc.' Ibid., 25.

21. Clement Greenberg, 'Surrealist Painting' (1944), in *The Collected Essays and Criticism*, vol. 1, *Perceptions and Judgements, 1939–1944*, edited by John O'Brien (Chicago and London: University of Chicago Press, 1986), 225–31 (229).

22. Waldemar Januszczak, *Guardian*, 17 June 1980, 10.

23. Carter Ratcliffe, 'Swallowing Dalí', *Artforum* 21 nº 1 (September 1982).

24. Salvador Dalí, 'Derniers modes d'excitation intellectuelle pour l'été 1934', *Documents* 34 (June 1934): 33–5.

25. 'J'ose le dire et je le crois que la technique *académique* serait le *Moyen* le plus *adequat* et le moins artistique pour la copie et la reproduction de certaines visions et images irrationelles qui se caractérisent par l'exacerbation paroxyque de leur concret comme pour la matérialisation et l'objectivation de certaines fantaisies involontaires rêves toute la valeur lesquelles résident dans la plus infirme nuance d'une certaine lumière ou expression de visage etc. Seule, à mon point de vue, la technique académique tellement discréditée et *indéfendable du point de vue esthétique intellectuelle* serait à prendre en considération par les surréalistes pour pouvoir en s'en servant, objectiver avec le plus de trompe l'oeil, avec le plus de fétichisme illusioniste le contenu du nouveau monde délirant auquel nous venons d'avoir accès et qui reste incommunicable pour le moment par n'importe quel autre moyen d'expression.' Letter to André Breton (25 January 1934), Gabrielle Keiller archive, Scottish National Gallery of Modern Art, Edinburgh. Though undated, this letter is a reply to Breton's demand of 23 January 1934 for urgent clarification of Dalí's views on a number of matters which were a source of growing consternation. In particular, he cites Dalí's calls for a *retour à Meissonier* and his execration of 'modern' art. Given the persecution of modernism under both Stalin and Hitler, Breton judges this reactionary.

26. Peter Conrad, review of the Salvador Dalí retrospective at the Tate Gallery, *Times Literary Supplement* (30 June 1980), 613.

27. Sigmund Freud, 'Civilisation and Its Discontents', *Pelican Freud Library*, 12: 288–9 and 296. This work was published in French translation in 1934 as *Le Malaise dans la Civilisation* (Paris: Denoël et Steele, 1934).

28. Clement Greenberg, 'Modernist Painting' (1960), in *The Collected Essays and Criticism*, vol. 4 (Chicago and London: University of Chicago Press, 1993), 89.

29. I have chosen Helen Chadwick's exhibition *Effluvia* for comparison with *Accommodations of Desires* (1929) because it chimes with so many of Dalí's obsessions from the edible to the excremental. Entering the exhibition space, one was greeted not by a purely optical experience but by an overwhelming smell of molten chocolate to the accompaniment of visceral bubbling and gurgling sounds all emanating from a chocolate fountain titled *Cacao* which dominated the exhibition.

30. The prestige of Jacques Lacan in poststructuralist circles has also, to some extent, boosted Dalí's respectability through the acknowledgement of Lacan's debt to him. Some of these points of intersection will be dealt with in this chapter. On this matter, see also Patrice Schmitt, 'De la psychose paranoïaque dans ses rapports avec Salvador Dalí', in

Salvador Dalí rétrospective, exhibition catalogue (Paris: Musée national d'art moderne, Centre Georges Pompidou, 1979–80), 262–6 and Alain Grosrichard, 'Dr Lacan, "Minotaure", Surrealist Encounters', in Focus on Minotaure: The Animal-Headed Review, exhibition catalogue (Geneva: Musée Rath, 1987–8), 159–73.

31. Sigmund Freud, Letter 79, 22 December 1897, 'Extracts from the Fleiss Papers', The Standard Edition of the Complete Psychological Works of Sigmund Freud, 24 vols (London: Hogarth Press, 1953–74), 1: 273.

32. 'elle m'avait toujours paru la chose la plus saisissante à faire.' Cited in 'La Vie publique de Salvador Dalí', in Salvadore Dalí retrospective, 32.

33. Valerie Holman has studied the Maldoror project in the context of Albert Skira's fine-art publishing ventures. Prepublicity for the book was extensive and included exhibitions of the etchings in Paris, London and New York. See Valerie Holman, 'Albert Skira and Art Publishing in France, 1928–1948', unpublished PhD dissertation, Courtauld Institute of Art, London, 1987, 87–99. In the event, it appears that only half the originally projected edition was printed in 1934.

34. Renée Riese Hubert, Surrealism and the Book (Berkeley and London: University of California Press, 1988), 189–219 (219).

35. '. . . où se déchaînent fureurs et démons de l'érotisme et de la cruauté'; 'qui touche à l'expérience et à l'expression poétiques.' Marguerite Bonnet, André Breton: Naissance de l'aventure surréaliste (Paris: Librairie Corti, 1975), 142.

36. André Breton, Qu'est-ce que le surréalisme? (Brussels: Editions René Henriquez, 1934), 25.

37. Salvador Dalí, 'Nouvelles considérations générale sur le mécanisme du phénomène paranoïaque du point de vue surréaliste', Minotaure n° 1 (June 1933): 65–7; Dalí, Collected Writings, 260.

38. Salvador Dalí, La Conquête de l'irrationnel (1935), in Collected Writings, 267.

39. This very clear derivation tends to get obscured in the Dalí literature by translating 'délire' as delirium, rather than as delusion or delusional.

40. Paul Sérieux and Joseph Capgras, Les Folies raisonnantes: Le Délire d'interprétation (Paris: Editions Félix Alcan, 1909).

41. Ibid. More succinct is the following definition: 'Une inférence d'un percept exact à un concept erroné, par l'intermédiaire d'une association affective' ('An inference from a correct perception to an erroneous concept by the intermediary of an affective link'). Gabriel Dromard, 'Interprétation délirante', Journal de psychologie (1910): 333.

42. Jacques Lacan, De la psychose paranoïaque dans ses rapports avec la personnalité (Paris: Seuil, 1980 [1932]). The meeting, instigated by Lacan, took place following the publication of Dalí's Minotaure article in 1933 (Dalí confusingly states he was thirty-three at the time). See Dalí, The Secret Life of Salvador Dalí, translated by Haakon Chevalier (London: Vision, 1948), 17–18.

43. Ibid., 18.

44. 'Une fois systématisé, le délire mérite une étude attentive. Dans le cas que nous décrivons, il signifie en effet de façon très lisible . . . le conflit affectif inconscient qui l'engendre.' Lacan, De la psychose paranoïaque, 272.

45. Dalí, 'L'Ane pourri', 223.

46. Lacan, De la psychose paranoïaque, 293.

47. 'le délire paranoïaque constitue déjà en lui-même une forme d'interprétation.' Salvador Dalí, 'Interprétation paranoïaque-critique de l'image obsédante "L'Angélus" de Millet', Minotaure n° 1 (1 June 1933): 66.

48. André Breton, Preface for Dalí's exhibition at the Galerie Goemans, Paris, 1929, in What is Surrealism? Selected Writings, 45.

49. Sigmund Freud, 'Psychoanalytic Notes on an Autobiographical Account of a Case of Paranoia (dementia paranoides)', Pelican Freud Library, 9: 185. That, as we shall see below, is the purpose of Dalí's paranoiac-critical interpretation of Millet's Angelus, namely to unravel the condensations, substitutions and displacements of a picture he regards as having been composed in a dream-like fashion.

50. 'Là où d'autres ne voient que coïncidences, eux, grâce à leur clairvoyance interprétative, savent démêler la vérité et les rapports secrets des choses.' Sérieux and Capgras, Les Folies raisonnantes, 27.

51. Freud, 'Psychoanalytic Notes on an Autobiographical Account of a Case of Paranoia', 218. Dalí, for his part, observes: "On this subject, how can we refuse to envisage sciences such as psychoanalysis as being "mildly systematised delusions" (without naturally the idea of delusion carrying in this case any pejorative sense).' Salvador Dalí, Le Mythe tragique de l'Angélus de Millet: Interprétation 'paranoïaque-critique' (Paris: Jean-Jacques Pauvert, 1978 [1963]), 149. It is surprising that Dalí never mentions Freud's Schreber case-study, in spite of the fact that it was available in French translation from 1932. Even if he had never read it, though, he would have been aware of the main outlines of Freud's theory of paranoia from Lacan's thesis.

52. Ibid., 126.

53. To my knowledge, the picture was first shown at the Julien Levy Gallery, New York, from 21 November to 10 December 1934 where it was exhibited with the title Imperial Monument to the Child-Woman, Gala. The assemblage figure kneeling in the right foreground consisting of bent-wood and skeletal forms is an almost exact replica of one of the Maldoror etchings and relates closely to the Javanese Mannequin of 1934 (fig. 85), another offshoot of that project.

54. 'Ces phénomènes, et spécialement les interprétations, se présentent dans la conscience avec une portée convictionnelle immédiate . . . Ils ne sont jamais le fruit d'aucune déduction "raisonnante".' Lacan, De la psychose paranoïaque, 345–6.

55. On this question, see Naomi Schor, 'Dalí's Freud', Dada/Surrealism n° 6 (1976): 10–17.

56. On the matter of paranoiac knowledge, Lacan states: 'In the course of studying "paranoiac knowledge" I was led to consider the mechanism of paranoiac alienation of the ego as one of the prerequisite conditions of human knowledge.' Jacques Lacan, 'Some Reflections on the Ego', International Journal of Psycho-Analysis 34 (1953): 11–17.

57. The collage-like, additive principle at work in this etching is a by-product of the technique employed in its creation. Rainer Michael Mason, who has studied the etchings from a technical angle, concludes that a photographic process known as heliogravure was used to transfer Dalí's drawings on to the metal plate which was then engraved by

assistants. Such a technique enables the superimposition of more than one source image, as seen here. Though Mason's researches may seem to vitiate their authenticity, it proves that conceptually the *Maldoror* series are uniquely, indisputably Dalí's. Rainer Michael Mason, *vrai* DALI / *fausse* GRAVURE, exhibition catalogue (Geneva: Cabinet des estampes du Musée d'art et d'histoire, 1992).

58. Dalí, 'L'Ane pourri', in *Collected Writings*, 223. Contemporary guidebooks to the Louvre indicate that the *Angelus* and Meissonier's *1814* hung together as part of the bequest of Alfred Chauchard but the *Gleaners* hung apart in the Salle des Etats – unfortunately!

59. Salvador Dalí, 'L'Angélus de Millet', invitation to the exhibition, 'Salvador Dalí: Les Chants de Maldoror' (Paris: Galerie des Quatre Chemins, 1934), reproduced in Dalí, *Collected Writings*, 282.

60. Dalí, 'L'Amour' (1930), in *La Femme visible* (Paris: Editions Surréalistes, 1930); *Collected Writings*, 191.

61. The relevant texts are 'Instincts and their Vicissitudes' and 'The Economic Problem of Masochism'. Jean Laplanche comments that 'there are two contiguous "vicissitudes" that come into play [in sadism and masochism]: "reversal into the opposite" and "turning round upon the subject".' Laplanche, *Life and Death in Psychoanalysis*, translated by Jeffrey Mehlman (Baltimore and London: Johns Hopkins University Press, 1976), 88.

62. Maurice Heine, 'Note sur un classement psycho-biologique des paresthésies sexuelles', *Minotaure* n° 3–4 (12 December 1933): 36.

63. Gaston Bachelard, *Lautréamont* (Paris: Librairie Corti, 1939).

64. Freud, 'Beyond the Pleasure Principle', *Pelican Freud Library*, 11: 327.

65. Isidore Ducasse, Comte de Lautréamont, *Les Chants de Maldoror*, translated by Alexis Lykiard (London: Allison and Busby, 1970), Chant 1, page 6.

66. Dalí, cited in Robert Descharnes, *Salvador Dalí* (New York, 1976).

67. 'The aggressive tendency proves to be fundamental in a certain series of significant states of the personality, namely, the paranoid and paranoiac psychoses.' Jacques Lacan, 'Aggressivity in Psychoanalysis' (1948), in *Ecrits: A Selection*, translated by Alan Sheridan (London: Tavistock, 1977), 16. Ambivalence in paranoia is considered by Freud in 'Some Neurotic Mechanisms in Jealousy, Paranoia and Homosexuality', *Standard Edition*, 18: 226–7.

68. 'La même image qui représente son idéal est aussi l'objet de sa haine.' Lacan, *De la psychose paranoïaque*, 253.

69. Alexandre Kojève, *Introduction to the Reading of Hegel*, translated by James H. Nichols Jr (Ithaca and London: Cornell University Press, 1993 [1980]), 4. Lacan attended Kojève's lectures on Hegel's *Phenomenology of the Mind* delivered at the Ecole des Hautes Etudes in Paris from 1933 to 1939.

70. Lacan (*Ecrits*, 16) postulates that 'Aggressivity is a correlative tendency of a mode of identification that we call narcissistic, and which determines the formal structure of man's ego.' A consequence of the primary identification with the mirror-image is to structure the subject as a rival to itself.

71. Jacques Lacan, 'Motifs du crime paranoïaque', *Minotaure* n° 3–4 (12 December 1933): 25–8.

72. 'sorties tout armées d'un chant de Maldoror'. Paul Eluard and Benjamin Peret, *Surréalisme au service de la révolution* n° 5 (15 May 1933): 27–8.

73. Bataille sets out his views on the perversions in a review of Krafft-Ebing's *Psychopathia Sexualis* reprinted in *Oeuvres complètes*, vol. 1 (Paris: Gallimard, 1992 [1972]), 275–6. See R. von Krafft-Ebing, *Psychopathia sexualis: Eine klinische-forensische Studie* (Stuttgart: F. Enke, 1886) (reprinted in multiple editions; French translation available in 1895). He argues that the perversions, as desublimated sexual desire, are a force of antagonism and discord opposed to the laws and conventions of the reigning social order in a dialectic without resolution. These sentiments, indebted to *Civilisation and Its Discontents*, are echoed by Dalí when he writes in 'L'Amour', see n.60 above, that: 'I wish it to be known that in love I attach a high price to all that is commonly named perversion and vice. I consider perversion and vice to be the most revolutionary forms of thought and activity.' With a nod in the direction of Bataille, Dalí adds: 'The ancient human sacrifices of the Aztecs have just taken on all the taste and all the light of love.' *Collected Writings*, 191–2.

74. Bataille explains that he omitted a study of *Les Chants de Maldoror* from *La Littérature et le mal* for the reason that the book stands so well on its own. He adds, however, that: 'A peine est-il utile de dire des *Poésies* qu'elles répondent à ma position.' Bataille, *Oeuvres complètes*, 9: 172.

75. 'mort d'une façon latente'; 'mort d'avance'. Dalí, *Le Mythe tragique de l'Angélus de Millet*, 142.

76. Lautréamont, *Les Chants de Maldoror*, Chant 4, strophe 123.

77. Daniel Paul Schreber, *Memoirs of My Nervous Illness*, translated by Ida Macalpine and Richard Hunter (London: Dawson and Sons, 1955), 135.

78. 'les anamorphoses les plus réussies sont celles qui représentent le mort, concrètement, le crâne.'

79. *Saint Anthony of Padua and the Infant Jesus* (at top) by an unknown artist employs a form of perspectival distortion popular in the sixteenth and seventeenth centuries known as anamorphosis. From the front, the saint with arms outflung in ecstasy and the Christ-child who appears to him in a vision simply look like an amorphous cloud. Viewing the picture from the left side at an oblique angle causes the image to come into focus. The picture belonged to the sculptor Jacques Lipchitz who loaned it to the *Fantastic Art, Dada, Surrealism* exhibition at the Museum of Modern Art, New York in 1936 (reproduced on page 249 of the catalogue). The juxtaposed works by Salvador Dalí, *Bathers* and *Female Nude* of 1928 relate to earlier parodic variants on Picasso's classical bathers but already demonstrate an awareness of surrealist art. The amorphous fleshiness of the bodies is a reflection of his preoccupation with soft (*super mou*) and contrasting hard forms. The consonance of these works – in one of which the only distinguishable feature is a big toe – with Georges Bataille's notion of the formless (*informe*) is self-evident, but this seems to be the first occasion that a link was implied between Dalí's soft forms and the anamorphosis, the subject of a later essay by Dalí himself. Both of these bather compositions are now in Florida at the Salvador Dalí Museum, St Petersburg.

80. 'relève d'un symbolisme minutieux lié, en général, à la déformation.' C.E. [Carl Einstein], 'Saint Antoine de

Padoue et l'enfant Jésus', *Documents* n° 4 (September 1929): 230. The prescience of Einstein's remarks is shown by the attention that subsequently has been bestowed on the anamorphosis, with essays by Dalí and, in his turn, Jacques Lacan. See also Jurgis Baltrusaitis, *Anamorphoses; ou, perspectives curieuses* (Paris: Oliver Perrin, 1955).

81. Dalí's article, 'Apparitions aérodynamiques des "Etres-Objets"', *Minotaure* n° 6 (winter 1935): 33–4; *Collected Writings*, 207–11, reproduces the anamorphic skull from Holbein's *The Ambassadors* (National Gallery, London), a clear influence on works from the same date.

82. Lautréamont, *Les Chants de Maldoror*, Chant 4, page 124. Apart from the theme of putrefaction, Dalí's soft forms (*structures molles*) incorporate a specific reference to sticky mucus and other bodily effluvia.

83. Dawn Ades, 'Morphologies of Desire,' in *Salvador Dalí: The Early Years*, exhibition catalogue (London: Hayward Gallery, 1994), 129–60.

84. The affective reactions of shame and disgust are cited by Freud in relation to the perversions as forms of resistance against which the sexual instinct has to struggle. See Sigmund Freud, 'Three Essays on the Theory of Sexuality', *Pelican Freud Library*, 7: 74–6. Quite independently of one another, Bataille and Dalí both refer to a study in the phenomenology of disgust by Aurel Kolnai, a Hungarian psychoanalyst, which had an important bearing on their conception of the matter. This text will be discussed at some length in relation to the *Metamorphosis of Narcissus* below.

85. Georges Bataille, 'Oeil', *Documents* n° 4 (September 1929): 216; *Visions of Excess*, 17.

86. Ibid., 19.

87. 'Il existe une manière d'être pourri, la *présence du cadavre* décompose l'être vivant.' Georges Bataille, 'Notes on Abjection', *Oeuvres complètes*, 2: 439. The cadaver is marked with the sign of nothingness, Bataille writes in *Eroticism* and it is that, rather than any physiological reaction, which lies behind the nausea and disgust induced by the sight of decomposition: 'A cadaver is not *nothing*, but this object, this cadaver is stamped from the beginning with the sign *nothing* . . . fear, which is at the root of disgust, is not motivated by an objectively verifiable danger' ('Un cadavre n'est pas *rien*, mais cet objet, ce cadavre est marqué dès abord du signe *rien* . . . la crainte, qui est le fondement du dégoût, n'est pas motivée par un danger objectif'). Georges Bataille, *L'Erotisme* (1957), *Oeuvres complètes*, 10: 60. This whole formulation is very much indebted to Heidegger's essay 'What is Metaphysics?' which appeared in French translation in the journal *Bifur* 8 (10 June 1931): 9–27.

88. Kristeva, *Powers of Horror: An Essay on Abjection*, translated by Leon S. Roudiez (New York and Guildford: Columbia University Press, 1982). Kristeva's analysis of abjection sheds light on the obscurity of Freud's hypothesis of a primal repression (*Urverdrängung*), a first repression which is at the origin of all unconscious formations. The link with abjection is shown by Laplanche and Pontalis's assertion that 'anticathexis is the sole mechanism of primal repression.' Jean Laplanche and J.B. Pontalis, *The Language of Psychoanalysis* (London: Karnac and the Institute of Psycho-Analysis, 1988), 334.

89. Dalí relates the onset of his insect phobia in an essay of 1929. Clearly, Dalí considers his fear of grasshoppers, of being devoured by these rapacious creatures, as an expression of castration anxiety. Interestingly, since it corresponds with Kristeva's reading of the abject, he implies a link in his text between the fear of incorporation and the onset of his affective ambivalence – fascination and horror in equal measures – as regards the *putrefact*. See Dalí, '. . . The Liberation of Fingers . . .', *Collected Writings*, 99–101. This account is also relevant to the picture *Myself, Aged 10 Years, as the Grasshopper Child (Castration Complex)* of 1933, reproduced in *Salvador Dalí Rétrospective*, 198.

90. Kristeva discusses 'fantas[ies] of incorporation by means of which I attempt to escape fear (I incorporate a portion of my mother's body, her breast, and thus I hold on to her.' Kristeva, *Powers of Horror*, 39.

91. Dalí would have been familiar with the concept of an 'iterative identification' with the object, of which this is an example, from Lacan's essay, 'Le Problème du style et la conception psychiatrique des formes paranoïaques de l'expérience', *Minotaure* n° 1 (1 June 1933): 69.

92. 'la crainte d'être absorbé, annihilé, mangé par la mère'. Dalí, *Le Mythe tragique*, 93.

93. 'La mère dévore son fils'. Ibid., 102.

94. 'la variante maternelle du mythe immense et atroce de saturne, d'Abraham, du Père Eternel avec Jésus-Christ et de Guillaume Tell lui-même dévorant leurs propres fils'. Ibid., 147.

95. 'La submersion du personnage de l'*Angélus* c'est-à-dire de *moi* dans le lait maternel, ne peut être interprétée (à l'aide de ce que les objets surréalistes à fonctionnement symbolique nous ont si bien appris au sujet des préoccupations de liquides servant d'intermédiaires aux désirs évidents de cannibalisme) que comme l'expression de la crainte d'être absorbé, annihilé, mangé par la mère.' Ibid., 93.

96. Lautréamont, *Les Chants de Maldoror*, Chant 2, page 77–8.

97. Paul Zweig, *Lautréamont: The Violent Narcissus* (Port Washington and London: Kennikat Press, 1977), 58.

98. 'À la sortie, je sodomisai Gala devant la porte même, déserte à cette heure, du musée. J'accomplissais cet acte d'une façon rapide extrêmement sauvage, enragée. Nous glissions tous dans un bain de sueur, à la fin asphyxiante de ce crépuscule d'été ardent qu'assourdissait le chant frénétique des insectes.' Dalí, *Mythe tragique*, 79–80. See, in connection, Nick Rogers, 'Mud Love: The Scatological Struggles of Louis Buñuel's *L'Age d'or*', unpublished MA report, The Courtauld Institute of Art, London, 1994.

99. Judith Butler, *Gender Trouble: Feminism and the Subversion of Identity* (London and New York: Routledge, 1990), 131ff.

100. Projection, a form of psychological defence whereby ideas or wishes that would be a source of anxiety were they to enter consciousness are vigorously expelled, is common to both paranoia and abjection (which means literally 'to cast out'). The role of projection in the production of the usual paranoid delusions of persecution is discussed by Freud in his analysis of the Schreber case. See *Pelican Freud Library*, 9: 196ff.

101. Zweig, *Lautréamont*, 61.

102. 'I do not like women! Nor even hermaphrodites! I must have beings who resemble me . . .' ('Moi, je n'aime pas les femmes! Ni même des hermaphrodites! Il me faut des êtres qui me ressemblent . . .'). Lautréamont, *Les Chants de Maldoror*, Chant 5, page 157.

103. Lautréamont, *Les Chants de Maldoror*, Chant 5, page 155.

104. 'Recherches sur la sexualité', *La Révolution surréaliste* n° 11 (15 March 1928): 33 and 38. Raymond Queneau: 'I notice that there exists among the surrealists a singular prejudice against pederasty' ('Je constate qu'il existe chez les surréalistes un singulier préjugé contre la pédérastie'). His remarks were made in response to Pierre Unik who professed a disgust of pederasty equal to that of excrement. Its truth is borne out by Breton's ensuing hysterical outburst accusing gays of, among other things, 'a mental and moral deficiency'.

105. 'Ainsi, André Breton, concluai-je, si je rêve cette nuit que je fais l'amour avec vous, demain matin je peindrai nos meilleurs positions amoureuses avec le plus grande luxe de détails.' Salvador Dalí, *Comment on devient Dalí: Les aveux inavouables de Salvador Dalí*, presented by André Parinaud (Paris: Robert Laffont, 1973), 154.

106. See David Vilaseca, *The Apocryphal Subject: Masochism, Identification, and Paranoia in Salvador Dalí's Autobiographical Writings* (New York: P. Lang, 1995). Though we start out from different material – his study is primarily concerned with Dalí's autobiographical writings – David Vilaseca arrives at similar conclusions to mine in this section.

107. Lautréamont, *Les Chants de Maldoror*, Chant 5, page 156.

108. 'He is as beautiful as ['Il est beau comme'] the retractility of the claws of birds of prey; or again, as the uncertainty of the muscular movements in wounds in the soft parts of the lower cervical region; or rather, as that perpetual rat-trap always reset by the trapped animal, which by itself can catch rodents indefinitely and work even when hidden under straw; and above all, as the chance meeting ['rencontre fortuite'] on a dissecting table of a sewing-machine and an umbrella!' Lautréamont, *Les Chants de Maldoror*, Chant 6, page 177.

109. André Breton, *Communicating Vessels*, translated by Mary Ann Caws and Geoffrey T. Harris (Lincoln and London: University of Nebraska Press, 1990 [1932]), 53.

110. Ades, 'Morphologies of Desire', 137ff.

111. Dalí, *The Secret Life*, 202–03.

112. El Conde de Lautréamont, *Los Cantos de Maldoror*, translated by Julio Gómez de la Serna with a prologue by Ramòn Gómez de la Serna (Madrid: Biblioteca Neuva, n.d.). This edition is undated though Ian Gibson has established with certainty that it was published by 1924 at the latest. See Gibson, *The Shameful Life of Salvador Dalí*, 117–18. An essay on the image in Lautréamont by Gómez de la Serna was included in a special issue of *Le Disque vert* in 1925. See Ramòn Gómez de la Serna, 'Image de Lautréamont', *Le Disque vert* (Brussels 1925), special issue: 'Le Cas Lautréamont' 66–76.

113. Lautréamont, *Les Chants de Maldoror*, Chant 4, page 111.

114. Kristeva, *Powers of Horror*, 4.

115. Dalí speculates on the surrealist possibilities of curved or non-Euclidean space in his writing at this junc-

ture. Ours is the era of the soft ('l'époque du mou'), he is convinced; 'in the actuality of the present time, space has become that succulent meat ['bonne viande'], colossally alluring, voracious and personal, that presses at every moment with its disinterested and soft enthusiasm.' Salvador Dalí, 'Apparitions aérodynamiques des "Etres-Objets"'; *Collected Writings*, 209.

116. 'Lautréamont, nous relevons en votre honneur l'épithète de fou dont on crut faire une injure!' Robert Desnos, 'Le génie sans miroir', *Les Feuilles libres* n° 35 (January–February 1924): 303. On this issue, Dalí uncharacteristically towed the official party line.

117. An anonymous article about Dalí's *Maldoror* illustrations appeared in the popular press under the banner 'Written by a Madman – Illustrated by a "Super-Realist"'. Written in a light-hearted vein, it asks rhetorically: 'But which is the more delirious, some will wonder, as they read Count de Lautréamont's book and look at artist Dalí's pictures.' In *American Weekly* (16 December 1934): 8.

118. Breton, *Entretiens*, 11.

119. In the previously cited letter to Breton at the time of his threatened expulsion from the group, Dalí defends himself against the charge of fascist sympathies ('de mon supposé Hitlérisme'). After giving Breton a resumé of a vast study in which he proposes to demonstrate that Hitler is a wet nurse, it is hard not to concede his point that: 'All of this is to remind you that my attitudes would be judged with the same hostility by National Socialists as by other surrealists, if not more so.' On a less flippant note, Dalí goes on to refer to the absolute novelty of the fascist phenomenon which, he claims, lacks a satisfactory explanation and shatters our intellectual security in the political domain. He attributes this novelty in part to its redeployment ('dépaysement truculent') of myths of the father, religion and the family.

120. 'L'os Dalí restait en travers de la gorge des sectaires du Parti.' Jean-Charles Gateau, *Paul Eluard et la peinture surréaliste, 1910–1939* (Geneva: Librairie Droz, 1982), 155–87. Given the nature of our inquiry, the visceral character of the hostile reactions Dalí typically incites is revealing. See, for example, the previously mentioned article by Carter Ratcliffe, 'Swallowing Dalí', 33–40.

121. George Orwell, 'Benefit of the Clergy: Some Notes on Salvador Dalí', in *The Collected Essays, Journalism and Letters of George Orwell*, vol. 3 (1943–45), edited by Sonia Orwell and Ian Angus (London: Secker and Warburg, 1968), 156–65.

122. Ibid.

123. While totally unforgiving of Dalí, on this point Nicolas Calas concurs: 'There is in this adolescent arrogance a Maldororian flavor', he writes, 'which saves it from becoming just another advertising slogan or the latest Slavian wisecrack.' See Calas, 'Anti-Surrealist Dalí', *View* 1 n° 6 (June 1941).

124. Freud to Stefan Zweig, 20 July 1938, in *Letters of Sigmund Freud, 1873–1939*, translated by Tania and James Stern and edited by Ernst Freud (London: Hogarth Press, 1961), 444.

125. For a useful introduction to the complex and contradictory status of narcissism in Freudian theory, see Joseph Sandler et al., *Freud's 'On Narcissism: An Introduction'* (New Haven and London: Yale University Press, 1991).

126. Sigmund Freud, 'Delusions and Dreams in Jensen's "Gradiva"' (1907), *Pelican Freud Library*, 14: 33–116.

127. See introduction, n.20.

128. Dalí, *The Secret Life*, 167.

129. Salvador Dalí, *Metamorphosis of Narcissus*, translated by Francis Scarpe (New York: Julien Levy Gallery, 1937); Dalí, *Collected Writings*, 324–9. Subsequent references will cite line numbers for the poem and page numbers for the preceding text in the English version.

130. See Haim Finkelstein, *Salvador Dalí's Art and Writing, 1927–1942: The Metamorphoses of Narcissus* (Cambridge: Cambridge University Press, 1996).

131. Kristeva, *Powers of Horror*, 14.

132. Dalí, *Metamorphosis of Narcissus*, p.10.

133. See, in particular, the lineage traced in Stephen Bann's richly suggestive *The True Vine: On Visual Representation and the Western Tradition* (Cambridge: Cambridge University Press, 1989), chapters 4 and 5.

134. Philostratus, *Imagines*, translated by Arthur Fairbanks (London, 1981), Book I, chapter 23, 91.

135. Dalí writes to Edward James inviting him to explore the geological recesses of his newest acquisition, but warning him with a mischievous wit: 'don't tire yourself too much, and don't fall into the water like him.' Letter to James, 15 June 1937, Edward James Foundation.

136. Dalí, *Metamorphosis of Narcissus*, lines 5–10.

137. Sigmund Freud, 'Beyond the Pleasure Principle', 308ff. The essay was available in French translation in 1927.

138. Aurel Kolnai, 'Der Ekel [Disgust]', *Jarhbuch fur Philosophie und Phaenomenologische Forschung*, edited by Edmund Husserl (Halle, 1929), 515–69. While I had been aware of this source for some time it was only by chance that I managed to locate it fairly recently. Since I first spoke on this matter, Robert Radford has ascertained that a Spanish translation appeared in the *Revista de Occidente* 26, n° 77 and 78 (Madrid 1929): 161–201, 294–347. Radford is well acquainted with my views but is apparently more circumspect than myself about accepting its importance for Dalí. See his shorter notice in *Burlington Magazine* 141 n° 1150 (January 1999): 32–3.

139. Kolnai makes a point of commenting that strong-smelling cheese contains something that must be called putrid. One is reminded of the genesis of Dalí's famous 'soft' watches.

140. Salvador Dalí, 'L'Amour' (1930), in *Collected Writings*, 191.

141. Ibid.

142. Bataille, too, seems to refer to this notion from Kolnai when he states: 'That nauseous, rank and heaving matter, frightful to look upon, a ferment of life, teeming with worms, grubs and eggs, is at the bottom of the decisive reactions we call nausea, disgust or repugnance.' Georges Bataille, *Eroticism*, translated by Mary Dalwood (London: Marion Boyars, 1987 [1962]), 56ff.

143. Roger Caillois, 'Mimétisme et psychasthénie légendaire', *Minotaure* n° 7 (10 June 1935): 5–10.

144. 'Cette assimilation à l'espace s'accompagne obligatoirment d'une diminution du sentiment de la personnalité et de la vie . . . La vie recule d'un degré.' Ibid., 9.

145. 'ainsi les tableaux peints vers 1930 par Salvador Dalí où, quoi qu'en dise l'auteur, ces hommes, dormeuses, chevaux, lions invisibles, sont moins le fait d'ambiguités ou de plurivocités paranoïaques que d'assimilations mimétiques de l'animé à l'inanimé.' Ibid.

146. Dalí, Letter to James, 15 June 1937.

147. Dalí, *Metamorphosis of Narcissus*, lines 35–7.

148. One is continually running up against the difficulty with Dalí that not every one of the myriad details in a picture can be tied in with a single overall interpretation, and perhaps we should resist the temptation to do so. Wittgenstein implies such a constraint on interpretation when he criticises Freud for suggesting that the test of a correct interpretation is when all the elements of the dream fall into place like a jigsaw puzzle. Wittgenstein (using the dream-picture analogy) says: 'Perhaps even the picture as a whole has no "right interpretation" at all'; that while it may be possible to interpret certain features of a picture, 'there may be no ground for saying that there must be an interpretation of the whole thing or of every detail of it along similar lines.' Ludwig Wittgenstein, 'Conversations on Freud; excerpt from 1932/3 lectures', in *Philosophical Essays on Freud*, edited by Richard Wollheim and James Hopkins (Cambridge: Cambridge University Press, 1982), 7.

149. Ovid, *Metamorphoses*, translated by Mary Innes (London, 1955), Book III, lines 353–6.

150. Julia Kristeva, *Tales of Love*, translated by Leon S. Roudiez (New York and Guildford: Columbia University Press, 1987), 35. Kristeva sees the articulation of the Narcissus myth as a defining moment for Western subjectivity: 'when he realises . . . that the other in the spring is merely himself, he has put together a psychic space – he has become subject.' Her suggestion that the myth constructs the introspective space of the Western psyche accords with our account of how space as setting is invested in Dalí's image.

151. Bann, *The True Vine*, 130.

152. Dalí, *Metamorphosis of Narcissus*, lines 70–75.

153. David Macey appears to be the originator of this view. See Macey, 'Fragments of an Analysis: Lacan in Context', *Radical Philosophy* (autumn 1983): 5. More plausible in my view is a link with Otto Rank's treatment of the Narcissus legend in his book on the double. Otto Rank, *The Double: A Psychoanalytic Study*, translated by Harry Tucker Jr (Chapel Hill: University of North Carolina Press, 1971). See chapter 5: 'Narcissism and the Double'.

154. Dalí, *Collected Writings*, 210.

155. Dalí, *Metamorphosis of Narcissus*, line 95.

156. Ibid., lines 104–05.

157. Freud, 'The Libido Theory and Narcissism', *Pelican Freud Library*, 1: 466.

158. Dalí, *The Secret Life*, 27. Dalí's representation of Narcissus also correlates closely with Ovid's description: 'As golden wax melts with gentle heat, as morning frosts are thawed by the warmth of the sun, so he was worn and wasted away with love, and slowly consumed by its hidden fire.' Ovid, *Metamorphoses*, Book III, lines 487–90.

159. Ovid, *Metamorphoses*, Book III, line 458.

160. Dalí, *Metamorphosis of Narcissus*, lines 121–7.

161. Dalí, *The Secret Life*, 367.

162. Ovid, *Metamorphoses*, Book III, line 419.

163. Dalí, *The Secret Life*, 170.

164. Dalí, *Metamorphosis of Narcissus*, lines 49–52.

165. On Dalí and Lorca, see Gibson, *The Shameful Life of Salvador Dalí*, chapters 4 and 5.

166. Dalí, *Metamorphosis of Narcissus*, lines 128–34.

167. Edward James, introduction to Metamorphosis of Narcissus, 6.

168. On Dalí and Gradiva, see Fiona Bradley, 'Gala Dalí: The Eternal Feminine', in Dawn Ades and Fiona Bradley (eds), *Salvador Dalí: A Mythology*, exhibition catalogue (Liverpool: Tate Gallery, 1998–9), 54–76. Jensen's novel and Freud's study of it were published together in French in 1931. Some time afterwards, Paul Eluard wrote to Gala 'J'espère que tu as bien reçu Gradiva' indicating that Dalí probably acquired the book from this source. Paul Eluard, *Lettres à Gala, 1924–1948*, edited by Pierre Dreyfus (Paris: Gallimard, 1984), 248.

169. Freud, 'On Narcissism: An Introduction', 88.

170. Kristeva, *Tales of Love*, 125.

171. Dalí certainly plays on this meaning of his name in caricatural works prior to this date (see fig. 109). Regarding the possible conflation of Narcissus with Christ, it was noted in chapter 3 that Poussin had employed an image of the *pietà* as a model for the dead Narcissus in his *Echo and Narcissus* (fig. 57), one of the most famous treatments of the subject.

172. Sigmund Freud, 'The "Uncanny" ' (1919), *Pelican Freud Library* 14: 356.

5 making faces

1. Paul de Man, 'Autobiography as De-facement', in *The Rhetoric of Romanticism* (New York and London: Columbia University Press, 1984), 76.

2. Lacan, *Ecrits: A Selection*, translated by Alan Sheridan (London: Tavistock, 1977), 17.

3. Ibid., 166.

4. The split between word and image corresponds, more or less, to what Lacan designates as the Symbolic and the Imaginary respectively (see section iii of this chapter).

5. Lacan, *Four Fundamental Concepts of Psycho-Analysis*, translated by Alan Sheridan (Harmondsworth, Middlesex: Penguin Books, 1977), 83 and 89.

6. Lacan, *Ecrits. A Selection*, 193.

7. William Blake, Milton, plate 41, line 2, in *Blake's Poetry and Designs*, edited by Mary Lynn Johnson and John E. Grant (New York and London: W.W. Norton and Co., 1979), 304.

8. *Joan Miró: Selected Writings and Interviews*, edited by Margit Rowell (London: Thames and Hudson, 1986), 157. There are four letters to the dealer Pierre Matisse specifically concerning *Self-Portrait 1*.

9. Ibid.

10. Margaret Barr, the wife of Alfred Barr, saw Miró at work on the self-portrait and has left an endearing account of Miró's daughter Dolorès, aged seven, with her own brush, adding 'whatever little kerriwibble she likes in the lower right corner'. Margaret Scolari Barr, ' "Our Campaigns", 1930–1944,' *New Criterion* (summer 1987): 43.

11. James Thrall Soby, *Joan Miró* (New York: Museum of Modern Art, 1959), 93. The picture was bequested by Soby to the Museum of Modern Art where it now resides. Studies of the picture are relatively few; see, in particular, William Rubin's entry on the picture in *Miró in the Collection of the Museum of Modern Art* (New York: Museum of Modern Art, 1973).

12. Miró, *Selected Writings and Interviews*, 257.

13. Johann Goethe, *Goethe on Art*, translated by John Gage (London: Scolar Press, 1980), 185.

14. Robert Lubar aptly describes Miró as an international Catalan. This is not so contradictory as it seems, for to be cosmopolitan – to look towards Europe rather than towards Madrid – was also to be a good Catalan. Robert Lubar, 'Miró Before The Farm: A Cultural Perspective', in *Joan Miró: A Retrospective*, exhibition catalogue (New York: Solomon R. Guggenheim Museum, 1973–87), 10–28.

15. This formulation is taken from Freud's 'On Narcissism: An Introduction', *Pelican Freud Library*, 15 vols (Harmondsworth, Middlesex: Penguin Books, 1973–87), 11: 84. Lacan's mirror stage describes the subject's narcissistic capture (*captation*) in an ego ideal as seen here. See Jacques Lacan, 'The Mirror Stage as Formative of the Function of the I', *Ecrits. A Selection*, 1–7.

16. Sigmund Freud, 'The "Uncanny" ' (1919), *Pelican Freud Library*, 14: 371.

17. Miró, *Selected Writings and Interviews*, 190.

18. Masson, *Le Rebelle du surréalisme: Ecrits*, edited by Françoise Will-Levaillant (Paris: Hermann, 1976), 290.

19. Illustrations from alchemical texts are a likely visual source for the motif of flaming hair, as they could equally have been an inspiration for various features of *Self-Portrait 1*. See, for example, Stanislas Klossowski de Rola, *The Golden Game: Alchemical Engravings of the Seventeenth Century* (London: Thames and Hudson, 1988), figs 30 and 498.

20. *Aquarelles de Turner. Oeuvres de Blake*, exhibition at the Bibliothèque Nationale, Paris, 15 January–15 February 1937. Three versions of the Blake drawing exist of which fig. 113, believed now to be a copy by the engraver John Linnell, can be identified on the basis of its inscription as the work listed as no. 14, *Tête imaginaire*.

21. Miró to Matisse, letter dated 12 February 1937, in Miró, *Selected Writings and Interviews*, 147.

22. 'chaque grain de poussière possède une âme merveilleuse'. Joan Miró, 'Où allez-vous Miró?', interview by Georges Duthuit, *Cahiers d'art* (1937): 261–66. I have followed the translation in Miró, *Writings and Interviews*, 153. See Blake's 'Auguries of Innocence', lines 1–4: 'To see a World in a Grain of Sand / And a Heaven in a Wild Flower: / Hold Infinity in the palm of your hand / And Eternity in an hour', in *Blake's Poetry and Designs*, 209.

23. This second chapter in Miró's encounter with the work of Blake is told by Ruthven Todd in 'Miró in New York: A Reminiscence', *Malakat Review* n° 1 (University of Victoria, B.C., 1967): 77–92.

24. See Miró, *Selected Writings and Interviews*, 293.

25. A footnote seems an appropriate place to acknowledge the insights as well as wit of Jacques Derrida's essay on boots, and the more serious matter of identification, in *The Truth in Painting*, translated by Geoff Bennington and Ian McLeod (Chicago and London: Chicago University Press, 1987).

26. 'torches de feu, en quoi se métamorphosent arbres, maisons, rochers, montent dans le ciel et rejoignent ces autres feux que sont les mondes voisins.' René Huyghe, 'Vincent Van Gogh: Sa Vie et son oeuvre', L'Amour de l'art (April 1937), special issue: 'L'Exposition Van Gogh': 27. The decorative background rhythms are, as the catalogue entry for the picture notes, painted in shades of turquoise and Veronese green which prevents a literal interpretation of them as flames, unlike the well-known sixteenth-century miniature by Nicholas Hilliard, A Man Against a Background of Flames. The young man of unknown identity is portrayed in three-quarter view holding a locket to his chest and is presumed to be burning with ardour for his lover. Whether or not Van Gogh – or Miró for that matter – was aware of, or influenced by, this very striking image it is difficult to say.

27. Miró, Selected Writings and Interviews, 158.

28. 'Il y a des circonstances où il vaut mieux être le vaincu que le vainceur, mieux Prométhée que Jupiter.' Ibid., 3.

29. See James Clifford, 'On Ethnographic Surrealism', Comparative Studies in Society and History 23 (1981): 539–64.

30. Georges Bataille, 'Sacrificial Mutilation and the Severed Ear of Vincent Van Gogh' (1930), in Visions of Excess, translated by Allan Stoekl (Minneapolis: State University of Minnesota Press, 1985), 61–72 (67).

31. Again, Bataille's argument draws upon ethnographic evidence. In 'The Notion of Expenditure' he cites as evidence of an inner drive towards loss the ritual of potlatch in American Indians of the northwest. Occurring on designated festival occasions, potlatch involves the giving away of extravagent gifts or destroying objects of great value (the source of his information is anthropologist Marcel Mauss's classic essay of 1925, The Gift). Bataille employs the term 'sovereignty', defined in opposition to Hegelian mastery, to evoke the prestige accruing from such a 'dissipation without reserve of riches'. More generally, Bataille contends that the realm of the sacred is constituted by operations of loss, most evidently so in the case of sacrifice. Bataille, 'The Notion of Expenditure' (1933), in Visions of Excess, 116–29.

32. Georges Bataille, 'Van Gogh Prometheus', October 36 (spring 1986 [1937]): 59.

33. One notable exception to this neglect is an article by Rosalind Krauss, 'Michel, Bataille et moi', October 68 (spring 1994): 3–20.

34. The theme of the death of God of course also reflects their Nietzschean proclivities. For a detailed analysis of the iconography of the Masson etchings, see Françoise Levaillant, 'Masson, Bataille, ou l'incongruité des signes, 1928–1937', in André Masson, exhibition catalogue (Nimes: Musée des Beaux-Arts, 1985), 30–41.

35. On Masson and Blake, see Katherine Beales, 'The Human Form Divine: André Masson and William Blake', unpublished MA report, Courtauld Institute of Art, London, 1990.

36. 'Aucune limite, aucune mesure ne peuvent être données à la violence de ceux que libère un vertige éprouvé devant la voûte du ciel.' Georges Bataille, 'Le Bleu du ciel', Minotaure n° 8 (15 June 1936): 51.

37. Georges Bataille, 'Corps célestes', Verve (spring 1938): 97–100; 'Les Mangeurs d'étoiles', in Louis Barrault et al., André Masson (Rouen: Wolf, 1940), 25–8.

38. 'la propriété de ces figures est de ne pas se rassembler sur elles-mêmes, mais d'exploser et de se perdre dans l'espace.' Ibid., 27.

39. 'les visages dessinés par Masson ont au contraire envahi les nuages ou le ciel. Dans une sorte d'extase, qui n'est que leur exaltation précipitée, ils s'anéantissent.' Ibid.

40. Regarding the exhibition history of Self-Portrait 1, see the catalogue compiled by Lilian Tone in Carolyn Lanchner, Joan Miró, exhibition catalogue (New York: Museum of Modern Art, 1994), 412.

41. The visionary epiphanies that are recounted in the lives of Christian mystics very often take the form of an apocalyptic loss of self. Miró's reply when, in 1951, he was asked to name his favourite poets is, therefore, very revealing: 'The Spanish mystics: Saint John of the Cross and Saint Theresa'. Miró, Selected Writings and Interviews, 227.

42. Identification is generally conceived of as a process of incorporation, or introjection, analogous to the physical ingestion of an object. What seems to be at stake in Miró's rapport with Blake and Van Gogh is the reverse of this: a forceful projection of the subject outside of himself. For a lucid account of the concept of identification in psychoanalysis see Jean Laplanche and J.B. Pontalis, The Language of Psychoanalysis (London: Karnac and the Institute of Psycho-Analysis, 1988), 205–08.

43. M.H. Abrams, Natural Supernaturalism: Tradition and Revolution in Romantic Literature (London: Oxford University Press, 1971), 47.

44. David Bindman, Blake as an Artist (Oxford: Phaidon, 1977), 166 and 169.

45. Both images have a sombre, almost monochrome, colour scheme. Most striking, however, is the rigid symmetry of design in each case which lends a strongly anthropomorphic aspect to Blake's drawing, and the extraordinary attention that each artist has lavished on minute details. I am grateful to Marcia Pointon for having suggested this very telling comparison.

46. One could go further and observe that Miró, borrowing the tragic mantle of Van Gogh, offers himself as a sacrificial victim on behalf of the Spanish people. But however nobly intended, this sacrifice made from the comparative safety of a Parisian studio must have risked seeming rather hollow. Miró may have intuited this, and in an effort to counter it, has, to my mind, succumbed to the temptation to overstate his convictions. Is there not also a degree of bystander's guilt to be discerned in the overblown rhetoric of the picture?

47. Miró, Selected Writings and Interviews, 189.

48. Rubin, Miró in the Collection of the Museum of Modern Art, 76.

49. Christian Zervos (ed.), Catalan Art From the Ninth to the Fifteenth Centuries (London and Toronto: William Heinemann, 1937).

50. The sequence in its entirety (F J M 1532–1538) is reproduced in Rosa Maria Malet et al., Obra de Joan Miró (Barcelona: Fundació Joan Miró, 1988).

51. 'Dans ce débacle totale . . . ce qui apparut à Masson comme la voie la plus efficace pour se trouver sur ses pieds, c'est la considération objective de soi, la définition de soi-même par le moyen du portrait.' Michel Leiris, 'Portraits', in *André Masson and His Universe*, edited by Michel Leiris and Georges Limbour (Geneva and Paris: Editions des Trois Collines, 1947), 198.

52. André Breton, *Surrealism and Painting*, translated by Simon Watson Taylor (London: MacDonald and Co., 1972), 36.

53. Joan Miró, 'Je rêve d'un grand atelier', in *Vingtième Siècle* 1 n° 2 (May 1938): 25–8; Miró, *Selected Writings and Interviews*, 162.

54. 'Nous ne nous doutions pas que nos recherches allaient nous mener vers le découverte des principes qui commandent la peinture populaire, celles des murailles, et qui font le secret de la tradition religieuse.' Albert Gleizes, *Art et religion; art et science; art et production* (Chambéry: Editions Présence, 1970).

55. 'socialement destinée à satisfaire l'individualisme bourgeois'; 'nous désirons réaliser et rénover un art mural collectif populaire actuel.' In Serge Fauchereau (ed.), *La Querelle du réalisme* (Paris: Cercle d'Art, 1987), 200 and 104.

56. 'Dans les grandes époques individu et communauté marchent ensemble.' Joan Miró, 'Où allez-vous Miró?', 264.

57. 'Le *portrait* est un genre essentiellement réaliste, et qui ne saurait s'accommoder de passablement de théories modernes qui condamnent le réalisme. Je dirais de ces théories sans m'y attarder, que ce serait déjà suffisant pour les condamner elles-mêmes que de remarquer qu'elles sont impuissantes à rendre compte comme d'un phénomène humain de l'existence du *portrait*.' Louis Aragon, 'Réalisme socialiste et réalisme français', in *Écrits sur l'art moderne* (Paris: Flammarion, 1981), 57. 'Nous assistons à la réssurection du portrait, document psychologique, qui exprime les vices, les tares, le malaise, mais aussi la révolte et les qualités nouvelles d'une période de transition' Jean-Francis Laglenne assured his audience. In Fauchereau (ed.), *La Querelle du réalisme*, 243–4.

58. This phase of Giacometti's work has been explored in *Alberto Giacometti: Retour à la figuration, 1933–1947*, exhibition catalogue (Paris: Musée National d'Art Moderne, Centre Georges Pompidou, 1987).

59. Significantly, perhaps, in view of the rhetorical climate outlined, Balthus is said to have painted only portraits during the previous year, though none of his sitters belonged to the social strata championed by Aragon. The best known is his portrait of André Derain.

60. In relation to the group of realist painters in the later 1930s known as the *Forces nouvelles*, Serge Fauchereau writes of their overriding concern to bear witness to the malaise of their epoch. They did so by depicting the plight of workers, the poor and the unemployed – which, of course, also included a good many artists in the decade. Fauchereau (ed.), *La Querelle du réalisme*, 20–22. We can recognise this as a relevant context for Miró's self-description as 'pessimist, tragically pessimist' in his 1937 interview with Georges Duthuit. It is also important to note here that René Huyghe in his catalogue essay co-opts Van Gogh to the cause of *misérablisme*. Commenting on Van Gogh's desire to represent the rural

poor in such works as *The Potato Eaters*, Huyghe continues: 'He refused to frequent happy people [and] no longer sought other than to translate unequivocally this misery: "In figures as in landscapes, I do not wish to express sentimentality or nostalgia, but a profound pain".' Huyghe, 'Vincent Van Gogh: Sa Vie et son oeuvre', 32.

61. *Pentimenti* are evident in the drawing of the left leg which indicate the phallic extension has been grafted onto a more naturalistic figure. Miró had attended life-classes at the Académie de la Grande Chaumière as part of his '*retour au realité*' in the year preceding this work.

62. Jacques Lacan, 'Anamorphosis', in *Four Fundamental Concepts of Psycho-Analysis*, 79–90. From a normal viewing position, the skull in Holbein's picture is nearly formless (*informe*) like a stain that spoils the pictorial illusion of wholeness; the way that Miró has chosen to apply water-colour in the *Woman in Revolt* makes it too seem like a blot or stain. The use of a deforming mirror to create *Self-Portrait 1* raises a question as to whether it is not also to be regarded as anamorphic.

63. We might speculate that the exposed penis has, as well, an apotropaic function to avert or ward off malevolent forces, the logic of which is spelt out by Freud: 'To display the penis (or any of its surrogates) is to say: "I am not afraid of you. I defy you. I have a penis." ' In Freud, 'Medusa's Head' (1940 [1922]),' *The Standard Edition of the Complete Psychological Works of Sigmund Freud*, 24 vols, ed. James Strachey (London: Hogarth Press, 1953–74), 18: 274.

64. Miró, *Selected Writings and Interviews*, 158.

65. Bataille, *Inner Experience*, translated by Leslie Ann Boldt (Albany: State University of New York Press), 5.

66. André Breton, *L'Un dans l'autre* (Paris: Eric Losfeld, 1970), 7. Surrealist games, as well as literary and artistic collaborations, have yet to be the subject of a comprehensive study which surely is warranted. See Nicholas Baker, 'Resurrecting the *Cadavre Exquis*: André Breton and the Surrealist Game', unpublished MA report, Courtauld Institute of Art, London, 1995.

67. Amongst the Bataillean surrealists in the mid-1930s there was a deliberate attempt to organise themselves along the lines of a secret society. The appeal of the occult and of alchemy to successive avant-gardes may be due, in part, to their connotations of esoteric knowledge. Likewise, meanings encoded in a picture and accessible only to adepts serve to demarcate those in possession of such knowledge from those without it. Ernst clearly delighted in indulging himself in this way: *Men Shall Know Nothing of This* of 1924, a picture and poem dedicated to Breton, gleefully declares its rebus-like opacity. The same argument could apply to the psychoanalytic references that function as a kind of *clé de voute* locking together Ernst's picture puzzles, especially in the period after his arrival in Paris. Freud observes in *The Interpretation of Dreams* that 'the productions of the dream-work, which, it must be remembered, are not made with the intention of being understood, present no greater difficulties to their translators than do the ancient hieroglyphic scripts to those who seek to read them.' *Pelican Freud Library*, 4: 457. Comments by Aragon and others make it clear that a select audience *was* cognisant of these meanings.

68. 'L'individu est mort. L'art du vingtième siècle sera profondément universel et collectif. Les temps machinistes vont bouleverser complètement la vie de l'homme, ils vont préparer les sociétés futures sans classes.' *Cercle et carré 2* (15 April 1930). Neither was anti-individualism the sole province of the Left. For the Royalist Charles Maurras, founder of Action Française, individualism was to be strictly subordinated to the collective – the race, nation, and tradition – a vision of order summed up by the dictum: 'Nécessité de subordonner, pour coordonner et pour ordonner.'

69. André Breton, 'The Exquisite Corpse, Its Exaltation', in *Surrealism and Painting*, 290.

70. For a withering critique of the bourgeois pieties of talent and individual genius see Max Ernst's 'Was ist Surrealismus?' (1934), in Ernst, *Ecritures* (Paris: Gallimard, 1970), 228–34.

71. Breton, *Manifestoes of Surrealism*, translated by Richard Seaver and Helen Lane (Ann Arbor: University of Michigan Press), 34–5.

72. One is entitled to ask what sort of communication are we talking about here. Breton cites echolalia and Ganser syndrome, two pathological disturbances of speech, as models for the liberation of dialogue from the constraints of logic. It may also be that the old nineteenth-century notions of suggestion and autosuggestion had life in them yet. 'It is a very remarkable thing that the Ucs. of one human being can react upon that of another, without passing through the Cs. . . . descriptively speaking, that fact is incontrovertible' writes Freud in 'The Unconscious', *Pelican Freud Library*, 11: 198.

73. 'Etre deux à détruire, à construire, à vivre, c'est déjà être tous, être l'autre à l'infini et non plus soi.' Paul Eluard, 'Note à propos d'une collaboration', *Cahiers d'art* n° 5–6 (1935): 137.

74. 'Disons: le surréalisme, une affirmation non pas collective, mais plurielle ou multiple.' Maurice Blanchot, *L'Entretien infini* (Paris: Gallimard, 1969), 600–01.

75. Jean Lafranchis, *Marcoussis: Sa Vie, son oeuvre* (Paris: Les Editions du Temps, 1961).

76. Miró's special affection for the poetry of Apollinaire is described in Margit Rowell, 'Magnetic Fields: The Poetics', in *Joan Miró: Magnetic Fields*, exhibition catalogue (New York: Solomon R. Guggenheim Museum, 1972).

77. See Jacques Dupin, *Miró, Engraver; Volume I, 1928–1960* (Paris: Editions Daniel Lelong, 1984), catalogue n°s 42 and 43. We also have the evidence of a joint etching by Miró and Hayter from 1947 – a work of less consequence, to be sure, than the *Portrait of Miró*. See *Hayter e l'Atelier 17*, exhibition catalogue (Rome: Calcografia, 1990), 192.

78. Miró, *Selected Writings and Interviews*, 153 and 154.

79. One could speculate that the lower a particular medium falls in a hierarchy of the arts, the more artisanal it is, the less is the pressure towards individual expression. Just as artists had to rely on the technical expertise of professional printmakers so too a number of photographic projects were the outcome of collaborations for similar reasons – see, for instance, the collaboration of Dalí and Brassaï in *Minotaure* n° 3–4 (December 1933): 68 and 75.

80. The version of Marcoussis' *Portrait of Guillaume Apollinaire* reworked in 1920 after the poet's death, in which the head is tightly framed, is more closely comparable to the *Portrait of Miró* than the original image of 1912 which includes the seated figure's torso.

81. 'Sous le bleu délavé du matin / Fanfare cinabre / Flaque de lait caillé (BLANC) et soufre / 3 points vert-de-gris, / la virgu[l]e violette / mais sur l'ecrin / des rousseurs / obscenes / un goufre / mache de l'antracite extra . . .'

82. Breton, 'Manifeste du surréalisme' (1924), in *Oeuvres complètes*, vol. 1 (Paris: Gallimard, 1988), 335 and 336.

83. Jacques Lacan, 'Intervention on Transference', in Juliet Mitchell and Jacqueline Rose (eds), *Feminine Sexuality: Jacques Lacan and the Ecole Freudienne* (London: Macmillan, 1982), 62. Is not Breton's notion of 'dialogue dans sa vérité absolue' – i.e. freed from the necessity to communicate sense – also analogous to Lacan's 'parole pleine'? Automatism could thus be understood in this Lacanian reading as language which speaks the subject's desire to the intention of another.

84. Ibid. Surrealism, for its part, acknowledges the material facticity of language. André Breton drew attention to a tendency in modern poetry to consider 'le mot en soi' as shown by the preoccupation with 'les réactions des mots les uns sur les autres.' Breton, 'Les Mots sans rides', *Littérature* n° 7 (1 December 1922): 12–14; reprinted in *Oeuvres complètes* 1: 284.

85. Shoshana Felman, *Jacques Lacan and the Adventure of Insight: Psychoanalysis in Contemporary Culture* (Cambridge, Mass. and London: Harvard University Press, 1987), 56. For an analysis of the status of linguistics in Lacanian theory see Jean-Luc Nancy and Philippe Lacoue-Labarthe, *The Title of the Letter: A Reading of Jacques Lacan*, translated by François Raffoul and David Pettigrew (Albany: State University of New York Press, 1992).

86. Beyond denoting language and the unconscious, the Other refers to the space of intersubjectivity as such. 'The Other is, therefore, the locus in which is constituted the I who speaks to him who hears' writes Lacan in *Ecrits. A Selection*, 141. For a clear-sighted guide to the multivalency of this term in Lacan's work, see Anthony Wilden, 'Lacan and the Discourse of the Other', in Jacques Lacan, *Speech and Language in Psychoanalysis*, translated with notes and commentary by Anthony Wilden (Baltimore and London: Johns Hopkins University Press, 1981).

87. The L-schema doesn't only pertain to situations involving two persons because every individual is 'a participator . . . stretched over the four corners of the schema'. Lacan, *Ecrits. A Selection*, 194. The axis o-o' thus evokes the spatial symmetry of the relation between the ego and its narcissistic reflected 'double'.

88. Ibid., 194 (translation modified). This notion of a place from which the question of one's existence is posed would seem to be germane to the function of the interlocutor in so many of the surrealists' games.

89. I am grateful to Sophie Bowness for bringing to my attention the *annoncé* for this exhibition which appeared in the magazine *Beaux-Arts* 76 n° 338 (23 June 1939): 4. 'Pour un portrait gravé de Miró: Miró et Marcoussis collaborent'.

90. Lacan, *Ecrits. A Selection* 17.

91. Ibid., 43.

92. 'L'art, puisque art il y a incontestablement, procède dans ce sens par destructions successives. Alors tant qu'il

libère des instincts *libidineux*, ces instincts sont sadiques.' Georges Bataille, 'L'Art primitif', *Documents* nº 5 (1930): 396. The points about Miró and Bataille are extracted from my review of an exhibition of Miró in the 1930s held at the Whitechapel Art Gallery in 1988–9. See 'Miró's *magie noire*', *Art Monthly* nº 124 (March 1989): 15. For an invaluable addition to the literature on this question, see also Briony Fer, 'Poussière/peinture: Bataille on Painting', in Carolyn Gill (ed.), *Bataille: Writing the Sacred* (London and New York: Routledge, 1995), 154–71.

93. As far as Lacan is concerned, ego psychology is misguided in its attempts to strengthen the ego defences. All that can be achieved by its 'peintures sincères' and 'rectifications' is to further alienate the subject in an imaginary construct. Lacan, 'Fonction et champs de la parole et du langage en psychanalyse', *Écrits* (Paris: Editions du Seuill, 1966), 249.

94. Marcoussis, who took part in the horse-play, appears in one of the photographs with a false beard he donned for the occasion. The sequence of images is reproduced in the catalogue *Man Ray Photographe* (Paris: Centre National d'Art Moderne Georges Pompidou, 1982), figs 50–53. See also the commentary by Mary Ann Caws, 'Ladies Shot and Painted', in Susan Rubin Suleiman (ed.), *The Female Body in Western Culture: Contemporary Perspectives* (Cambridge, Mass. and London: Harvard University Press, 1986), 262–87.

95. '*La femme garde toujours dans sa fenêtre la lumière de l'étoile, dans sa main la ligne de vie de son amant.*' André Breton and Paul Eluard, 'L'Amour', in *L'Immaculée Conception* (Paris: Editions surréalistes, 1930); reprinted in Breton, *Oeuvres complètes* 1: 877.

96. See Lacan, 'The Agency of the Letter in the Unconscious', *Ecrits. A Selection*, 171.

97. Though the term itself was coined much later, it is appropriate to speak of a politics of identity in this case. Apart from the present drawing, defiance to the Franco regime is expressed most notably in a self-portrait drawn on an old sheet of newsprint from 1938 referring to the last ditch stand of Republican forces in the Aragon region.

98. Breton, *Surrealism and Painting*, 4.

99. Letter to Pierre Matisse, 12 February 1937, cited in Miró, *Selected Writings and Interviews*, 147.

100. Joan Miró, reply to an inquiry, *Cahiers d'art* 14 nº 1–4 (April–May 1939): 73; Miró, *Selected Writings and Interviews*, 166.

101. 'dégage le même pathétique que de la négation éperdue du chasseur dans le chant d'amour du coq de bruyère.' Breton, 'Joan Miró "Constellations"' (1958), *Le Surréalisme et la peinture*, 263.

102. Reality appears only as marginal, states Lacan. Strictly speaking, the Real is unrepresentable, but as death (absence) it none the less haunts the symbolic: 'reality, foreclosed as such in the system, and entering into the play of the signifiers only in the mode of death'. Lacan, 'On a Question Preliminary to Any Possible Treatment of Psychosis', *Ecrits. A Selection*, 196.

103. Lacan, 'Actes du Congrès de Rom', *La Psychanalyse* 1 (1956): 251, cited in David Macey, *Lacan in Contexts* (London: Verso, 1988), 46.

epilogue

1. 'Qui sait si, de la sorte, nous ne nous préparons pas quelque jour à échapper au principe de l'identité?' André Breton, 'Max Ernst' (1921), *Oeuvres complètes*, 1: 246; *What is Surrealism? Selected Writings*, 8.

2. Elisabeth Roudinesco, the author of an authoritative intellectual biography of Lacan, reminds us that 'the surrealist experience brought to light, for the first time in France, a conjuncture of the Freudian unconscious, language and the decentring of the subject, which would very largely inspire the formation of the young Lacan' ('l'expérience surréaliste met au jour, pour la première fois en France, une rencontre entre l'inconscient freudien, le langage et le décentrement du sujet, qui va très largement inspirer la formation du jeune Lacan' Elisabeth Roudinesco, *La Bataille de cent ans: Histoire de la psychanalyse en France*, vol. 2 (Paris: Seuil, 1986), 42. On Lacan and the surrealists, see also Carolyn Dean, *The Self and Its Pleasures: Bataille, Lacan, and the History of the Decentered Subject* (Ithaca and London: Cornell University Press, 1992).

3. These issues surfaced interestingly at the time of the *L'Amour fou: Photography and Surrealism* exhibition (Corcoran Gallery of Art, Washington, August–October 1985) which had, I think, as an explicit agenda to recuperate surrealism to poststructuralism. A major stumbling block in that project proved to be the treatment of the female body in surrealist photography where a relentless fetishisation rather took the shine off these works in the eyes of Hal Foster, 'L'Amour faux', *Art in America* (January 1986): 116–28 and an indignant Rudolf Kuenzli in 'Surrealism and Misogyny', *Dada/Surrealism* nº 18 (1990): 17–25. Rosalind Krauss returns to questions raised at that time in her most recent book, *Bachelors* (Cambridge, Mass. and London: MIT Press, 1999).

PHOTOGRAPH CREDITS

Marti Catala, figs 73, 116, 119; © 1999, Art Institute of Chicago, All Rights Reserved, fig. 62; © Musée National d'Art Moderne, Centre Georges Pompidou, Paris, fig. 43, 118; Jean-Loup Charmet, fig. 28; Chelsea College of Art & Design, London (photo Donald Smith), fig. 25; Vincent Everarts, fig. 95; Freud Museum, London, fig. 99; Enrique Juncosa, fig. 8; MAN International Arts Holding Corporation, frontispiece; © Man Ray Trust/ADAGP/Telimage, Paris – 1999, fig. 128; © 1988 The Metropolitan Museum of Art. Photograph by Malcolm Varon, fig. 78; Musée du Grenoble, figs 18, 127; Museo Nacional Centro de Arte Reina Sofia Photographic Archive, Madrid, fig. 79; © 1995 The Museum of Modern Art, New York, fig. 117; © 1999 The Museum of Modern Art, New York, figs 2, 15, 50, 51, 75, 110, 120, 126; © 2000 The Museum of Modern Art, New York, figs 59, 60; Oeffentliche Kunstsammlung Basel, Martin Bühler, fig. 10; © Photo RMN – figs 54 (photo R G Ojeda), 56 (photo R G Ojeda/P Néri), 57, 58, 72 (photo Béatrice Hatala), 76 (photo Hervé Lewandowski), 79, 91 (photo Béatrice Hatala), 111 (photo J G Berizzi), 114; © Photo RMN – Picasso, figs 52, 55, 67, 68, 69, 70, 71, 74; Photograph © 1999 The Solomon R. Guggenheim Foundation, fig. 104; Sotheby's, fig. 30; © Tate Gallery, London 1999, figs 34, 37, 61, 85, 92, 100, 113.

reproduction rights

© Salvador Dalì - Foundation Gala-Salvador Dalì/DACS 2000, frontispiece and figs 63, 78, 81, 85, 94, 95, 99, 100, 104, 108, 109; © Salvador Dalì Museum, Inc., figs 82, 83, 84, 87, 89, 90, 93, 96, 97; © ADAGP, Paris and DACS, London 2000, figs 1, 2, 3, 4, 5, 6, 7, 9, 11, 12, 14, 15, 16, 17, 18, 19, 20, 21, 22, 23, 24, 25, 28, 29, 32, 34, 35, 36, 37, 38, 39, 40, 41, 43, 44, 45, 46, 48, 61, 73, 88, 110, 111, 112, 115, 116, 118, 119, 121, 126, 122, 123, 124, 125, 127, 129; © FLC/ADAGP, Paris and DACS, London 2000, fig. 10; © DACS 2000, fig. 103; © ADAGP, Paris and DACS, London 2000 (for Tanguy and Mirô) © Man Ray Trust/ADAGP, Paris and DACS, London 2000, fig. 120; © Man Ray Trust/ADAGP, Paris and DACS, London 2000, figs 31, 128; © Succession Picasso/DACS 2000, figs 50, 51, 52, 53, 54, 55, 59, 60, 62, 64, 65, 66, 67, 68, 69, 70, 71, 72, 74, 75, 91; © Succession Picasso/DACS 2000 © Salvador Dalì - Foundation Gala-Salvador Dalì/DACS 2000, fig. 76; © The Henry Moore Foundation, fig. 92; © Foundation Garcìa Lorca, Madrid/DACS 2000, fig. 107; Cecil Beaton photograph by courtesy of Sotheby's London, fig. 108.

INDEX

Note: Page numbers in *italics* refer to illustrations.